"Using the opera musical genre, Jean Derricotte-Murphy has put together a hermeneutic for capturing the presence of the Lord from a Womanist perspective with clarity about who the Lord is, how the Lord is, and where the Lord is at work in the lives of people and the world through all of the scenes, situations, and stages of life whether good or bad, happy or sad, sick or healthy, impoverished or abundant."

—**WILLIAM S. EPPS**, senior pastor, Second Baptist Church Los Angeles

"Jean Derricotte-Murphy has indeed written her magnum opus, her masterpiece, from her unique perspective as a Black woman, educator, theologian, ordained minister, opera singer, and as a Womanist to her core. She provides a 'Balcony Hermeneutic' of the oppression of Black diasporic humanity through the lens of opera. New ground is indeed plowed, cultivated, and harvested in this theological gem. Brava!"

—**MARSHA FOSTER**, president emerita,
Ecumenical Theological Seminary

"At last, we have research that interrogates elite concert hall box seat aspirations through what Jean Derricotte-Murphy astutely coins as a 'Balcony Hermeneutic.' The balcony is one of the most contested spaces in both performing arts and Black religiosity throughout US history. This research reveals the fantastic hegemonic imagination about the ways in which power is asserted when the prism of intersectionality is considered within our racially segregated past."

—**ALISHA LOLA JONES**, associate professor
of music, University of Cambridge

"Jean Derricotte-Murphy's *A View from the Balcony* is a 'Grand Opera' orchestration of insurgent Womanist intelligence in multiple keys, building on a base beat of Black Performance Theory and Mvengain anthropological critique, embroidered in personal solo riffs to give a new score to an old tune. Syncopating the tired metronome of American-style racial, patriarchal classist, etc., domination through a balcony-cadence of bombast, throw-down, and send-up, Derricotte-Murphy's aria sounds out the amnesiac 'white' depths of the art form and re-opens this stage to its underground voices of beauty."

—**JAMES W. PERKINSON**, professor of social
ethics, Ecumenical Theological Seminary

A View from the Balcony—
Opera through Womanist Eyes

A View from the Balcony— Opera through Womanist Eyes

Praxis for Developing a Balcony Hermeneutic of Restorative Resistance

Jean Derricotte-Murphy

Foreword by JoAnne Marie Terrell

CASCADE *Books* · Eugene, Oregon

Cascade Books
An Imprint of Wipf and Stock Publishers
199 W. 8th Ave., Suite 3
Eugene, OR 97401

www.wipfandstock.com

PAPERBACK ISBN: 978-1-6667-7224-1
HARDCOVER ISBN: 978-1-6667-7225-8
EBOOK ISBN: 978-1-6667-7226-5

Cataloguing-in-Publication data:

Names: Derricotte-Murphy, Jean, author. | Terrell, JoAnne Marie, foreword.

Title: A view from the balcony—opera through womanist eyes : praxis for developing
 a balcony hermeneutic of resistance / Jean Derricotte-Murphy ; foreword by JoAnne
 Marie Terrell.

Description: Eugene, OR : Cascade Books, 2024 | Includes bibliographical references
 and index.

Identifiers: ISBN 978-1-6667-7224-1 (paperback) | ISBN 978-1-6667-7225-8 (hardcover)
 | ISBN 978-1-6667-7226-5 (ebook)

Subjects: LCSH: Womanist theology. | African American women—Religious life. | Mu-
 sic—Religious aspects. | Art and religion.

Classification: BT83.9 .D47 2024 (paperback) | BT83.9 .D47 (ebook)

VERSION NUMBER 08/14/24

Permissions

Dedicated in loving memory to:

My parents, The Reverend Roger P. Derricotte and Barbara Epps Derricotte, who instilled in me a love for the Creator, knowledge, people, and the Black Church.

My mother-in-love, Leola T. Murphy, who supported and encouraged my every educational pursuit.

My maternal grandfather, The Reverend Doctor William A. Epps; uncles, The Reverend William A. Epps Jr. and The Reverend Doctor Charles T. Epps Sr.; cousins, The Reverend Ashford Epps Hunter and Doctor Charles T. Epps Jr., who each modeled before me scholarship and compassion in the love and care of all God's people.

Octavia Derricotte, my paternal great-grandmother, and Hattie Pearl Epps, my maternal grandmother, who modeled before me proto-Womanist strength, faith, and fortitude despite discrimination. To my paternal grandmother, Bessie, who died before I was born, Delphia, my enslaved great-great-grandmother, and the unnamed African ancestral women and men who survived the Middle Passage to thrive despite American slavocracy.

I stand on your ancestral shoulders.

Doctor Marilyn A. Thompson, soprano and voice teacher par excellence, who discerned and nurtured my tripartite calling as the singer/artist/scholar I would become before I knew this me existed. Thank you.

The Reverend Doctor Jerrolyn S. Eulinberg, Womanist scholar, colleague, friend, and encourager, gone too soon. Following in your footsteps, your book became my model and my inspiration.

Doctor Delores S. Williams, teacher, mentor, and friend, who personally introduced me to Womanist Theology during its formation. You gave me a theological place to land as a Black woman in America, pondering the question you asked in every class, "Who do *you* say God is?" For your faith in my ability as a scholar, your gentle yet firm nudge to pursue more than I dreamed

I could, and for reminding me to tell my story. This book is built upon the Womanist praxis and methodology I learned at your feet. Thank you.

Minister Carla Carrington, my daughter in ministry, who persistently prodded in almost every phone conversation, "Jean, when are you going to write your book?" Carla, here is the book.

Contents

Foreword

FROM THE PERSPECTIVE OF her own tri-dimensional experiences as a professional opera singer, ordained minister, and longtime educator, Jean Derricotte-Murphy has articulated a thought-provoking work, *A View from the Balcony—Opera through Womanist Eyes*. Centering Black women's artistry and experience and utilizing novelist Alice Walker's Womanist rubrics,[1] Derricotte-Murphy critiques the history of exclusion of African Americans from the rarefied halls of the opera house amid class-bound assumptions concerning the social desirability of Black operagoers. Black people who simply enjoyed opera were, in the modern era in our nation's history, automatically relegated to seating in balconies, regardless of their financial fitness or social standing. Derricotte-Murphy also examines the "multi-dialogical, liturgical, and didactic intent"[2] of Toni Morrison's womanish work as the librettist for Richard Danielpour's opera *Margaret Garner*, which was loosely based on the true story of a runaway slave who killed her two children rather than subject them to lives of servitude and utter denigration. Garner was a proto-Womanist, whose celebrated resistance to social, cultural, and religious norms comports with Walker's rubrics, which include descriptions of womanish Black women such as "outrageous, audacious, courageous . . . *willful* . . . Responsible. In charge. Serious," and the analogy, "Womanist is to feminist as purple is to lavender," which invokes an intensified, racially charged, class-bound experience of sexism.

In keeping with the Womanist ethic of inclusivity ("not a separatist, except periodically, for health"), Derricotte-Murphy also employs the theological and artistic lenses of the well-beloved Cameroonian theologian,

1. Walker, *In Search of Our Mothers' Gardens*, xi–xii.
2. Williams, "Womanist Theology," 69.

historian, anthropologist, and charter member of the Ecumenical Associa-
tion of Third World Theologians (EATWOT), the late Engelbert Mveng, SJ
(1930–1995). Himself a world-celebrated visual artist, Father Mveng coined
the term "Anthropological Poverty" to describe the unrelenting economic,
religious, spiritual, and cultural immiseration of continental and diasporic
African peoples during the Trans-Atlantic slave trade from the sixteenth to
the nineteenth centuries, nearly four hundred years' worth of evidence of its
failed original intent to traffic Black bodies in perpetuity. The entire sordid
colonial and imperial history of the Western Hemisphere and Pacific Rim
includes the systematic theft of native peoples' lands and natural resources,
of African peoples' freedom, dignity, and humanity, as well as the creation
of a color caste system and a concomitant metrics of exceeding worth based
on proximity to whiteness. During and since the end of the slave trade, Eu-
ropeans willfully arrogated to themselves the standards of beauty, morality,
intellect, and culture, so that well into the era of postmodernity, millions, if
not billions, of once-free human beings are still enslaved, both to the ide-
ology of their own inferiority and to the presumptive superiority of their
European captors. To these truths of Black peoples' daily, ongoing existence,
Mveng proposed that art can be utilitarian, if it bespeaks alliance with life.[3]

It is this understated "alliance with life" that is the power of *A View
from the Balcony*, which the author affirms through her re-valuing of this
limitation placed on earlier Black audiences. Although commonly regarded
as undesirable seating, far from proximity to the stage, balconies nonethe-
less provide empowering, panoramic views of onstage activities, and grant
a degree of immunity from restrictive policies to the audience, which can
make an impact on the performance and performers.

Perhaps even more enduringly, *A View from the Balcony* enshrines
Black women's stories in the collective unconscious as examples of ex-
traordinary courage and self-direction in response to their often-hostile
contexts. While utilizing the tools of Womanist/Black Feminist Anthropol-
ogy/Ethnology, as well as Black Performance Studies, Derricotte-Murphy's
work distinguishes itself as one of methodological rigor and artistic merit,
as it raises up the pressing issue of the role of creative self-expression in
the ongoing work of survival and liberation. The didactic intent of her
book, through its rigor, organization, and accessibility, is both apparent and
a reflection of her deep sense of vocation as a teacher for the academy as
well as the church. Situating herself in the historical and ongoing collective
experience of slavery and discrimination, and critiquing the canons of art,
Derricotte-Murphy's book nonetheless joyfully affirms a range of *tastes* in

3. Mveng, *Afrique dans l'Eglise*.

the African American experience, and equally importantly, celebrates her own and others' musical gifts. Art, like beauty, is in the eye, ear, and heart of the beholder, hearer, and lover.

JoAnne Marie Terrell, PhD, LHD
Chicago Theological Seminary

Acknowledgments

THERE HAVE BEEN MANY supporting cast members and backstage crew in the production of this book. To name them all would be a short dissertation, but I thank everyone who supported me during this project. However, it is necessary to give special recognition to the following people.

I express my utmost gratitude and love to my family: my children and grandchildren, but especially to my husband of fifty-four years, Terry A. Murphy Sr. His patience, understanding, encouragement, love, and support give me the space and time to write, never complaining but instead providing a caring, quiet environment (sometimes preparing a meal) so I can study, research, and write. Thank you for letting me find and be my continually transforming self.

For helping me realize a lifelong dream and pointing me to Chicago Theological Seminary in its pursuit, I thank The Reverend Doctor Marsha Foster. You have been a coach, prayer partner, and dear friend, recognizing in me more potential than I was willing to claim for myself. Thank you for not letting me give up on that dream when life presented challenging obstacles.

For engaging me in meaningful conversations around colonialism and its devastating aftereffects on the African American church and community, I am thankful for The Reverend Doctor Jimmie T. Wafer, my pastor, friend, and brother. Thank you for your prayers and for allowing me space to preach, teach, apply my theories, and create and enact rituals of remembrance within the Black Church.

During moments of discouragement, there were always those sister girlfriends who listened, understood, and wouldn't let me give up while praying me through an impasse: Dr. Sherry Dukes Williams, soprano and my *Porgy and Bess* touring partner; longtime friend Minister JoyAnne

Amani Richardson, concert pianist, accompanist, and composer; and Minister Peggy Davis, prayer partner, and pound cake provider. You are God-sent blessings who stand with me on spiritual and musical stages. Thank you for watching from the wings with the score in hand, ever ready to prompt with encouraging words that keep me on task.

I am indebted to Doctor Elenore Glass, adjunct professor and clinical instructional coach at Wayne State University in Detroit, Michigan, who acted as my second set of eyes, helping me to clarify and articulate my theories for this research. Special thanks to Doctor Terese Volk Touhey, associate professor of music emerita from Wayne State University in Detroit, Michigan. These scholar-friends were just a phone call away, ready with encouraging and astute observations concerning this work which enabled me to articulate my position and theories clearly.

Much appreciation goes to the director of the Learning Commons at Chicago Theological Seminary, Yasmine Abou-El-Kheir, for helping me access library resources while off campus and locating scholarly articles needed to enhance this research.

Special thanks to two Womanist theologians who offered encouragement and support and whose scholarship grounds this work. I am grateful to The Reverend Doctor Linda E. Thomas, Womanist theologian and professor of theology and anthropology at the Lutheran School of Theology at Chicago, for your time, advice, and wisdom shared during our conversations and for serving on my PhD committee. Your research and experience around ritual in an African American context underpins my research and inspires me to do ritual work within my context. I'm also grateful to my dear friend The Reverend Doctor JoAnne Marie Terrell, the Kenneth B. Smith Sr. Professor of Public Ministry and associate professor of theology, ethics, and the arts at Chicago Theological Seminary. Not only did you serve as my PhD advisor, but you introduced me to Engelbert Mveng's theory of anthropological poverty and helped bridge the connections between theology and the performing arts. Thank you for going beyond your academic responsibilities and becoming a true friend, supporting me during traumatic life experiences, and never letting me lose sight of my goals, even when they seemed unattainable.

I'm grateful for that core group of friends and colleagues, otherwise known as the Balcony Focus Group, who read the first draft of this book, giving honest opinions, thoughtful critiques, and suggestions. You helped me identify and clarify the intent of this work. This book could not have been completed without your support and encouragement: Reverend Doctor Denise Henderson, Reverend Doctor Jacqueline Nelson, Reverend

Doctor Douglas Nabor, Reverend Cheré Nabor, Reverend Doctor Jimmie Wafer, Reverend Donald Pailen, Esq., and Mr. Terry A. Murphy Sr.

A special thanks to Mr. Bryce Rudder, the digital asset manager of the Detroit Opera House. Despite having the server go down, you spent valuable hours searching through archived photos of *Margaret Garner* (2005) and *Porgy and Bess* (2006) by hand to locate appropriate images as historical evidence of my participation in these productions. I am grateful for your quick response and resolution to my request. Thank you.

Many thanks to my colleague and Grammy Award winner Kenneth Overton (kennethoverton.com), baritone, and host of *Black Opera Live*. That you took time from your busy performance schedule to update my list of African American composers and librettists, so it now includes newer operas planned for production through 2025, is not taken lightly and is greatly appreciated.

I appreciate The Reverend Doctor Raedorah C. Stewart (iWriteSolutions.com) for seeing me through two major writing projects. More than *just* an editor, you are my cheerleader and prayer warrior who talks me through periods of writer's block, encouraging me to keep writing. Thank you for reminding me that my work is sacred, indeed.

To the Creator, the Supreme Spirit, who has "transformed me by the renewing of my mind" throughout this process and taught me to pray to and worship *Gye Nyame*—your holy name in Twi, the uncolonized tongue of the Akan people of Ghana, West Africa. Thank you, Gye Nyame, for creating this art form called opera and for allowing it to touch the lives of audiences and performers alike. Thank you, Gye Nyame, for allowing me to see the world through this artistic medium called opera and for never ceasing to be the Creator who does exceedingly above and beyond anything I can imagine, continually surprising me.

Introduction: Dress Rehearsal

Places!

"For I know the plans I have for you," says the LORD. "They are plans
for good and not for disaster, to give you a future and a hope."

—*JEREMIAH 29:11 (NLT)*

Places!

*Saturday, May 7, 2005. The Detroit Opera House is poised to
launch its very first world premiere production. Intense excite-
ment permeates the opera house. Every voice is warmed up, every
instrument tuned: composer to librettist, principals to chorus. The
house is packed; the stage manager calls, "Places"; the conductor
raises his baton; and the overture to the opera* Margaret Garner
*begins. As the curtain rises, I proudly stand on this stage, part of
the chorus of this premier performance of a twenty-first-century
American opera written by an African American woman libret-
tist, Toni Morrison, and assume the persona of an enslaved wom-
an of African descent living in antebellum Kentucky in 1856. I
blend my mezzo-soprano voice with the other voices in the "slave"
chorus to tell the story of our ancestors—the mournful laments
and solemn prayers of a people with bondage on their backs and
freedom on their minds. It is concomitantly a daunting task and
a personally proud moment to don the costume of a slave and
portray the indomitable spirit of enslaved Black women living in
nineteenth century America.*[1]

1. My personal reflection of what has become my seminal academic and perfor-
mance work, and onus of this research.

1

THIS EXPERIENCE ENGULFED ME, pulling me inside the multifaceted story unfolding onstage. Not only did *Margaret Garner* present the history of slavery in America to audiences through a contemporary performance, but it also reflected the history of Black people in America, generally, and in American opera, specifically. I was struck by the grievous history of American opera as it perpetuated insidious, incestuous systems of exclusion, racism, and bigotry. Yet, each of us standing on that stage was a living, breathing, singing symbol of resistance to a racist, patriarchal, imperialistic system of oppression and segregation practiced in this nation and articulated within the artistic genre of opera. Being a member of this performance was in itself an act of resistance.

Through this and similar operatic experiences over several decades, I engaged this research as a participant observer informed by autoethnographic evidence of my tripartite Womanist experiences as an opera singer, educator, and ordained minister. I am an eyewitness to opera's influence on performers and audiences alike. Critically examining and curating personal experiences, I contend that opera is a form of social drama and resistance theater that can affect activists and allies, effect social change, and initiate healing for wounded psyches of descendants of formerly enslaved and colonized peoples. Further, the relevance of opera interpreted with theological reflection serves as a corrective discourse against negative narratives and stereotypes about Black people propagated by the dominating culture and American theological anthropology.

Statement of the Problem

This theological and cultural analysis explores ways opera exists as a dissenting voice and countercultural form of resistance aimed at "shift(ing) the intellectual paradigm"[2] and effecting a "Shift of the Gaze"[3] of Western epistemological understandings that have historically denigrated and oppressed Black and brown people in the United States to recognize empirical evidence of this phenomenon through performing arts—specifically, opera. Framed by opera's artistic genre to critique how African Americans have been regarded and disregarded in society, this research takes a "Balcony View" of American history through the lens (opera glasses) of operatic performances and the history of opera in America. As such, opera glasses inspect and critique social, sociopolitical, class, and systemic racism inflicted upon African Americans tooled to denigrate, oppress, and force Black and brown people

2. Cannon, *Katie's Canon*, 24.
3. Terrell, *Shift of the Gaze*.

to subvert their African cultural ethos. Systemic oppression erroneously interpreted African bodies, being, and cosmology as demonic and caused diasporic Africans to suppress authenticity, restrict embodied fullness, and thereby suppress artistic expressions, cultural celebrations, and religious practices.

Engelbert Mveng's theory of "Anthropological Poverty"[4] is the foundational basis for examining African Americans' perception, practice, and performance within American opera. Mveng's theory argues that European colonizers ignored and denigrated indigenous cosmologies, cultures, and spiritualities to subsume and eradicate African cosmology, art forms, spirituality, rituals, and languages among the peoples on the continent of Africa and in the Diaspora. According to Mveng, this myopic, demonic[5] Eurocentric worldview created a type of poverty for diasporic Africans that is far greater and more psychologically damaging than economic poverty. I hold this same theory can be applied to descendants of enslaved Africans in the Americas whose enslavers attempted to strip all vestiges of Africanity and humanity and further propose opera as an effective tool to reverse the aftereffects of Mveng's substantiated Anthropological Poverty.

Through a Womanist anamnestic approach, this work qualitatively investigates how the forced imposition of dominant Western cultural norms and values upon diasporic Africans has affected how African Americans view, create, and re-create ourselves, our culture, arts, and religious practices. Developing a "Balcony Hermeneutic" and naming the "Balcony Perspective," this work employs an ontological approach to peer through metaphoric opera glasses—brought into focus by my Womanist theological lens—to investigate how anthropological impoverishment of diasporic Africans affects individual and communal appreciation, acceptance, and performance of the arts—particular to this study, opera.

Additionally, this work investigates and demonstrates how African Americans use opera as resistance strategically to thrive within a genre of performing arts that has historically ostracized and obstructed their artistic participation. As a means to refute the widely held negative stereotypes propagated against diasporic Africans in the Americas since being forcibly

4. This premise of Anthropological Poverty is developed by Mveng in *Art d'Afrique Noire*.

5. Throughout this research I use the term *demonic* based on the work of Womanist founding mother and scholar Delores S. Williams, who identifies and develops the concept of demonarchy in her paper "Color of Feminism: Or Speaking the Black Woman's Tongue," as the way in which institutional white rule controls Black women's lives and bodies using "racism, violence, violation, retardation and death as instruments of social control" (51). Williams, "Color of Feminism," 42–58.

brought to this continent in 1619, Black performing artists have long embraced and performed instrumental and vocal European-influenced classical art forms.

An Anamnestic Approach: Sankofa

America suffers from "historical amnesia,"[6] purposefully forgetting and intentionally minimizing diabolical truths about the founding of this nation. As a fledgling nation, America sought to form a national and cultural identity separate from European influence. Yet, it is opera—once considered a form of European high cultural theater—as it evolved into a medium of American entertainment, society, and culture that becomes a way to expose and critique public discourse around race and the development of racist and separatist ideologies, pedagogies, and epistemologies.

A brief but thorough anamnestic investigation of the history of racism in American culture, unobstructed through the medium of opera, exposes how Anthropological Poverty American-style was shaped and affected white Americans' perceptions of Black and brown-skinned people. Unearthing opera's racist roots lays bare the prejudicial treatment of Blacks in the nation and in opera and also reclaims the art form for and gives full permission to African American performing artists to exercise their right of creative self-expression in and through opera.[7] Through mastering operatic performance, stage presence, performed and written critiques of the Euro-focal dominant culture, opera singers become models for other African American artists to survive and thrive in hostile social, professional, and cultural environments.

Understanding anamnesis[8] to be a tool of memory retrieval in the promotion of psychological healing, this work contends that a thorough historical recollection, or a Sankofa moment[9] through cultural anamnesis,[10]

6. Rains, "Indigenous Knowledge," 317–31. Rains, a First Nations scholar and educator, documents incidents of American historical amnesia of its treatment of indigenous people since European "settlers" arrived in the Americas and through their westward expansion.

7. Terrell, *Power in the Blood?* Here, Terrell names the goals of *survival, liberation,* and *creative self-expression* as governing norms in Womanist Theology.

8. Terrell, *Power in the Blood?*, 126–27.

9. *Sankofa* is the West African notion of retrieving past wisdom and experiences for building a future. Its Adinkra symbol is usually a bird looking backwards with an egg in its mouth while walking forward.

10. Terrell, *Power in the Blood?*, 126. Terrell posits that anamnesis is a "painful yet necessary (experience) for the healing/wholeness of the psyche." She holds that a

is required to heal historical national and Cultural Amnesia;[11] and that this anamnesis can be initiated through the examination of opera as a genre of artistic performance. Womanist anamnesis interrogates multiple traumas inflicted upon Black women and the entire Black community by racism, sexism, homophobia, heterosexism, and classism by recreating necessary, albeit often painful, memories essential to personal and communal healing.[12] Consequently, the considerable emphasis of this work is evaluating and analyzing the opera *Margaret Garner* written by Richard Danielpour and Toni Morrison (2005). This twenty-first-century opera's principal character is an enslaved Black woman, and it recreates a particularly loathsome era in American history to examine national cultural attitudes as portrayed in the treatment and embodiment of the principal female character.

Guiding Questions

Questions that guide and direct this work are: How can being restricted to the balcony of church, theater, and society offer a different experience of an artistic performance or daily existence as distinct from having full access and proximity to the onstage performance/activity? What agency does the Balcony audience have? In what ways does the Balcony audience influence the experience of the artistic performance for other attendees? In what ways does the Balcony audience impact the performance itself? Is it possible to reimagine an oppressive practice into a "Balcony Hermeneutic" designed to (a) decolonize the historical mind, (b) combat continuing systemic American racism, classism, and the lingering effects of Anthropological Poverty, (c) shift the social milieu, and (d) create a healing movement utilizing art and art theory?

How I Enter

Kenyan anthropologist Mwenda Ntarangwi takes an unprecedented personal look at American anthropology through his eyes as an African/Third World anthropologist, or as he says, through his "Reversed Gaze"[13] looking from the inside out to critique Western anthropology. Because anthropologists

complete and honest anamnesis, or a thorough looking at the source of the problem, is required for healing the wounded psyches of the entire community.

11. Holmes, *Joy Unspeakable* (1st ed.), 81.

12. Terrell, *Power in the Blood?*, 126.

13. This term is the developed premise of Ntarangwi in his seminal work, *Reversed Gaze*.

and ethnologists rarely study their own communities, he posits that it is necessary for an insider/outsider to become a "participant observer"[14] to scrutinize the sometimes questionable practices within American anthropology that continue to employ racist and hegemonic procedures and standards, particularly as they pertain to how African peoples and cultures, whether on the Continent or in the "American metropolis,"[15] are viewed and studied.

Similar to Ntarangwi's *Reversed Gaze* is Cheryl Rodriguez's concept of "Native Anthropology,"[16] which gives permission to the researcher to do ethnographic studies of and at home and to do research within one's own society and culture. These perspectives establish parameters for my location in this research—a native-participant-observer, African American woman, and opera singer. Emphatically so, my "personal history, self-identity, . . . ethnicity, kinship, social class [and] gender"[17] organically inform this project. As an opera-singing, preaching, teaching, Womanist theologian and scholar privileged to have performed in opera houses in the United States, Japan, and across Europe, I am uniquely positioned to observe from within the structure of the opera chosen for this discourse—*Margaret Garner.*[18]

My embodied research is primarily influenced by Ntarangwi's approach to the reversed gaze. As a theological and ethnological study, this project assumes the reversed gaze on American opera using "opera glasses" as a symbolic and metaphoric lens to critique racist practices inherent within this entertainment genre. By exploring the adverse effect of Mveng's Anthropological Poverty[19] upon African American's perception, practice, and performance in American opera, I contend that opera has the potential to foster theological reflection; is a practical medium to challenge and transform socially accepted racist rhetoric; and initiates ritual healing for the wounded psyches of descendants of enslavers and the formerly enslaved and colonized peoples.

14. Ntarangwi, *Reversed Gaze*, xi.

15. Ntarangwi, *Reversed Gaze*, xii.

16. Rodriguez, "Home Girl Goes Home," 235.

17. Rodriguez, "Home Girl Goes Home," 235.

18. *Margaret Garner*, a two-act opera, is based on the life of a runaway enslaved woman. African American mezzo-soprano Denyce Graves was the major principal in the first performance at the Detroit (Michigan) Opera House in May 2005. Black woman, Nobel and Pulitzer Prize winner Toni Morrison is the librettist; and American Richard Danielpour is the composer. I was privileged to be cast as a member of the Black slave chorus.

19. Mveng, "Paupérisation et Développement en Afrique."

Qualitative Research Methodologies

This work is an anamnestic Womanist reflection on the historical contexts of oral and written literary traditions of Black women survivors of multiple oppressive experiences—enslavement, reconstruction, Jim and Jane Crow, and the New Jim Crow[20]—by engaging creative means of survival and expressing their faith in the Divine through musical artistry and vocal performance. To mine these social contexts, a qualitative interdisciplinary tripartite approach that interweaves Womanist Theology, Black Feminist and Womanist Anthropology, and Black Performance Theories is employed to investigate Mveng's theory of Anthropological Poverty as it applies to how African American women are perceived and portrayed in opera productions from the antebellum era to performances in the twenty-first century. Amplifying this countercultural voice decolonizes, deconstructs, and decenters Westernized epistemologies of knowledge production. It further corrects the effects of Anthropological Poverty's colonialistic, hegemonic narratives imposed upon African American peoples. This new voice, introduced to the scholarship and performance of opera, evolves from this tripartite approach.

Opera Glasses: Womanist Theology

Emerging in the 1980s, Womanist thought spans the breadth of academic movements of African American women. The rigors of theological education compelled a Womanist Theology to speak our particular language apart from feminist and Black liberation theologies. Thus was born Womanist Theology. It recognizes African American women's tripartite and multidimensional oppression—racism, sexism, classism, ageism, and ableism—as unique barriers to women of color. While Black women are the main subject, Womanist Theology seeks the wholeness of the entire community: male and female, young and old, heterosexual and homosexual. Womanist Theology critically re-examines biblical texts for Eurocentric and patriarchal interpretations and teachings that continually oppress Black women and the African American community.

Further defining Womanist Theology, dean of the Vanderbilt Divinity School and professor of Womanist Ethics Emilie Towns explains:

> Womanist theology . . . was born in the womb of Black women's experiences and has been cultivated throughout history. Womanist theology employs materials by and about Black

20 Michelle Alexander, *The New Jim Crow.*

foremothers as resources for contemporary reflection that provide a conscious background for God-talk. Rather than assume the universal claims of traditional theologies, womanist theology acknowledges that all theological reflection is limited by human cultural, social, and historical contexts. These limits are not negative, but merely representative of our humanity.[21]

My Womanist theory and Christological understanding for this research are informed by methodologies developed by founding ancestral Womanist theologians Delores S. Williams and Katie G. Cannon. The curtain for my Balcony Hermeneutic rises on the premise set forth by Williams in *Womanist Theology: Black Women's Voices*. She explains:

> Christian womanist and theological methodology needs to be informed by at least four elements: (1) A multidialogical intent. (2) A liturgical intent. (3) A didactic intent, and (4) A commitment both to reason and to the validity of female imagery and metaphorical language in the construction of theological statements.[22]

Williams erects the structure of Womanist theological methodology upon the foundational praxis that

> Womanist reflection assumes [a] theological task committed to the survival of a whole people. . . . The primary audience for womanist theological work is the African-American community. . . . [While it also] invites nonblack audiences into dialogue . . . [it] searches for the African-American community's understanding of womanhood and God's relation to it.[23]

In key and onstage with Williams's methodology, Cannon's methodology asserts that

> Womanist methodology critically analyzes social-cultural traditions and conflicts in order to burst asunder the dominant understanding of theology and produce new archetypes that release the Afro-Christian mind and spirit from the manacles of patriarchy so that the black woman might emerge and discern just what kind of moral agents we really want to be.[24]

21. Townes, "Womanist Theology," 160.
22. Williams, "Womanist Theology: Black Women's Voices," 69.
23. Williams, "Hagar in African American Biblical Interpretation," 171–72.
24. Cannon, *Katie's Canon*, 111.

With the Black woman forming her own moral agency, Cannon further necessitates the need for (1) "historical reconstruction of black women's history in the United States";[25] (2) Black women's literary traditions which express the ethical character of Black life;[26] and (3) "literary traditions [as] the nexus between the real-lived texture of black life and the oral-aural cultural values implicitly passed on from one generation to the next."[27]

In concert with Williams's theological task and Cannon's literary traditions is Womanist ethicist JoAnne Marie Terrell's anamnestic approach to memory retrieval. As she discusses in her book, *Power In the Blood? The Cross in the African American Experience*, anamnesis is the "retrieval of experience that is painful yet necessary for the healing/wholeness of the psyche."[28] Embracing the multiplicity of African American women's artistic expressions, Womanist cultural anamnesis becomes an agency of theological reflection through the retrieval of the stories of our enslaved ancestors passed down through oral histories, slave narratives, or intuited within our emotional spaces; anamnestic memory can be evoked, massaged, and nuanced by the telling and hearing of personal and communal stories through storytelling, literature, artistic performances, visual arts, and music.[29]

The Balcony View: Womanist/Black Feminist Anthropology/Ethnology

In critique of patriarchal, Western, Euro-centered anthropology, Womanist, and Black feminist anthropologists challenge traditional colonialist, hegemonistic, and racist ideologies that formed the dominant production of knowledge and address questions imposed upon gender, race, sexuality, ability, and class narratives. Developing my Balcony Hermeneutics is my "Reversed Gaze"[30] calling out and correcting errant, dominant narratives about Black bodies. Anthropologist and Womanist theologian Linda Thomas and her ritual use are centering this work.

Thomas posits using "an anthropological methodology [which] encourages womanist religious scholars to embrace the cultural, symbolic and

25. Cannon, *Black Womanist Ethics*, 5.

26. Cannon, *Black Womanist Ethics*, 83.

27. Cannon, *Black Womanist Ethics*, 5.

28. Terrell, *Power in the Blood?*, 126.

29. Terrell, *Power in the Blood?*, 126–27.

30. Ntarangwi, *Reversed Gaze*. Ntarangwi's theory of reversing the gaze of Western anthropology through the lens of an insider/outsider informs the development of my Balcony Hermeneutics.

ritual diversity dispersed throughout the religious lives of [all] women of color."[31] This celebratory emphasis on Black women's lives liberates my hermeneutic to (1) "validate past lives of enslaved African women by remembering, affirming, and glorifying their contributions"; (2) "excavate, analyze, and critically reflect on life stories of our foremothers"; and (3) gather data from the "ideas and actions of past centuries (generations) to reconstruct knowledge."[32]

Furthermore, the activist and native anthropologies of Black feminist anthropologists Irma McClaurin[33] and Cheryl Rodriguez[34] equip me to critique the imposition of Anthropological Poverty as a restricting and restrictive lens on African Americans, and a lamentably inadequate signifier of the richness of Black lives as principal creators of art and culture.

The Balcony Perspective: Black Performance Theory

The emerging field of Black Performance Studies offers resistance tools to speak in "direct contrast and with a countercultural voice to traditional performance studies."[35] In resistance, I consider instead theories introduced by performance arts professor Soyica Diggs Colbert (Georgetown University) and professor of African American and theater studies Daphne Brooks (Yale University) to anchor the anthropological methodologies of Linda Thomas with Black Performance Theory. Colbert's work looks at Black historiography through the archives of theatrical productions by "Black writers [who] challenged existing historical narratives by inserting their own voices

31. Thomas, "Womanist Theology," 490.

32. Thomas, "Womanist Theology," 491.

33. McClaurin, "Forging a Theory," 1–23. McClaurin proposes the development of "activist anthropologists" to produce a way to "redirect the trajectory of the discipline away from its colonial and racist origins" with the intention of working toward decolonizing anthropology.

34. Rodriguez, "Home Girl Goes Home," 233–57. Rodriguez's native anthropology offers a way for researchers to do ethnographic studies in their own societies and cultures sharing "factors such as ethnicity, kinship, social class or gender" while using their personal history, self-identity, and own perspectives.

35. Bial, introduction to *Performance Studies Reader*, 4. I reference the pioneering works of Victor Turner, Richard Schechner, and Dwight Conquergood for a preliminary discussion of Ritual, Performance Theory, and Performance Studies. The works of Norman Denzin and Henry Bial, though, steer the conversation away from the conventional understanding of performance and ritual and point toward the political and social contexts in which they are now viewed. Bial says that "the major site of scholarship for performance studies in the twenty-first century . . . now consider[s] the perspectives and prospects that take shape, texture and flavor of the times and places [from] which they emerge."

... therefore remaking the very meaning of history."[36] Comparably, Brooks advances that Black Performance Theory is defined against the colonial invention of blackness by opposing and yet simultaneously working within the existing epistemological system through stage and theatrical works that resist and disrupt American anti-Black sentiment.[37] This research, therefore, attempts to work within an epistemological system that continues to hold and act upon anti-Black sentiment within the world of opera by taking a reversed gaze—the Balcony View—upon the challenges of Blacks in American opera and society.

Chapter Overviews

This volume invites the reader to attend a hypothetical operatic performance from the advantaged balcony viewpoint of an imaginary opera house. Each chapter is titled in operatic vernacular to explain the audience's journey and likely experience through an operatic production. As such, the *introduction* or *dress rehearsal* is the final rehearsal or run-through of the show before opening night, with all performers on stage in full costume accompanied by a full orchestra. Here I explain my premise, position, and praxis. The research problem and guiding questions are presented, and the qualitative research methodologies are described. A description of this research's anamnestic approach, the metaphors of opera glasses,[38] Balcony View,[39] and balcony perspective are explained. The reader is introduced to Engelbert Mveng's theory of Anthropological Poverty that is the foundational basis of this thesis.

Chapter 1. Overture is the orchestral introit from which the story unfolds. In this section, I explore how our country has found itself deeply entrenched in the residuals of a five-hundred-year-old edict from the Holy Roman Catholic Church, the Doctrine of Discovery, and how this doctrine of the church has seeded the hate, racism, and white supremacy sanctioned, practiced, and perpetuated by some American "Christians" and churches. It also seeks to show how lies told and manipulated by people in powerful positions can be believed as truth by the masses and become tools of propaganda to advance destructive, deadly agendas.

Chapter 2: Act 1, Scene 1—Recitative is a solo sung in a vocal style that imitates speech and often explains the plot's anticipated actions and

36. Colbert, *African American Theatrical Body*, 4.
37. Brooks, *Bodies in Dissent*, 3.
38. See photo, appendix A: "Author's Opera Glasses."
39. See photo, appendix B: "Balcony View—Detroit Opera House."

the main characters' actions. In this section, I simultaneously explore how Western/European philosophy and ideologies shaped the American psyche while excavating the Western philosophical underpinnings of colonialism, racism, and literary imperialism. I establish counter-hegemonic epistemologies aimed at reframing and reversing those ideologies through African Sage Philosophy, Womanist and Black Feminist Anthropology, and Black Performance Theory.

Chapter 3: Act 1, Scene 2—Ensemble casts the chorus in four-part harmony to support the principal characters and to develop the storyline. This chapter explores the consequences of colonization from the viewpoint of the colonized. It presents the balcony viewpoint of four indigenous scholars, contrasting Engelbert Mveng's theory of Anthropological Poverty with Enrique Dussel's Political Poverty, Winona LaDuke's Religious Colonialism and Environmental Poverty, and S. Lily Mendoza's Cultural Deracination. Each identifies their people, ancestral tribes, languages, and cosmologies; describes the destruction and generational effects of Western colonization's cultural, spiritual, and physical oppression; and then offers indigenous practical, philosophical, and theological strategies for decolonization.

Chapter 4: Intermission offers audience members and performers a brief time to pause, reflect on previous acts, and prepare for the rest of the performance. This chapter highlights the scholarship of Womanist theologians Barbara A. Holmes, JoAnne Marie Terrell, Linda E. Thomas, and literary giant Toni Morrison to explore how cultural trauma and amnesia are addressed through cultural anamnesis and ritual as a means of healing the collective cultural trauma of African Americans. Morrison's "rememory" and Thomas's "re-member" combines with Holmes's and Terrell's theories to create a metaphoric image for reimagining the terrorizing memories, ancestral and present day, into life-affirming, emotionally healing images to confront the effects of racism.

Chapter 5: Act 2, Scene 1—Trio is harmoniously sung by three principal or supporting characters. After establishing what art is and who determines what can be deemed art, I explore Paul Tillich's Eurocentric theology of art and contrast it with Mveng's African and Terrell's Womanist theologies and theories of art. These become tools for decolonization to facilitate the shifting away from a Eurocentric gaze to recognizing that all art and every individual falls under the "Gaze of God," which offers a healing concept ready to empower the formerly colonized.

Chapter 6: Act 2, Scene 2—Duet, two voices singing a melodious song, setting the stage for the audience/reader to be transported to emotional, social, and spiritual experiences of opera as a spectacular entertainment genre and transformative social drama. This chapter seats the reader

in the balcony of an imaginary opera house, describing the elements of opera, the structure of an opera house, and the links between the history of opera and the systemic institutional racist policies that adversely affect Black and brown people in America. From this Balcony Perspective, the reader discovers that audience members have agency to affect and influence the outcome of a performance and critique the sociopolitical structures of oppression, allowing opera to become an initiator for social change in a non-threatening environment.

Chapter 7: Act 2, Scene 3—Aria is a passionate solo by a principal lead that sets the emotional flavor of the opera. This section on the historical roots of American opera traced through blackface and minstrelsy builds the foundation upon which Mveng's Anthropological Poverty is contrasted with America's racial history. Historical and factual explorations of obstacles Black singers faced and overcame to practice their craft highlight ancestral and contemporary Black female opera singers: Sissieretta Jones, Marian Anderson, Grace Bumbry, and Jessye Norman.

Chapter 8: Act 3, Scene 1—Musical Soliloquy is a brief account of the actual events of Margaret Garner and her enslaved family in antebellum United States, and their attempted but foiled escape in a quest for freedom opens the chapter. I share my personal reflections as a performer in this opera by Toni Morrison, along with my analysis of the libretto and Morrison's genius implementation of what she calls "historical imagination" to portray the faith, resolve, agency, and humanity of a people considered less than human on the stage of American grand opera.

Chapter 9: Finale is the closing act that summarizes the story, its subplots, and its intent. Using a Womanist countercultural and intersectional discourse, this chapter employs Black Genius to describe how Balcony Hermeneutics is birthed out of the need to reverse the devastating effects of Anthropological Poverty, becoming a corrective to European hegemonic, androcentric, xenophobic ideologies and activities. Rituals of Restorative Resistance are the outgrowth of Balcony Hermeneutics.

Conclusion: Curtain Call gathers principal artists, entire cast, and conductor together on stage at the end of the opera in response to the audience's applause. The Balcony Hermeneutic was introduced and infused into the American mindset as a new healing paradigm for the Academy, church, and the arts by telling the un-whitewashed history of America and American racism through an anamnestic view from the balcony. This work has invited the reader on an anamnestic journey through difficult and painful truths of American history presented as an operatic performance. These truths have been presented through grand opera, a non-threatening, artistic entertainment genre allowing the audience/reader to see, feel, and

hear history differently. The voices of the formerly colonized have taken the stage, telling history from their perspectives, indicting the church and governments for the mistreatment, displacement, enslavement, and continued oppression of their people. It has offered a Balcony Perspective suggesting that specifically selected twenty-first-century operas have the potential to become healing agents in a country and society still suffering from cultural and historical amnesia and malignancy as a lingering result of American Anthropological Poverty. The Balcony Hermeneutic realizes that we are all in the same theater regardless of the placement of our metaphoric or actual seats and invites everyone to become "Balcony People" as equal participants in the whole of American society. In revealing how the underpinning of racism and the systemic grip of white supremacy is birthed from the Doctrine of Discovery, this work becomes a tool to combat, resist, and reverse the lingering effects of Anthropological Poverty and racism. Balcony people now gather center stage, hand in hand, for their final bows.

1

Overture

How Did We Get Here?

So, God will cause them to be greatly deceived and they will believe these lies.

—*2 Thessalonians 2:11 (NLT)*

Healing through History: How Did We Get Here?

THROUGH THE COVID-19 PANDEMIC of 2020 through 2023 and the Capitol insurrection of 2021, this nation's prevalent social and religious divisions have been revealed as never before. American politics and the American church are at a crossroads. Will we survive the catastrophic economic, health disparity, and misinformation of 2020 to the present and remain a viable church and country without engaging in deep retrospective and introspective soul-searching? Do we, as a people and nation who claim Christianity, recognize conflicting Christianities and acknowledge what has brought us to this critical point of dissonance and despair? Will the country continually refuse to honestly and critically examine the often invisible, inherent origins embedded within America's founding principles? Or can we truthfully unearth the brutal and intemperate dogmas and teachings derived from the Doctrine of Discovery, evolved into the ideology of white supremacy, and propagated through the teachings of antebellum and post-Civil War preachers widely held and still preached from some pulpits today? How can

those who call themselves preachers of the gospel of Jesus spew hatred and promote division yet claim to preach a gospel of love?

Christianity American-style suffers from historical amnesia. The church feigns ignorance of the colonizing dogmas that underpin its existence. Most Christians in the twenty-first century do not know much about Pope Alexander VI's 1493[1] declaration that the entire world would be subject to Roman Catholic rule to spread the gospel and convert everyone to Christianity. It empowered explorers to "go into all the world, baptizing" at gunpoint any people they encounter and deem non-Christian while failing to recognize other people and cultures' humanity, spirituality, and cosmology.

As a fledging country, the United States considered itself a Protestant nation, yet it readily adopted and adapted the premise of the Catholic Church's Doctrine of Discovery in its formation. How this papal bull still determines the doctrines and teachings of Christianity American-style must be critically examined to understand how America justified its westward expansion through its inhumane treatment and displacement of First Nations People and its enslavement of Africans in the name of God, politics, and economic gain. American Christianity has never, as a body, acknowledged its complicity in these heinous acts, has never repented, and thereby remains arrogant and unrepentant, still seeing itself as innocent of these atrocities.

I feel compelled to present this obscure yet factual information as historical evidence to those still crafting calls and formulating ministries as well as to those with years of experience as pastors and preachers so that they might reexamine the foundations of their faith to better equip themselves to preach a liberating gospel and work toward a more equitable and just society. Examining the philosophies birthed from the Doctrine of Discovery, which created the ethos of Manifest Destiny and fostered colonization and enslavement, will hopefully empower American Christians to critically assess the embedded cultural assumptions of entitlement and violence within Western thought and American theological anthropology. Revealing such truths fosters a dialogue that challenges long-held Western philosophical and theological thought and practices, introducing the voices of indigenous theologians and presenting alternative ways of reading and interpreting scripture.

Modern indigenous theologians and scholars indict the church for its historic role in the colonization and desecration of their people and lifeways since 1492 and the subsequent European invasion of North and South America. This same indictment can be levied against the church in America. The papal bull of 1493 reveals an "other" mentality in how it sanctioned

1. See appendix C: "Pope Alexander VI's Papal Bull, May 4, 1493."

European world dominance in the name of God and Christianity. The result was the desecration, destruction, genocide, and forced assimilation of newly encountered indigenous people, colonizing and stealing African lands and resources while enslaving Africans for economic gain. Invasion of foreign lands and genocide of indigenous people has been encouraged by these blatant misinterpretations of scripture disseminated by papal bulls.

These church documents became the forerunners and legal justification of chattel enslavement of Africans (1619–1865), the Indian Removal Acts (1830),[2] Manifest Destiny (1845), and most recently, "Trump's America" and the culture of whiteness. This same mindset of domination and superiority continues to fuel hateful behaviors. Can a historic anamnestic inquiry, or a Sankofa moment, take us back to the root of this demonic undertaking to examine and understand where this type of hatred began, revealing and reversing the centuries-long influence of an almost forgotten church edict? How can this destructive, demonic doctrine be dismantled?

I question whether or not American Christians know anything at all about the Doctrine of Discovery and challenge that American theological institutions have not, for the most part, examined their foundational underpinnings directly linked to this obscure and little-known ecclesial document upon which the Roman Catholic Church sanctioned its invasion of the non-European world. Or how it emboldened a fledging country to create a missionary project empowered by a self-proclaimed religious authority from Christ to propagate a theology of hate rather than love through its methods of conversion—violence, enslavement, genocide, colonization, and the destruction of cultures, languages, spiritualities, and cosmologies that did not align with European/white sensibilities.

America must face the hard reality that Christianity in America has become a polarized, segregated ecclesiastical body before it can truly move toward becoming a Beloved Community or "the beacon on the hill," as it claimed to be. It must confront the origins of the dogmas of difference, intolerance, and hate within the church in America. This reckoning will be painful yet necessary to usher in the recognition required to bring forth proper awareness, repentance, reconciliation, and restoration. Healing will require a thorough, complete, and honest examination of American history—how religion played a role in the founding and expansion of this nation and how this form of Christianity at its roots was fraught with the ideology of whiteness, hegemony, exceptionalism, nationalism, and xenophobia. To

2. See appendix D: "'On Indian Removal' by President Andrew Jackson" and appendix E: "Indian Removal Act Documents Signed by Jackson."

understand America and Christianity American-style, we must examine and uncover the principles upon which they were founded.

This ecclesiastical and theological blight on the church cannot be rectified without addressing the taproot of racism embedded within it, including in American denominational churches. A critical examination of traditional religious formation and its texts is paramount, acknowledging the nationalism and ideology of whiteness inherent in its teachings. Does the church produce genuinely committed followers of the historical and scriptural Jesus, or a "Jesus" made in the image of white supremacy to soothe the souls of perpetrators and holders of racist practices and principles? This challenges how American Christian exceptionalism and hegemony privilege white people and puts human and environmental sacramentality at stake. A radical change and attitude shift must happen to rectify this historical amnesia. An anamnestic approach to theological education, biblical studies, teaching, and preaching is necessary.

A proposed strategy for addressing this challenge is introducing what I have coined a Balcony Hermeneutic. Introducing this new strategy of critical and postmodern hermeneutical interpretation into the core structure of theological interpretation privileges the voices of African, Asian, Native American, African American, and other indigenous theologians and scholars as primary sources for corrective narratives. As these scholars examine American Christianity's origins and theological anthropology, they examine distortions and misinterpretations of the passage "go into all the world." In dealing with newly "discovered" cultures and people, the church perpetrated violence in the name of God. Outside the long-established canonization of Eurocentric religion placed on the periphery and deemed inferior and demonic by papal decree, it challenges Western classical philosophy and its invention of a racial hierarchy.

This research challenges American historical amnesia by telling a true and corrective narrative by placing the voices of indigenous people and descendants of the formerly enslaved and colonized center stage. I call this approach a Balcony Hermeneutic to bring about healing through history—an audacious Womanist approach that promotes cultural healing through a corrected history.

The Big Lie

What is a lie? It is an untruth, a "false statement made with deliberate intent to deceive."[3] My parents taught me that telling a lie was a sin contrary to

3. *Merriam-Webster*, s.v. "Lie."

God's word and will. In my home, lying was not tolerated. A liberal pun-ishment was handed down when I was caught lying. Having grown up in a Black Christian home where traditional Christian values and principles were taught, I naively believed that these principles were taught in every home where Christianity was professed. So, I tried as hard as I could not to tell lies. I'm not perfect, I didn't always meet the standard, but when it came to substantial, significant issues, I followed this commandment, thou shalt not lie.[4] Didn't everyone?

It became apparent that not everyone adhered to this commandment, not even those who claimed to be Christians. Not only were lies told, but getting away with lies was rewarded. So telling lies is ingrained in the mak-ing and fabric of our society.

Little lies are one thing thought to be harmless. But they lead to big-ger and bigger lies, and big lies are something else. During America's tense political season of 2015 to 2021, largely fueled by Christian nationalism and reprehensible party campaigning, lying became a daily part of the political messaging intended to gain voter support and is now at an all-time high. In the political climate of 2020, the country was divided over "the big lie," predicated on a sitting president's refusal to accept defeat, thus claiming the election was rigged, stolen, and illegal. As a result of this lie, believers staged the January 6, 2021, insurrection. As they have come to be called, election deniers carried these lies and created political platforms for the 2022 mid-term elections, with some winning office.

We continue to be inundated with fake news sources and propaganda years after the incumbent Republican candidate lost the 2020 election and continues to claim it was rigged, stolen, and illegitimate. I have heard the same lies, and wonder why some people embrace them as truth. I wonder what brought us to accept and embrace lies as truth. Why are people so prone to believe lies, especially those who call themselves Christian?

Big lies have happened often enough that the term has a dictionary entry. A big lie is defined as "a deliberate gross distortion of the truth used especially as a propaganda tactic."[5]

> The *big lie* is the name of a propaganda technique, originally coined by Adolf Hitler in *Mein Kampf*, who says "*The great masses of the people . . . will more easily fall victim to a big lie than to a small one*," and denotes where a known falsehood is stated and repeated and treated as if it is self-evidently true, in hopes of swaying the course of an argument in a direction that

4. Exodus 20:16 (NRSV): "You shall not bear false witness against your neighbor."
5. *Merriam-Webster*, s.v. "Big Lie."

takes the big lie for granted rather than critically questioning it
or ignoring it.[6]

The best explanation for this mass following of the lies of a person in power
comes from Adolf Hitler's quote: "If you tell a big enough lie and tell it fre-
quently enough, it will be believed."[7]

Hitler and the Nazi regime used this propaganda tactic to convince
Germans that the Jewish population was worthy of annihilation. A similar
tactic spread and perpetuated racist lies told by an American presidential
candidate and eventual president regarding Mexicans, Africans, and people
from "shithole countries"[8] intended to cause fear and distrust of non-white
citizens and immigrants. I fear something similar can happen in America if
these lies are not confronted and dismantled.

Doctrine of Discovery

As difficult as it has been for some of us to navigate through the political
era of the "big lie" of the twenty-first century, this seems to be a consistent
historical pattern: one entity seeking to gain power and control over another
through lies. Telling political lies to obtain power, position, and territory did
not begin with either of these situations and most likely goes back further
than we can historically trace. The purpose of this research, however, is to
connect these lies to another lie that has existed for more than five hundred
years and which I believe is the culprit for the hatred and oppression that
has afflicted the entire world since the inauguration of the papal bulls in
1493 and 1495.

> Two papal bulls, in particular, stand out: (1) Pope Nicholas V
> issued "Romanus Pontifex" in 1455, granting the Portuguese a
> monopoly of trade with Africa and authorizing the enslavement
> of local people; (2) Pope Alexander VI issued the Papal Bull "Inter
> Caetera" in 1493 to justify Christian European explorers' claims
> on land and waterways they allegedly discovered, and promote
> Christian domination and superiority, and has been applied in
> Africa, Asia, Australia, New Zealand, and the Americas.[9]

What appears to have been a purposeful misinterpretation of Scripture
promoted power for some and subjugation for others. A movement that

6. European Center for Populism Studies, "Big Lie," §1.
7. Buckenmaier, "If You Tell a Big Enough Lie," §1.
8. Dwyer, "'Racist' and 'Shameful.'"
9. Upstander Project Editors, "Doctrine of Discovery," §1.

affected the whole known world and left its path of destruction through lies that bred lies upon lies upon lies is still rendering a world fractured and at war since lies foster hatred and violence against those considered "other." (At this writing, Russia has attacked and invaded Ukraine in an unprovoked assault and a two-year-long war.)

Much has been written about the atrocities perpetrated against native and indigenous peoples based on the self-proclaimed authority of these Holy Roman Catholic Church's papal bulls permitting the conquistadores and explorers to "go into all the world" to "steal, kill and destroy" in the name of God. Most scholarly articles, papers, and books have not trickled down to American Christianity or the average American of any ethnicity except for First Nations people. Member of the Eastern Shawnee Tribe and professor of law at Arizona State University Robert J. Miller explains:

> The United States and most of the non-European world were colonized under an international legal principle known as the Doctrine of Discovery, which was used to justify European claims over the indigenous peoples and their territories. The doctrine provides that "civilized" and "Christian" Euro-Americans automatically acquired property rights over the lands of Native peoples and gained governmental, political, and commercial rights over the indigenous inhabitants just by showing up. This legal principle was shaped by religious and ethnocentric ideas of European and Christian superiority over other races and religions of the world. When Euro-Americans planted their flags and religious symbols in lands they claimed to have discovered, they were undertaking well-recognized legal procedures and rituals of discovery that were designed to establish their claim to the lands and peoples.
>
> The European colonists in North America, and later American colonial, state, and national governments, utilized the doctrine and its religious, cultural, and racial ideas of superiority over American Indians to make legal claims to the lands and property rights of Indians. For example, President Thomas Jefferson expressly ordered the Lewis and Clark expedition to use the principles of the Doctrine of Discovery to make American claims over Native peoples and lands across the continent. Later, the idea of American Manifest Destiny incorporated the Doctrine of Discovery to justify U.S. western expansion, and it continues to be used today to limit the governmental, sovereign, and property rights of American Indians and Indian nations.[10]

10. Miller, "Doctrine of Discovery," 87.

Based on the evidence of the devastating influence of the Doctrine of Discovery, I contend that this country was conceived in lies, born in lies, baptized and confirmed in lies, nurtured in lies, and expanded in lies. Lies have been devised, revised, and perpetuated to maintain the original lies so deeply embedded in the country's lifeblood, now so obscured that they have become a cultural truth—a belief and legal system created to maintain power, possessions, and financial gain. So many lies have been told, purposely and intentionally, to mislead the public, intended to instill fear about people of color. The latest lie from the former president is that Russia does not threaten American democracy, but instead it is threatened by "certain Americans."[11] This looks and sounds alarmingly similar to the lies Hitler fed the German people in 1945.

A Balcony Hermeneutic: A New Interpretive Lens

In this work, I present to the Christian church in America, particularly the white evangelical church, the historical roots from which its doctrines and teachings have come and how those teachings have created a climate of racism and hatred. To truly usher in the Kingdom of God on earth, "Christians" need to reflect critically on what it means to "follow Jesus." They need to ask hard questions about the belief system they have inherited and be courageous enough to make the necessary changes.

Taking an open mind to reading the narratives from the perspectives of colonized people will require some personal soul searching, as well as focusing on the voices of Black and brown people, listening to their stories, and not hiding behind white fragility for fear of being uncomfortable when presented with narratives and truths that do not align with or perpetuate white privilege. It will further require the critical re-reading of scriptural passages used by the church to enslave, annihilate, and subsume people of non-European descent.

Against the backdrop of Western thought, theology, religious traditions, and society, how does one undo and correct over five hundred years of lies? By presenting a historical narrative that has not been simply whitewashed but rather a history that has been pushed to the periphery of history, I ask my reader to hear the voices of those who have been marginalized— the persecuted, colonized, and enslaved—to recognize that these racist philosophies and church doctrines continue to impact the world, specifically the United States: white supremacy, white nationalism, and the fears and violence inherent in the ideology of whiteness.

11. Maddow, "Trump Sees American Foes."

I do this by presenting a new hermeneutical interpretive lens through my perspective as a Womanist theologian—a Balcony Hermeneutic. By gathering historical narratives from formerly colonized peoples and their descendants, I intend to push the inquisitive reader to do more in-depth research for truths from sources other than conventional Western resources. By challenging them to see and hear America through indigenous people's eyes, I challenge them to go beyond traditional historical and theological texts and explore the teaching of Critical Race Theory, the 1619 Project, or African American history in public educational institutions. Doing so reverses the historical gaze interpreted through the eyes of white European settlers and colonizers, their descendants, and those still attempting to silence particular histories through criminalizing wokeness.

Several biblical scholars, theologians, and historians support my theory by pointing out a specific document and edict by the Roman Catholic Church that set the course for the modern world's colonization, as well as the conquest of non-whites that orchestrated white supremacy, nationalism, violence, destruction, hatred, and subjugation. All Americans still live with the residuals of the Doctrine of Discovery.

In the age of Black Lives Matter, the quest to dismantle racism, and the lingering effects of colonization, I believe we, the members of the American church of all denominations, ethnicities, and cultural backgrounds, must look at the origins of the foundations of America in order to reveal the lies upon which this land was obtained and this nation was established. These lies are based on a self-declared right to annihilate, steal, kill, and destroy any people standing in the way of its self-perceived right to land ownership and national expansion.

This country cannot heal or become the "land of the free," Christ's beloved community, or "the city on a hill" until it faces its painful history. Why do the 1619 Project and Critical Race Theory (a higher educational endeavor never intended for public school curriculums) frighten many white supremacy stakeholders, even if they claim not to be racist? Why does learning the actual truth of the founding of this nation and the atrocities perpetrated in the name of Christian values and country expansion frighten so many? Why does learning about the history of Chinese, Japanese, and Mexican immigrant mistreatment, slavery in America, and the Trail of Tears get overlooked in American history classes and textbooks and even outlawed in some states? Why is it so difficult to simply face the truth and rebuild based on the promises of the Constitution and the Fourteenth Amendment?[12] What are people so afraid of? Perhaps some fear they will be

12. Imbriano and Yellin, *Amend.*

treated the same as those enslaved, whose land they stole, or the survivors of genocide and internment. The list is long. America has much to repent for.

Repentance is required to be forgiven of sins by a true Christian, following the teachings of Jesus of Nazareth, the biblical Jesus. America has sinned against so many, yet America has never publicly acknowledged these sins. Why is it better or easier to hold on to and continue propagating and perpetrating the lies rather than face the truth if we believe the biblical scripture, "then, you will know the truth, and the truth shall set you free?"[13] Perhaps because it will require a national reckoning and repentance, a repentance that can lead to repair, restoration, and reparations for those most affected by the racist policies and systems grown in and sanctioned by American Christianity.

I am a Womanist theologian, ethicist, and ordained Baptist preacher: a follower of Jesus of Nazareth, Jesus of the Way. I have gone through a personal metamorphosis or transformation,[14] from taking everything taught based on white evangelical presentations as "gospel truth," listing to popular white and Black TV evangelists (televangelists), and trying with my whole heart to follow God based on their teachings. But something wasn't making sense. It was no longer sitting well within my spirit. I had earned a master of theological studies and a doctor of ministry. I was still using the standard "approved" commentaries for sermon preparation until one day, something I read in a popular commentary struck me like a bolt of lightning. The god (small g) this particular writer was trying to convince me was universal didn't match what I knew about God (capital G), the God my grandparents and parents taught me about and trusted in. This wasn't the same God I heard the elders testify about in prayer meetings. Nor was this "god" the same God I had come to personally know. Right then, I made a vow to seek out commentaries written by people of color, which was a daunting task at that time. That's what I told my pastor; I was done with white, patriarchal, usually German male "scholars" telling me/us who God is, presenting themselves as primary sources for all of Christianity, and claiming to be experts on a religion they had stolen from a Jewish religious sect who followed a brown-skinned, Palestinian Jesus of Nazareth, fabricating a white Jesus whose followers withhold from those they consider "other" the love of the God and very Jesus they claim to follow.

Now I read, study, and teach Scripture to resist hegemony and white supremacy and recovery from colonized minds. Doing so is not merely resistance to colonized religion but a restorative resistance to restore the Way

13. John 8:31–32 (NIV).

14. Being transformed by the renewing of my mind (Rom 12:2; author's paraphrase).

to its original understanding by placing biblical stories within the context of their time and place. Using history to heal those who have been lied to for so long brings reconciliation and true kingdom-building. We are *all* created in the image of God—the *imago Dei*.

I approach this resistance from a Balcony Perspective, or a *View from the Balcony*, which creates a Balcony Hermeneutic. I use the balcony as a metaphor because it aptly describes the perspective from which all those "othered" by European invasions and expansions have been forced to view and experience the world. As a theatergoer and performer, my perspective of balcony seating comes from two views: as an audience member and a cast member. As an audience member, I often choose to sit in the balcony to watch a theatrical or operatic production. This gives me an expansive view of the staged performance and other audience members in the theater. As a cast member, I had an opposite view of the theater from the stage and could see, though not clearly, audience members seated on the main floor and the balcony. From this balcony perspective, I critique American Christianity or Christianity American-style and the racist history of a nation that could enslave Africans and persecute indigenous people, and produce continued hatred and mistreatment of Black and brown bodies today. This perspective or Balcony View critically examines the history of America from the viewpoint of the enslaved and First Nations People. This perspective restores dignity to descendants of enslaved persons—culturally, spiritually, individually, and collectively. Using the theater as a metaphor for American society also reminds the gatekeepers and stakeholders of white supremacy that "the whole world is a stage, and everybody plays a part."[15] We are all in the same theater, experiencing the production from different perspectives. It calls to task those who claim to be Christian yet ignore the teachings of the Christ they claim to follow—from any perspective.

I believe this nation can be healed. However, healing can only take place by facing the raw, uncensored, unpleasant, un-whitewashed history of this nation's making from the balcony's vantage point.

Summary

This chapter sets the stage and timbre for my work by asking the underlying question: How did we get here? How do we find ourselves in a country so polarized by perceived differences that democracy now teeters on the brink? How and can we be healed? It places some of the responsibility for this breach in our society squarely on the shoulders of the "church," indicting it for its

15. Fantastic Four, "Whole World Is a Stage."

role in the colonization and destruction of nonwhite, non-European cultures and people since 1492, the enslavement of Africans, the desecration of First Nations People, and the creation and perpetuation in America of racist exceptionalism in its quest for expansion and power. I challenge the American church, or Christianity American-style, to learn its history and familiarize itself with the documents upon which it was founded by introducing twenty-first-century Americans to a five-hundred-year-old Holy Roman Catholic Church document that few are aware of: the Doctrine of Discovery.

Further assessing the social and political climate of America in 2024 by tracing and connecting lies told by Hitler to the German people regarding its Jewish population in Germany in the 1940s, I question how the "big lie" can be believed by so many, even when its claims have been proven false. Though he and his regime knew they were telling lies, they also understood the psychology of the masses—tell a lie loud enough, convincingly enough, and long enough that people will believe it. I caution Americans that we are seeing a similar tactic today—lies breeding lies which can lead to disastrous results for those being lied upon. Presenting evidence that America was founded on the principles of the Doctrine of Discovery, giving itself permission in the name of "God" to invade, displace, enslave, and annihilate people and cultures standing in the way of its quest for expansion, I suggest that "go into all the world," did not mean to "steal, kill, and destroy."

By examining the historical facts of the founding of this nation, I ask the American church at large to examine its founding principles, ideologies, and present-day practices; to address its historical amnesia; and to examine its complicity in the rise of white nationalism, Christian nationalism, white supremacy, and institutional racism. I suggest the "church" is no longer following the teachings of the biblical Jesus of Nazareth, but instead has invented and created a Jesus that looks like them to justify their behavior and claim they are doing God's work.

I invite the reader to re-examine the unpleasant and sometimes painful history of the founding and expansion of this nation, to be willing to listen to narratives from the voices of those who tell a different, true, and corrective history from their balcony perspective.

2

Act 1, Scene 1—Recitative

Reframing Philosophy from a Balcony Viewpoint

You will know the truth, and the truth will set you free.

—JOHN 8:32 (NLT)

The tragedy for man is that the Western intellectual elite has, over the years, successfully imposed its own culture and philosophy over the masses.

—*HENRY ODERA ORUKA*, AFRICAN SAGE PHILOSOPHY

What does it mean when the tools of a racist patriarchy are used to examine the fruits of that same patriarchy? . . . For the master's tools will never dismantle the master's house. They may allow us temporarily to beat him at his own game, but they will never enable us to bring about genuine change.

—*AUDRE LORDE*, THE MASTER'S TOOLS

Philosophical Ideologies

WHAT IS PHILOSOPHY? PHILOSOPHICAL thought is determined by whom? Philosophy is the pursuit of wisdom and an investigation of "the meaning

of life, . . . the nature of evil, ultimate reality, [and] the existence of God."[1] African philosopher and first president of modern-day Ghana Dr. Kwame Nkrumah explains:

> Philosophy . . . is one of the subtle instruments of ideology and social cohesion. . . . It affords a theoretical basis for cohesion . . . and performs [an] ideological function when it takes shape as political philosophy or as ethics.[2]

> Philosophical systems [exist] in the context of the social milieu which produced them [therefore] when philosophy is regarded in the light of a series of abstract systems, it can be said to concern itself with two fundamental questions: first, the question "what there is"; second, the question how "what there is" may be explained.[3]

Anthropologists note a common pursuit from the earliest evidence of human existence: the quest to determine "what is there," to develop mores and social systems to give meaning and stability to their existence, and to ultimately define how these historically affect human existence. An honest inquiry into existence within the cosmos must be addressed and revisited, especially in light of racist, hegemonistic, sexist, and xenophobic ideas that have permeated, dominated, and influenced world ideologies since 1492 based on the presuppositions and subtle instruments of classical Western/American philosophical and theological ideology.

From the fifteenth to the nineteenth centuries Europeans purposefully considered themselves superior to all other people based on their own (ir)rational and "modern" understanding of their place in the world. Only Westernized "Christianity" was considered the true religion, and designated "others" they encountered and conquered were forced to abandon traditional religious practices. The historically labeled European Age of Enlightenment[4] is what I redefine to be the "Era of Great Terror"[5] for Africa, the Americas, Asia, and other lands colonized by Europeans. Drawing from what Europeans claimed as "truth," theories and belief systems of European superiority gave way to white privilege and white supremacy: the unchallenged

1. Clark et al., *101 Key Terms in Philosophy*, 69.

2. Nkrumah, *Consciencism*, 6.

3. Nkrumah, *Consciencism*, 5–6.

4. The Age of Enlightenment is a European intellectual and philosophical movement which emphasizes reason, individualism, and science. See Duignan, "Enlightenment."

5. This phrase emerges as my revisionist/corrective perspective of the European idea of enlightenment.

presumptions of duty and right to claim previously inhabited land; and holy or wholly purpose to "civilize" indigenous populations by subsuming, absorbing, or forcing the vilified others to assimilate into European culture in order to meet white, European linguistic, beauty, and religious standards.

Because Europeans did not understand (nor demonstrate the desire to learn) the languages, customs, religions, and spiritual practices of African and Native peoples, they labeled these previously unencountered and unknown cultures, traditions, and rituals primitive and barbaric.[6] Finding no books or written accounts—familiar to the colonizers—of the indigenous history, knowledge, and wisdom inherent within the tribal rituals of African or First Nation Peoples, Europeans errantly assumed there was no African or Native history prior to their "discovery" and indeed no indigenous philosophy or theology before their arrival. Or perhaps, they purposely ignored evidence to the contrary.

In addition to being intrinsically linked to Eurocentrism, which gave rise to modernity, colonialism, and chattel slavery, Western classical philosophy also "whitewashed" and silenced non-European philosophical canons and theological voices, denigrating Black and brown bodies, spirituality, and thought from the late eighteenth to the early twentieth centuries. Immanuel Kant and G. W. F. Hegel, eighteenth-century Western philosophers, were instrumental in the movement to rewrite philosophical history and erase pre-existing, non-Western philosophical thought (and the humanity of people) from world history.

African American philosopher Charles Mills regards Kant as the "philosophical spokesman for the Enlightenment."[7] Per Mills, Kant can be regarded as "the founder of the modern concept of race," who put "the racial classifications of Carolus Linnaeus on a philosophical foundation."[8] On Kant, Mills observes:

> There is, to begin with, his notorious statements in *Observations on the Feeling of the Beautiful and Sublime* (1764) that "so

6. A prime example of colonial imperialistic social and anthropological thought that disparages Africanity is the work of Scottish poet, novelist, and part-time anthropologist Andrew Lang. In Lang's *Myth, Ritual and Religion*, he refers to indigenous, tribal, African peoples as "savage and barbaric" and further fosters the idea of "scenes of savage performance—dances, ceremonies, rituals, pantomimes as . . . the 'mad doings' and 'howlings' . . . of uncivilized countries" (ch. 9).

7. Mills, *Blackness Visible*, 106. Mills examines Kantian influence on enlightenment philosophies and the solidifying of the racial hierarchy through Kant's social ontology, his views on personhood and his impact on eighteenth- and nineteenth-century philosophy.

8. Mills, *Blackness Visible*, 74.

fundamental is the difference between [the black and white] races of man . . . it appears to be as great in regard to mental capacities as in color," so that a "clear proof that what [a Negro] said was stupid" was that "this fellow was quite black from head to foot." . . . More problematic . . . is Kant's later essay "on the different races of man" (1775), in which he outlines a classic hereditary and anti-environmentalist account of innate racial differences that essentially anticipates post Darwinism "scientific" racism.[9]

Kant was not alone in his racist and xenophobic theories of exclusion and European exclusivity based on ethnicity. Hegel likewise "restricted philosophy to the (white) 'Germanic' people, . . . those from Western Europe."[10] The racist views of Kant, Hegel, and other Enlightenment philosophers were based on and can be linked to the invention of racial taxonomy and racial hierarchy theories constructed by French naturalist Louis Le Clerc Comte de Buffon and developed by Swedish botanist Carolus Linnaeus who developed a system of natural classification which divided humanity into four major groups (European, American, Asian, and African).[11] Essentially,

towards the end of the 18th century, German scientist Johann Blumenbach constructed a racial classification that built upon Linnaeus's work and proposed five racial types: Caucasian, Mongolian, Ethiopian, American, and Malay . . . [which] posited the Caucasian as the ideal. . . . Any divergences from the Caucasian ideal were considered inferior.[12]

These racist theories were fodder for Western philosophical notions of superiority, which fueled Eurocentrism and modernity and determined non-European ethnic groups as inferior, particularly darker-skinned peoples. These theories paved the way for an extended period of Western-style colonization, including the widespread genocide (holocausts) of any ethnic groups relegated as "other."

9. Mills, *Blackness Visible*, 74.

10. Mills, *Blackness Visible*, 74.

11. Yudell, "Short History." Yudell gives an abbreviated historic summary of European "scientific" hierarchical development and explains how this invention became propaganda for shaping and promoting the notion of genetic inferiority of non-Europeans.

12. Yudell, "Short History."

A Balcony Viewpoint: Philosophy and Theology from the Periphery

"Others'" Voices

Several African scholars, theologians, and philosophers provide specific philosophical and theological underpinnings for this research: John Mbiti,[13] Kwame Nkrumah,[14] Kwame Gyekye,[15] Musa Dube,[16] and Elizabeth Mburu.[17] They challenge continental and classical philosophy and theology as the definitive experts by which all (non-white) cultures, cosmologies, and theologies should be measured. By including and recognizing "other" philosophical and theological voices as primary sources, this research harmonizes with American writer, Black feminist, and Civil Rights activist Audre Lorde's guiding testimony, "The master's tools will never dismantle the master's house."[18] Upon the countercultural voices of these scholars, my Balcony Theory and Hermeneutics are so informed.

The foundation of this research rests upon the theory of Anthropological Poverty as developed by the late Cameroonian priest Engelbert Mveng.

13. Mbiti, *African Religions*. Mbiti's philosophical and theological positions concerning indigenous African belief systems in relation to African life and the ways in which inadequate and flawed Western theories denigrated African religions and culture are fully discussed.

14. Nkrumah, *Consciencism*. Philosopher and first president of modern-day Ghana Nkrumah critically examined the roots of Western philosophy and the devastating effects colonialism and Western Christianity left on the land, economics, mind-sets, and cultures of African people.

15. Gyekye, *Essay on African Philosophical Thought*. This work rejects the Western notion that African philosophy only began when Western-trained African philosophers began writing African philosophical thought in Western languages. Gyekye holds that African philosophical material is held in the ancient oral traditions of African people and is distinctly different from Western thought.

16. Dube, "Reading for Decolonization." Dube challenges texts published under Western imperialization, charging that in doing so colonized Africans were miseducated, resulting in the systematic devaluing of African culture and societies. She proposes critically re-reading scriptural texts to be the remedy for decolonizing the Bible in the minds of Africans.

17. Mburu, *African Hermeneutics*. Recognizing that most African biblical scholars are Western-trained and rely on Western interpretations, Nigerian theologian Mburu examines how an African hermeneutic can be born out of a re-examination of early church history focusing on North African church fathers such as Augustine and Origen as a source of pride to promote biblical interpretation from an African context.

18. Lorde, *Master's Tools*. This short essay title is a mantra for scholars and social scientists working within their fields to dismantle racist practices across academic, social, and religious institutions and social systems. It is also my mantra, chant, and sacred word as I do this work.

He posits that the effects of colonialism in Africa led to the destruction of indigenous values and religious beliefs, a loss of identity, and the weakening of artistic creativity and traditional culture—among his own people in Cameroon and throughout the African continent.

European colonialism and imperialism have ravaged African colonies and empires since the 1800s. Mveng's philosophical and theological theory grew from his personal experience as one born during colonization and subjugation who lived to see his country regain its independence. But he also saw how, though now relieved of European rule, the vestiges of colonization adversely impacted Cameroonians. To restore traditional African ways of life, Mveng felt compelled to help his community regain pride in being African. He proposed this transformative process: identify the offender, name the oppression, and offer concrete solutions to decolonize the minds of Cameroonians, all Africans, and diasporic Africans.

Understanding Mveng's theory of Anthropological Poverty necessitates comprehending systems that gave rise to the European mindset of deforming ideologies that actualized colonization. My research interrogates: What gave Europeans the right to believe they were superior to other ethnic groups? What gave Europeans the right to believe and act on the assumption that they had permission to invade, conquer, and dominate other lands and people?[19] Answering these questions establishes the philosophical and theological underpinning for this research. By assuming a Balcony View through the eyes of African and African American philosophers and theologians and listening to indigenous voices from Latin America, the Philippines, and the United States, I critically assess, examine, and oppose classical Western philosophy and theology. By engaging these scholars, we challenge long-held assumptions about Western continental and classical philosophy and American theological anthropology as superior expert voices for all (non-white) cultures, cosmologies, and theologies. As a result of valuing philosophical and theological voices of the "other" as primary sources this research harmonizes with Lorde's conclusion: "The master's tools will never dismantle the master's house."[20] This departure from Western philosophers and theologians toward scholars of color from Africa, the Americas, Asia, and other formerly colonized lands forges tools suitable for the task of decolonizing indigenous and diasporic minds.

19. LaDuke, "Our Bodies."
20. Lorde, *Master's Tools*, 16–21.

Literary Imperialism

Imperialism is "state policy, practice, or advocacy of extending power and dominion, especially by direct territorial acquisition or by gaining political and economic control of other areas."[21] Included in territorial acquisitions through military invasions is the intentional devastation of indigenous systems of knowledge production—written or oral—thus affecting literary imperialism. An agent of Anthropological Poverty, literary imperialism strips indigenous archives of history and knowledge by excluding, diffusing, or rewriting through the lens of the invader; and then coercing acceptance and forcing assimilation of native peoples into the dominant culture through this systematic miseducation.

The purposeful exclusion of ancient non-European thought from eighteenth-century European philosophy is best explained in Lloyd Strickland's seminal work, "How Philosophy Became Racist":

> Most non-western philosophies that used to form part of books on philosophy's history have increasingly been excluded outright, while those that remained have often been treated superficially or dismissively, or included only for their value in explaining the development of western ideas. Whether consciously or not, the picture that is often painted in textbooks on the history of philosophy is that philosophy has been an exclusively western concern, with any ideas and doctrines of any value—and thus worthy of recording in a history of philosophy—developed by whites.[22]

By excluding ancient Chinese, African, Islamic, Jewish, and other non-European philosophies from philosophy texts, Europeans permitted themselves to claim that their new texts were comprehensive histories of world philosophy. This was easily accomplished as they

21. Editors of Encyclopaedia Britannica, "Imperialism."

22. Strickland, "How Western Philosophy Became Racist," §9. Here Strickland surveys what he calls the whitewashing of philosophy based on Kantian and Hegelian theories. He identifies ancient philosophies erased from textbooks written in the eighteenth, nineteenth, and twentieth centuries while claiming to be concise histories of philosophy. Some excluded philosophies included: Ethiopian, Egyptian, Libyan, Arabic, Islamic, Jewish, and Chinese. Tracing this "whitewash" narrative through European authors, such as Bertrand Russell, Strickland succinctly shows how the deliberate deletion of non-Western philosophies was based on racist and xenophobic Western thought. He recommends twenty-first-century philosophical texts, such as Adamson's *History of Philosophy without Any Gaps*, to rectify eighteenth-century Western philosophical omissions and deletions.

established criteria for what counted as philosophy drawn from Kant's own works. . . . These criteria ensured that virtually all non-western thought would no longer qualify as philosophical, making philosophy an exclusively European enterprise. Accordingly, some Kantians began to strip non-western systems from their histories of philosophy, [while] . . . those that continued to include non-western thought typically did so only in order to show that it did not qualify as true philosophy.[23]

Imperializing Texts

While Strickland documented how historical philosophical texts were manipulated or whitewashed to exclude and control all non-European philosophy, Motswana feminist theologian Musa Dube critiques how similar imperialistic strategies use "imperializing texts" to control and dominate epistemological and theological spaces. According to Dube, "Imperializing texts designates those literary works that propound values and representations that authorized expansionist tendencies grounded on unequal international/racial relations."[24] She identifies such as

texts that legitimize and authorize imperialism include canonized classics of ancient and contemporary times of different disciplines and genres . . . such as the Bible, the Iliad . . . English and French novels . . . travel narratives, anthropological documentation, . . . missionary reports, . . . [and] museum collections.[25]

Through published documents such as these, literary imperialism infected the minds of both the colonizers and the colonized. Because travel journals and missionary reports projected myopic prejudicial mores of portraying Africans as primitive, barbaric, and uneducated, Europeans convinced themselves that it was their benevolent duty to control the continent's land, resources, and people. Their voracious appetite and greed for Africa's natural resources emboldened them to confiscate land and people violently. The colonizers' well-planned intention was to educate, or to miseducate, indigenous populations to become subservient imitations of Western standards, to view their traditional ways as inferior, and to develop a disdain for

23. Strickland, "How Western Philosophy Became Racist," §3.

24. Dube, "Reading for Decolonization," 37–38. Here Dube surveys the history of imperialism from ancient Babylon and Hammurabi through the Assyrian, Hellenistic, and Roman Empires. She explains the meaning of *King* implies dominion over space and people and that *Savior* further implies power, fostering an imperial ideology.

25. Dube, "Reading for Decolonization," 42.

traditional African practices and self-loathing once they were established on the continent. European texts inundated African educational systems. Importing such texts functioned to displace local cultures and colonize the minds of young schoolchildren. Texts were buttressed with teachings that discounted and disregarded African history before white Europeans invaded and portrayed white Europeans as intelligent, benevolent, beautiful, and godly saviors. At the same time, Africa and her people were portrayed as primitive, childlike, unattractive, and godless heathens.

European texts and interpretations denigrated African people and spirituality, imposing Western patriarchal values and sexual standards upon African societies. Patriarchal readings of biblical texts devalued women—a blatant counter to many African matriarchal societies' acceptance of women in leadership positions. According to Dube:

> One of the strategies of imperialistic texts is the employment of female gender to validate relationships of subordination and domination. . . . [A] sociological study of colonial processes and literature shows that "native women have often been the first agent of contact" providing . . . "a classic literary motif of the tragic romance between the European man and native woman" . . . The use of female gender to describe the colonized serves the agenda of constructing hierarchical geographical spaces, races, and cultures, but it also comes to legitimate the oppression of women in societies where these narratives are used.[26]

With the production and interpretation of texts controlled by colonizers, indigenous values and cosmologies were eventually rejected by indigenous people as European texts became effective tools to supplant indigenous cultures and colonize the minds of African people. For Dube, "the Bible is one of the imperializing texts. For many African nations, the success of colonization is inseparably linked with the use of the Bible."[27]

To Dube's point, Kenyan theologian Elizabeth Mburu raises this question: "If our hermeneutical models are all from the West, how can we devise particular applications in an African context?"[28] Cognizant of the historic fact that nineteenth-century readings and biblical interpretations brought to the African continent by European missionaries continue to be prominent in the African church in the twenty-first century, she notes that African biblical scholars are Western trained and influenced, still following and teaching Western biblical interpretations. Mburu further posits that

26. Dube, "Reading for Decolonization," 42.
27. Dube, "Reading for Decolonization," 43.
28. Mburu, *African Hermeneutics*, 5.

> African readers of the Bible face . . . challenges that most mod-
> els and methods of biblical interpretation or hermeneutics are
> rooted in a Western concept. . . . Most theological resources
> [are] produced by Western writers. . . . Africans are still trying
> to imitate foreign ways when it comes to "reading, interpreting,
> and applying the Bible in our everyday lives."[29]

To rectify this imperial carryover of biblical interpretation, Mburu sug-
gests the need for Africans to understand their ancestors' primary role in
early church formation, church history, and biblical presence. Decolonizing
the African mind requires reintroducing African Christians to their historical
context. Stressing the influence that the early church fathers and theologians
such as North Africans Augustine and Origen had upon doctrinal formation
and church structure should empower African theologians to "present a con-
textualized, African intercultural approach"[30] to biblical studies.

Reframing Philosophy and Theology through Indigenous Perspectives

Finding no evidence of written historical accounts of the culture, European
invaders errantly assumed that African philosophy and theology did not
exist. Another view is necessary to refute, reveal, and recast long-standing
Eurocentric lies of superiority—a View from the Balcony—of Western
philosophical thought through the eyes and history of excluded and practi-
cally erased cultures. This work, "Reframing the Practice of Philosophy,"[31] is
explained by African American philosopher George Yancy:

> The idea "Reframing" suggests the sense in which one steps
> back and takes another look, realizing that the current frame
> excludes all that does not fit within the demarcated limits of that
> frame. In fact, that which is outside the frame is constituted as
> that which is unintelligible and ersatz. . . . To reframe the cur-
> rent practices of philosophy . . . reveal[s] the limits of its cur-
> rent practices, its current assumptions, its current conceptual
> allegiances, and its current self-images. The aim is to expand the
> hermeneutic horizons of what is possible philosophically [and
> to] . . . challenge fundamental normative assumptions about

29. Mburu, *African Hermeneutics*, vii.
30. Mburu, *African Hermeneutics*, vii.
31. Yancy, *Reframing the Practice of Philosophy*.

philosophy, doing philosophy, coming to philosophy, and stay-
ing in philosophy.[32]

The work of reframing philosophy and dismantling the master's
philosophical house commences by acknowledging that there is a "color
line . . . within philosophical spaces"[33] drawn by long-held stereotypes and
pejorative notions of inferiority about Black and brown bodies. This color
line excludes certain non-European languages from canon formation and
knowledge production. Yancy asserts that philosophical, linguistic hegemo-
ny against non-European languages is an epistemological reality and notes
that, prevalent within the Academy, "biases that stipulate certain languages
as the only legitimate media for philosophical expression are revealed as
sites governed by raced (white) conceptions of linguistic intelligibility."[34]
Latin American, African, Asian, and Middle Eastern languages are system-
atically excluded from academic, social, and political spaces, further perpet-
uating the opinion that only white European knowledge production is valid.
Whiteness in philosophy affords the errant notion of "genuine philosophy
and philosophers to look white regardless of fundamental differences or
gender."[35] Yancy further asserts:

> The history of philosophy from Plato to Derrida is a family
> relationship [recognizing] white philosophers as a priori. . . .
> Philosophical traditions are populated by raced (white) bodies
> . . . the specific whiteness of the philosopher's flesh becomes
> transfigured as the universal body.[36]

Philosophers and theologians of color identify and challenge white
Eurocentric averse assumptions and inherent biases against the cultures,
languages, cosmologies, and spiritual practices of people of color by examin-
ing how dominant Western philosophical and theological canon formation
and knowledge production exclude their voices and devalue their bodies.
By employing counter-hegemonistic and counter-cultural tools of autobi-
ography, ethnophilosophy, and reinterpreting classic and sacred texts, male
and female philosophers and theologians of color are diligent to challenge,
correct, and change racist and patriarchal narratives and practices within
philosophical and theological spaces; thus making their "presence felt and
ushering in their own philosophical voices, traditions, [and] epistemic

32. Yancy, *Reframing the Practice of Philosophy*, 5.
33. Yancy, *Reframing the Practice of Philosophy*, 5.
34. Yancy, *Reframing the Practice of Philosophy*, 5.
35. Yancy, *Reframing the Practice of Philosophy*, 8.
36. Yancy, *Reframing the Practice of Philosophy*, 8.

assumptions"[37] to decolonize Western influences on views unique and valuable to the formerly colonized.

To undertake decolonizing philosophy and theology, this balcony perspective takes a critical anamnestic look at continental ideology in order to identify and deflate the colonial images and systems of racism, superiority, and exclusion inherent within the imperialistic mindsets of colonizers, and it excises the lingering effects of European occupation on the formerly colonized. My point of departure for this august undertaking is African Sage Philosophy—wisdom inherent within ancient traditional and contemporary African cosmologies.

African Sage Philosophy

> "African Sage Philosophy" is the name now commonly given to the body of thought produced by persons considered wise in African communities, and more specifically refers to those who seek a rational foundation for ideas and concepts used to describe and view the world by critically examining the justification of those ideas and concepts. . . . These themes involve questions regarding the nature of the supreme being, the concept of the person, the meaning of freedom, equality, death and the belief in the afterlife.[38]

African Sage Philosophy, also referred to as African cosmological wisdom, is the expression of thoughts, ideas, and opinions of those considered wise persons, male or female, within ancient and contemporary African societies who speak counter-narratively to Western knowledge production and canon formation. Recognizing sage philosophy as an epistemological system affirms knowledge production of individuals and communities previously invalidated by colonialism. African Sage Philosophy debunks Eurocentric and colonial biases against unpublished thought by acknowledging that wisdom passed down through oral traditions is as valid a form of philosophical thought as is any written document. As a form of ethnophilosophy, African Sage Philosophy "provide[s] evidence of abstract thought about philosophical topics addressed by African thinkers."[39]

Dismas Masolo observed that the Kenyan philosopher Henry Odera Oruka questioned how sayings of ancient Greek sages could be regarded as

37. Yancy, *Reframing the Practice of Philosophy*, 5.
38. Masolo, "African Sage Philosophy," §1.
39. Masolo, "African Sage Philosophy," §5.

having philosophical value while sayings from ancient African traditions were completely dismissed as valueless or having no form of reason.[40] Considered by Eurocentric eyes as "others," Africans were not deemed appropriate subjects or producers of philosophical thought.[41] There has been, and remains, a "long tradition of Western scholarship . . . that denied Africans not only the existence of organized systematic philosophical reflection, but reason itself."[42] African Sage Philosophy holds that this Eurocentric way of thinking is irrational and "rather absurd, for no society of humans can live for any amount of time, let alone making any advances in their own ways of seeing and doing things, if they do not have reason, or if the ideas and concepts upon which their cultures are built do not make sense."[43]

Agreeing with Masolo and Oruka, Ghanaian philosopher Kwame Gyekye affirms that "there is no good reason to suppose that the lack of written sources implies the absence of philosophical thinking";[44] and that the "history of thought in Africa will have to include the philosophical production of past traditional thinkers (or sages)."[45] Correlating with Masolo's assertions, Gyekye confirms that

> African philosophical thought is expressed both in the oral literature and in the thoughts and actions of the people. Thus, a great deal of philosophical material is embedded in the proverbs, myths, and folktales, folk songs, rituals, beliefs, customs, and traditions of the people, in their art symbols and in their sociopolitical institutions and practices.[46]

Further, Kenyan theologian and philosopher John Mbiti describes African philosophical systems:

> Philosophy of one kind or another is behind the thinking and acting of every people. . . . African philosophy . . . refers to the understanding, attitude of mind, logic and perception behind the manners in which African peoples think, act, or speak in different situations of life. . . . There is no formal separation between the sacred and the secular, between the religious and the non-religious, between the spiritual and the material areas of

40. Masolo, "African Sage Philosophy," §7.
41. Yancy, *Reframing the Practice of Philosophy*, 9.
42. Masolo, "African Sage Philosophy," §11.
43. Masolo, "African Sage Philosophy," §11.
44. Gyekye, *Essay on African Philosophical Thought*, xi.
45. Gyekye, *Essay on African Philosophical Thought*, xi.
46. Gyekye, *Essay on African Philosophical Thought*, 13.

> life. [Religion and Philosophy] accompanies the individual from
> long before his birth to long after his physical death.[47]

In addition to "religion, proverbs, oral traditions, ethics, and morals,"[48] Mbiti concludes that African philosophical systems are no different from European philosophy. By studying these traditional African systems, it can be discerned that philosophy is not for individual or specific group advantages but for the entire community's benefit opposed to the individuality espoused in Eurocentric philosophical thought.[49]

Recognizing the exclusion of African philosophical thought from traditional Western philosophical canon and epistemology and how Western thought inaugurated and perpetuated African colonization, Princeton-educated philosopher and first president of modern-day Ghana Kwame Nkrumah critically examined the roots of Western political philosophy. Using empirical evidence about the denigrating and devastating effects of Eurocentric bias, modernity, colonialism, and imperialism on African people and their land, Nkrumah suggests there must be philosophical alternatives to the materialistic and idealistic philosophy of Western politics that invaded Africa. A proponent of Pan-Africanism,[50] Nkrumah proposed that political and social movements be established to regain and reclaim the land, dignity, and culture of all African peoples affected by colonial rule on the continent and throughout the diaspora.

Even after regaining its independence, Ghana, as have other now independent African nations, reeled from the residuals of the political philosophy of racism and inferiority and its vice grip on government officials and the survival behaviors of the people. As president, Nkrumah attempted to rectify this by turning to philosophical alternatives for African political activity that would reject Western democracy and embrace socialism. In doing so, Nkrumah hoped to lead a more egalitarian political system. He simultaneously recognized that "for the formerly colonized, it is especially impossible to read the works of Marx and Engels as desiccated abstract philosophies having no bearing on our colonial situation."[51] Nkrumah cautions:

> Disparaging accounts had been given of African society and
> culture as to appear to justify slavery, and slavery, posed against
> these accounts, seemed a positive deliverance of our ancestors.

47. Mbiti, *African Religions and Philosophy*, 1, 2.

48. Mbiti, *African Religions and Philosophy*, 2.

49. Mbiti, *African Religions and Philosophy*, 2.

50. Pan-Africanism is an ideological and cultural movement evoking unity of African people on the continent and throughout the African diaspora.

51. Nkrumah, *Consciencism*, 5.

> ... African culture and society [was presented] as being so rudi-
> mentary and primitive that colonialism was the duty of Christi-
> anity and civilization. Our highly sophisticated culture was
> said to be simple and paralyzed by inertia, and we had to be
> encumbered with [Western European] tutelage.[52]

This Western European "tutelage" has influenced continental and diasporic
Africans' self-perception, ways of being, artistic expression, and religious
and spiritual practices.

Nkrumah further indicts the church for perpetuating false accounts of
African people, religious practices, and culture that sanctioned the "church
[to] exercise her divine right of grab,"[53] completely ignorant of or ignoring
"the fact that man is regarded in Africa as primarily a spiritual being, being
endowed originally with a certain inward dignity, integrity and value. [This]
stands refreshingly opposed to the Christian idea of the original sin and
degradation of man."[54]

Agreeing with Nkrumah's summons for philosophical alternatives,
South African scholar and philosopher Mabogo P. More rightly critiques
European enlightenment philosophers and the grip their ideology held on
the world in light of the devastating centuries-long actions inflicted upon
the thoughts and bodies of colonized Africans and other brown-bodied
people. More critiques, "Dominant forces in Western philosophy express
and articulate exclusionary expressions, statements and attitudes, but also
... these articulations of otherness have had great impact on subsequent
reception of African philosophy"[55] and people. He further accounts that

> the influence of Plato, Aristotle, Descartes and Locke on the
> Enlightenment became expressed in Kant who laid the philo-
> sophical foundations for a purely formalistic rationalism. ...
> For Kant, Hume, Voltaire, Montesquieu and a host of other En-
> lightenment philosophers, ... a person's skin colour determines
> his/her rationality. By virtue of their blackness, black people are
> excluded from the realm of the rational and the civilised. ...

52. Nkrumah, *Consciencism*, 62.

53. Nkrumah, *Consciencism*, 43.

54. Nkrumah, *Consciencism*, 68.

55. More, "African Philosophy Revisited," 109. More critiques Western philosophi-
cal thought from Plato to Hegel detailing each philosopher's role in creating/invent-
ing the concept of the "other." He signifies how Eurocentrism developed during the
Enlightenment and continued through the age of colonialism in the 1950s; and further
explains how Hegelian theories and philosophies impacted European philosophers and
ushered in racist, sexist, and hegemonistic thought into Western/European social and
religious beliefs.

> The Enlightenment's construction of the racialised other almost always makes a correlation between physical characteristics and moral qualities. Accordingly, a person is wild, lazy, callous etc. precisely because and to the extent that s/he is black. Conversely, a person is good, civilised, calm, considerate, etc. because white.[56]

More concludes that Western philosophy's blatant racism considered Blacks subhuman, unintelligent, and inferior, and by default all other groups of non-European descent were also deemed subhuman. The claim that whites were rational and civilized while Blacks were barbarian and primitive without culture or history before European "discovery" was the groundwork for the invention of a false racial hierarchy based on white Europeans as the measure of one's humanity.[57] Vestiges of these negative stereotypes of Black people versus the positive stereotypes of white people birthed during the Enlightenment era remain today. This same false ideology and rhetoric based on an invented racial hierarchy are being perpetuated and perpetrated in the twenty-first century. Those who have been relegated to the balconies of society must, and do now, speak up and out to refute colonized lies and offer the Balcony View to any who continue to uphold colonized belief systems. The Balcony View offers resistance to colonized positions presenting Brexit,[58] Make America Great Again,[59] and European countries

56. More, "African Philosophy Revisited," 114.

57. More, "African Philosophy Revisited," 113–14.

58. Beauchamp, "Brexit Was Fueled by Irrational Xenophobia." Some Brexit supporters argue that allowing more immigrants into the country would place an undue burden upon British social systems, that immigrants were coming specifically to take advantage of public welfare benefits, would fill jobs that native-born Brits should have, and tax housing and education systems. Beauchamp proposes that the real force behind the call for the British exit from the European Union, or Brexit, was not the narrative of economic burdens due to immigration, but was "xenophobia—fear and hatred of immigrants. Bigotry based on national origin." He provides statistical and historical evidence to substantiate his position that many Brits opposed immigration of refugees based on their "long-lasting, deep-seated hostility towards new people coming into their country." Citing research done by the University of Oxford, Beauchamp proves these claims to be false; yet Brits overwhelmingly voted for Brexit in June 2016. Beauchamp concludes, "British voters made an unjustifiable and irrational decision, grounded in fear of people who spoke different languages or whose skin was darker than theirs." See Brexit voting results at British Broadcast Company, "EU Referendum Results."

59. During the same year that Brexit, fueled by xenophobia, became the pivotal political point for the British people, Donald Trump was campaigning to become the president of the United States running on the slogan that former President Bill Clinton suggested "was actually a racist dog whistle, one 'white southerners' would surely understand." See the following articles: Margolin, "Who Really First Came Up"; and Domise, "Yes, a MAGA Hat."

refusing entry to brown-bodied immigrants.[60] Again, the colonizing mind-set categorizes, discriminates against, and segregates people based on these long held Western misconceptions and misunderstandings of humanity as many races rather than multiple, equal ethnicities and people groups that comprise all of humanity, the human race. Colonization is the result of these philosophical ideologies.

Black Feminist and Womanist Anthropology

Reversing the Western Anthropological Gaze

African American anthropologist Audrey Smedley argues that "race was institutionalized beginning in the 18th century as a worldview, a set of culturally created attitudes and beliefs about human group differences."[61] Calling it the "science of humankind," Smedley renders that "anthropology materialized as an academic discipline connected with universities in the closing decades of the 19th century. In the United States, it was considered a unitary science covering all aspects of the human condition."[62] "The cultural structuring of a racial worldview coincides with the colonial expansion. . . . Race is a cultural construct invented by human beings."[63] However, colonized peoples "did not participate in the invention of race or the compilation of racial classifications imposed upon themselves and others."[64]

Historically, Western anthropologists and ethnographers have studied the poor and powerless, whether in foreign countries or in the United States, from a Eurocentric viewpoint. This perspective has created lasting adverse effects for people of color in this country and the world. Conversely,

60. Frej, "Here Are the European Countries." Frej outlined the then growing number of European countries who were limiting or preventing entry to Middle Eastern refugees, immigrants, and migrants into their countries. The article highlights their xenophobic, anti-Muslim rhetoric and reactions to the plight of millions of people seeking asylum. Britain, France, Denmark, Romania, Slovakia, Czech Republic, and Germany each limited the number of refugees they would accept. European anti-immigration stance and resistance or refusal to provide ample humanitarian assistance is summed up in a statement by Hungary's Prime Minister Viktor Orbán in which he expressed their "religious fears about the rising presence of Muslims in Europe." Frej reported that as these countries disregarded the plight of refugees, the European Commission president Jean-Claude Juncker appealed for more open-door policies, insisting, "The Europe I want to live in is illustrated by those who are helping . . . [not] one that is refusing those who are in need." Frej concludes his words fell on deaf ears.

61. Smedley, "Origins of the Idea of Race," §1.

62. Smedley, Race in North America, 309.

63. Smedley, Race in North America, 16.

64. Smedley, Race in North America, 16.

as a critique of patriarchal, Western, Euro-centered anthropology and epistemological systems, Womanist and Black feminist anthropologists challenge traditional colonialist, hegemonistic, and racist ideologies that inform the dominant production of knowledge and address questions centering around gender, race, sexuality, ability, and class. To develop my Balcony Theory—which will allow me to take a "Reversed Gaze"[65] in naming and correcting dominant narratives around Black bodies—I center on the work of anthropologist and Womanist theologian Linda Thomas.

Thomas's Womanist approach to anthropology includes a theological component that requires the reconstruction of knowledge that empowers Black women's voices. This reconstruction includes the entire Black community, encompassing "notions of gender, race, class, heterosexism, and ecology."[66] A Womanist theological, anthropological approach

> creates fresh discursive and practical paradigms and "talks back" (hooks 1988) to structures, white feminists, and black male liberation theologians. Moreover, womanist theology asserts what black women's unique experiences mean in relation to God and creation and survival in the world. Thus the tasks of womanist theology are to claim history, to declare authority for ourselves, our men, and our children, to learn from the experience of our forebears, to admit shortcomings and errors, and to improve our quality of life.[67]

This requires researchers to be engaged in critical conversation across disciplines that embrace

> an anthropological methodology [which] encourages womanist religious scholars to embrace the cultural, symbolic and ritual diversity dispersed throughout the religious lives of [all] women of color . . . [that will] unearth the ethnographic sources within the African American community in order to reconstruct knowledge and overcome subordination. And, finally, womanist theology seeks to decolonize the African mind and to affirm our African heritage.[68]

In 1999, Thomas introduced that "womanist anthropology of survival and liberation is a new paradigm for the 21st century";[69] and she continues

65. Ntarangwi, Reversed Gaze.
66. Thomas, "Womanist Theology," 489.
67. Thomas, "Womanist Theology," 489–90.
68. Thomas, "Womanist Theology," 490.
69. Thomas, "Womanist Theology," 497.

to call anthropologists into the field, to enter as guests and "work . . . among poor and working-class black women"[70] to create a model that hears their voices above the researcher's voice, ensuring that their concern will be heard and moved into the foreground of anthropological discourse.[71] Comparably, as a critique of patriarchal, Western, Euro-centered anthropology, feminist anthropology seeks to challenge the production of knowledge and addresses questions centering around gender, race, sexuality, ability, and class. It is also interested in reducing bias in the publication of male-dominated research findings and academic hiring practices.[72] For Black feminist and Womanist anthropologists, the main point of departure from classical anthropology is systemic and institutional racism. While traditional anthropology has been changing since the 1960s and 1970s and acknowledges and addresses the predicaments that its colonialist, hegemonistic, and racist ideologies have inflicted upon people of color worldwide, it has still not directly addressed the specific issues faced by women of all ethnic groups and nationalities.

Witnessing Thomas's bold assertions is anthropologist A. Lynn Bolles, who necessitates indicting and correcting the dominant Western narrative by accurately describing and reclaiming culture and history—namely, setting the story straight. Bolles emphatically charges that Black and Third World anthropologists must "produce works on race, ethnicity, inequality, expressive cultural ways, self-validating rituals, and the political, economic and social practices of Africa and the African Diaspora";[73]and that these works must acknowledge the "embeddedness and relationality of race, class, and gender in a synergistic way."[74] Black feminist Cheryl Rodriguez observes that

> feminist and womanist theorists . . . have critically examined the discipline's historical connections to hegemonic systems as well as its value in knowledge production and representation. . . . Anthropologists who are members of oppressed groups are attracted to the discipline because of our growing understanding that rigorous analysis and documentation of the cultures and histories of our peoples can be essential tools in the quest for progressive social change.[75]

She further explains:

70. Thomas, "Womanist Theology," 499.
71. Thomas, "Womanist Theology," 499.
72. Anderson-Leavy, "Feminist Anthropology."
73. Bolles, "Seeking the Ancestors," 28, 30.
74. Bolles, "Seeking the Ancestors," 35.
75. Rodriguez, "Anthropology and Womanist Theory," 85.

> In response to [using the] term ["feminist"], "womanist," "Black
> feminist," "African feminist," and "Third World feminist" have
> been used in a number of contexts to denote the liberatory
> theories, perspectives, and actions of Black women who are
> particularly concerned with Black women's historical, cultural,
> social, economic, and political realities globally . . . the use of
> the term "womanist" clarifies our connection and commitment
> to understanding our own cultural realities as Black women.[76]

Black Feminist Anthropologists are addressing these critiques of
mainstream anthropology by using the classic ethnographic methodologies
of research, as well as "tools of literature, sociology, history, and the inter-
disciplinary arenas of black studies and women's studies to engage at inter-
sections where the personal is political and professional."[77] Black feminist
poet and anthropologist Irma McClaurin claims that Black Feminist An-
thropology is birthed "against the backdrop of historical social and schol-
arly malignment and academic racism [and] . . . becomes a conscious act of
knowledge production and canon formation"[78] which takes into account the
intersections of "gender, race, and class as the foundational components of
its scholarship."[79]

The three essential goals of Black Feminist Anthropology[80] are: (1)
to locate the experiences of Black women around the world at the apex of
feminist anthropology; (2) to recognize the interrelation between women
and men, and the role of gender in structuring human societies; and (3) to
voice a strong vindicationist thread against the deviant interpretations of
the culture and lives of Black people worldwide. It also seeks to "represent
the interests of the oppressed, raising the consciousness of exploitation, and
leading them in the direction of resistance and counter-hegemony."[81] An-
thropologists of color are asserting and inserting themselves into the field of
Black Performance Theory, working from what Bolles identifies as African
American sociologist and anthropologist John Gibbs St. Clair Drake's idea
of a "vindicationist praxis."[82] A vindicationist praxis of scholarship and re-
search holds that research is conceived and conducted as a form of activ-
ism and that racism, which intersects with class, is considered the "central

76. Rodriguez, "Anthropology and Womanist Theory," §31–32.
77. Cole, foreword to *Black Feminist Anthropology*, x.
78. McClaurin, "Forging a Theory," 1.
79. McClaurin, "Forging a Theory," 15.
80. McClaurin, "Forging a Theory," 15.
81. McClaurin, "Forging a Theory," 15.
82. Bolles, "Seeking the Ancestors," 41.

problem in the contemporary world."[83] Expanding these parameters, Mc-Claurin contends that the work of "activist anthropologists . . . [may] redirect the trajectory of the discipline away from its colonial and racist origins"[84] to work toward decolonizing anthropology. She further posits that

> Black feminist anthropology constructs its own canon that is both theoretical and based in a politics of praxis and poetics [that] seeks to deconstruct the institutionalized racism and sexism that has characterized the discipline of anthropology in the United States and Europe. . . . [It] is intended to interrupt/disrupt the elitist, sexist, and racist dynamic that have plagued anthropology historically and continue to inform its . . . knowledge production and reproduction.[85]

A seminal publication on shifting the gaze is African American anthropologist Faye Harrison's three-volume edited anthology entitled *Decolonizing Anthropology*[86] where the voices of scholars formally considered other speak up and speak out against the residuals of colonial anthropological authority, recognizing that "a decolonized anthropology requires the development of 'theories based on non-Western precepts and assumptions.'"[87] To decolonize anthropology, ethnologists of color actively engage in the struggle to reclaim their history and cultures by self-naming and self-identifying to determine what knowledge is relevant and how to produce it. They are becoming interventionists who no longer passively accept the negative images that have been presented about their communities and cultures, correcting the ways in which people of color are portrayed and perceived. They present and publish research intended to deconstruct the false notions put forth by decades of public policymaking that reinforces entrenched racism and systemic racist institutions. They also collaborate with each other, with Third World, and Western anthropologists who wish to collaborate in working toward rectification and reconciliation.

One tool of decolonization and reclamation being used by anthropologists of color is autoethnography. Using this literary tool the researcher can self-define as "native" when interpreting ethnographic data. A blending of autobiography and ethnography, autoethnography is a form of qualitative research which allows researchers to

83. Bolles, "Seeking the Ancestors," 41.
84. McClaurin, "Forging a Theory," 49–50.
85. McClaurin, "Forging a Theory," 2.
86. Harrison, *Decolonizing Anthropology.*
87. Harrison, "Anthropology as an Agent of Transformation," 7.

use their personal experiences as a lens through which to describe and analyze ethnographic data. . . . [It is] a form of cultural mediation, autobiographical reflexivity, and ethnographic representation [which] is an innovative strategy of knowledge production.[88]

For Rodriguez, Native Anthropology is a way to do ethnographic studies of and at home, and to do research in one's own society. As a native anthropologist the researcher shares "factors such as ethnicity, kinship, social class, or gender"[89] with the community being researched. She encourages Black feminist anthropologists to use their personal history, self-identity and own points-of-view to

challenge the distorted images of black womanhood that have been perpetuated through the social sciences . . . work to "retain our voices [and] to name and identify ourselves as independent women thinkers and actors inside the uniformity of institutions."[90]

A reversed gaze on traditional ethnography with these ethnographic methods can dismantle patriarchal and imperialistic norms, allowing for a new paradigm of equitable, justice-seeking anthropology. By writing stories, reclaiming history, culture, and cosmology, Harrison suggests that knowledge production can correct the misconceptions and lies prevalent in society to this day, inform, re-inform, and move the discipline and society toward the development of public policies that promote a healthy, productive life for all of humanity. Performance studies is an ethnographic method to dismantle and reverse Western anthropology's historical patriarchy.

Performance and Performance Studies

To perform is to do something. Any and all human activity and behavior can be considered performance, from tying one's shoes to combing one's hair, from cooking a meal to caring for children. Performance occurs in everyday life; the arts, sports, entertainment, business, technology, sex, play, and ritual. The online *Merriam-Webster Dictionary* defines "perform" as: "to do in a formal manner or according to prescribed ritual; to carry out an action or pattern of behavior; to give a performance."[91]

88. Harrison, "Anthropology as an Agent of Transformation," 17, 18.
89. Rodriguez, "Home Girl Goes Home," 245.
90. Rodriguez, "Home Girl Goes Home," 254.
91. *Merriam-Webster*, s.v. "Perform."

> Performances . . . occur in many different ways constructed as
> a "broad-spectrum" or continuum of human actions ranging
> from ritual, play, sports, popular entertainment, the perform-
> ing arts (theater, dance, music) and everyday life performances
> to the enactment of social, professional, gender, race, and class
> roles.[92]

Anita Gonzalez, professor of theater and drama at the University of Michigan, holds that any performance "involves enactment, re-creation, or storytelling. Performances present humans in relationship to the exceptional circumstances that surround them."[93] Tommy DeFrantz, professor of dance and chair of the African and African American studies program at Duke University, explains:

> Performance . . . involves the excitement of breath to create sub-
> ject or subjectivity. . . . It emerges in its own conscious engage-
> ment and is created by living people. . . . [It] involves subjectivity
> occasioned by action born of breath. People make performances
> happen whether they be in the nightclub, in church, in the class-
> room, on the job, or on a stage.[94]

Performance studies, as an academic discipline, is an outgrowth of and critical critique of traditional Western Performance Theory that has been developed as a way to rethink and reframe traditional epistemological Western ways of knowledge production within the theater, the Academy, and the wider society. It is a paradigm shift away from the colonialistic, hegemonistic, imperialistic, racist, and homophobic epistemologies entrenched within the United States and Europe that have heretofore determined the ways in which non-Western, non-Eurocentric cultures and peoples have been identified, classified, and denigrated.

According to Richard Schechner, "the academic discipline of performance studies has emerged as a response to an increasingly performative world."[95] It has come "into existence within the last third of the 20th century in response to changing intellectual and artistic circumstances."[96] Performance studies is an academic discipline designed to "address and interact with the powerful combination of the local and global or 'glocal' space

92. Schechner, *Performance Studies*, 2.
93. DeFrantz, "From Negro Expression," 6.
94. DeFrantz, "From Negro Expression," 6.
95. Schechner, *Performance Studies*, 5.
96. Schechner, *Performance Studies*, 5.

humans find themselves in in the 21st century."[97] This glocal space creates room for voices of the marginalized to speak and be heard in the creation of their own valid and validated countercultural narratives and epistemologies.[98]

In agreement with Schechner's description of Performance Studies Henry Bial suggests that it is an elusive academic "field [which] includes theatrical practitioners and critics, anthropologists, folklorists, sociologists, and cultural theorists . . . [who] work without a net . . . walk on hot coals, [and] search in a dark alley at midnight for a black cat that isn't there."[99] As an academic discipline its goal is to challenge the traditional Eurocentric hegemony of Western drama with a "coming of age drama" for and about marginalized and oppressed people; doing something that matters and brings people together rather than splitting them apart.[100]

Accordingly, Bial asserts that Performance Studies originated from the need to rethink how human performances have traditionally been analyzed. These new ways include technological, political, and social changes that alter traditional concepts and create a "catastrophic paradigm shift"[101] interested in identity and identity formation, particularly that of the marginalized and oppressed.

Bial further contends that Performance Studies is not just about what we study, but about how we study. He suggests that Performance Studies developed out of a radical revitalization of anthropology (Turner) and theater studies (Schechner), shifting away from dominant Western linear boundaries of understanding the world to see the world as a performance. Performance Studies grew from the challenges to Eurocentric philosophical and anthropological hegemony when marginalized and oppressed peoples began seeking ways to claim their own identity as televised countercultural social movements bloomed in the United States and Europe in the 1960s and seventies (protests, sit-ins, marches). Originating as the rejection of traditional Western academic disciplines and epistemologies, Performance Studies are ever-changing and focus on positive values that embrace the contributions of new players seeking to express their identity. This rejection of Western epistemological systems created

> a desire to shift from dominant understanding of the world as a
> book—a linear, static catalog with clear boundaries—to a world

97. Schechner, *Performance Studies*, 5.
98. Schechner, *Performance Studies*, 22.
99. Bial, introduction, to *Performance Studies Reader*, 2.
100. Bial, introduction, to *Performance Studies Reader*, 2.
101. Bial, "Performance Studies 3.0," 402.

as performance. . . . Because the shift was intended in part to challenge traditional Eurocentric hegemony, the archetype of this performance was not in the traditional Western drama, but the coming of age ritual; . . . the idea of doing something that matters, that has efficacy, that brings people together rather than splitting them apart is crucial.[102]

To this point Dwight Conquergood explains that Performance Studies seriously critiques and challenges traditional Western epistemologies and offers and opens alternative avenues that embrace different ways of knowing and epistemologies that "cut to the root of how knowledge is organized in the Academy."[103] In agreement with Bial, he suggests that it is a radical intervention into the ways knowledge is produced. This new way embraces scholarly written and creative works, i.e., papers and performances. He says historically "the dominant way of knowing in the Academy is that of empirical observation and critical analysis from a distanced perspective."[104] Conquergood further points to Western hegemonic textualization to argue that dominant epistemologies and hegemonic "textualization needs to be exposed and undermined . . . [to] open and excavate spaces of agency and struggle from every day performance practices . . . to reveal . . . conscious, creating, critical, contrapuntal responses to the imperialist project"[105] outside of Western influence.

Recognizing that Performance Studies is a field situated within ethnography, Norman Denzin issues what he calls a manifesto in which he invites "social scientists and ethnographers to think through the practical, progressive politics of a performative cultural studies . . . [which will] connect critical pedagogy with new ways of writing and performing culture"[106] in the creation of an "emancipatory discourse."[107]

Countercultural and anti-colonialist movements consist of the voices of indigenous people (First Nations People, African, African American, Latinx, Filipino, and others) who question the validity of Western epistemologies to describe and prescribe unilateral theories as the standard by which all cultures and art forms have been and are evaluated. Performance studies in its present iteration "challenges existing ways of knowing and representing the world" and "requires morally informed performance and

102. Bial, "Performance Studies 3.0," 405.

103. Conquergood, "Performance Studies," 145.

104. Conquergood, "Performance Studies," 146.

105. Conquergood, "Performance Studies," 147.

106. Denzin, "Call to Performance," 24.

107. Denzin, "Call to Performance," 24.

arts-based disciplines that will help people recover meaning in the face of senseless, brutal violence, violence that produces voiceless screams of terror and insanity."[108]

For this challenge, Denzin calls for a "militant utopianism to help us imagine a world free of conflict, terror, and death."[109] This compares with Engelbert Mveng's cosmic battlefield, where life and death confront each other. Mveng calls for engagement in artistic expression to gain victory over death. Perhaps Denzin's militant utopianism can offer a place to express a "performance discipline that will enable us to create oppositional utopian spaces, discourses, and experiences within our public institutions."[110]

Black Performance Theory: Creating Counter Hegemonistic Pedagogy, Epistemology, and Resistance Performances

As has been established, Performance Studies are ever-changing and evolving as they continue to move toward recognizing more inclusive ways of being and knowledge production. Both Bial and Conquergood see the need for a necessary "catastrophic paradigm shift" away from the colonialistic, hegemonistic, patriarchal, imperialistic, racist, and homophobic epistemologies that have previously determined how non-Western, non-Eurocentric cultures and peoples have been identified, classified, and denigrated. They each call for the reevaluating and reconstituting of marginalized and oppressed peoples by giving space and place for other voices to speak and be heard in the creation of their own valid epistemologies. Bial suggests that the formally colonized and oppressed rely on historical memory to reclaim and recover their lost identities.[111]

Black Performance Theory offers the very catastrophic paradigm shift spoken of by Bial and Conquergood. It finds fault in Western theory and creates a seismic shaking and rearranging of dominant controlling thought, which has measured culture, art, and performance by and through one standard—the Western gaze. The emerging field of Black Performance Theory is one such voice that is "Shifting the Gaze." Four scholars speaking to my sensibilities are D. Soyini Madison, E. Patrick Johnson, Daphne Brooks, and Soyica Diggs Colbert. Each builds their theory from their African American

108. Denzin, "Call to Performance," 7, 6.
109. Denzin, "Call to Performance," 6.
110. Denzin, "Call to Performance," 6.
111. Bial, "Performance Studies 3.0," 1–2.

perspective in theater and the social sciences. Each recognizes the need to create a new and corrective narrative about blackness in the United States and the Diaspora to be constructed to undo the adverse effects that slavery, white supremacy, and patriarchy have had upon people of color as well as the larger society. For them, Black Performance Theory allows emerging scholars to speak in their voices within the discipline of Performance Studies yet counter-culturally as a positive remedial articulation of blackness.

Madison describes this emerging field as one that intentionally works inside *and* outside the field of Performance Studies calling to its attention the traditional lens through which the concept of blackness and the view of African American people have been propagated in the United States. Building upon Turner's and Schechner's understanding of performance, performativity, and performative, she briefly looks at the ways in which everyday life activities and situations are evaluated, reenacted, and performed. She describes the performance as that which refers to forms of cultural staging that are conscious, reflective, framed, and contained within a limited time span of action. Performance includes plays and carnivals, poetry and prose, weddings and funerals, jokes and storytelling, and everyday activities. Performativity refers to actions that mark identity through repetitive enactments, reiterations of stylized norms and inherited gestures, from how we sit, walk, dress, dance, play, etc. Performativity includes our body language, our actions and our actual doings. Performative is a combination of performance and performativity; it is doing something to make a difference.[112]

Madison argues that Black Performance Theory "excavates the coded nuances as well as complex spectacles within the everyday life of resistance by once known a/objects that are now and always will have been agents of their own humanity."[113] It is oppositional in that "it honors the subaltern rhetorical roots of black symbolism that survive and break through the timeworn death wish cast against black expression."[114] She calls scholars working within Black Performance Theory as writers and performers to action, to do something that will change the narrative and challenge Western hegemonistic epistemologies within the fields of anthropology, sociology, theology/religion, and the performing arts. By speaking, performing, and writing from their perspectives and with their dissenting voices that are challenging yet inviting of other perspectives, she believes it is possible to create epistemologies that correct the negative perception of blackness and allow all players to have a say in the way knowledge is produced, especially

112. Madison, foreword to *Black Performance Theory*, viii.
113. Madison, foreword to *Black Performance Theory*, viii.
114. Madison, foreword to *Black Performance Theory*, viii.

when that knowledge is about their own cultures. For Madison, Black Performance Theory "embraces beauty across the poetics of bodies in the aesthetics of their creations . . . and honors . . . its existential truths wrapped in art and purpose."[115]

Throughout history, negative stereotypes about Blacks have been propagated in America's description of Blacks. E. Patrick Johnson calls for them to be undone. He asserts that historically performative constructs of institutional racism like Sambo, Step-N-Fetch-It, Jezebel, Aunt Jemimah, and Pickaninny, which denigrate Blacks, have not been erased, but rather replaced with terms like welfare queen, prostitute, pimp, drug dealer, drug pusher, or criminal, which are code words used by dominant society to continue to denigrate Black people. These negative stereotypes have "historically insured physical violence, poverty, institutional racism, and second-class citizenry for blacks."[116]

For Johnson, Black Performance Theory is a discipline at work to change negative stereotypes about Black people in America. It is a way to reframe Performance Theory by forcing the Academy to rethink how it defines performance and its praxis that considers its white supremacist, patriarchal, capitalist, homophobic groundings. He suggests that African Americans create their own theatrical performances in order to undo the stereotypical labels placed upon them by the dominant culture. These performances, to be seen in both the African American community and the wider society, will be useful tools in changing the narrative.[117] Toni Morrison has done this in her libretto for the opera *Margaret Garner*.

Thomas DeFrantz, an acclaimed African American performance artist, affirms Johnson's observation that "Black Performance has been a sustaining and galvanizing force of black culture and a contributor to world culture at large; it has not always been recognized as a site of theorization in the Academy."[118] A "more complicated dynamic happens when whites appropriate blackness, many times exoticizing . . . blackness."[119] Again, DeFrantz captures Johnson's point of view:

> [He] explains the fraught terrain of blackness as a manifestation of the epistemological moment of race, one that manifests itself in and through performance. . . . Black Performance has

115. Madison, foreword to *Black Performance Theory*, viii.
116. Johnson, "Blackness and Authenticity," 4.
117. Johnson, "Blackness and Authenticity," 4.
118. DeFrantz, "From Negro Expression," 8, 9.
119. Johnson, "Blackness and Authenticity," 4.

the potential of simultaneously forestalling and enabling social change.[120]

DeFrantz notes that historically, Black people have been named and categorized by Western dominant knowledge production systems: anthropology, sociology, theology/religion, and literature. Black Performance Theory rejects the naming of African people by the colonizer. It self-names subaltern people in our own words and our voices, engages in dialogue with hegemonic systems, and breaks negative stereotypes. Black Performance Theory counterculturally works within Performance Theory and Performance Studies to promote and embrace the notion of Blackness as positive to reverse negative effects while creating a new epistemology. It is the catastrophic paradigm shift called for by Bial and Conquergood. With the potential to inspire social change, Black Performance Theory challenges hegemonic mainstream ideas of sexuality, religion, class, race, and codes of beauty. It is a countercultural corrective to white supremacy, patriarchy, capitalism, and homophobia. Black Performance Theory promotes Black culture through artistic genres—theater, dance, and literature.

As a countercultural voice Daphne Brooks, professor of African American studies and theater studies at Yale University, sets Black Performance Theory against the colonial invention of Blackness by opposing and simultaneously working within the existing epistemological system through stage and theatrical works that resist and disrupt American anti-Black sentiment.[121] Her work examines how "the colonial invention of exotic 'darkness' . . . has historically been made to envelop bodies and geographical territories in the shadows of global and hegemonic domination."[122]

In her study of artistic performances by Blacks from 1850 to 1920, Brooks traces historic events such as lynchings and the artistic responses of Blacks to those events in theatrical presentations as social protest against white supremacy and the negative stereotypes that were being propagated about Black people and Black bodies. Just as Black Performance Theory works within an epistemological system to undo hegemonistic ideology, Brooks says that Black artists and performers also worked within the existing theatrical system to protest the negative and turbulent American sociopolitical climate and white theater culture of the time. This countercultural work by Black artists created "Resistance Performances" that were directly opposed to yet worked within the existing theatrical and literary systems. Black stage performers and producers of literary works were

120. DeFrantz, "From Negro Expression," 9.
121. Brooks, *Bodies in Dissent*, 3.
122. Brooks, *Bodies in Dissent*, 8.

political activists who developed and portrayed positive narratives of Black culture as resistance to and disruption of American anti-Black sentiment and activities. Black artists "resisted, complicated, and attempted to undo the racial, gender, sexual, and class categories"[123] in America through their artistic performances and literary works. Brooks elucidates:

> The marginalized . . . experimented with culturally innovative ways to critique and to disassemble the condition of oppression . . . [using] the tactics of heterogeneous performance strategies in visual media . . .—religious, classical and secular song, . . . drag performances . . . musicals, spiritualism and modern dance—in order to defamiliarize the spectacle of blackness and transatlantic culture.[124]

Summary

No longer being influenced by a European mindset, decolonization takes many avenues, each to restore native/indigenous histories, dignity, cosmology, languages, literary works, and artistic expressions to the people from whom they were stolen. Per Yancy, this chapter explores how scholars of color are reframing the philosophical, anthropological, theological, and artistic expressions of the descendants of the formerly colonized and enslaved and aptly describes colonized people through their own eyes, speaking with their voices to refute and break the hold that Western control and thought has had on the world for both the colonizers and the formerly colonized.

African philosophers Masolo, Gyekye, Mbiti, and Nkrumah remind us that African Sage Philosophy, or the inherent wisdom of ancient traditions, thrived long before Europeans set foot on the continent of Africa. Theologians Dube and Mburu point us to attempts by literary imperialism to erase written or oral indigenous systems of knowledge production, replacing native histories, theologies, and philosophies with Western printed texts and interpretations to "Westernize" the African mind. Determined to set the story straight, Womanist and Black feminist anthropologists critique mainstream anthropology, explaining that the racist worldview privileging whiteness is a cultural construct that has had detrimentally adverse effects on people of color throughout the world. Womanist theologian and anthropologist Thomas proposes a theological and anthropological reconstruction of knowledge production that empowers Black women to excavate

123. Brooks, *Bodies in Dissent*, 3.
124. Brooks, *Bodies in Dissent*, 5.

ethnographic sources within our communities to unearth and convey our ancestors' cultural and spiritual traditions that are necessary to decolonize the African American mind. Harrison, Rodriguez, and Bolles promote using autoethnography as a tool to interpret ethnographic data; such allows use of personal histories, self-identity and points of view to challenge Western patriarchal and imperialistic voices in dismantling strongly held and wrongly assumed images of Black womanhood/personhood.

To create corrective narratives about blackness and Black bodies, Madison, Johnson, Brooks, and Colbert skillfully shift the gaze away from dominant Western systems of knowledge production by intentionally working inside *and* outside the fields of Performance Studies, Performance Theory, and theater. Calling attention to ways in which the negative concept of blackness has been perpetrated and presented worldwide, these and other scholars of Black Performance Theory intend to annul the harmful effects slavery, white supremacy, and patriarchy have had upon people of color. Working within traditional Performance Studies by making space for scholars and performers to speak in their own voices while counterculturally presenting positive remedial articulations of blackness, they resist anti-Black sentiment by portraying positive narratives about Black culture. Essentially, scholars of Black Performance Theory, Black stage performers, and producers of literary works are political activists.

3

Act 1, Scene 2—Ensemble

Decolonizing Narratives

The thief comes only to steal and kill and destroy. I came
that they may have life and have it abundantly.

—*JOHN 10:10 (NRSVUE)*

The genocide of cultures and peoples (which has often been instigated
and accomplished by the Western White Christian groups or
governments) . . . mandates womanist participation in . . . dialogue with
diverse social, political, and religious communities concerned about
human survival and productive quality of life for the oppressed.

—*DELORES S. WILLIAMS*, "WOMANIST
THEOLOGY: BLACK WOMEN'S VOICES"

[A colonizer is a] foreigner having come to a land by the accident of history
[who] has succeeded not merely in creating a place for himself but also in
taking away that of the inhabitant, granting himself astounding privileges to
the detriment of those rightfully entitled to them . . . upsetting the established
rules and substituting his own. . . . [A] colonizer as a usurper who "endeavors

to falsify history, he rewrites laws, he would extinguish memories—
anything to succeed in transforming his usurpation into legitimacy."

—ALBERT MEMMI, COLONIZER AND THE COLONIZED

Colonialism, Anthropological Poverty

THE VIEWS AND VOICES of those whose cultures and peoples have been op-
pressed by European and American political, cultural, and social control
are crucial to understanding how colonization was experienced and defined
from the perspective of colonized people. One cannot begin to wholly
comprehend how indigenous scholars view the demoralizing effects upon
African, Asian, First Nations People, those in the Diaspora, and other colo-
nized peoples until fully grappling with the history of colonization since
1492.[1] By viewing its impact through the eyes of the colonized and their
descendants, the devastating and lasting effects that this virulent imperial-
istic conquest and consumption of non-European peoples by European and
American empires has had upon the civilizations, cosmologies, cultures,
and creative arts of the peoples they encountered will be better understood
when viewed from the context of those who were occupied, discounted, and
displaced by this heinous practice of domination. Therefore, a brief explora-
tion of the historical, social, and religious contexts of colonialism from the
view of the colonized will set the context for this research.

Mveng is not the only indigenous scholar who recognized, identified
and named the atrocities that colonialism forced upon their people. This
chapter chronicles historical, social, and religious contextual groundings for
Mveng's theory of Anthropological Poverty and places him in dialogue with
indigenous scholars Enrique Dussel (South America—Cultural Poverty),[2]
S. Lily Mendoza (the Philippines—Cultural Deracination),[3] and Winona
LaDuke (United States—Environmental Genocide).[4] Among the many in-
digenous scholars, philosophers, and theologians who have written about
colonialism's devastating effects on their people, cultures, and artistic

1. Sailing for Spain, the Italian explorer Christopher Columbus is credited with
"discovering" the "New World" in 1492. This discovery ushered in a wave of invading
conquistadores to the Americas and the subsuming of native people's land, language,
ways of worship, and resources. Thus began a long dark era of colonization by European
nations that lasted almost five hundred years.

2. Dussel, "Transmodernity and Interculturality"; and *Invention of the Americas*.

3. Mendoza, "Tears in the Archive"; and "Back from the Crocodile's Belly."

4. LaDuke, *Recovering the Sacred*; and *All Our Relations*.

expressions, and who propose theories and remedies for decolonizing their minds, souls, and spirits are these three scholars. The work and theories of these scholars will dialogue with Mveng's theory of Anthropological Poverty in forming a Balcony Hermeneutic as a hermeneutic for healing colonized minds and communities.

Roots of Colonization

Colonization is taking over a country and its people by a foreign invader; "the act or practice of appropriating something that one does not own or have a right to."[5] It entails sending groups of "settlers" to distant lands to establish political and cultural control over that land, its resources, and its people.

> Colonization is the forming of a settlement or colony by a group of people who seek to take control of territories or countries. It usually involves large-scale immigration of people to a "new" location and the expansion of their civilization and culture into this area. Colonization may involve dominating the original inhabitants of the area.[6]

Margaret Kohn, professor of political science, and Kavita Reddy, physician and philosopher, point out that colonization is not a modern phenomenon. Ancient Greeks, Romans, Ottomans, and Moors all colonized conquered territories. But the face of colonialism radically changed in the fifteenth century as technological advances allowed navigation across vast bodies of water which could now transport people and ideologies to foreign lands miles away from European shores. "The modern European colonial project emerged when it became possible to move large numbers of people across the ocean and to maintain political sovereignty in spite of geographical dispersion."[7]

With the building of the caravel, a small, fast sailing ship developed in the fifteenth century by the Portuguese equipped with guns and high-powered cannons, Europeans could sail the coast of Africa as well as venture across the oceans with military power unmatched by the native

5. *Merriam-Webster*, s.v. "Colonization."

6. Al Tinawi, "Impact of Colonization," 235. Though this research is intended to focus on the impact of colonization on the psychological behavior of African writers, it also gives a good overview of the history of colonization in Africa inclusive of European expansion, the role played by Christian missionaries, European economic incentives, and the link of colonization to capitalism.

7. Kohn and Reddy, "Colonialism," §4.

populations.[8] This gave them the ability to dominate the Atlantic, Indian, and Pacific Oceans and to forcibly colonize Black, Brown, and Asian inhabitants.[9] The European maritime pursuits of the fifteenth century initiated the systematic usurping, discrediting, and destruction of cultures, systems of knowledge, and artistic expression of the indigenous inhabitants of the Americas, Asia, and Africa—peoples whose advanced civilizations existed long before Europeans "discovered" them.

The crowns of Spain, Portugal, and Britain claimed lands they had not previously been able to reach. White Western Europeans "settlers," and ultimately white Americans, occupied these territories and oppressed and marginalized the populations they encountered, as they colonized the world by using military power bolstered by imperialistic philosophy and supremacy ideologies. As they circled the globe, they used military power to colonize lands and people. The beginning of colonization ushered in the end of the quality of life known by indigenous people before the European invasions.

Eurocentrism, Modernity, Colonization, and Creation of the "Other"

Eurocentrism is the presupposition that Europe is the center of the world. Eurocentrism, also known as the European Ego, spawned modernity, from which colonialism emerged. According to Dussel, modernity is an invented myth, an "ideological construct which deforms world history"[10] resulting in "the discovery, conquest, colonization and integration of Amerindia,"[11] Africa and Asia through the exultation of European "values, inventions, discoveries, technology and political institutions as its exclusive achievement."[12] He observes, "The 'Myth of Modernity,' that is, the idea of European superiority over the other cultures of the world, began to be sketched out (over) five hundred years ago"[13] and further explains:

> Modernity is a world phenomenon, commencing with the *simultaneous* constitution of Spain with reference to its periphery, Amerindia, including the Caribbean, Mexico, and Peru. *At the same time*, Europe, with diachronic precedents in Renaissance

8. Editors of Encyclopaedia Britannica, "Caravel."
9. Dussel and Fornazzari, "World-System," 223.
10. Dussel and Fornazzari, "World-System," 223.
11. Dussel, *Invention of the Americas*, 11.
12. Dussel, *Invention of the Americas*, 11.
13. Dussel, "Philosophy of Liberation."

Italy and Portugal, proceeds to establish itself as the center managing a growing periphery. The center gradually shifts from Spain to Holland and then to England and France even as the periphery grows in the sixteenth century in Amerindia and Brazil, on the African coasts of the slave trade, and in Poland; in the seventeenth century in Latin America, North America, Caribbean, coastal Africa, and Eastern Europe; and in the Ottoman Empire, Russia, some Indian kingdoms, Southeast Asia, and continental Africa up until the mid-nineteenth century. . . . Later, the managerial position of Europe permits it to think of itself as the reflexive consciousness of world history and to exult in its values, inventions, discoveries, technology, and political institutions as its exclusive achievement.[14]

Eurocentrism of the 1400s and 1500s evolved from Western philosophical ideologies developed during the Age of Enlightenment. The European presumptuousness of this era is the result of fabricating and propagating self-serving values, emboldening the notion that

the inhabitants of the discovered lands . . . appeared as possessions . . . to be conquered, colonized, modernized, [and] civilized as if they were the modern ego's material. Thus Europeans . . . portrayed themselves as "the missionaries of civilization to all the world" especially to the "barbarian peoples."[15]

Because this European philosophical ideology gave rise to the demonization of their designated other, Dussel holds that it is necessary to look at the origins and development of modernity[16] to understand the epic proportions of the wide-reaching systemic institutionalization that has enslaved and removed, displaced and destroyed, conquered and colonized ancient indigenous peoples since 1492.[17] He further asserts that "modernity is in fact, a European phenomenon [which] . . . appears when Europe affirms

14. Dussel, *Invention of the Americas*, 11.

15. Dussel, *Invention of the Americas*, 35.

16. Elvin, "Working Definition of 'Modernity,'" 210–11. Professor emeritus of the School of Culture, History and Language at the College of Asia and the Pacific, Elvin suggests that for Europeans modernity is the "ability to create power . . . therefore define 'modernity' as a complex of more or less realized concerns with power. The complex contains at least the following three components: 1. power over other human beings, whether states, groups or individuals, according to the level of the system under consideration; 2. practical power over nature in terms of the capacity for economic production; and 3. intellectual power over nature in the form of the capacity for prediction, and—more generally—of an accurate and compactly expressed understanding." Elvin concludes that power has "the capacity to change the structure of systems."

17. Dussel, *Invention of the Americas*, 12.

itself as the center of a world history that it inaugurates . . . [as] part of its self-definition."[18]

With modernity came "an irrational . . . justification for genocidal violence"[19] and "the myth of a special kind of sacrificial violence which eventually eclipsed whatever was not European . . . by controlling, conquering, and violating"[20] any people or culture that it encountered. These "others" were pushed to the periphery. Thus a false myth of superiority was perpetrated over the "discovered" peoples of the Americas, Africa, and Asia, ignoring and erasing the histories of the conquered and inventing a self-definition that created "a Eurocentric fallacy in their understanding of"[21] themselves and those they considered "others." The all-pervasive vestiges of Western colonialism inflicted calamity upon the indigenous lifeways and people of the lands they conquered and remain apparent in the twenty-first century.

Colonization Viewed through Indigenous Eyes: Four Stories from the Balcony

Latin America, Enrique Dussel, and Political Poverty

Latin America (Mesoamerica) became the first foreign periphery of modern Europe. Over 350 years of European colonization and dominance of the Caribbean, Mexico, Central and South America, and portions of Southwest North America began in 1492. Portugal, Holland, France, and primarily Spain invaded and conquered the indigenous peoples, erroneously named "Indians," through deception and violent military actions. With powerful weapons unknown to the indigenous people and armor impenetrable by bows and arrows, indigenous warriors and resistance fighters were at a stark disadvantage against the European armies and settlers.

At the end of the fifteenth century, Spain was the predominant foreign invader, eventually establishing colonies in over twenty-five countries and territories. Spanish conquistadores (meaning "the ones who conquered") violently and ruthlessly murdered kings and massacred entire tribes of native (Indian) peoples. Abuse, disease, misery, enslavement, and death at the hands of these foreign invaders became the way of life for native people in Latin America. This massive and long-lasting epidemic of European colonization eviscerated the languages, tribal customs, religious beliefs, and rituals

18. Dussel, "Eurocentrism and Modernity," 65.
19. Dussel, "Eurocentrism and Modernity," 66.
20. Dussel, *Invention of the Americas*, 12, 33.
21. Dussel, "Eurocentrism and Modernity," 65–76.

of ancient civilizations such as the Incas (Peru), Mayans (Mexico), Aztecs (Mexico), and Taíno (the Caribbean). Contact with Spanish explorers and missionaries proved disastrous as native ways of being were subsumed, annihilated, acculturated, or assimilated into the dominating culture. This so-called discovery led to the genocide and enslavement of the indigenous peoples of South and Central America and Mexico.

Starting with Christopher Columbus's maiden voyage and subsequent voyages of Spanish explorers like Vasco de Balboa (1513, Panama and the Pacific), Ponce de Leon (1513, Florida and Puerto Rico), Hernando Cortez (1519, Mexico), and Francisco Pizarro (1531, Peru),[22] the colonial era of Latin America imposed a physical and spiritual conquest which lasted from 1492 to 1826. Explorers sailed under the auspices of the Spanish crowns and with the blessing of the Catholic Church. Dussel infers:

> God is thus used to legitimize actions that modernity would consider merely secular. After the Spanish had discovered the geographical space and conquered bodies geopolitically, as Foucault would say, they needed to control native imagery by replacing it with a new religious worldview. Thus the Spaniard could completely incorporate the Indian into the new system coming to birth: mercantile-capitalist modernity. But the Indian remains modernity's exploited, dominated, covered-over "other face."[23]

Believing that God had ordained these colonial enterprises and operating with the misinterpretation of the Scripture passage "go into all the world,"[24] European invaders acted on their supposed Christian duty to convert every indigenous person they encountered to the Christian faith. Conversion did not come through evangelizing and persuasion but forcibly through violent and bloodied encounters. Typically, "Before battling the Indians, the conquistadores read them the requirement (*requerimiento*), which promised to exempt the Indians from the pains of defeat if they would merely convert to the Christian-European religion."[25] These requirements were read in Spanish, a language that the native indigenous people did not understand. Therefore, they couldn't comply; yet they were perceived to be

22. Macik and Zimmerman, "Spanish Exploration Timeline." For further study, a brief account of the ruthlessness of the conquistadors and atrocities committed against the indigenous people of Mesoamerica is chronicled by Minster, "10 Facts about the Spanish Conquistadors."

23. Dussel, *Invention of the Americas*, 51.

24. Matthew 28:19 (KJV), "Go ye therefore, and teach all nations, baptizing them in the name of the Father, and of the Son, and of the Holy Ghost."

25. Dussel, *Invention of the Americas*, 51.

infidels and enemies of the Holy Catholic Church, worthy of conquest, punishment, and or death. In this way, ancient indigenous religious rituals and traditions were subsumed and integrated into the Roman Catholic religion.

Biblical and religious incongruities were stark. According to Dussel, Christianity is founded on love, while conquistadores acted with hate and brutality toward native people:

> Contradictions abounded, however, since the Spaniards preached love for religion (Christianity) in the midst of an irrational and violent conquest. It is also difficult to understand how the Spanish could have cruelly imposed cultural re-education and at the same time focused that re-education on a crucified, innocent victim, the memory that lay at the foundation of Christianity. Further, while the conquest depicted itself as upholding the universal rights of modernity against barbarism, the indigenous peoples suffered the denial of their rights, civilization, culture, and gods. In brief, the Indians were victimized in the name of an innocent victim and for the sake of universal rights.[26]

From its initial imposition, colonization was met with resistance and constant struggles for liberation, reclaiming the land and resources, and recapturing indigenous peoples' independence from colonial powers. This struggle would be devastatingly bloody and take over 350 years to acquire victory. Latin American countries gradually regained their independence between 1810 and 1825.[27] However, monumental damage had been done. Although European nations no longer exercised military and political control over South and portions of North America, many years of Spanish oppression and domination permanently impacted the people, their customs, political systems, and social structures. Class distinctions were clearly evident. There was a disproportionate number of the poor versus the rich. Native languages and religions had been annihilated. The Catholic Church was firmly planted in Latin America and held immense control over the population's minds, religious thought, and practices even after Spanish rule had ceased.

A contemporary of Mveng, Enrique Dussel was born in Argentina in 1934 and experienced the devastating residual effects that vestiges of European colonialism left on his country and the indigenous people of the Americas. While Argentina had been free of Spanish rule since 1816, its influence was still apparent in the official language of the country and the names of cities, towns, and people. Philosopher, historian, liberation

26. Dussel, *Invention of the Americas*, 50–51.
27. Gonzalez, "Latin American Independence Days."

theologian, and professor, Dussel identifies the year 1492 as the beginning of "the myth of modernity," the "Invention of the Americas,"[28] and European intrusion on and invasion of indigenous peoples. Dussel contends that Europeans inserted themselves into already inhabited spaces "to interfere without right or permission"[29] into the lives of the native peoples of the Caribbean, North, Central, and South America, claiming and renaming lands to stroke their egos while their voracious greed usurped and devoured regions of rich resources and native inhabitants.

What Europeans considered to be the discovery of the "New World," native peoples saw as an invasion and "intru[sion] on our continent."[30] Holding that "invasion is now an existential interpretative category, the same as invention, discovery, conquest, and evangelization,"[31] Dussel offers an entirely different historic account than that of the European or white American—the viewpoint of the invaded. He reports a different story from Mayan sixteenth-century codices:[32]

> The 11 Ahuau Katun,[33] first on the list, is the initial Katun. It is the Katun on which the strangers arrived, with red beards, children of the sun, white colored men. Alas! Let us weep that they came! They came from the east, the messengers of the sign of divinity, the strangers of the land. Alas! Let us weep that they came, the great heapers of stones atop stones, the false gods of the earth who cause fire to shoot forth from the ends of their arms.[34]

Dussel says, "The colonization of the indigenous person's daily life and later that of the African slave illustrated how the European process of modernization or civilization really subsumed [or alienated] the Other under the Same."[35] In its physical, as well as spiritual conquest of the "other," colonialism "depicted itself as upholding the universal rights (of Europeans) against barbarism, [and] indigenous people suffered the denial of their rights,

28. Dussel, *Invention of the Americas*, 50–51.

29. Dussel and MacEoin, "1492: The Discovery," 447.

30. Dussel and MacEoin, "1492: The Discovery," 447.

31. Dussel and MacEoin, "1492: The Discovery," 448.

32. During a February 2020 visit to the Museo Nacional de Antropología in Cancún, Mexico, I had the privilege of viewing actual Mayan codices. See appendix F: "Boturini Mayan Codices"; appendix G: "Boturini Mayan Codices"; and appendix H: "Dresden Mayan Codices."

33. Bikos, "Mayan Calendar."

34. Dussel, *Invention of the Americas*, 448.

35. Dussel, *Invention of the Americas*, 45. Chapter 2 gives a detailed explanation of "other" and "same." Also see Stuchtey, "Colonialism and Imperialism."

civilization, culture, and Gods."[36] This spiritual conquest imposed Christian doctrine upon the colonized and erased indigenous rituals and sacred spaces, thus forcing the religion of the oppressor upon the oppressed. "Modernity elaborated a myth of its own goodness, rationalized its violence as civilizing, and finally declared itself innocent of the assassination of the other."[37]

Political Poverty and Philosophy of Liberation

Dussel approaches his critique of this Western hegemony and colonization with a thorough historical assessment of this diabolical system from the inception of European invasions to the regaining of independence. It is almost two hundred years after liberation and the adverse effects of colonization are still plaguing the formerly colonized. Dussel calls this Political Poverty, or the stripping away of legal, social, and religious power from the formerly colonized oppressed poor. Political Poverty makes a clear distinction between the rich, the working class, and the poor, thus creating a "growing population of the 'structurally unemployed' or the 'socially excluded.'"[38]

He identifies "the poor masses, women in a patriarchal system, non-whites amid white racism, the unemployed, etc. . . . as individual members or passive subjects suffering oppression or social exclusion"[39] barred by political systems that "function in a way that directs the life of the community"[40] exiling certain groups to the periphery of society. Indicting the capitalistic economic and political systems that colonialism implanted in Latin America, Dussel contends, "In effect, a *system* like capitalism that has the market or the 'world of commodities' as its necessary reference point . . . , produces by its logic disequilibrium, which Hegel himself recognized perfectly."[41] This disequilibrium constructs a Political Poverty that the poor and oppressed did not initiate, yet profoundly affects them.

To combat Political Poverty, Dussel proposed a counter-philosophical discourse or a Philosophy of Liberation for the decolonization of native minds and political, social, and religious systems marked by European influence. A philosophy of liberation does not defer authority to euro-American philosophies. Still, it centers the voices of Latin American and other subaltern scholars

36. Dussel, *Invention of the Americas*, 50.
37. Dussel, *Invention of the Americas*, 50.
38. Dussel, "From Critical Theory," 26.
39. Dussel, "From Critical Theory," 26.
40. Dussel, "From Critical Theory," 26.
41. Dussel, "From Critical Theory," 27.

as a counter-philosophical discourse, whether it be as a critique of colonialism, imperialism, globalization, racism, and sexism, which is articulated from out of the experience of exploitation, destitution, alienation and reification, in the name of the projects of liberation, autonomy and authenticity. That is, the philosophy of liberation has presented itself as an "epistemic rupture" that aims to critique and challenge not only basic assumptions and themes of Euro-American philosophy, but also to make philosophy more responsive to and responsible for the socio-political situation in which it always finds itself. . . . The philosophy of liberation affirms cultural diversity, gender and racial equality, and political sovereignty.[42]

The Americas, Winona LaDuke, Religious Colonialism, and Environmental Poverty

Member of the Mississippi Band of the Anishinaabeg of the White Earth Reservation, Native American activist and scholar Winona LaDuke gives a historic overview of the role played by the church in the colonization of the Americas and First Nations People:

Papal law was the foundation of colonialism; the church served as handmaiden to military, economic, and spiritual genocide and domination. Centuries of papal bulls posited the supremacy of Christendom over all other beliefs, sanctified manifest destiny and authorized even the most brutal practices of colonialism. Some of the most virulent and disgraceful manifestations of Christian dominance found expressions in the conquest and colonization of the Americas. . . . The history of religious colonialism, including genocide perpetrated by the Catholic Church, (particularly in Latin America) is a wound from which native communities have not yet healed.[43]

As does Mveng, LaDuke indicts the church for its failure to operate in the belief system by which it claimed to live. She distinguishes differences between Native and American Christian ideas, beliefs, and practices. Indigenous people affirm the sacred relationship of humans to and with all creation, giving gratitude and caring for the gifts of water, air, animals, and land given by the creator. As America expanded westward, it claimed/stole

42. Mendieta, "Philosophy of Liberation," §3.
43. LaDuke, *Recovering*, 11, 12.

the lands of the original inhabitants as its own, desecrating sacred spaces and perpetrating genocide upon the people, in the name of Christianity.[44]

Ancient complex indigenous cultures and civilizations inhabited Mesoamerica,[45] the geographical areas now known as Mexico and Central America, before the Spanish invasion just over five hundred years ago. "Archaeologists have dated human presence in Mesoamerica to possibly as early as 21,000 BCE."[46] This violent and virile invasion of already occupied lands brought destruction, xenophobia, and a "deep fear of native spiritual practices."[47] LaDuke recounts:

> The Spaniards remade most of coastal California, enslaving Indigenous communities to the work of the Lord in 32 missions created for the perpetration of this work. . . . By 1848 . . . through the ministering . . . of the church, the so-called Mission Indians had been decimated by the diseases and cruelty of the Spaniards.[48]

Mickey Gemmill, Native American spokesman from the Pitt River Tribe, recounts, "you could go out and kill any Indian man, woman, or child in California and get a bounty."[49] During the 1850s, Congress held closed-door hearings in Washington and appropriated approximately $2 million to exterminate the California Indians. First Nation people's religious and spiritual practices were outlawed in colonized America, and Indians could face a death sentence or be committed to insane asylums for worshiping in their traditional ways. "The Wounded Knee Massacre of 1890 occurred in large part because of the fear of the Ghost Dance Religion."[50]

While the dominant narrative would have us believe that native peoples committed large-scale massacres of white American settlers, indigenous historic accounts relate a counter-narrative of the mass destruction of native peoples. "The native oral history breaks the silence of the genocide . . . and destruction of a people"[51] with documentation of massacres of na-

44. LaDuke, *Recovering*, 11, 12.

45. Feinman, "Prehispanic Mesoamerican World," 34–50. Here Feinman surveys the people and cultures that comprised prehispanic Mesoamerica and the effects of Spanish conquests upon these civilizations.

46. Editors of Encyclopaedia Britannica, "Mesoamerican Civilization."

47. LaDuke, *Recovering*, 11.

48. LaDuke, *Recovering*, 68.

49. LaDuke, *Recovering*, 68.

50. LaDuke, *Recovering*, 12.

51. LaDuke, *Recovering*, 69.

tive people of Northern California. LaDuke references David Stannard, who describes this insidious invasion:

> From almost the instant of first human contact between Europe and the Americas, firestorms of microbial pestilence and purposeful genocide begin laying waste the American natives. . . . Disease and genocide were independent forces acting dynamically—whipsawing their victims between plague and violence, each one feeding upon the other, and together driving countless numbers of entire ancient societies to the break-and often over the brink—of total extermination . . . from fifteenth-century Hispaniola to nineteenth-century California.[52]

Because the habitats, sacred places, and villages of native peoples on the East coast "impeded white settlement [in the] fairest parts of Florida"[53] and other places desired for white American expansion, President Andrew Jackson signed into law the Indian Removal Act in 1830 "giving him power to remove all Eastern Indians from their land to Indian territory"[54] as established by the government in areas west of the Mississippi River, far from their ancestral, sacred lands.

LaDuke calculates the twentieth and twenty-first century's environmental atrocities and inequities perpetrated on native people and lands, from clearing forests for large-scale lumber production to the dumping of industrial and nuclear waste in landfills and waterways on Indian land, calling it the "toxic invasion of Native America."[55] At the turn of the century, her reservation was clear-cut (deforested) as America's craving for lumber led

52. LaDuke, *Recovering*, 69.

53. LaDuke, *All Our Relations*, 29.

54. LaDuke, *All Our Relations*. The United States government used this act, as well as other Indian treaties, to forcibly remove and thus displace Native people from ancestral and tribal lands. This forced relocation of the Cherokee, Creek, Choctaw, Chickasaw, and Seminole nations to areas in Oklahoma, now designated Indian territory, is now known as the Trail of Tears. In 1838, the Cherokee Nation was forced at gunpoint to abandon their lands in the southeastern portion of the United States and walk more than one thousand miles to land "given" them by the government. Over four thousand Cherokee people died on their way. For more information see Africans in America, "Indian Removal"; and NC Bookwatch, "Theda Perdue." See also Dunbar-Ortiz, *Indigenous Peoples' History of the United States* for a more thorough accounting of the removal of Native people from their lands by force at the hands of the United States government. See appendix D: "'On Indian Removal' by President Andrew Jackson" and appendix E: "Indian Removal Act Documents Signed by Jackson."

55. LaDuke, *All Our Relations*, 2.

to the clearing of tribal lands, and desecration of forests, rivers, and sacred places.[56] LaDuke charges:

> Environmental destruction threatens the existence of native people, traditional culture, food, and relationship with the land. . . . While native peoples have been massacred and fought, cheated and robbed of their historical lands, today their lands are subject to some of the most invasive industrial interventions imaginable. . . . 317 reservations in the United States are threatened by environmental hazards ranging from toxic waste to clearcuts.[57]

In her work as an environmental activist along with the Indigenous Environmental Network, LaDuke and other indigenous peoples of the Americas—USA, Canada, and Hawaii—are fighting to protect "Mother Earth for future generations."[58] They recognize that "in the final analysis, the survival of native America is fundamentally about the collective survival of all human beings."[59] To do so, they are working through the court systems to hold the nation to its treaties made with their ancestors, to fight against large corporations that continually pollute the land, and fight for environmental justice, to prevent the further pollution of clean water, and to demand large corporations to clean the toxic waste left behind as a result of industrial expansion. Indigenous people have always resisted the encroachment upon their territory and their ways of being by the colonizing mindset of white Americans and are working together to recover their lands, restore their forests, to recover, remember and "keep [their] traditions—language, culture, housing, ceremonies, and way of life—against colonialism, assimilation, and globalization, and all that eats [their] culture."[60] For LaDuke and other First Nations people this requires a "process of remembering and restoring the relationship between people and the earth [as] a crucial part of healing the community from the violations [perpetrated against] their way of life."[61]

56. LaDuke, *All Our Relations*, 1.
57. LaDuke, *All Our Relations*, 1.
58. LaDuke, *All Our Relations*, 4.
59. LaDuke, *All Our Relations*, 5.
60. LaDuke, *All Our Relations*, 27.
61. LaDuke, *All Our Relations*, 20.

Asia/The Philippines, Lily Mendoza, and Cultural Deracination

Dussel and LaDuke are not alone in their recognition of the ways that European colonization has devastated people and cultures the world over. S. Lily Mendoza, professor of intercultural studies at Oakland University in Michigan, tells a similar story of the colonization of the Philippines and the ways in which the culture, religion, and arts of her people had been subsumed first by Spanish then by American imperialism.[62]

Mendoza's account of the violent takeover of her country aligns with LaDuke's and Dussel's accounts of the conquest and colonization of their people, each telling a different story than that of the colonizer. She recognizes this type of violence as "epistemic violence,"[63] that which is inflicted by the colonizer on the psyches of the colonized "when their sense of themselves and their world is exploded through denigration, demonization, delegitimization, and disallowance."[64]

Mendoza also indicts the church for its role in the colonization of the Philippine Islands:

> As I delved further into this history, I learned that this ideology, presuming white racial superiority that undergirded the US civilising project in the Philippines and elsewhere, pretty much wore the garb of Christian religion. Europe's supremacist identity, after all, is—historically—Christian-derived, and its genocidal settling of the so-called New World, justified as God ordained, sanctioned by the Christian "Doctrine of Discovery."[65]

62. When Mendoza lectured at Ecumenical Theological Seminary in Detroit, Michigan, in the fall of 2013, I was privileged to hear her story of living under American colonization of her homeland during her childhood and her struggles to and successes in reclaiming her indigenous Filipina identity, language, and ways of artistic and spiritual expression in her adult years.

63. Mendoza, "Back from the Crocodile's Belly," 4.

64. Mendoza, "Back from the Crocodile's Belly," 4.

65. Mendoza, "Back from the Crocodile's Belly," 5. The Upstander Project defines the Doctrine of Christian Discovery thus: "The Doctrine of Discovery established a spiritual, political, and legal justification for colonization and seizure of land not inhabited by Christians. It has been invoked since Pope Alexander VI issued the Papal Bull 'Inter Caetera' in 1493. The Papal decree aimed to justify Christian European explorers' claims on land and waterways they allegedly discovered, and promote Christian domination and superiority, and has been applied in Africa, Asia, Australia, New Zealand, and the Americas. If an explorer proclaims to have discovered the land in the name of a Christian European monarch, plants a flag in its soil, and reports his 'discovery' to the European rulers and returns to occupy it, the land is now his, even if someone else was there first. Should the original occupants insist on claiming that the land is theirs, the

The attempt at the wholesale destruction of Philippine cosmology by totally removing the racial and ethnic characteristics of the Philippine people through the removal of tribal history, languages, and spirituality is what Mendoza calls Cultural Deracination.[66] Philippine social institutions, languages, artistic expressions, religious and spiritual practices were forbidden and nearly erased. Their economy was controlled while their natural resources were extracted from the island—first by Spain for 350 years and then by the United States from 1899 to 1946.[67] She briefly summarizes this history:

> Conveniently, Spain, . . . was loathed to accept defeat at the hands of what it derisively saw as "mere Indios." In a face-saving move, it decided to strike up a deal with the United States in an 1898 Treaty drawn up in Paris that would have the two powers agree to hold a mock battle, by the end of which, Spain was to cede the Philippines to the United States for the price of $20 million. The deal done, the US then proceeded to invade the Philippines in early 1899, leaving in its wake the massacre of half a million to a million Filipinos, the commission of torture and other numerous war crimes and atrocities, the burning and destruction of whole villages and the laying to waste of the country's infrastructure. . . . [The] conquest of the Philippine islands was effectively secured through the ensuing ideological subjugation of the populace. Brief as the US formal occupation may have been (half a century) compared to Spain's protracted regime of over three centuries, American colonialism in the end is deemed to have marked the Filipino psyche in far more lasting ways, if not more insidiously.[68]

Mendoza holds that when colonialism is interrogated one can discover that what has been taught as ideologically normal by American and Western standards can be deconstructed:

> If . . . ideology as a discursive formation has served as a powerful weapon of domination in the hands of colonial rulers . . . the deconstructed rereading of the same can challenge and smash

'discoverer' can label the occupants' way of being on the land inadequate according to European standards. This ideology supported the dehumanization of those living on the land and their dispossession, murder, and forced assimilation. The Doctrine fueled white supremacy insofar as white European settlers claimed they were instruments of divine design and possessed cultural superiority" (See Upstander Project, "Doctrine of Discovery").

66. Mendoza, "Tears in the Archive," 235.

67. Mendoza, "Tears in the Archive," 235.

68. Mendoza, "Back from the Crocodile's Belly," 4.

the fixity of those ideologically sutured meanings by exposing
their political and historical contingency and by unpacking
their various mechanisms of repression and control.[69]

One way to deconstruct and unpack these mechanisms of repres-
sion and control is by reclaiming indigenous knowledge and spirituality.
Mendoza believes that it is necessary to expose and unravel "the artificial
suturing in colonial narratives"[70] that have successfully fostered the belief
of inferiority and the ideological construction of systems still intent on
marginalizing indigenous peoples. Speaking particularly about Filipino
colonization she witnesses:

> Greater violence [of colonialism] comes in the form of a total-
> izing discourse meant not only to capture bodies to bring them
> to subjection, but to encourage the internalization by the subject
> people of their own colonial/racialized subjectivity. [Through]
> . . . inscribed mechanisms of control and ideological surveil-
> lance, colonialism secures its subjects willing submission.[71]

Mendoza further explains that destroying native language is a major
component of subsuming colonized people and that "part of colonialism's
project is to discredit the native's way of being."[72] She shares her personal
story through ethnoautobiography as a "colonized subject"[73] affected by "the
United States doctrine of 'Benevolent Assimilation,'[74] or the wholesale de-
struction of the (Philippine) social institutions . . . and natural resources."[75]
Referring to Renato Constantino's work Mendoza observes that the "deci-
sion to adopt English as the medium of instruction as the masterstroke

69. Mendoza, "New Frameworks," 156–57.

70. Mendoza, "New Frameworks," 155.

71. Mendoza, "New Frameworks," 155.

72. Mendoza, "New Frameworks," 238.

73. Mendoza, "Tears in the Archive," 236.

74. President William McKinley issued the Benevolent Assimilation Proclamation
on December 21, 1898, making the Philippines a colony of the United States. It stated,
in part, that the United States had "come, not as invaders or conquerors, but as friends,
to protect the natives in their homes, in their employment, and in their personal and
religious rights." It also stated that the United States "wanted to win the confidence,
respect, and affection of the inhabitants of the Philippines by assuring them in every
possible way that full measure of individual rights and liberties which is the heritage
of free peoples, and by proving to them that the mission of the United States is one of
benevolent assimilation substituting the mild sway of justice and right for arbitrary
rule." For a detailed description of this doctrine and its effects upon the Philippine
Islands, see Miller, Benevolent Assimilation.

75. Mendoza, "New Frameworks," 160.

in the plan to use education as an instrument of colonial policy. . . . This linguistic move . . . secured the capture of the Filipino mind, bringing it to a colonial way of thinking."[76] Philippine colonial education under the Americans forced the removal of tribal languages from the education system and replaced them with English. Students were forced to speak English and reprimanded for speaking their native tongue. Their textbooks were written in English by American "scholars," systematically rewriting and erasing their history. Thus, Mendoza contends that the goal of the systemic "colonial education under the Americans . . . was to train Filipinos to become citizens of an American colony."[77]

> We were told who we were, and what we were like by outsiders who presumed to know us better than we knew ourselves. And because their views were authoritatively inscribed in theories—the very instruments of knowing—we unsuspectingly took that knowledge as accurate descriptions of us. That internalization (of the colonial view) proved to be our debasement. . . . The United States with its white Anglo-Saxon Protestant values and culture universalized as the default measure of what it means to be human. The implicit message was, to become fully human, you must become like us. . . . It is as though we Filipinos were born "wrong" and the task of education, along with religious instruction and all the other institutions of government, was to set us "right," to make us into the "correct" kind of human beings, speaking the "correct" language, taking on the "correct" worldview, and imbibing only the "correct" knowledge.[78]

To combat the effects of colonialism a nationalist movement within the Philippine educational Academy has initiated a "project of rewriting Philippine history and systematically debunking the colonial narratives written mostly from the perspective of American scholars and missionaries."[79] By telling their own story and the reclamation of history through indigenous eyes, Filipino people have begun to speak for themselves and develop tools to reclaim their culture and their country.[80] Mendoza calls this an "indigenous re-turning."[81] The reclamation of Filipino indigenous languages, art forms, and traditions is for Mendoza sacred work. This sacred work entails

76. Mendoza, "New Frameworks," 160.
77. Mendoza, "New Frameworks," 160.
78. Mendoza, "Tears in the Archive," 236.
79. Mendoza, "New Frameworks," 161.
80. Mendoza, "New Frameworks," 161.
81. Mendoza, "Back from the Crocodile's Belly," 6.

reclaiming even fragmented memories of indigenous languages, songs, and stories to invoke remembrance as a tool of healing. Doing this sacred work seeks to reconstruct and recover her own indigenous soul and "sense of God and spirit"[82] while bringing healing to formerly colonized people who still suffer from the aftereffects of years of cultural deracination and epistemic violence.

Africa, Engelbert Mveng, and Anthropological Poverty

There has been European presence on the continent of Africa since Rome established a North African province in Tunisia in 146 BCE.[83] However, the mode of colonization being addressed in this research began in 1870 and lasted until 1980. The slave trade had been a lucrative business for Portugal, Britain, and France from 1441[84] until the practice of transporting enslaved Africans officially ended in 1807.[85] No longer able to legally transport enslaved Africans to the New World, Europeans devised different ways to extort humans and natural resources of the African continent for economic gain. The Industrial Revolution was also spreading throughout Europe and the rapid changes brought with them unexpected social issues: e.g., child labor exploitation, surge in poverty, substandard housing, and pollution. Not all Europeans were incorporated into the new economic structure and many commoners were left unemployed, hungry, and homeless. A new European lower-class had been created, which governments and monarchies did not readily address.

Simultaneously, European countries were vying for position to determine which would be most powerful. In an attempt to thwart war among European nations the German chancellor, Otto von Bismarck, convened what has come to be known as the Berlin Conference of 1885.[86] At this conference, European countries decided they had the authority and "God-given" right to divide the continent of Africa among themselves and proceeded to establish international guidelines to divide and acquire African land, resources, and people. Not only would this give them control of Africa's natural and human resources, it would allow them to establish colonies and settlements where their unemployed, homeless, and criminals could be sent, thereby solving two problems with one diabolical decision. Thus

82. Mendoza, "Back from the Crocodile's Belly," 6.

83. Editors of Encyclopaedia Britannica, "Africa."

84. Carey, "Slavery Timeline 1400–1500."

85. Carey, "Slavery Timeline 1801–1900."

86. Harlow, introduction to Scramble for Africa, 13.

began the "Scramble for Africa,"[87] or the carving up of African territory by European powers. Britain, France, Germany, Italy, Belgium, Holland, and Portugal drew boundary lines on a map of the continent of Africa, created new countries, and claimed all of the land and the people for themselves. Only Ethiopia and Liberia escaped colonization. This is the modern origin of the long Western hegemonistic, imperialistic, military, economic, and cultural reign over Africa and her people.[88]

Mveng's life was rooted in this historical context. Born in Cameroon in 1930 during the time of French colonial rule, his personal experiences seeded the development of his theory of Anthropological Poverty. The country gained its independence from France in 1960, yet he recognized that the people of Cameroon continued to suffer from the devastating physical, cultural, economic, and emotional effects of having been subjected to European colonization by Germany since 1884, then after World War I as a protectorate divided between France and Britain by the League of Nations.[89] A historian, anthropologist, visual artist, priest, philosopher, and liberation theologian, Mveng understood that the effects of colonialism, which had been forced upon the whole of Black Africa, led to the destruction of indigenous personal and community values and religious beliefs of Black Africans. It led to a loss of identity and a weakening of artistic creativity and traditional culture.[90] For Mveng the "depersonalization of the African man under the colonial regime was a discounting of all he was, all he had, everything he did, and a reduction to a state of indigence and misery we call the state of Anthropological Poverty."[91]

Mveng held that while economic poverty wreaked havoc upon the continent of Africa during and after colonization, leaving in its wake financially and materially impoverished people, Anthropological Poverty was a much more serious infestation of impoverishment because it striped human beings of their fundamental nature, humanity, artistic expressions, and traditional cosmology. This type of poverty "consists in despoiling human beings not only of what they have, but of everything that constitutes their being and essence—their identity, history, African roots, language, culture, faith, creativity, dignity, pride, ambitions, [and the] right to speak."[92] The demonic

87. Chamberlain, *Scramble for Africa*.

88. Harlow, introduction to *Scramble for Africa*, 8.

89. For a very brief history of Cameroon before and after European colonization see Longley, "Brief History of Cameroon"; and Cordell, "French Colonies—Cameroon."

90. Heyer, "Annihilation Anthropologique," 136–37.

91. Mveng and Lipawing, *Théologie*, 32.

92. Mveng and Lipawing, *Théologie*, 220.

roots of this type of poverty produced "slavery, colonialism, neocolonialism, racism, apartheid, and the universal derision that has always accompanied the 'civilized' world's discourse upon and encounter with Africa—and still accompanies them today."[93] Also referring to Anthropological Poverty as anthropological annihilation Mveng asserts:

> With regard to slavery and colonization, we speak of anthro- pological annihilation. It is not a question of genocide, because the Black, because of his physical strength and his aptitude for manual work, was a sought-after and precious commodity. Anthropological annihilation deprives him of his human at- tributes, to reduce him to the state of the beast of burden, to instrumentalize him, to objectify him.... The African man who, under the colonial regime, had lost his identity, his language, his culture, his history, his spiritual inheritance, his fundamental rights and his dignity, did not, always and everywhere, recover them under independence. Often he has lost everything, mate- rial goods, attributes and fundamental rights of his person. ... African poverty does not only affect the material, social and even political life of man. It affects the human condition in its deepest roots and in its fundamental rights. Man lives in a state of anthropological impoverishment.[94]

The roots of Anthropological Poverty (despoiling the African body, mind, and spirit) are tied to the Christian evangelization of Africa, which according to Mveng was poisonous at its roots.[95] Western Christianity's "imperialist and invasive"[96] ideology brought with it a "confrontation of cultures"[97] that was built upon the Western "arrogance of theological discourse."[98] Mveng identified the problem with all of Christendom as the failure or inability of First World or Western Christianity to dialogue with Christians from the Third World. He said "there has been only, on the part of the First World, a monologue of arrogance, derision, and domination addressed to the Third World."[99] Third World peoples were ignored and subsumed under the mission language of Western Christianity.

93. Mveng, "Third World Theology," 220.

94. Mveng, "Paupérisation et Développement en Afrique."

95. Mveng, "Cultural Perspective," 73.

96. Mveng, "Cultural Perspective," 73.

97. Mveng, "Cultural Perspective," 73.

98. Mveng, "Cultural Perspective," 72.

99. Mveng, "Cultural Perspective," 73.

Mveng held that the First World's refusal to acknowledge or accept other cultures and people as human equals created by God prevented them from acknowledging the "thousands of years of art, culture, wisdom, spiritual life, and holiness amassed by the peoples of the Third World."[100] He asserts:

> Culture is essentially a way of conceiving the human being, the world, and God. . . . The culture of the West has never accepted the existence of other cultures. Its conception of the human being and the world reduced the rest of humanity to simple instruments for the realization of its own projected undertaking: its intentions for the human being, its intentions for society, and its intentions for the political, economic, and cultural organization of the world. Evangelization—Western-style . . . was poisoned in its roots. . . . The language of mission ignored all of it in the proclamation of the good news of salvation in Jesus Christ.[101]

Indicting flagrant contradictions between the mission language of Western Christianity and the message of the gospel, Mveng charged that

> the gospel preaches compassion where the West preaches derision and arrogance. The gospel announces deliverance where the West preaches domination and subjugation. . . . The good news of Jesus Christ . . . has ceased to be the message of salvation and liberation for the oppressed, and has become an instrument of domination in the service of the mighty of this world. God's word, the sacred scriptures, [and] the church of Jesus Christ have been perverted.[102]

For Mveng "the basic problem remains the foundations of Western anthropology, which would impose themselves upon the world. The concept of the human being that the West seeks to export to us is based on domination, power, death [and] struggle."[103] Anthropological Poverty calculates the impoverishing effects that colonialism forced upon the whole of Black African life and describes the stress and distress, known and unknown, of the formally colonized. He believed that acknowledging this form of poverty "ought to constitute a serious subject for the reflection of theologians because 'anthropological impoverishment' can take on 'theological' forms

100. Mveng, "Cultural Perspective," 73.
101. Mveng, "Cultural Perspective," 73.
102. Mveng, "Cultural Perspective," 73, 74.
103. Mveng, "Third World Theology," 220.

as well: it drains [and] voids persons of everything that can enable them to recognize Christ as a person."[104]

Mveng's essays—"Third World Theology—What Theology? What Third World?"[105] and "A Cultural Perspective"[106]—challenged the Western church to recognize that those people and countries Europeans determined to be an inferior Third World were fully capable of expressing their own theology in their own words from their own cultural background. He asserted that at the hand of Western theology and religious practices the very lifeblood of the people had been drained. Calling Western Christianity and missionary language a monopoly of Christ, the church, the faith, and the world, he called out its contradictory message and teachings: the biblical Christ offered compassion and mercy while the Western church operated in dominance and arrogance. Mveng called the church to task for failing to value the thousands of years of history, tradition, art, wisdom traditions, spirituality, and religious practices that existed long before Europeans stepped foot on the continent of Africa. He held that African people had a long inherent understanding of the Divine and a way of worship that Western Christianity failed to recognize. He indicted the church for its role in the colonization of the minds and bodies of African people. Mveng pointed to the arrogance of the Catholic Church and the Second Vatican Council when he challenged the church to "pierce the walls of arrogance of their cultural bastions."[107] He criticized Western theology, and by default American Theological Anthropology, showing that it "monopolized Christ, the church, the faith, and the world, . . . claim[ing] that their discourse is universal theology."[108] Knowing that there is no universal theology Mveng identified this Eurocentric viewpoint and monopoly of the faith as cultural arrogance. In order to combat this arrogance Mveng called for the decolonization and deculturation of the gospel, the recognition of all cultures, and the proclamation that

> the Christ of the gospel was the Christ of the marginalized, the poor, [and] the oppressed, . . . the Christ of the gospel was the suffering servant, filled with the spirit of Yahweh, and sent to proclaim the good news of liberation to captives, to the oppressed.[109]

104. Mveng, "Third World Theology," 220.
105. Mveng, "Third World Theology," 217–21.
106. Mveng, "Cultural Perspective," 72–75.
107. Mveng, "Cultural Perspective," 72.
108. Mveng, "Cultural Perspective," 72.
109. Mveng, "Cultural Perspective," 73.

The First World is still in denial of its imperialistic history and has made no attempts to dialogue with Third World Christians. No longer waiting for the First World to be the initiator of or partner in such dialogue, Mveng and other Third World theologians hold that the necessary dialogue to effect change and bring healing must be between the Third World and the gospel. "The Gospel must be de-westernized and restored to the peoples of the Third World."[110] There must be a deculturation of Christianity, of cultures, and the arts and a "pierc[ing] of the walls of arrogance of [Western] cultural bastions"[111] as a remedy for undoing the effects of Anthropological Poverty and the residuals of the cultural trauma it has inflicted upon the colonized. Mveng and other Third World theologians in essence call for "Shifting the Gaze"[112] away from Westernized Christianity to seeking "the Gaze of God"[113] in the recognition of every human being as a sacred creation made in the image of God.

In seeking the Gaze of God Mveng felt the necessity of expressing himself through his God-given artistic talents. Visual art became the medium through which he began the personal decolonization of his mind and spirit, which ultimately led to decolonizing the minds, spirits, and theology of African people on the continent and in the diaspora.

Summary

The "church" has summarily been indicted by every performer in this chapter for its role in the invention, spread, perpetuation, and entrenchment of the lies that bred colonization, racism, white nationalism and supremacy, and the creation of a "church" that looks nothing like the one Jesus established when he told Peter "upon this rock I will build my church."[114] Four esteemed philosophers, theologians, and activists have contributed their "Balcony View" of the history European colonizers and settlers will not tell but is necessary to hear in order to undo the devastating lingering effects of invasion, colonization, and its aftermath.

Rediscovering and restoring languages that were once forbidden, reclaiming stolen artifacts and lands, creating modern art based on ancient traditions, and revisiting and restoring ancient primal religions refute the negative narratives surrounding Black and Brown bodies that have

110. Mveng, "Cultural Perspective," 73.
111. Mveng, "Cultural Perspective," 72.
112. Terrell, "Ten Tenets of Art."
113. Mveng, "Black African Arts," 141.
114. Matthew 16:18 (NRSVUE).

permeated the world, adversely affecting the colonized by causing them to believe the oppressor's lies. Examining how Europeans embolden themselves to denigrate, confiscate, and obliterate native peoples and spaces gives voice to indigenous scholars as they attempt to undo the literary imperialism that permeates the world. Thus, a critical analysis of the patriarchal, Eurocentric ideologies that have impacted the world as a whole, this chapter presents ways that the pernicious Western gaze can be contradicted, deflated, and reversed.

I have cast the voices of indigenous scholars Dussel, LaDuke, Mendoza, and Mveng in concert, summoning other indigenous scholars of every discipline the world over to engage in the arduous process of decolonizing the history and minds of their people in order to shift the gaze, challenge classical intellectual epistemologies, and change the narratives that have plagued and devastated formally colonized peoples. Exposing to the world the tactics employed by European hegemonic and xenophobic philosophic ideologies that have whitewashed, erased, hidden, enslaved, and annihilated their ancestors, the scholars in this work name the multiple oppressions inflicted upon their people as Political Poverty, Religious Colonialism, Environmental Poverty, Cultural Deracination, and Anthropological Poverty. Each offers solutions to recover, reveal, retrieve, and restore their histories, cultures, spiritualities, and artistic expressions as avenues toward healing for their people and others still struggling to shed the weight of having been stripped of their humanity and cultures. They have, in essence, employed a Balcony Perspective and hermeneutic, and reversed the "white gaze" as they evaluate and expose the harm European colonization has inflicted upon their people, lifeways, resources, land, and countries, to restore them to their rightful owners, and to reclaim the humanity that was denied them under centuries of European domination.

4

Intermission

Forgetting. Remembering. Re-membering

Then [Jesus] added, "Every teacher of religious law who becomes a
disciple in the Kingdom of Heaven is like a homeowner who brings
from [their] storeroom new gems of truth as well as old."

—*MATTHEW 13:52 (NLT)*

Memory (the deliberate act of remembering) is a form of willed creation. It
is not an effort to find out the way it really was—that is research. The point is
to dwell on the way it appeared and why it appeared in that particular way.

—*TONI MORRISON*, "MEMORY, CREATION, AND WRITING"

The power of narrative is the way the story speaks truth to power. In
the rich tradition of African-American literature, fiction most certainly
tells the truth.... My role as a Womanist theologian and anthropologist,
then, is to release the voices of those whose stories are untold.

—*LINDA E. THOMAS*, "ANTHROPOLOGY,
MISSION AND THE AFRICAN WOMAN"

Cultural Amnesia, Cultural Anamnesis, Rememory and Collective Memory, Ritual and Re-Memory

WHAT IS COLLECTIVE MEMORY? What influence might it wield in healing and reversing damage done by Anthropological Poverty to formerly enslaved and colonized people? In the context of my research, collective memory is shared recollections of a group's historical past and identity, shaped and passed down through oral and written narratives, artifacts, and artistic expressions—it is shared knowledge, wisdom, information, and memories of a social or ethnic group. I posit, therefore, that in retrieving these memories, African American identity can be culled by persons and communities suffering still from inhumane atrocities perpetrated against them by persons who profited from the systemic radical evil of colonization and slavery.

Cultural Amnesia: Barbara A. Holmes

When an individual has been subjected to a horrific event resulting in physical or psychological wounding, one has experienced trauma. Cultural trauma happens when members of a community have been subjected to heinous events that deeply scar their collective memory and consciousness, "marking their memories forever and changing their future identity in fundamental and irrevocable ways."[1] The profound evil of slavery left indelible marks on the psyches and hearts of Black people, even after emancipation. Many formerly enslaved people kept stories of hardship and abuse to themselves. Often, former slaves determined it was easier to forget the atrocities perpetrated against them rather than to dwell on their traumatic past. For the newly emancipated this entailed the keeping of secrets and untold stories "too painful to talk about."[2] Theologian and president emeritus of United Theological Seminary of the Twin Cities Barbara A. Holmes's mother explained: "When the elders tried to tell some of the stories of oppression, silent tears would flow without ceasing. Some things, (they said), must be forgotten to forgive."[3] This intentional cultural amnesia became a communal response to suffering that also created a type of cultural malignancy.[4] Holmes explains:

1. Volbrecht, "Cultural Trauma and Collective Identity."
2. Holmes, *Joy Unspeakable* (2nd ed.), 16.
3. Holmes, *Joy Unspeakable* (2nd ed.), 80–81.
4. *Merriam-Webster*, s.v. "Malignancy." Definitions: "the state of being malignant." Malignant is defined as (1) "tending to produce death or deterioration: tending to infiltrate, metastasize, and terminate fatally. (2a) evil in nature, influence, or effect (2b) passionately and relentlessly malevolent: aggressively malicious."

> In times past, intentional cultural amnesia may have proven to be an efficacious palliative. However, considering the state of the world in general and the black community in particular, most would agree that memory loss and avoidance leave a crumbling cultural and spiritual inheritance for future generations. . . . External responses to unthinkable acts of radical evil, no matter how reasonable, eventually veer toward the demonic.[5]

Amnesia is the partial or total loss of memory.[6] Cultural amnesia happens as the result of a cultural, ethnic, or social group intentionally or unintentionally forgetting their past because it is too difficult and painful to remember.[7] When people forget their past and do not teach it to future generations, this amnesia becomes a malignancy that festers, inflicting transgenerational wounds that weaken individual and community identities. According to Holmes, cultural amnesia and malignancy can only be healed through collective memory, the intentional retrieval and re-creation of stories that, though painful, are necessary to tell and re-enact to become the remedy to heal collective trauma.[8]

Cultural Anamnesis: JoAnne Marie Terrell

As Holmes identifies memory and remembering as tools for healing cultural trauma and amnesia, Terrell proposes using cultural anamnesis to evoke such memories. Anamnesis is a memory retrieval technique initiated by oral and written practices found beneficial for emotional, psychological, and medical healing. As discussed in her book *Power in the Blood? The Cross in the African American Experience*, Terrell establishes that anamnesis is the "retrieval of experience that is painful, yet necessary, for the healing/wholeness of the psyche."[9] She further explains, "Collective anamnesis requires thoroughgoing honesty about how black women and their families have been disempowered by the social sins of racism, sexism, heterosexism, homophobia and classism."[10]

5. Holmes, *Joy Unspeakable* (1st ed.), 81.

6. *Merriam-Webster*, s.v. "Amnesia": "(1) loss of memory due usually to brain injury, shock, fatigue, repression, or illness; (2) a gap in one's memory; (3) the selective overlooking or ignoring of events or acts that are not favorable or useful to one's purpose or position."

7. Holmes, *Joy Unspeakable* (1st ed.), 80.

8. Holmes, *Joy Unspeakable* (1st ed.), 139.

9. Terrell, *Power in the Blood?*, 126.

10. Terrell, *Power in the Blood?*, 127.

This Womanist approach to memory retrieval closely examines the multiple traumas inflicted upon Black women, specifically, and upon the Black community, generally, and commits itself to promoting and seeking "the wholeness of entire peoples, male and female. . . . To be Black in America is to have suffered a collective history of chattel slavery and to have that history purportedly justified by divine sanction."[11]

Womanist Cultural Anamnesis serves as a theological reflection that includes personal and communal "experiences and insights"[12] in the healing of cultural traumas and cultural amnesia. It

> recognizes reflection upon personal and collective experience as discrete sources in the construction of theological statements . . . of liberation . . . [and also] affirms the didactic value of "intergenerational dialogue" with their predecessors—the slave women who first articulated the meaning of African-American women's struggle to come to faith as well as the families and constituencies to which womanists belong and from which they derive theological insight.[13]

Recognizing that descendants of formerly enslaved Africans in America still experience embedded cultural trauma, Terrell holds that a complete and honest anamnesis, thoroughly critiquing the source of the problem, is required for healing the wounded psyches of the Black community. Additional definitions of anamnesis include: "(1) the recollection or remembrance of the past; reminiscence; (2) the recollection of the ideas which the soul had known in a previous existence, especially by means of reasoning";[14] and (3) "a reawakening of already existing dormant or latent knowledge."[15]

Understanding the painfully challenging impact that re-creating personal, communal, or ancestral memories may evoke, Terrell recognizes the necessity of this spiritual and emotional exercise to facilitate the healing of the African American psyche. Retrieval of the stories of our enslaved ancestors passed down through oral histories, slave narratives, and intuited within our emotional spaces, anamnestic memory can be evoked, massaged, and nuanced by the telling and hearing of personal and communal stories through storytelling, literature, artistic performances, visual arts, and music.[16] Terrell regards historical African American women icons like Phyllis Wheatley,

11. Terrell, *Power in the Blood?*, 126.

12. Terrell, *Power in the Blood?*, 127.

13. Terrell, *Power in the Blood?*, 126.

14. Dictionary.com, s.v. "Anamnesis."

15. Uebersax, "Anamnesis."

16. Terrell, *Power in the Blood?*, 126–27.

Sojourner Truth, and Harriet Tubman to be "proto-womanists"[17] who possessed human qualities of agency that helped them to "endure, survive, and resist forced breeding, separation from their children and spouses and death."[18] Accordingly, these and other enslaved African women in America were "outrageous, audacious, courageous, willful, responsible, [and] in charge."[19] By definition, Margaret Garner of the opera can be considered a proto-Womanist. The opera based on her life is an anamnestic narrative that invokes reminiscence of the lives of enslaved Black women in America.

Memory, Rememory, and Collective Memory: Toni Morrison

Womanist theologians Holmes, Thomas, and Terrell concur that a prime source for theological reflection and repositories of cultural memories of the African American community is preserved in the literature of African American writers, specifically the historical narratives of Black women writers. Such narratives include *Jonah's Gourd Vine* and *Their Eyes Were Watching God* by Zora Neale Hurston, *Jubilee* by Margaret Walker, *In Search of Our Mothers' Gardens* and *The Color Purple* by Alice Walker. Storytellers, sages, and griots of our history, African American writers offer valuable accounts of Black community and survival through historical novels, autobiography, poetry, memoir, fiction, and nonfiction. Toni Morrison is one such writer. Her acclaimed novels *Beloved, Song of Solomon, Sula, Tar Baby, Jazz,* and *Paradise,* to cite a few, give glimpses into African American life in ways that few other writers have given the reader, particularly the African American reader. Morrison's catalog of works does what Thomas describes as "unearthing the sources of the past in order to discover fragments to create a narrative for the present and the future"[20] and what Harrison identifies as "autoethnography in the form of fiction as a literary tool."[21]

Relying on her childhood memories of people, events, and stories told by her ancestors, slave narratives, and historical accounts, Morrison adeptly uses narrative as a vehicle to interweave autobiography, memoir, and imagination in the excavation and portrayal of what she calls the "interior or inner

17. Terrell, *Power in the Blood?*, 136. "Proto-womanist" is a Terrell neologism naming Black women ancestors who demonstrated Womanist qualities outlined in the Alice Walker rubric of womanism.

18. Terrell, *Power in the Blood?*, 136.

19. Williams, "Womanist Theology," 66.

20. Thomas, "Womanist Theology," 491.

21. Harrison, "Writing against the Grain," 402.

life"[22] of her characters. Citing Zora Neale Hurston, Morrison understands, "I have memories within that came out of the material that went to make me."[23] Of her own memories, she shares, "The art of imagination is bound up with memory. Along with personal recollections, the matrix of the work I do is the wish to extend, fill in, and complement slave autobiographical narratives."[24] To this task, she remained steadfast and

> deadly serious about fidelity to the milieu out of which I write and in which my ancestors actually lived. Infidelity to that milieu—absence of the interior life, the deliberate excising of it from the records that the slaves themselves told—is precisely the problem in the discourse that proceeded without us. How I gain access to the interior life is what drives me and . . . which both distinguishes my fiction from autobiographical strategies and which also embraces certain autobiographical strategies. It's a kind of literary archaeology. . . . What makes it fiction is the nature of the imaginative act.[25]

While Morrison did not explicitly identify as a Womanist, a Womanist methodology defined by Linda Thomas, can be recognized throughout her works. Per Thomas, "Womanism calls for an awareness of the sharp flaws in the ways history and theologies have been constructed for hundreds of years."[26] Comparably, Morrison focused her works on "creating . . . discomfort and unease in order to insist that the reader rely on another body of knowledge"[27] rather than solely on Western literary canon's cultural hegemony, intellectual domination, and "wanton, elaborate strategies undertaken to erase [the] presence of Africanisms from view."[28] She called this erasure "savage" and says it calls attention to the "canonical rerouting or radical

22. Morrison, "Site of Memory," 192.

23. Morrison, "Site of Memory," 192.

24. Morrison, "Site of Memory," 198, 199. Slave narratives are a collection of first-person narratives of desperation, daily life, protest, escape, and quests for freedom by enslaved Africans in America. Some of these stories were actually written in the eighteenth century by African Americans themselves, including Olaudah Equiano, Phyllis Wheatley, Harriet Jacobs, Frederick Douglass, and Henry Bibb. Others were held in the oral tradition from former slaves by the Federal Writers Project from 1936 through 1938. Additional sources of slave narrative can be found in Northup's 1853 memoir, *Twelve Years a Slave*; and Bontemps, *Great Slave Narratives*.

25. Morrison, "Site of Memory," 192.

26. Thomas, "Womanist Theology," 311.

27. Morrison, "Memory, Creation, and Writing," 387.

28. Morrison, "Playing in the Dark," 1007, 1008.

upheaval and elimination of Egypt as the cradle of civilization . . . [to] replace it with Greece."[29] Citing political historian Martin Bernal, Morrison observes:

> For 18th and 19th century Romantics and racists it was simply intolerable for Greece, which was seen not merely as the epitome of Europe but also as its pure childhood, to have been the result of the mixture of native Europeans and colonizing Africans and Semites. Therefore the ancient model had to be overthrown and replaced by something more acceptable.[30]

According to Morrison, and in agreement with Mveng's theory, this erasure created an "impoverishment of the reader's imagination"[31] produced by the ways that

> knowledge is transformed from invasion and conquest to revelation and choice . . . ; how agendas in criticism have disguised themselves and in doing so impoverished the literature it studies. Criticism as a form of knowledge is capable of robbing literature not only of its own implicit and explicit ideology but of its ideas as well.[32]

This clearly aligns with Williams's methodology, which holds that a multi-dialogical intent which brings "discord as disruption of the harmony of both the black . . . and white American social, political, and religious status quo"[33] is a vital part of Womanist theological reflection.

Morrison's brilliant use of imaginative language weaves truth with fiction, thereby creating narratives using what she called "invisible ink," her way of writing so that the reader/audience is summoned into and taken away with the words and the meaning of the story. In her novels her aim was to tell the story without the "white gaze" by removing white characters and the white voice from the plots. In her final 2019 documentary, *The Pieces I Am*, Morrison says that losing the "white gaze," particularly the white male gaze, was the locus of her work. "It was not the dominant voice, rather, it was peripheral; not wrong, just not important."[34] In the opera *Margaret*

29. Morrison, "Unspeakable Things Unspoken," 7.

30. Morrison, "Unspeakable Things Unspoken," 7.

31. Morrison, "Memory, Creation, and Writing," 387. This revelation aligns with Mveng's theory of Anthropological Poverty and also with Musa Dube's theory of imperializing texts as discussed in chapter 2.

32. Morrison, "Playing in the Dark," 1007.

33. Williams, "Womanist Theology," 69.

34. Greenfield-Sanders, *Toni Morrison*.

Garner the white characters are peripheral yet necessary to tell the story, for American slavery did not exist in a vacuum. The predominant voices are those of the Black and enslaved characters who refused to capitulate to the gaze of the slaveholder. The white characters portray the oppressor's voice, the white gaze in American history as the purveyors of American Anthropological Poverty. The Black characters deflect this gaze, as heard in the orchestration and lyrics and seen in the stage directions.

Ritual and Re-Memory: Linda Thomas

As she examines ritual, Linda E. Thomas takes a Womanist theological and anthropological approach which calls for the reconstruction of Western epistemological systems to empower Black women's voices. This entails a critical intersectional, interdisciplinary conversation with anthropologists, theologians, and theater professionals. Paraphrasing Thomas, I believe that a "traditional imperialistic approach"[35] to defining and understanding ritual "does not work" with my attempt to promote ritual and performance as vehicles to healing and wholeness for marginalized communities.[36] Therefore, I reference definitions developed by anthropologists, theologians, and theater professionals of color as primary sources for this research.

In her essay "Ritual and Belief Systems," Johnnetta B. Cole, anthropologist and former president of Spelman and Bennett Colleges, claims that

> [humans] everywhere attempt to explain and control the world around them. . . . Religion is a belief system involving *myths* that explain natural and supernatural phenomenon and *rituals* by which beliefs and myths are acted out. It provides a rationale for human existence and makes intelligible and acceptable the world in which men and women live.[37]

Thomas further develops the purpose of the enacted ritual as cultural communication that expresses the values of a community and that, as a ceremonial act, ritual can create order in an otherwise chaotic world. Rituals can "provide therapeutic healing for spheres of human struggles"[38] and deconstruct toxic, life-threatening situations while creating a new reality.[39] Ritual enactment becomes a tool of remembering, as well as a technique

35. Thomas, "Anthropology," 12.
36. Thomas, "Anthropology," 12.
37. Cole, "Ritual and Belief Systems," 381.
38. Thomas, *Under the Canopy*, 63.
39. Thomas, "Remember and Re-Member," 245.

of reversal and inversion of oppression, trauma, and colonization. During her fieldwork in post-apartheid South Africa, Thomas found that ritual and faith went hand-in-hand.[40] Enacted rituals were a necessary component of the church's life and the community of people who had not yet recovered from the cultural trauma of apartheid. It was through the practice of rituals that the people could gain a sense of order out of the evil, chaotic, and oppressive world imposed upon them by apartheid. Members of the South African church that Thomas studied created a supportive community that allowed healing of their bodies, spirits, and psyches, recognized their humanity, and enabled them to express their faith as they saw fit without white South African influence through enacting sacred rituals. Thomas explains:

> Ritual cannot exist without theology and vice versa. . . . Ritual is culturally defined communication rendered by a community's goals. In addition to expressing a group's collective values, ritual secures results beyond the original expressive intention of participants. . . . Ritual, like all ceremonial rites, is both action and assertion. When ritual and religion are joined, human drama unfolds, building a relationship between people and their beliefs about the supernatural. Ritual expression [is] usually associated with moral problems, social conflict, and healing. . . . Ritual dramatizations were the means by which transformation occurred in member's bodies and social relations. . . . Ritual created an orderly world where members believed themselves to have some semblance of control. . . . Ceremonial rites provided steadiness during crisis, coherence during transition, and balance during tragedy. Ritual furnishes peace of mind in a threatening, demonic world.[41]

Enacting rituals presented opportunities for Black South Africans to "remember and re-member."[42] The act of remembering allowed them to acknowledge historical and contemporary realities that remain painful, yet when inverted, lead to a re-membering, or the putting back together of healthy and whole individuals and communities. There is a striking similarity between the cultural traumas of African Americans and Black South Africans. The intentional enactment of sacred African American rituals may offer comparable restoration, healing, and wholeness to the African American community. Ritual, particularly ritual within an African American religious or theatrical context, is a means of resistance, resilience, and

40. Thomas, *Under the Canopy*, 63.
41. Thomas, *Under the Canopy*, 62, 63.
42. Thomas, "Remember and Re-Member," 246.

restoration and moves the collective toward a hermeneutic of healing for traumatized, marginalized communities.

Further witnessing Thomas's work, Holmes suggests that worship creates a liminal space as a shift from the everyday world. Within this worship space, "contemplative practices facilitate a transition from the everyday world to an altered reality."[43] As such, Holmes explains:

> In African cosmologies contemplation is mystical, pragmatic, and efficacious. . . . Contemplative spaces are ritual references to the silences from which we are born and into which we die. Our lives are bracketed by the liminal spaces that Victor Turner describes as betwixt and between realms of life and death. . . . African contemplations acknowledge spiritual entities and energies as part of the everyday world.[44]

Holmes elicits Turner's[45] descriptions of betwixt and between as being "uncanny in its similarity to the plight of enslaved Africans."[46] Captured Africans were constrained, forced to make a physical and psychic transition from "personhood to property [to] non-identity"[47] in a forced altered reality. Referencing Turner, she considers that "liminars are stripped of status and authority, removed from a social structure maintained and sanctioned by power and force, and leveled to a homogeneous social state through discipline and ordeal."[48] Stripped of their humanity, considered property and sexual objects, Turner's description of a liminar aptly describes the plight of Margaret Garner and other enslaved African women. Though Turner refers to this power as sacred, I suggest it can also be demonic. Holmes says that it has another meaning that includes "human resilience and divine omniscience."[49] Margaret Garner would not have considered her enslavement sacred but rather a demonic wilderness experience where her resilience and agency created a secret sacred space impenetrable by the demonic forces of oppression.

Linda Thomas asserts that the act of remembering "pushes us toward recognizing the hurt and pain of the African-American community and other oppressed people."[50] Remembering forces us to recognize old reali-

43. Holmes, *Joy Unspeakable* (1st ed.), 29.

44. Holmes, *Joy Unspeakable* (1st ed.), 51.

45. Turner, *Ritual Process*.

46. Holmes, *Joy Unspeakable* (1st ed.), 70.

47. Holmes, *Joy Unspeakable* (1st ed.), 70.

48. Holmes, *Joy Unspeakable* (1st ed.), 70.

49. Holmes, Joy *Unspeakable* (1st ed.), 29.

50. Thomas, "Remember and Re-Member," 249.

ties as well as present social and systemic "patterns that have been advanta-
geous for some and restrictive for others."[51] She posits that to re-member
is to recognize these realities but to decide to begin behaving in new ways
despite and because of them. Morrison's rememory fused with Thomas's re-
membering "satisf[ies] the impulse to make use of histories, even traumatic
and shameful histories. . . . Recuperation [or] digging up the past, reflects an
epistemic practice historical legacy necessitates."[52]

Summary

As the intermission during a theatrical performance allows the audience to
pause and reflect on what they have already seen in anticipation of what is
to come, this chapter prepares the reader to attend the metaphoric operatic
production being staged for the next portion of this work. By suggesting
ritual and ritual enactment can become agents of healing cultural trauma,
cultural malignancy, and cultural amnesia through collective memory, it
prepares the reader/audience to witness enacted social rituals of repair with
an open mind.

Thus, Holmes's cultural amnesia, Terrell's cultural anamnesis, Morri-
son's collective memory, and Thomas's ritual and re-memory address spe-
cific issues inherent within the Black church and community that stress the
importance of memory and ritual to effect collective healing. Together they
compose a cohesive and safe space for reflection in preparation for facing
the difficult task ahead: healing traumatized communities.

For many, remembering traumatic experiences, whether historical or
personal, creates an emotional and spiritual discordance. When traumatic
events have been experienced by an entire group of people, particularly to
this work African Americans, forgetting or not addressing them may seem
to be expedient but, in essence, has the potential to create cultural malig-
nancy. When not healed, malignancy festers, scarring the psyche and stunt-
ing the growth of the whole community.

The cultural trauma that has scarred the group consciousness of most
Blacks in this country results from the profane and profound evil of slavery
in America. While some would prefer this history be forgotten and erased, I
suggest that a Womanist approach to memory retrieval will begin the heal-
ing process for the cultural malignancy evoked by this trauma for both the
descendants of the formerly enslaved and descendants of former enslavers.

51. Thomas, "Remember and Re-Member," 249.
52. Colbert, *African American Theatrical Body*, 186.

Such memory retrieval can come in cultural anamnesis, the intentional looking back at difficult memories and experiences that examine the historical trauma inflicted upon the Black community. One type of spiritual and emotional experience can be ritual enactment. These scholars suggest that rituals, whether religious, ceremonial, or secular, can create order in an otherwise chaotic world. It can invert symbols of terror (enslavement, apartheid) into symbols of liberation and healing, can create spaces of theological reflection, and can bring participants to emotional spaces that may be necessary to flesh out deeply buried traumas, even those traumas experienced by our ancestors long gone that are still embedded within our DNA.

Each of these scholars recognizes the necessity for retrieving the oral histories of our ancestors that remember a painful past to re-member, or put back together again, communities that have suffered damage through no fault of their own because of the social sins of racism. Retrieving ancestral stories can be accomplished through artistic mediums such as literature, visual arts, music, and performance. Naming the real-life Margaret Garner a "proto-womanist" acknowledges her ancestral relationship, allowing her story to represent and honor the countless, nameless enslaved Black women. Thus, Morrison's opera *Margaret Garner* becomes a ritual, a staged anamnestic experience for audiences and performers alike, inviting all the participants to begin dialogue around the social and theological issues still negatively impacting this country, giving this and recent operas by African American composers and librettists potential to affect healing in 2024 and beyond.

5

Act 2, Scene 1—Trio

Artists at Work

Lead me by your truth and teach me, for you are the God who saves me.
All day long, I put my hope in you.

—PSALM 25:5 (NLT)

Art is the language of the African soul.

For us black Africans, art is our supreme mode of expression.
Intellectual speculation has its merits . . . but in every civilization
art represents the peak of human creative experience.

—ENGELBERT MVENG, L'ART D'AFRIQUE NOIR

Great art belongs to all the people, all the time—indeed it is made for
the people by the people. . . . It is art that allows us to stand erect.

—MAYA ANGELOU, "ART FOR THE SAKE OF THE SOUL"

Art and Opera

Art?

WHAT IS ART? WHO and what determines what is considered to be art? Some ask whether art can even be defined as the parameters of such definitions differ from culture to culture and are fluid throughout time. An e-learning arts repository poses a historical definition of art as

> a highly diverse range of human activities engaged in creating visual, auditory, or performed artifacts—artworks—that express the author's imaginative or technical skill and are intended to be appreciated for their beauty or emotional power.... Though the definition of what constitutes art is disputed and has changed over time, general descriptions center on the idea of imaginative or technical skill stemming from human agency and creation. ... In its broadest form, art may be considered an exploration of the human condition, or a product of the human experience.[1]

Art, further described by American philosopher John Hospers, is

> anything that is human-made. Within the scope of this definition, not only paintings and sculptures but also buildings, furniture, automobiles, cities, and garbage dumps are all works of art: every change that human activity has wrought upon the face of nature is art, be it good or bad, beautiful or ugly, beneficial or destructive.[2]

For the purpose of this monograph, "art" is divided into two forms: visual arts and performing arts. Visual arts are usually created for aesthetic value but can also be utilitarian. Usually, they are static, stationary objects made by artists and displayed for viewing in private homes, galleries, and museums (paintings, photographs, and sculptures), designed by architects to be erected in public places (buildings), or envisioned and created by engineers and designers to function for human use (automobiles, furniture).

Performing arts are neither static nor stationary but are fluid forms of human artistic expression displayed through human activity, usually in theatrical presentations performed before live audiences. The intention of performing arts is to convey a story to an audience in a dramatic production. In performing arts, artists are performers who use their bodies and their voices to convey a message to an audience through staged presentations, whether

1. LumenLearning.com, "What Is Art?"
2. Hospers, "Philosophy of Art," §6.

musical concerts or recitals, plays, opera or musical theater, spoken word/ poetry, dance, and more.

Whether visual or performing, all art "includes numerous cultural expressions that reflect human creativity . . . [and] are more than simply performances for an audience; they may also play crucial roles in culture and society,"[3] reflecting "intangible cultural heritage domains."[4] History has proven that the intangible cultural heritage of many indigenous peoples colonized by European invaders has not been respected or preserved. Be it language, lifeways, or artistic expressions, many were subsumed or annihilated under European imperialism that forced their own aesthetic values upon foreign people, cultures, and lands.

Aesthetics/Esthetics[5]

According to anthropologist Evelyn Hatcher, "the word esthetics refers to the pleasurable response to what is beautiful in nature and art,"[6] but the assumed universal esthetic standards of art, and therefore beauty, have historically been evaluated in Western terms and cultural understanding.[7] Considering Hatcher's explanation, aesthetics is defined as

> a branch of philosophy dealing with the nature of art, beauty, and taste, with the creation and appreciation of beauty. It is more scientifically defined as the study of sensory or sensory-emotional values, sometimes called judgments of sentiment and taste.[8]

This definition further interrogates what makes for beauty and who determines beauty standards. American philosopher Crispin Sartwell posits, "The classical conception is that beauty consists of an arrangement of integral parts into a coherent whole, according to proportion, harmony, symmetry, and similar notions. This is a primordial Western conception of beauty and is embodied in classical and neo-classical architecture, sculpture, literature, and music whenever they appear."[9] This primordial Western conception of beauty includes how listeners critique multiple musical genres, especially opera.

3. UNESCO, "Performing Arts," §1, 3.
4. UNESCO, "Performing Arts," §1.
5. Khrystyna K., reply to "Esthetics or Aesthetics."
6. Hatcher, *Art as Culture*, 197.
7. Hatcher, *Art as Culture*, 9.
8. Kisak, *Aesthetics*, 1.
9. Sartwell, "Beauty," §30.

Theories and Theologies of Art: Tillich, Mveng, and Terrell

Mveng's understanding of how Anthropological Poverty negatively impacted the perception, production, performance, and acceptance of all African art forms is the foundation from which Western theories of art and performance are critiqued in this research. Primary theologians engaged as interlocutors with Mveng in this conversation are German-American Lutheran Protestant Paul Tillich and African American Womanist ethicist JoAnne Marie Terrell.

Paul Tillich: A Western Theology of Art

In Tillich's understanding of religion, God is *and* is more than the ultimate reality. Therefore, everything that expresses God, intentionally or not, expresses ultimate reality. He considered three ways that humans experience and express this ultimate reality: (1) Philosophy which seeks the truth about the universe and existence; (2) Art which uses aesthetic images to express ultimate reality; and (3) Religion, where ultimate reality is made manifest through ecstatic experiences expressed in symbols and myths.[10]

According to Tillich, the theology of art contributed to the theology of culture in the twentieth century. He situates art and religion in the same ontological space while pointing out distinctions. He concluded that religion and art use a set of symbols that represent divine beings and symbolic statements and/or "doctrinal formulations about their relationship to humans."[11] Yet visual art is an aesthetic expression of ultimate concern, while theology is the talk of the manifestation of the divine in all beings and through all beings. This produces a theology of fine arts that becomes a "doctrine of the manifestation of the divine in the artistic art and its creations."[12]

Because Tillich focused on "fine art," he constructed an understanding of art precipitated by the Western concept of art, namely by those artistic endeavors that produced paintings and sculptures populating museums and contemporary architecture. From what he referred to as a personal mystical experience of viewing *Madonna and Child with Singing Angels*[13] by Sandro Botticelli, an Italian painter, in a Berlin museum, he began to reflect upon how personal encounters with fine art can affect the human condition.

10. Derricotte-Murphy, "Paul Tillich."
11. Tillich, "Fine Art and Architecture," 205.
12. Tillich, "Fine Art and Architecture," 205–6.
13. Botticelli, *Madonna with Child.*

Tillich argued that the human condition had been affected by Western industrial and capitalistic structures that separated and compartmentalized human existence into distinct divisions of labor: body and mind, theory and practice, intellect and emotion, and religious and secular. Such separation and compartmentalization disconnect human beings from themselves, causing emotional distress, anxiety, and alienation. This understanding is partly comparable to Mveng's assertion that Anthropological Poverty strips humans of self and creates fragmented beings. Tillich felt that human nature innately resists such separations and that visual art facilitates moving human beings toward making the reconnections that are necessary to reclaim the self from such compartmentalization.[14] He theorized that art could lead one to a revelatory ecstasy and an encounter with the power of being itself.[15]

For Tillich, then, art—specifically fine art—is an expression of human freedom that has the power to transcend, to free one to ethically deliberate and decide, and to offer freedom from bondage to the situations of life. For him, creative freedom expressed through the arts allows humans to play and create a world outside of the natural—a world that can transcend reality. This creativity does three things: (1) expresses the quality of reality; (2) transforms a given reality by creating beauty; and (3) anticipates or offers salvation. For Tillich, the very act of creation and discovery is the miracle of art. Art can address the social structures of evil and the social neuroses created by demonic social structures that keep people in bondage. Tillich contends that the task of visual art is to show the beauty in what would otherwise be a destructive and ugly world.[16]

Engelbert Mveng: An African Theology of Art

Stripping Africa of her dignity and her artifacts, Western missionaries and colonizers of the nineteenth century described and reduced indigenous African art forms as primitive, crude, childish, demonic, and without beauty. Still, they summarily absconded tribal and communal artifacts— hand-carved sculptures, masks, and jewelry—for private collections and to display in European museums. In the twentieth century, European painters, such as Picasso, borrowed African motifs in the creation of their own artistic endeavors.[17] This blatant theft and appropriation of African artifacts and

14. Tillich, "Art and Society," 13.
15. Tillich, "Art and Society," 12.
16. Tillich, "Art and Society," 20–21.
17. Duerden, "'Discovery' of the African Mask." Here Duerden points out "it has been customary for art historians to refer to 'the discovery of African art' by Western

styles of art is but one result of what Mveng called the "basic problem . . . of Western anthropology, which . . . impose[d] itself upon the world."[18] It is but one of the facets of the effects of Anthropological Poverty[19] which created for the African an "ontologically ugly world"[20] and "despoiled human beings . . . of everything that constitutes their being and essence—their identity, history, . . . creativity, dignity, [and] pride."[21] One way that Mveng sought to undo the damaging and destructive effects of Anthropological Poverty was to restore African dignity by recognizing and promoting the importance and beauty of African artistic expression to the world and restoring creative pride and dignity to African peoples for their music, carvings, dance, ritual, and painting.

Complementary to Tillich's hypothesis, "If art expresses reality in images and religion expresses ultimate reality in symbols, then religious art expresses religious symbols in artistic images [as philosophical concepts],"[22] Mveng regarded symbols and artistic images in African art to be a religious liturgy that claimed it to be essential:

> Black African art is essentially a *cosmic liturgy* and a *religious language*. Such language establishes a permanent link between the destiny of humanity and that of the cosmos. . . . I think it is religious language. In any case it has to do with the essential thing, with the perduring link between humanity, the cosmos, and God. Hence, we must take the language of African art seriously, for it is addressed specifically to theologians. . . . The language of black art is anthropological, cosmological, and liturgical.[23]

painters and sculptors in the first ten years of the twentieth century. The term 'African art' may have come into common use because these artists thought they had made a 'discovery.'" This meant that "some artists in Europe saw some pieces of 'African art,' and seeing them was a kind of revelation. These pieces had not been regarded as art previously, but now they had suddenly acquired a new status. . . . The 'discovery' then, was the appropriation of an object that became known as 'the African mask,' a face covering that had been torn away from its context. . . . Picasso 'discovered' African art in 1905 . . . [He] showed a painting to his friends in 1907, to which he gave the title *Les demoiselles d'Avignon*, and this painting, owned now by the Museum of Modern Art in New York, represents among its figures one appearing to be wearing an African mask."

18. Mveng, "Third World Theology," 220.

19. See chapter 2 for a full description of Mveng's theory of Anthropological Poverty.

20. Terrell, "Ten Tenets of Art, Episode 1."

21. Mveng, "Third World Theology," 220.

22. Tillich, "Art and Ultimate Reality," 151.

23. Mveng, *Art d'Afrique Noire*, 137–38.

Therefore, Mveng approached symbolism in African art as a theistic religious language, not a system of concepts; that art is a living organism, articulate, flowing with life and liberation, often a silent language articulated through symbols.[24] African art is an elaborate prayer language that expresses fundamental African worldviews and places humans and human attitudes in the presence of God.[25]

Mveng sought to undo the effects of Anthropological Poverty through his life and work as a theologian and visual artist by decolonizing and de-Westernizing African artistic expressions and theological understandings.[26] In his book *L'Art d'Afrique Noire: Liturgie Cosmique et Langage Religieux* (*Art of the Black African: Cosmic Liturgy and Religious Language*), Mveng endorses art as a theological language and the language of the African soul whose symbolism represents a liturgical aspect of the mystical, philosophical, and sacramental unions of humans with the Divine.[27] Both practical and philosophical, African art, therefore, is a form of prayer that expresses the unfinished unification between the world, humans, and God.[28] "Thus, the language of African art . . . celebrates the human adventure under the gaze of God."[29]

Mveng further reasons that life and death daily confront each other on a cosmic battlefield and that the very work of African art is a form of cosmic liturgy and a "cosmic celebration of life's victory over death."[30] He portends:

> Artistic expression is the supreme way in which [African artists] express their victory over death. . . . In black Africa, death takes the form of racial hatred and bigotry . . . neocolonialism, economic exploitation, cultural suppression, and the spiritual suffocation of disembodied religions. . . . Our survival requires the restoration of our cultural sovereignty.[31]

Further, regarding aesthetics and beauty, Mveng defends African art:

> To write a book about black African esthetics would be to write about creative wisdom. For us, esthetics is not in the order of

24. Mveng, *Art d'Afrique Noire*, 7, 8.

25. Mveng, *Art d'Afrique Noire*, 6, 7.

26. Hmsarthistorian, "Engelbert Mveng." See this blog for examples of Mveng's visual artwork.

27. Mveng, *Art d'Afrique Noire*, 7, 8.

28. Mveng, *Art d'Afrique Noire*, 7, 8.

29. Mveng, *Art d'Afrique Noire*, 141.

30. Mveng, *Art d'Afrique Noire*, 140.

31. Mveng, *Art d'Afrique Noire*, 141.

sensuousness linked with concupiscence. The laws of esthetics are the laws of life and love. The beautiful is love incarnated, objectified, and personified. And for us, love is always the victory of life over death.[32]

JoAnne Marie Terrell: A Womanist Theory of Art

African American Womanist ethicist and theologian JoAnne Marie Terrell asserts that everyone is an artist.[33] As artists, all people bear the image of divinity and have sacred work to do through their particular artistic mediums. Therefore, each artist has and must be given permission to explore the full range of his or her creative gifts and talents that may encompass one or multiple artistic expressions.[34] In Terrell's podcast, *Shift of the Gaze: Arθeology for Our Time*, she outlines "Ten Tenets of Art"[35] while exploring how a Western/white gaze has negatively permeated humanity to shape and become the normative gaze through which people, cultures, and art have historically been viewed. Her "Ten Tenets of Art" offers remedies to reverse or *shift* that gaze toward a more egalitarian worldview of who and what is beautiful and what constitutes art.

Expanding on the adage "beauty is in the eye of the beholder,"[36] Terrell's eighth tenet claims "art, like beauty, is in the eyes, ears, and heart of the beholder,"[37] thus indicting what she has identified as the "Western/white gaze that has historically diminished the value and experiences of black and brown people themselves."[38] This white gaze prevented them from seeing their worth and value within their own indigenous artistic expressions by forcing conformity to "standards of whiteness and ways of knowing."[39] She reminds us that all art is beautiful, has value, and aligns with life regardless of who creates the art. Terrell critiques:

32. Mveng, *Art d'Afrique Noire*, 141.

33. Terrell, "Ten Tenets of Art, Episode 1."

34. Terrell, "Ten Tenets of Art, Episode 1."

35. Terrell, "Ten Tenets of Art, Episode 1."

36. The quote "beauty lies in the eyes of the beholder" has been attributed to Plato. It has been expanded upon by philosophers, writers, and artists throughout literary history.

37. Terrell, "Ten Tenets of Art, Episode 8."

38. Terrell, "Ten Tenets of Art, Episode 3."

39. Terrell, "Ten Tenets of Art, Episode 1."

The Western gaze fosters closed-minded definitions of art and beauty, validates some images and controls much of the discourse about what and who can be considered beautiful. . . . This forecloses a sacred understanding of some brown and black people of themselves.[40]

Agreeing with Mveng's assessment of art as creative wisdom that expresses life, Terrell's seventh tenet maintains that "art can be utilitarian if it speaks alignment with life."[41] She argues that all art forms, be they visual, musical, written, or performed, align with life and that the genius of the artist is to be a co-creator with the Divine.[42] In episode 3 of this podcast series, Terrell explores Mveng's shift away from a European gaze toward an indigenous African gaze in both his art and appreciation of his own culture and explains how this shift caused his art to take on a social agenda which affirmed the lives and humanity of African peoples. She agrees that Mveng needed to have an African gaze to become an artist and shift away from the white gaze. Working from an African gaze, Mveng also shifted the effects of Anthropological Poverty away from the European gaze. In this shift, his art was not just about being art for art's sake, to be displayed and admired for its beauty, but it also became a creative cultural remedy and social agenda intended to confront and combat the oppressive residuals that decades of colonial entrenchment had left upon the minds and self-image of the people of Cameroon and across the whole of Black Africa and the Diaspora. This shifting away from European standards of beauty and what had been considered acceptable as art in Western eyes was a direct form of resistance intended to reverse the harmful effects of Anthropological Poverty and affirm the life and humanity of African people.

Mveng and Terrell develop their theories of art from a Balcony Perspective. African and African Americans found themselves metaphorically seated in an artistic balcony, forced to the periphery of Western thought and Western concepts of art, which did not place equal value on the artistic expressions of their own people and cultures. By examining and shifting away from the detrimental ways in which traditional Western art theories have accepted some and rejected other art forms, each sees the value in placing all art forms in the same criteria, believing that all art can be healing, uplifting, and appreciated for its own beauty, form, and function. It is not necessary to denigrate one specific artistic style or genre to elevate and favor those in one's own culture.

40. Terrell, "Ten Tenets of Art, Episode 5."
41. Terrell, "Ten Tenets of Art, Episode 1."
42. Terrell, "Ten Tenets of Art, Episode 5."

To shift away from a Western gaze and understanding requires a critical re-examination of predetermined ideas about what constitutes beauty and art, keeping in mind that "aesthetic sensibilities—what we think is pleasing to us—has been shaped by conscience and unconscious ideas and perceptions that have guided our understanding of what and who has value."[43] We must inquire through what gaze art is being viewed and who is interpreting or narrating the artistic story. Terrell holds that as we shift our gaze away from Western standards of art and beauty, we will see ourselves as valuable creators of art. Each person bears the image of Divinity, has a purpose and sacred work, and has permission to explore the full range of her or his creative gifts and talents, fully entitled to join in the discovery of those gifts.[44]

Summary

From Tillich's understanding of ultimate reality, as expressed in the arts, particularly religious arts, we find that his perception was facilitated by the viewpoint of a Western gaze. He does not appear to include any artistic works outside of the European or European-American experience in his claim that art has the ability to heal. If, as Tillich asserts, art is intended to or can move humans toward wholeness and decompartmentalization, then by reasonable deduction, arts of other cultures also have the ability to heal and make whole persons who have been fragmented by the effects of Anthropological Poverty's Western ideas of acceptability and beauty that were forced upon them while their own concepts of what is beautiful were taught to be crude and primitive and inferior to any art produced by European painters and sculptors. Africans and other indigenous peoples internalized this rejection of self and denigration of their indigenous art forms, preferring European artistic expression over their own.

Mveng recognized how he esteemed Western artistic expressions more highly than Cameroonians and other Africans. He became defragmented and whole once he viewed his own culture through African eyes and an African gaze, recognizing the power and healing inherent in embracing and working from his own cultural understanding and ways of artistic expression. While Tillich recognized the negative influence that Western industrial and capitalistic structures could have on human development and proposed art as a prescription for healing the human psyche, he did not address the ways that indigenous art forms could offer the same decompartmentalization,

43. Terrell, "Ten Tenets of Art, Episode 3."
44. Terrell, "Ten Tenets of Art, Episode 3."

or defragmentation, for formally colonized populations as they view and participate in their own cosmological sensibilities in the production of art. Therefore, art becomes the ultimate reality or the essential thing in combating Anthropological Poverty's aftereffects upon Africans in Africa and the Diaspora. Art represents life.

Terrell's understanding of the necessary shifting away from a white gaze completely aligns with Mveng's conclusion that "thus, the language of African art . . . celebrates the human adventure under the gaze of God."[45] Terrell's "Ten Tenets of Art" direct every human toward seeking the Gaze of God or the Gaze of the Creator while in the process of shedding the harmful, stunting, debilitating, erasing Western white gaze. A permanent shift of the gaze recognizes that the humanity, beauty, and artistic talents of all are not determined by a particular set of cultural standards, especially Western white standards.

45. Mveng, *Art d'Afrique Noire*, 141.

6

Act 2, Scene 2—Duet

Opera House, Opera, and Audience

Now sing praises to God! Every kingdom on earth sing to the Lord!

—*PSALM 68:2 (CEV)*

The opera house has provided an important social focus for urban
cultures, its public rituals perhaps offering a secular substitute for
the religious rituals that once structured social patterns of existence.
The geographical location of opera houses within cities tells us a
good deal about their function within a particular society.

—*NICOLAS TILL, "THE OPERATIC EVENT"*

What Is Opera? A Brief Overview[1]

THE IMPETUS OF THIS work is an explanation of what informs my position
and entry into this research. As a participant-observer, I approach this re-
search with my tripartite Womanist experiences as an opera singer, educator,
and ordained minister who has encountered the shared experiences of opera

1. Opera Philadelphia, "Opera 101." Opera Philadelphia's website explains and de-
fines opera, vocal ranges, voice types, and common opera terms.

between performers and audiences. While opera has historically been a ready vehicle of racial separation in America, opera can affect, and effect, social change and theological reflection while initiating healing for the wounded psyches of the descendants of formerly enslaved and colonized peoples.

Journalist Angelica Lasala discovered that Western opera's original and first precursor is attributed to Sister Hildegard von Bingen, a little-known twelfth-century German monastic nun, musician, and scholar.[2] Considered a visionary and a prophetess, von Bingen composed *Ordo Virtutum*, a morality play set to music, as a theological reflection on virtuous living. Preparing to stage a revival of this work in 2005, Roger Brunyate of the Peabody Music School in Baltimore, Maryland, noted that *Ordo Virtutum* (*The Company of the Virtues*) was a dramatic ritual set to music that

> was no mere didactic morality [play], but a spiritual celebration—a joyous, transcendent ritual which we may not understand in detail, but whose overall dedication, surety, and exaltation affects us in ways that go beyond mere words, lessons, or even narrative.[3]

Ordo Virtutum is regarded as the earliest written account of a Western dramatic ritual enacted with music and lyrics intended to affect the hearer "in ways that go beyond mere words."[4] With von Bingen named as the first Western operatic composer, and by duly acknowledging her contribution to the world of Western classical music, the historic patriarchal and prejudicial hold on this genre of music weakened significantly. For a Womanist theologian and opera singer, this distinctive discovery cannot be diminished in scholarship around opera, performance, and composition. Therefore I suggest that selected operas performed in the twenty-first century, when staged as a ritualistic social drama, can evoke comparable visceral responses that von Bingen imagined, thus moving audiences and performers to reflect critically on the actions portrayed on stage in light of the social contexts of the day.

So how did this genre of music with deep European connections become part of the fabric of American entertainment? Operas are staged plays set to music, usually in two or three acts, with short intermissions. Today this performing art is a spectacular theatrical multimedia experience that involves visual, verbal, oral, and aural elements on a grand scale. Dialogue in an opera is sung to orchestral accompaniment. It is embellished with elaborate staging, functional and ornate scenery, special lighting effects,

2. Lasala, "Earliest Opera Ever Written." This article includes a link to the film *Hildegard von Bingen*, Runcie et al.

3. Brunyate, "Back to the Source," §8.

4. Brunyate, "Back to the Source," §8.

elaborate costumes, and illustrative dance to tell a dramatic or comedic story. English journalist and critic Alexander Waugh explains that

> opera is the most exciting, the most involving and often the most spectacular of all the performing arts, combining all the great skills of song, instrumental playing, drama, dance and design into one.[5]
>
> [It] is a unique and lavish art form quite unlike any other. It cannot be compared to film, theater, ballet or music at a concert. Opera has its own life force, and when its many disparate elements—solos, ensembles, choruses, lighting, design, orchestra, movement and dance—work together, it can be one of the most exhilarating and captivating of all of the performing arts. . . . In many ways opera is the easiest of all the musical arts to appreciate because it consists of a three-way process between the words, the music, and the visual presentation. . . .[6]
>
> Just as the words of opera are able to bring meaning to the music, so the music also enhances the meaning of the words. . . . In opera . . . the movement of the music is used to awaken the senses of the listeners and arouse their emotions through its extraordinary power of suggestion.[7]

Because opera involves several arts disciplines simultaneously, it is usually performed in architecturally distinct theaters called opera houses. Opera houses are typically large buildings for audience seating, orchestra pit, performance stage, backstage areas for set and costume design, rehearsal halls, dressing rooms, hair and makeup rooms, and production offices. Historically, opera houses have been standalone buildings—such as the Metropolitan Opera House in New York City—but more modern performing arts centers now house opera alongside various other artistic genres. The Kennedy Center in Washington, DC, is an example of a multipurpose arts venue with its expansive campus of theaters, stages, and creative spaces.

Opera is occasionally confused with musical theater. While both are staged productions in large theaters, set to music, and feature acting, singing, and dialogue, there are distinct differences.[8] Operas may be sung in foreign languages or English, while musical theater is usually sung only in English.[9]

5. Waugh, *Opera*, 11.
6. Waugh, *Opera*, 9.
7. Waugh, *Opera*, 10.
8. Roberts, "What's the Difference."
9. Tommasini, "Opera? Musical?"

Further, the mechanics of vocal production are different. Opera singers are expected to project their voices throughout the opera house without amplification (no microphones), while lead singers in musical theater are outfitted with microphones. In opera, the dialogue (the libretto) is set to orchestral music sung by the main characters (principals) and the chorus. In musical theater or a musical, portions of the dialogue are spoken rather than sung, and there may be more dancing involved in the production.[10] An adaptation is when an opera is produced as musical theater: Oscar Hammerstein's *Carmen Jones* is an adaptation of George Bizet's *Carmen*; Jonathan Larson's *Rent* is based on *La Bohème* by Giacomo Puccini; and Claude-Michel Schönberg's *Miss Saigon* is based on Puccini's *Madama Butterfly*.[11]

Strikingly distinctive to opera are its vocal performances, whether solo or choral. Solos are either *recitative* or *arias*. The *recitative*, or speech that is sung, narrates details of the plot, whereas *arias*, or lyrical solos, reveal a major character's personal emotion and state of mind. The *chorus* comments, usually in four-part harmony, as a group or community on the action of the main characters or the storyline.

Why Opera? Is It Relevant?

Opera may be paradoxically germane as a form of American entertainment, although deeply rooted in European history and America's racist history. Admittedly, opera is an art form marginally patronized by most Americans of any racial or cultural background. Often thought of as an elitist genre of musical entertainment, it is usually deemed as a Western classical genre, admired by the "snobbish" and "upper crust," and suspected as "uppity and bougie" by everyday people.[12] Opera is not a major part of American mainstream or popular culture and is often considered a frivolous, highbrow, fossilized, and nostalgic art form.[13] Most Americans are not familiar with the names of contemporary opera stars as they are with the names of pop, R&B, hip-hop, country, or gospel performers. Fewer are fluent in European languages of Western grand opera performances: Italian, French, German, and Russian. Most would be ignorant of the composer's names, living or dead.

Nevertheless, Americans, even those who claim not to like this art form, know more about opera than they think. Americans have unwittingly been introduced to Western classical music and grand opera through no

10. Campbell, "Musical Theatre."
11. Hoya, "Video Roundup."
12. Derricotte-Murphy, "Porgy and Bess Speaks," 85.
13. Suna-Koro, "Ecstasy of Lament," 66.

effort of our own. Theme music for television shows, incidental music for commercials, and soundtracks for popular movies successfully employ this genre of music to impact audience thoughts and emotions. As a veiled form of music education for the masses, opera scores are woven into the fabric of American popular culture. At the same time, audience members have been fixated on movie and television screens, not realizing they were subversively inundated and introduced to Western classical music. From children's programming to adult blockbuster films, opera scores largely influence character development and plot progression on the big screen and have impacted knowledge production and the culturalization of the American public.

While glued to their television sets, children of the 1950s watched Saturday morning cartoons[14] scored with operatic music from Smetana's *The Bartered Bride*[15]or Wagner's *Tannhauser*[16] without them or their parents recognizing this subtle introduction to opera and intolerant worldviews. *Los Angeles Times* journalist Diane Haithman charts that opera, often considered a form of highly cultured entertainment, found its path into American consciousness through popular culture. By giving several examples, Haithman shows the connections between opera arias and pop culture as reflected in television, commercials, popular songs, and movies:

> Perhaps opera took up residence in your brain when you first saw the classic 1957 Bugs Bunny cartoon "What's Opera, Doc?" which borrows liberally from Wagner's operas, especially "The Flying Dutchman" and "The Valkyrie" (recall the horn-helmeted Elmer Fudd jabbing his spear down the rabbit hole, yelling "Kill the wabbit!" to the Valkyrie leitmotif). Or maybe it took hold when Beyoncé Knowles sang of the tragedy of a "guy named Zeke" who loses his can of Pepsi in "Pepsi's Carmen," a big-budget, music-video-style TV commercial (not to be confused with an earlier MTV movie also starring Knowles, "Carmen: A Hip Hopera"). . . . Maybe opera burrowed into your consciousness more recently, as you listened to that roly-poly puppy extolling K9 Advantix flea powder to music from Ponchielli's "La Gioconda" in a current TV spot—the same melody borrowed more

14. Mancini, "15 Pieces of Classical Music."

15. Keller, "Notes on the Program." Keller writes program notes for a New York Philharmonic performance of Smetana's *The Bartered Bride* giving a brief bio of the composer and description of the social context of Czechoslovakia (Bohemia) during the 1860s explaining how this and other European operas were becoming tools of patriotic movements against oppressive invading forces.

16. New York Public Radio, "Wabbits and Wagner." This story gives a biographical sketch of Wagner, his anti-Semitic views, and the influence that his music had on Hitler and the rise of Nazism. See also Biography.com, "Richard Wagner Biography."

than 40 years ago by Allan Sherman for his novelty song about summer camp, "Hello Muddah, Hello Fadduh!," probably better known at this point than the opera itself.[17]

Opera continues mainstreaming into American popular culture through subliminal television commercials and movies. From candy to cars, coffee to beer, products such as Pepsi-Cola, Heineken Beer, Rice Krispies, Extra chewing gum, Bud Light, Dove soap for men, Ghirardelli Chocolate, Lincoln Navigator, JG Wentworth,[18] and many more use scores from operas to entice audiences and increase sales. "Due to its ability to enhance the underlying emotion of a scene,"[19] opera scores and arias have made their way into the movies: e.g., Figaro's aria from the *Barber of Seville* in *Hopscotch* (1980), "Amami Alfredo" from *La Traviata* in *Pretty Woman* (1990), an aria from *Madama Butterfly* in *Fatal Attraction* (1987), "Sull'aria" from *Le Nozze di Figaro* in *The Shawshank Redemption* (1994), "Habanera" from *Carmen* in *Up* (2009), and "Nessun Dorma" from *Turandot* in *Mission Impossible: Rogue Nation* (2015).[20]

These are a few examples of how opera has been infused into American society and popular culture from the early days of television and cinema up until current productions, engaging those who may never intentionally enter an opera house. From slapstick cartoon comedy to catchy advertisement jingles, to big-screen drama and love affairs, these mediums of popular cultural production have taken Americans to the opera. Regardless of one's preference for music, opera is all around us and firmly woven throughout the "fabric of our lives."[21]

In its attempt to popularize opera across America and to reach audiences without accessibility to grand opera houses, the Metropolitan Opera began live radio broadcasts of its Saturday matinee performances in 1931.[22] Americans of all ethnicities and class distinctions with access to a radio could enjoy opera performances at home. Radio broadcasts knew no racial boundaries, and many African Americans were introduced to this music genre while doing household chores as an opera played in the background. Several of my opera colleagues have shared their personal

17. Haithman, "Wuv Affair with Arias."

18. Branstetter, "Opera Commercials."

19. Moss, "Opera in TV Commercials."

20. Glyndebourne, "10 Times Opera Stole the Scene."

21. This phrase is a play on the words from the commercial slogan for Cotton™: "Cotton, the fabric of our lives."

22. Metropolitan Opera, "Saturday Matinee Broadcasts."

stories of being introduced to opera this way by a parent who simply liked how the music sounded.

Through modern technological advances, the accessibility of grand opera for audiences across the country and the world has expanded in the twenty-first century. Saturday matinees continue to be broadcast across the nation through radio and satellite. The Metropolitan now offers "Met Opera on Demand"[23] through streaming television services and broadcasts of live performances of select operas through its "Opera at the Cinema"[24] series at select movie theaters worldwide. One who appreciates this entertainment genre can now enjoy grand opera at home, in your car, or at the movies.

Drawing upon opera as an avenue of theological reflection and exploration into the effects of systemic patriarchy and racism in American society is a unique quandary. Because Western opera developed as an artistic expression and vehicle that addressed the social, economic, and political climate of seventeenth-century Italy, twenty-first-century operas still have "the capacity to engage current political affairs and debates . . . [and] also raise issues that [are] more problematical and less easily resolved"[25] than other means of dialogue. In his article entitled "Why Opera?," American journalist Dennis Romero suggests that audiences came to the opera to "tap into deep wells of emotion . . . , [giving] expression to a new, more reflective, interior sense of self . . . that helped them learn how to navigate the new social order in which they were finding themselves."[26] This sentiment is embraced by theologian and chair of the department of theology at Xavier University Kristine Suna-Koro, who affirms that "opera is all about excitement, passions, and ecstasy. . . . [It can be] a locus of divine revelation in and through music, or the locus of authentic human response to God's self-disclosure."[27] For her, opera is an "unchurched expression of lament without hindrance . . . and pretentious intellectual self-control. . . . [It is an] exciting resource for spirituality . . . worship, [and] theological concern in an honestly sensuous mode."[28]

Acceding to Suna-Koro and Romero's conclusions, opera can transport audiences to different social, emotional, and spiritual experiences. This assertion confirms my choosing opera as the locus for this study. When intentional, opera can transform minds and present complex social issues

23. Metropolitan Opera, "Met: Live in HD."
24. Metropolitan Opera, "Met: Live in HD."
25. Romero, "Why Opera?," 402.
26. Romero, "Why Opera?," 408.
27. Suna-Koro, "Ecstasy of Lament," 67.
28. Suna-Koro, "Ecstasy of Lament," 68, 79.

in a non-threatening medium. It offers audiences alternative perspectives beyond familiar and preconceived notions of America and the world; and accommodates expressions of political and social voices of the marginalized "other." Opera inherently lifts spirits and invokes critical thinking about sensitive subjects.

In *Black Opera: History, Power, Engagement*, ethnomusicologist Naomi André holds that despite its prejudicial past, "opera can be relevant, provocative, and empowering. Opera is an art form that has potential for being a site for critical inquiry, political activism, and social change."[29] She further asserts that "opera is a genre that elicits a wide range of our emotions (love, anger, joy, fear, and so on); it makes us think and feel"[30] and that

> opera's enduring and wide-ranging popularity, rich traditions of artistic collaboration and exchange, diversity of styles, and ability to blur the lines between cultivated and vernacular forms of art make questions about the intersections between race, ethnicity, and identity within the genre both trenchant and valuable.[31]

Despite the historic racist exclusion of Black performers from opera house rosters, African Americans have embraced opera since the art form arrived in America. Further, regardless of obstacles employed to thwart and prevent their success by dominant Eurocentric cultural gatekeepers, African Americans pose a powerful presence on opera stages worldwide. Even African American non-opera patrons can usually name and identify historical and contemporary African American opera singers Marian Anderson, Robert McFerrin, Paul Robeson, Leontyne Price, Jessye Norman, Kathleen Battle, and Denyce Graves.

Historically, Western opera emerged as a subversive form of entertainment that critiqued the sociopolitical structure of struggling seventeenth and eighteenth-century European monarchies and city-states like Italy, France, and Bohemia (present-day Czechoslovakia), making it "one of the most successful reform movements in European history."[32] Opera is credited with giving Italy a national protest song through the music of Giuseppe Verdi's *Nabucco*, "*Va Pensiero Sull'ali Dorate*" ("Go Thought, On Golden Wings"). Exampling this trend, Italian director Joseph Palau explains:

> Born alongside Italy's press for nationhood, Verdi's operas provided Italians with the music that expressed the passion for their

29. André, *Black Opera*, 238.
30. André, *Black Opera*, 1.
31. André, *Black Opera*, 1.
32. Dizikes, *Opera in America*, 15, 16.

cause and became an important part of Italy's national identity. . . . Verdi . . . poured his artistic potential into breaking the oppressor's yoke through music.[33]

Assessing the relevance of twenty-first-century opera, art critic Philip Kennicott concludes that "opera never was central to American society and it never will be. . . . [It is] marginalized within American culture . . . [but if] opera matters to a few people, deeply and with transformative power, perhaps that's relevance enough."[34] He further explains that opera is a form of art that should "stand apart from the baser trends of society . . . [that] what matters is . . . the ability of the art form to be a forum for human compassion."[35] Kennicott hypothesizes that "if art doesn't teach us about the other, about things foreign and unfamiliar, what good is it?"[36]

Comparable to seventeenth- and eighteenth-century opera (namely, works by Verdi and Puccini), perhaps twenty-first-century opera, performed as social drama and resistance art, possess the same transformative emotive power to splinter well-established oppressive systems of hegemony, xenophobia, racism, sexism, and homophobia; and might catalyze national reform movements in American society around these issues. An opera with this intent would present to society another genre of music with effectual power to challenge demonic, oppressive, and systemic race and class distinctions.

Balcony Perspective

Throughout this work, the terms *balcony* and *opera glasses* are metaphors for my Womanist viewpoint of both the activity in an opera house and American xenophobia that relegates and consigns Black people to multifarious balconies of every phase of the American citizenry.

Since America's inception or the "Birth of a Nation,"[37] dominant European culture has consistently maintained a segregationist position with

33. Palau, "Giuseppe Verdi." In this short biographical sketch of Verdi's life, Palau briefly outlines the composer's rise to fame alongside Italy's struggles with Austria for independence from the 1840s to the 1870s. It further highlights the role that Verdi's music, especially "*Va Pensiero*," played in empowering Italy's resistance and unifying the country.

34. Kennicott, "Is Opera Still Relevant," 36.

35. Kennicott, "Is Opera Still Relevant," 37.

36. Kennicott, "Is Opera Still Relevant," 35.

37. Using the term "Birth of a Nation" is an intentional play on words referring to two American movies of the same title. The first is a 1915 silent film highlighting the rise of the Ku Klux Klan (KKK) and promoting racist and anti-Black propaganda. The

interactions with non-European peoples.[38] As a social statement of power and supremacy, white American slaveholders, theater owners, and dramaturgs, church authorities and parishioners, politicians, and ordinary citizens consigned African Americans to the "balcony" of all facets of American society. Notably, the historic practice existed of relegating Black people to structural balconies of churches,[39] concert halls, and theaters from the eighteenth through mid-twentieth centuries. Whites designated the balcony, gallery, or cheap seats for African Americans, other people of color, and poor whites who could not afford orchestra or mezzanine seats. "Upperclass" whites reserved the "good seats" for themselves. This menacing practice was intended to separate, ostracize, denigrate, and oppress nonwhites and poor white Americans.

The particularly insidious practice of keeping "Blacks in the balcony"[40] during antebellum church services was to control the daily movement of enslaved Africans while supposedly evangelizing and converting them to enslaved submission through the misrepresented Christ and promised salvation. After Emancipation, privileged whiteness made public works (e.g., transportation) and public spaces and events (e.g., parks, theater and theater-going) as difficult, degrading, and disparaging as possible for African Americans.

This oppressive practice of keeping "Blacks in the balcony" further defined how African American performers and opera singers have been historically perceived and received by the American public. Despite the negative narratives and obstacles, African Americans have been involved in professional classical performances since colonial times. Despite the cultural and social obstacles implemented to denigrate and prevent Black opera performers, pioneering African American artists trained in European classics (e.g., Elizabeth Taylor Greenfield and Sissieretta Jones) gave concerts consisting of Western classical repertoire during the nineteenth century in front of predominantly white audiences.[41]

second, a 2016 film, was based on the true story of Nat Turner, an enslaved Black man who led an unsuccessful revolt (a.k.a. the Southampton Insurrection) against enslavement in 1831. See Griffith, *Birth of a Nation*; and Parker, *Birth of a Nation*.

38. Bedard, "Immigrant Experience." Bedard discusses America's discrimination against Irish, Italian, Polish, and Jewish immigrants. For some groups, assimilation into America's white culture has lessened overt discrimination as future generations spoke English with no detection of a foreign accent.

39. See appendix I: "Church Balcony—Pulpit View."

40. Amt, "Down from the Balcony," 1.

41. Story, *And So I Sing*, 1–28.

While the dominant culture intended to keep Black bodies enslaved and subsumed through its Balcony Mentality and mandates, I propose that there may have been unknown, unseen, and unperceived advantages to balcony seating. Overlooked by racist opera gatekeepers was the fact that whether in orchestra front row seating or the balcony, everyone in the theater saw the same performance but from a different perspective. Black and white church attendees and theatergoers were in the same venue, seeing and experiencing the same event. These "other" vantage points and perspectives gave each group a unique stance to evaluate the performance and the existing social structure.

Isolating and setting themselves apart from Black bodies may have made some whites feel superior, but it may not have given them the advantage they intended. It may have kept them from clearly seeing the fully staged production without missing essential parts of the story and subplots. I contend that American society can be compared to theatergoing; we are all in the same place simultaneously, yet experiencing historical and sociopolitical events from very different vantage points. This distinctively American form of theological anthropology created a narrow and myopic view that prevented oppressors from seeing the full panorama of the human story and accepting Black and brown people as human equals.

In the twenty-first century, architectural balconies are no longer identified as a place of racist separation. Instead, the balcony is occupied as the less expensive seats in the theater or as the overflow space in a church. However, a "Balcony Mentality" still permeates American culture for both the oppressor and the oppressed. The marginalized remain overtly and covertly relegated to the balconies throughout much of American society and culture, thus attesting to what Cameroonian Jesuit theologian Engelbert Mveng calls Anthropological Poverty, the deprivation of the presumption of the full humanity of African peoples. From this perspective, I develop a "Balcony Hermeneutic" that affords my Womanist eye to critique America through opera—essentially privileging me to take "A View from the Balcony."

The Opera House and the Audience

Personal experiences have situated me as a performer on the opera stage and as an audience member seated on the main floor and the balcony of various opera houses. Therefore, this autoethnographic exploration of the affect and effects of balcony seating metaphorically uses Womanist opera glasses to view and analyze the impact of balcony seating from the perspective of the audience and the performer.

The Opera House

Theaters are architecturally designed public spaces to foster social engagement among a particular public, theatergoers. Theater interiors are designed to place the public in spatial relationships with each other.[42] Historically, the theater was where the aristocratic, royal, and ruling classes mingled and displayed their status at social events. Today theater creates a world where people of all classes interact in spaces specifically designed to "make believe . . . reflect real situations, characters, and places."[43] Theatrical performances are well-planned, coordinated public events that bring audiences and performers together in a context emphasizing symbolic reality that is bounded in time and space.[44]

Upon entering the theater, audiences anticipate that they are about to experience an otherworldly moment as both a personal and communal encounter. As such, theater design directly affects the interaction between audience members, whether it places them in close proximity to each other or separates them by floors, sections, boxes, or partitions. Examining the seating arrangements in an opera house to understand how seating affects these spatial relationships and audience responses to and during a performance is necessary. Examining the photographs of the interior of the Detroit Opera House, from which I've experienced a personal view from the balcony and the stage, will show the audience spatial connections and proximity to the stage, front-row orchestra seats, and other theater seats. These photos indicate how audience members can be shaped into a cohesive group or separated from each other by means of the seats they occupy.[45] Opera houses are designed to accommodate large audiences. For example, the Detroit Opera House in Michigan seats 2,700; City Opera in New York City, formerly housed at the State Theater in Lincoln Center, sat 2,586;[46] and the Auditorium Theater in Chicago seats 3,901. The audience's size and placement can create an intimate atmosphere, a sense of community, or isolation in a large crowd.

42. Read, "Theater of Public Space."

43. Read, "Theater of Public Space," 58.

44. D'onofrio, "Anthropology and Theology."

45. See appendix J: "Mezzanine or First Balcony View—Detroit Opera House" of the stage, and appendix K: "Upper Balcony View—Detroit Opera House" for a view of the orchestra pit and stage apron from the upper balcony.

46. City Opera has since been downsized and relocated to the Rose Theater at Lincoln Center, which seats 1,233.

Seats: Orchestra, Main Floor, or Balcony

Since theaters are designed to create spatial relationships for theatergoers, there is a distinct relationship created by the space between the balcony audience and other audience members. Depending upon the architectural plans of the house, most balconies are not designed for personal social interaction with those seated on the main floor except when entering or leaving the theater. There is separate access to the balcony, either by stairs, ramps, or elevators. When referring to the photographs,[47] it is easy to see the stark difference between the main floor and balcony seating and the proximity to the stage and orchestra seating. Balconies are much further away from the stage than front-row orchestra seats and hang over the lower level while offering a distant yet panoramic view of the stage and orchestra seats. Usually, there is no direct personal interaction between audiences on the balcony and main floor during a performance. Historically, this spatial divide can and has been an intentional division of classes and races.

Though often sought after as a symbol of status and prestige, front-row center orchestra main floor seats often have poor sightlines of the entire stage. Placed directly behind the orchestra pit and below eye level with the stage, these seats, usually in row 1 through row 5, allow an unobstructed downstage view (the front of the stage) with the ability to see clearly the facial expressions of the performers and staged vignettes. However, it may be difficult to see any action taking place upstage (the back of the stage) because of the angle of the stage in proximity to the seats if the seats are slightly below the stage or sloped forward.

Based on this placement of front-row center orchestra seats from row 1 through row 5, I postulate that being seated in this section on the main floor does not necessarily afford the best view of a performance. Rather it offers the viewer a myopic sight line of the stage and of society, creating a "main floor mentality" or the false self-prescribed and perceived notion of privilege and power. In these seats one cannot see who is behind them or above them, nor can one clearly see every action taking place on the entire stage. Peripheral vision may allow one to see to the left or to the right, but when seated and looking forward at the stage, a full view of all activity in the house is very unlikely. Being seated front row center in the theater sometimes requires the craning of one's neck in order to see all of the action on the stage. In a live production, some of the action and scenery may not be visible from the front row; thus, parts of important scenes might be missed.

47. See appendix L: "Main Floor Stage View—Detroit Opera House" for a view of the stage from the back of the main floor and the upper balcony overhanging the back main floor seats.

One might not be able to see stage left or stage right clearly where important subplots may be taking place, and it would be almost impossible to see what is happening upstage.

Conversely, the entire stage can be seen from the balcony. The balcony is considered "the upstairs seats in a theater, concert hall, or auditorium, [or the] highest tier of seats in a theater, above the dress or upper circle."[48] The *gallery* is described as the "highest balcony in a theatre, containing the cheapest seats."[49] Balconies are usually two to four stories above the main floor, thus the moniker "nosebleed section"[50] is sometimes used to refer to the upper balcony or gallery which is often difficult to access. There may be many stairs and steep inclines leading to the seats. The high altitude may make one dizzy. There may be pillars blocking the view of the stage. Objects will appear smaller, and details may be blurred, but despite the obstacles of balcony seating, there is a panoramic view of everything taking place during a live staged production. If one has opera glasses, action on the stage can be magnified for clarity and identification. It is possible to adjust the lenses of the opera glasses to zoom in on specific characters and scenes to grasp the production fully. Viewing a performance from the balcony may be more advantageous than from the main floor.

Audience and Audience Agency

The Audience

What role does an audience play during an operatic performance, and does an audience have agency in affecting the outcome of a performance or the ways in which other audience members perceive the performance? First, we must ask who is the audience in the twenty-first century. An audience can be described as a group of people who gather together in a public space to watch or listen to something: a movie, a theatrical production, a reading of poetry or prose, or a concert either pre-recorded or live streamed, or in person at a live performance. Usually, audience members are spectators who only participate in the actual live performance if that performance is an interactive theater where the audience is invited to take an active part in

48. Dictionary.com, s.v. "Balcony." See appendix M: "Center Balcony Stage View—Detroit Opera House."

49. Dictionary.com, s.v. "Gallery."

50. Nigellus, "Nosebleed Seats": "Nosebleed Section: seats in a theater usually for a live performance that are so high and far away from the stage that one can get a nosebleed from the high altitude." See appendix N: Highest tier "'Nosebleed' Balcony Seating—Detroit Opera House."

determining the plot, or a concert where the performers invite the audience to sing along.

Opera audiences differ from concert attendees because each type of event's behavioral decorum and etiquette vary somewhat. Each experience taps into individual emotions, and the audience is expected to react when moved by the music. Concertgoers are expected to be noisy in response to the performers and agreement with other concertgoers. Conversely, noise in the audience during an operatic production, such as talking, singing or humming along, or even coughing, is viewed as intrusive and distracting for other audience members and performers. But it is expected that the audience will respond with applause or shouts of "Bravo/Brava/Bravi"[51] at the end of an aria, after a poignant scene, at intermission, and at the end of the performance for final curtain calls.[52]

For this study, I am making a clear delineation in determining that the audience I am referencing are those who physically attend a live operatic performance as opposed to those who attend concerts or musical theater. By custom and tradition, an opera audience is not as demonstrative as a concert audience, but there is still interplay and energy between them and the performers. While listening to the music, the opera audience is usually more reflective than reactive. They don't sing along with arias as a concertgoer might sing along with a well-known popular song. They listen attentively and concentrate on the singer's interpretation of the piece, showing their appreciation, or not, at the end of the song through thunderous, enthusiastic or polite, perfunctory applause.

It is also essential to know who constitutes this audience. It can be assumed that an opera audience is composed of people who appreciate this musical genre. It must be considered that each audience member has chosen to be there, investing time and resources. The audience has come anticipating an enjoyable, emotionally moving, spectacular musical and visual experience. Regardless of the seating choices everyone in the theater is in the same place at the same time, seeing and experiencing the event from different vantage points, giving each a different interpretation and perspective of the performance. Each audience member brings their unique personal, cultural, and sociopolitical knowledge and experience into the theatrical space, bringing a form of agency that impacts the performance in subtle or palpable ways. They have come for many reasons: to hear a particular singer or opera star (e.g., Kathleen Battle or Denyce Graves), as a supporter of

51. Audience approval of a performer or performance is verbally expressed in "Bravo!" for a male, "Brava!" for a female, and "Bravi!" for a group.

52. Ferris, "Opera Protocol Tips."

the arts, because they are familiar with the music (i.e., "Summertime" from *Porgy and Bess*),[53] for an evening out, as a social gathering, or to personally support the performers.[54]

Audiences and audience dynamics differ according to the particular performance being attended: opening or closing nights, an evening performance, a matinee, special student performances, or full-dress rehearsal. Each draws a unique audience which generates a different energy at each performance. Opening night is usually a formal affair where patrons of the arts, contributors, and dignitaries attend pre-performance receptions and events before the main event. Closing night may also be a formal affair celebrating the successful run of the production after the last curtain call. Evening performances and matinees are attended by members of the community, music lovers, and professionals. Student performances invite local area school students to special weekday matinee performances as a way to introduce students to opera and build new audiences. A full-dress rehearsal may invite ticketed audiences to the fully staged final dress rehearsal. Tickets are usually gratis. The dynamics of each performance are very different, whether playing to a full house or to an empty theater during rehearsals. No two performances are ever identical.

A certain synergy exists between the performers and the audience. During the opera, the house lights are down and the audience sits in darkness while special lighting is projected upon the stage and the artists so that every portion of the production can be seen. From the artist's perspective, the audience is obscured in the darkness, but their presence is evident. Usually, the artists cannot see audience members' faces or facial and body expressions. But from sounds such as gasps, moans, laughter, or applause at appropriate times during the opera, the cast knows if the audience is in sync with the activity on the stage. At the first rise of the curtain, the level of applause creates soundwaves that reverberate through the house from the balcony to the stage, energizing other audience members and the artists, from chorus members to the principals. While the audience sits in expectation, the artists reciprocate this energy by pouring their all into the performance. The relationship now built between the audience and artists is corporately acknowledged at the end of the performance. If the audience has enjoyed the production, there will be long rousing applause and standing ovations.

53. Gershwin et al., *Porgy and Bess*.

54. I found this to be true each time I performed whether in New York, Detroit, or Chicago. Friends, family, and co-workers were in the audience. Some were professional musicians. Some were first-time attendees knowing little or nothing about opera and who came to support me.

As this research examines the perspective and advantage of balcony seating, it must also determine who makes up the Balcony audience. Historically balconies of theaters and churches were designated seats for Black Americans until the civil rights movement in the 1960s. Up to that time, balcony seating was a policy of intentional segregation. Yet despite this practice, Black Americans operated in and continued to resist the American sociopolitical system controlled by white hegemonistic patriarchal supremacist ideologies even if seated in the balcony. As Blacks began to come down from the balcony and integrate into the dominant society to take their places on the main floor, some of the advantages of balcony seating were forgotten or no longer thought important as they now enjoyed the newly gained privilege of sitting on the main floor. Their newly acquired main floor view differed from that in the balcony and may have become distorted by the perceived yet elusive notions of equality and privilege.

Sitting in the balcony today is a choice based on personal preference, including ticket costs (economics) or preferred view (aesthetics,) rather than being a culturally or legally imposed racial and class divide. People of all ethnicities, ages, political persuasions, sexual preferences, physical abilities, educational backgrounds, and class distinctions are seated in the balcony.

For this research, my balcony audience is the African American community making the balcony a choice rather than a mandate. However, this Balcony audience can include members of any marginalized community. This audience understands the historic precedents of relegating Blacks to the balcony, but now uses these seats to see all of the actions of a fully staged performance while metaphorically peering upon the whole of American society. This vantage point allows the Balcony audience to see (1) other spectators (audience members) who are seated in the orchestra, box seats, or the main floor front row center; (2) the all-encompassing view of actions happening on-stage depicting American society; and (3) systemic institutional racist policies that adversely affect Black and brown people.

This balcony audience also employs opera glasses[55] to see the activity on the stage more clearly. Opera glasses are specially designed but smaller binoculars intended for indoor use at theatrical productions that can be carried in a small purse or pocket. With opera glasses, the viewer can focus on the dynamics of one scene at a time. When in focus, opera glasses allow the viewer to see clearly the facial expressions of the performers onstage and the detailed scenery and subplots that may be taking place anywhere on the stage. Detailed scenery and subplots represent the systemic institutional racist, hegemonic, xenophobic, and patriarchal systems that people of color

55. See appendix A: "Author's Opera Glasses."

must constantly navigate to survive and thrive within the American cultural and sociopolitical framework. Performers and some audience members seated on the main floor represent the policymakers and keepers of these oppressive systems. For this research, opera glasses become the lenses through which the Balcony audience views, evaluates, and interprets the staged performance and life in American society.

Audience Agency

Audience Agency is the power and influence of an audience, individually or collectively, to impact the performance dynamics for other audience members and performers. Audience members have "individual power over their perspectives within a performance."[56] In a study of cinema audiences, associate professor of film studies at the University of Groningen (the Netherlands) Julian Hanich says that each audience member is alone with about two thousand other individuals looking at the make-believe staged world being presented before them.[57] They are isolated yet an integral part of the group. During a movie, audience members do not verbally communicate with each other but "sees and feels it *with* them if not like them."[58] This collective theatrical experience is not passive or static but is "a constantly transforming outcome of our attention, intentions, actions, and emotions."[59] This description aptly applies to opera balcony audiences.

Since the specific balcony audience I am referencing is the African American community in twenty-first-century America, agency takes on a form of resistance. The balcony audience is paying close attention to the intentions and actions of the players on the stage, and how the staged and rehearsed realities have been planned and played out against communities of color. The main floor audience can be observed applauding the message projected from the stage and giving consent to perpetrate those actions within the larger society.

Though direct agency does not occur inside the theater during the performance, it functions as a reflective observational tool that allows the community to assess the conditions of the present social context. Once the specific areas of concern have been identified, this Balcony audience can now work as a community to address each issue. No longer silent, Balcony People intentionally speak and act as one group.

56. Finckel, "Navigating Shared Space."
57. Hanich, *Audience Effect*, 3–4.
58. Hanich, *Audience Effect*, 3–4.
59. Hanich, *Audience Effect*, 3–4.

Opera: Sacred Space and Ritual

Attending opera is a ritualistic experience. Each audience member contributes to the social and symbolic rituals inherent in the event. Going to the theater can function as a social performance that ritualizes gathering a group of like-minded people identifying with other audience members through their presence and appreciation for the art form. This transitory, newly formed community has gathered to witness another ritual, a staged performance where actors portray real-life situations in a fictitious ritualized presentation. Each group, audience and artists, is in essence, an actor performing a set of rituals that could not take place without the participation of the other.

According to British professor of opera and music theater Nicholas Till, theater becomes a transformative space determined by "the location and design of the performance space, the contribution of the audience to the event, and the social and symbolic rituals of the event."[60] Till turns to theater historian and professor of theater arts and performance studies at the University of Pittsburgh Bruce McConachie, who informs us that

> there is always a symbolic dimension to the performance event.
> . . . "Theatre helps people to constitute themselves as social beings," and defines the theatrical event as "a type of ritual which functions to legitimate an image of a historical social order in the minds of its audience."[61]

This ritualistic experience brings audiences and performers together in an event that they have never experienced before nor will be exactly duplicated again. Audience members expect to hear what they have never heard before and be transported to an emotional place where they have not been before. Each is in the spirit of the moment. A ritual activity occurs between the audience and performers with expectations from each, transforming the moment, and creating an opera into a sacred space. This shared sacred space is the result of a symbiotic relationship, a coming-together created between audience and artists through a theatrical encounter which challenges each one's personal interpretation of the moment. Audience interpretation of an operatic event is developed as they

> watch and listen to others for facial, postural, and vocal clues . . . process this information through their bodies and minds . . .[and] embody the (characters) emotional states. . . .

60. Till, "Operatic Event," 2.
61. Till, "Operatic Event," 2, 3.

> Embodying others' emotions produces emotions in us, even if
> the situation is an imagined or fictitious one.[62]

According to McConachie, human sensitivity and social cognition are carried with them into the theater. This spectacular visual and aural environment

> provides spectators with the ability to "read the minds" of ac-
> tors/characters, to intuit their beliefs, intentions, and emotions
> by watching their motor actions. This mode of engagement, also
> known as empathy, extends to our understanding of actors' use
> of props and even their gestures and spoken language. Empa-
> thy is not an emotion, but it readily leads viewers to emotional
> engagements. . . . Spectators often gain a conscious awareness
> of their emotional commitments, which encourages them to
> form sympathetic or antipathetic attachments to certain actors/
> characters. As spectators, we want to be moved to emotional
> extremes; laughter and tears provide a kind of catharsis that is
> good for our bodies.[63]

When "spectators project themselves onto the emotional life of an actor/ character on stage . . . this process is called 'identification.'"[64] If, as McCo- nachie postulates, there is an emotional contagion that takes place in the theater as the audience makes a personal connection and develops empathy with the inner life of the characters, it is possible for the emotions of the balcony audience to generate to other parts of the audience in the theater. As the balcony audience expresses its feelings through applause, laughter, or silence, their responses may become a catalyst that affects the tone of the performance for the rest of the audience.

Opera as Transformative Social Drama

As a Womanist theologian and performer, I entered this study expecting to discover ways opera intersects with Womanist Theology, anthropology/ ethnology, and Black Performance Theory/theater and gives place and voice to the genius of African American writers, composers, and performers. This work further determines how attending select operatic performances has the potential to afford the audience a moment of transformation within a spectacular entertainment experience causing opera to become a ritualistic

62. McConachie, *Engaging Audiences*, 66.
63. McConachie, *Engaging Audiences*, 65.
64. McConachie, *Engaging Audiences*, 65.

event capable of reconstructing knowledge production as well as becoming a form of staged social drama with the capacity to excavate old mindsets, develop new consciousness, and initiate social change.

Why do people attend opera? In a 2014 study of returning opera audiences, researchers found that 15 to 45 percent of operagoers surveyed attend to experience "an opportunity to consider the human condition."[65] Another 45 to 70 percent looked for "a feeling of connection with the character and the story."[66] Most attended for "the combination of the visual, musical, and theatrical"[67] experience. This same study found that among new operagoers, almost 45 percent looked for a "performance [that] offered a new perspective on other people's lives . . . [and] encouraged them to think differently about the world."[68]

For the purpose of this research, social drama is defined as any dramatic theatrical production or presentation that portrays a segment of a society of a particular era, depicting a specific issue or population in order to bring awareness of their predicament before an audience. It expresses a countercultural narrative by presenting opposing views to those of the dominant mainstream cultural society by making a bold or subtle political or social statement that exposes multifarious oppressions of racism, sexism, homophobia, xenophobia, ageism, poverty, etc. Social drama is more than entertainment, it is a teaching tool about the historic and/or contemporary societal issues that brings both audience members and performers to self-reflective and reflexive moments of reevaluating personal views, placement, or complicity regarding specific controversial topics that adversely affect particular segments of the population, particularly those populations outside of the audience members' cultural, ethnic, or social group.

Richard Schechner's understanding of theater as a transformative experience is helpful in developing my perspective of social drama. He writes: "I located it in *transformation*—and how people use theater as a way to experiment, act out, and ratify change. . . . At all levels, theater includes mechanisms for transformation."[69] Therefore, a theatrical social drama has the capacity to draw audience members into the performance as it unfolds on the stage, thus creating a transformative moment in the midst of a spectacular entertainment event. Social dramas, the stage presentations of social conflicts or social injustices, can penetrate and break the fourth wall, that

65. O'Neil et al., "Opera Audiences," 33.

66. O'Neil et al., "Opera Audiences," 33.

67. O'Neil et al., "Opera Audiences," 33.

68. O'Neil et al., "Opera Audiences," 40.

69. Schechner, *Performance Theory*, 170, 171.

imaginary wall between performers on stage and the seated audience. The production may not offer resolutions, but it will suggest avenues of transformation or transformative action that individuals or groups can implement outside of the theatrical experience.

For audiences and performers alike, the opera *Margaret Garner* becomes a theatrical, social drama aimed at combating cultural amnesia by creating a site of memory for the descendants of the enslaved and the enslavers. It invokes collective memory and creates a moment of cultural anamnesis, or a Sankofa moment, where critically looking back (anamnesis) at historic events empowers individuals or groups to move toward healing, restoration, and reconciliation. Understanding the importance of memory for healing cultural trauma, Morrison privileges that "'Memories within' are the subsoil of my work. . . . My job becomes how to rip that veil drawn over 'proceedings too terrible to relate.'"[70] This opera stirred up national collective memories by ripping the veil off the devastating true story of American slavery for both descendants of the enslaved and the enslavers by symbolically reordering a historical moment "through narration, visual representation, and acoustic signification . . . to create historical events that demonstrate the political power of aesthetics."[71]

In crafting her work to re-tell the true story of Margaret Garner through the medium of grand opera, Morrison's libretto skillfully and subtly interweaves truth with fiction while depicting the religious and faith traditions of enslaved people. It also clearly displays the body politics and forced surrogacy of one enslaved African woman and the agency she employed to assert and maintain her humanity.[72] I believe that this opera can become a primary source for developing theological discourse while invoking collective memory through theatrical rituals as "acts of recuperation and restoration, creating sites that have the potential to repair the damage slavery and its aftermath caused."[73]

How did Morrison portray the theology of the enslaved in the opera? Her libretto shows the contradictions of slave theology with that of the enslavers, whose American theological anthropology did not value the humanity of the enslaved. Yet the enslaved knew *their* God saw and recognized them as fully human and heard their prayers. As expressed in act 1, scene 1, the enslaved felt the breath, mercy, and gift of the grace of God *despite* the theology of the slaveholders who did not recognize or treat Black bodies

70. Morrison, "Site of Memory," 190–92.
71. Colbert, *African American Theatrical Body*, 5.
72. Williams, *Sisters in the Wilderness*, 62–71.
73. Colbert, *African American Theatrical Body*, 12.

as human. In stark contrast to Southern American theology, the enslaved recognized the humanity of every person, even those who whipped, raped, and mistreated them, and understood that a day of judgment and reckoning would come. They could re-interpret sermons touted by the slaveholders' preachers citing the biblical text. This sentiment is captured in the refrain of a slave spiritual: *"Everybody talkin bout heben ain't gwine dere."*[74] The family prayer ritual pivots scene 2 in the first act as Cilla, the community elder and wise woman, prays, *"Dear Lord in heaven let us be guided by your heavenly light."*[75] Despite every oppression, the enslaved community survived and thrived, relying on ritual enactment and faith in a God who "knew no respect of persons."[76]

Turner and Schechner establish that ritual[77] and performance are linked together to display human activity.[78] Building on this understanding Diggs Colbert believes that rituals enacted in the theater helped to create and renegotiate space, resist oppression, and reject the narratives of the defenders of the middle passage and slavery by producing a "temporal disruption" of historic sites of violence.[79] Ritual, particularly ritual within African American religious and artistic contexts, is, therefore, a means of remembrance, recovery, resistance, resilience, and restoration that moves toward a hermeneutic of healing for traumatized, marginalized individuals and communities.

Opera as Theatrical Ritual and Resistance Performance

As discussed previously, opera is a spectacular, fully staged dramatic or comedic theatrical production consisting of orchestral and vocal music that explores and presents human relationships in story form, relaying a message to an audience. Though it has historically been considered an elitist form of entertainment, it is now much more accessible and geared toward

74. "I Got a Robe," traditional African American spiritual sung in dialect as remembered from my childhood.

75. Danielpour and Morrison, *Margaret Garner*.

76. Rom 2:11 (KJV).

77. *New Webster's Comprehensive Dictionary*, s.v. "Ritual," 849. Ritual is defined as "(1) of or relating to or practiced as a rite or rites; (2) A strictly ordered traditional method of conducting and performing an act of worship or other solemn ceremonies; any method of doing something in which the details are always faithfully repeated."

78. Comparably addressed by Turner, *From Ritual to Theatre*; and Schechner, *Between Theater and Anthropology*.

79. Colbert, "Rituals of Repair," 198–99, 212.

twenty-first-century audiences. Here, I hold that specific American operas can be classified as social performances or social dramas where societal issues are being reflectively acted out on stage. I base my assumption on Dennis Romero's historical description of opera as having "the capacity to engage current political affairs and debates."[80] He considered opera to be "the perfect vehicle for the expression of . . . social and intellectual tendencies . . . that gave expression to a new, more reflective interior sense of self."[81]

George Houston Bass, African American playwright and professor of theater arts in Afro-American studies at Brown University, establishes that the creation of ritual within the African American community and theater productions are birthed from the wealth of folk material and cultural experiences embedded in African American life. As a theater artist, his self-appointed task became to "create specific theater rituals of our collective experiences that will help us to gain a deep spiritual recognition of ourselves as a community—as a whole people; black people."[82] As part of the African American struggle for freedom and self-determination, such theater rituals would "work to rebuild our collective sense of dignity and self-respect, purge ourselves of Eurocentrism's that deny our human worth, and define the myth and mysteries of our community in order to strengthen and rebuild families and communities."[83] Carlton Molette, professor of theater at the University of Connecticut, further explains ritual to be

> formalized behaviors that evolve out of a common culture, [and] in the traditional sense of the word cannot emerge full-blown overnight and be shoved at a people. . . . When the word "ritual" is used to describe [a] . . . behavior it can . . . also mean a performance—in and for a community—that attempts to alter the values of that community, [or] that culture.[84]

Theatrical "performance . . . involves enactment, re-creation, or storytelling. Performances present humans in relationship to the exceptional circumstances that surround them."[85] These definitions of performance allow me to narrow my focus or shift my gaze to the theatrical genre of opera. Using the opera *Margaret Garner* as my point of departure, I contend that theater/opera, when politically charged, can be an initiator for social change and promote cultural and social awareness by addressing difficult social issues

80. Romero, "Why Opera?," 408.

81. Romero, "Why Opera?," 408.

82. Bass, "Folk Traditions as Referents," 14.

83. Bass, "Folk Traditions as Referents," 14.

84. Molette, "Ritual Drama," 24.

85. DeFrantz, "From Negro Expression," 6.

in a non-threatening environment.[86] Each performance, through the artistic interpretation of the performers, can create environments that promote "social change through small but significant revisions of familiar scripts which are . . . carved from deeply rooted cultural texts."[87] *Margaret Garner* is a performed staged ritual, a revisiting, and a revision of a familiar though unpleasant, deeply rooted American cultural and theological text in Black and white communities that, when ritualized in the theater, becomes a point of memory or "rememory"[88] that addresses national amnesia.

Colbert offers that theatrical experiences, whether for the audience or performers, can result in "individual and shared experiences."[89] Theater helps to create and renegotiate space where audiences experience staged "ritual reenactments [that] produce a temporal disruption"[90] that can present historical events in new ways and correct misconceptions around long-held assumptions and attitudes around race, cultures, and lifestyles. As the staged drama unfolds, the individual actors create a collectivity of staged spectacles where each actor's "body is loaded with its own history and that of the character,"[91] which can create for the audience a "cultural oscillation that weaves back and forth from old to new, from Africa to the United States, the past to the present."[92] Black opera singers and performers hold embedded memories of our captured and enslaved ancestors within our Black artistic bodies. It is sacred memory and sacred work. Personal histories cannot be separated from performances, especially this collectively shared history. A prime example is Margaret's lullaby, as performed by Denyce Graves. It was impossible to separate her personal experience as a mother holding her

86. Giovetti, "Top 10 Politically-Charged American Operas." The precedence for this theory is based on other twentieth-century American operas that have addressed difficult political issues such as (1) *Crucible* (1961, Robert Ward, addresses McCarthyism); (2) *Mother of Us All* (1947, Virgil Thompson, addresses women's suffrage and feminism); (3) *Consul* (1950, Gian Carlo Menotti, addresses immigration issues); (4) *Dead Man Walking* (2000, Jake Heggie, prison reform and the death penalty); (5) *Harvey Milk* (1995, Stewart Wallace, anti-Semitism); (6) *X, the Life and Times of Malcolm X* (1985, Anthony Davis, civil rights and the social climate for African Americans during the 1940s and fifties); and (7) *Death of Klinghoffer* (1991, John Adams, the Palestinian question).

87. Alexander et al., *Social Performance*, 14.

88. Morrison, *Beloved*, 43. Morrison coined the neologism "rememory," meaning to remember a memory, through the character, Sethe (the character based on the historic Margaret Garner), who ponders, "I used to think it was my rememory. You know. Some things you forget. Other things you never do."

89. Colbert, *African American Theatrical Body*, 3.

90. Colbert, *African American Theatrical Body*, 212.

91. Colbert, *African American Theatrical Body*, 212.

92. Colbert, *African American Theatrical Body*, 212.

infant daughter from that of the character Margaret holding, rocking, and singing to her child. The two melded into one as the staged drama became a truth that every mother in the theater, regardless of culture or ethnicity, could personally relate to as her warm, rich, soothing voice filled the theater.

Because the librettist Toni Morrison was an African American woman intent on telling the story of an enslaved Black woman through the artistry of Black opera singers, I take the liberty to name this work Black theater. Colbert describes the inherent impact of Black Theater is to

> shock . . . audiences into reflection through the insertion of performances that disrupt the expected narrative process. . . . Black Performance disrupts the static materiality of objects . . . [and] renders the black theatrical body flexible and therefore radically alters conceptions of bodies and places. . . . Black Performance moves through bodies, places, and time and in that motion extends [to] black political movements.[93]

Colbert further demands that society

> examines the center of African-American drama and theatrical production that draws on the social, cultural, political, and economic conditions surrounding each play's attempt to repair the losses and attenuate the haunting legacy of trans-Atlantic slavery and its racialized, gender, and class-specific aftermath . . . African-American literary traditions of black performance traditions expressed in . . . preaching, . . . rituals, . . . and singing of blues and gospel. These performance traditions create the "performative ground of African-American literary texts" . . . [that] employed performances to resuscitate black people in time and space . . . as acts of recuperation and restoration creating sites that have potential to repair the damage slavery and its aftermath have caused.[94]

Either through performing in a Black body or being written by a Black composer or librettist, Black theater, including opera, rises as a countercultural voice with the potential to correct and repair the racist hegemonic narrative surrounding Black bodies and Black culture as a means to "reproduce, recuperate, reenact, resist, [and] create rituals of repair"[95] and restoration.

Recognizing the importance of memory and history as imaginative innovation in the theater, Colbert cites Morrison's neologism "rememory"

93. Colbert, *African American Theatrical Body*, 51, 263.
94. Colbert, *African American Theatrical Body*, 11, 12.
95. Colbert, *African American Theatrical Body*, 51.

to describe "the communal nature of recuperation."[96] The process of rememory "satisf[ies] the impulse to make use of histories, even traumatic and shameful histories. . . . Recuperation [or] digging up the past, reflects an epistemic practice historical legacy necessitates."[97] Morrison skillfully and artistically incorporated "rememory," remembering a memory, throughout the libretto for the opera *Margaret Garner*, unearthing the horrific history of slavery and placing it before a twenty-first-century audience to reorient the story and retell this moment through the perspective of the enslaved.

Spring-boarding from Turner's understanding of social drama as a social process[98] which first "manifests itself as a breach of the norm, the infraction of the rule of morality, law, custom or etiquette, and some public arenas,"[99] Colbert argues that rituals enacted through theatrical performance can create "rites of repair . . . as acts of redress and social justice."[100] In the theater this is done by symbolically re-ordering the social and political hierarchy. Staged theatrical rituals also refigure geography and shift emphasis that can "reinstate . . . sovereignty or political authority,"[101] while recognizing "public acknowledgment of wrongdoing and group entitlements."[102]

Margaret Garner, the opera, utilized public ritual space to symbolically re-order the historical social and political climate, and offer theatrical rites of repair for those in the balconies and seated on the main floor.

Summary

Setting the stage for the audience/reader to be transported to emotional, social, and spiritual experiences embedded within this work, this chapter

96. Colbert, *African American Theatrical Body*, 185.

97. Colbert, *African American Theatrical Body*, 186.

98. Schechner, *Performance Studies*, 75–77. According to Schechner, Turner's theory of social drama happens in conflict situations which can be identified by four phases; (1) breach—interruption of normal social relations, (2) crisis—widening the breach, (3) redress—action aimed at resolving the crisis, and (4) reintegration—returning to the original group after the elimination of breach and crisis. He further sees social dramas as a social process or sequence of interactions within crisis situations that are conflictive, competitive, or agnostic within social structures; political, psychological, philosophical, or theological perspective; it is a process of converting patriarchal values and ends through hermeneutical attention. See also Turner, *Anthropology of Performance*.

99. Turner, *From Ritual to Theatre*, 70.

100. Colbert, *African American Theatrical Body*, 2.

101. Colbert, *African American Theatrical Body*, 198.

102. Colbert, *African American Theatrical Body*, 199.

has introduced the reader to opera as a spectacular entertainment genre. Clearly distinguishing opera from musical theater, it seats the audience in the balcony of an imaginary theater. Assuming the audience is new to opera it opens with an educational stance to be sure that the audience understands exactly what opera is: a two or three-act theatrical performance that conveys a story in a dramatic production consisting of orchestra, singing, staging, lighting, and scenery, usually presented in an opera house. It makes the audience comfortable by helping them realize that, whether they know it or not, they know more about opera than they think, having been introduced to this genre through popular American cultural entertainment such as television and movies.

The architectural structure of an opera house is described; the stage, main floor, and seating arrangements place audience members in spatial relationships with one another and the performers. It is noted that being an observer in attendance at an opera is in itself a ritual performance. Audience members as ritualized participants have gathered to witness a staged dramatic ritual which they expect will create a spectacular, otherworldly personal or communal experience delivered through the visual and aural presentation. If the emotions and the inner life of a character portrayed on stage resonate and connect with an audience member, identification takes place that allows an audience member to see, hear, and feel in ways that may challenge inherited biases.

Though the audience is usually a silent observer of the activity on an opera stage, this research recognizes that there is a measure of agency an audience can influence on the outcome of a performance. To this point, audience agency represents how those who have been relegated to architectural and societal balconies interpret all of the activity in an opera house as metaphoric representatives of the systemic institutional racist policies that adversely affect Black and Brown people in American society. It is from these seats, or the Balcony Perspective, that this audience can critique the sociopolitical structures of oppression. Thus, an understanding of the audience as Balcony People offers the notion that opera attendance in the twenty-first century has the power to impact audiences in ways that foster theological reflection, critique oppressive social structures, and offer new paradigms that brings audience members and performers together to identify and solve areas of concern to put forth justice and equity for everyone in the opera house. We are all in the *same* opera house.

7

Act 2, Scene 3—Aria
And So We Sing

I will sing to the LORD as long as I live; I will sing
praise to my God while I have being.

—*PSALM 104:33 (NRSVUE)*

The singer starts by having his instrument as a gift from God.
... When I sing, I don't want them to see that my face is black.
... I want them to see my soul, and that is colorless.

—*MARIAN ANDERSON*

Be black, shine, aim high!

—*LEONTYNE PRICE*

I am here and you will know that I am the best and will hear me.
The color of my skin or the kink of my hair or the spread of my
mouth has nothing to do with what you are listening to.

—*LEONTYNE PRICE*

The Historic Roots of American Opera: Minstrelsy, Blackface, and Blacks in Opera

WHILE AMERICA WAS A fledgling country forming its own cultural identity and epistemological ideologies, it rebuffed imported European art forms such as opera, yet it fully embraced, accepted, integrated, and expanded the Western European philosophical teachings of racial hierarchies as developed by Kant and Hegel.[1] The "New World" ideology, dependent on racial superiority, took shape as Manifest Destiny[2] and white supremacy and, thus, created a form of American Anthropological Poverty. This thought aligns with Mveng's contention that European colonizers ignored and denigrated African cosmologies, cultures, and spiritualities with the intention of subsuming and eradicating all African cosmology.[3] The same ideology and its systemic oppressive practices in America were perpetrated against enslaved Africans. Further, as the country expanded its concept of the racialized "other,"[4] this misappropriated sense of power emboldened the European colonizers to annihilate First Nations People[5] with impunity and to import and enslave Africans to create a free source of labor.

Captured, kidnapped, and forcibly brought to America, the African was stripped of homeland, language, spirituality, religion, and artistic expression; yet the attempt to annihilate all African art forms, song, dance, and the drum failed. Despite the oppressively horrendous conditions of slavery, Africans still sang and used music from the motherland as cultural codes among their community to relay messages, express emotions, and resist their enslavement. Even as whites attempted to strip them of all they had and who they were, the genius of the survival of enslaved Africans can be linked to their artistic expression as they resorted to song as a form of resisting the conditions forced upon them. While enslaved Africans may have

1. See chapter 2 for an explanation of the impact of Kant and Hegel's philosophical ideologies on the development of racial theories and hierarchies which led to the colonization of the Americas, Africa, and Asia, the forced enslavement of Africans in America, and the subsequent development of national policies oppressing nonwhites in America.

2. LaDuke, *Recovering the Sacred*. In this seminal work, LaDuke discusses ways in which Christianity posited and sanctified Manifest Destiny in the colonization of the Americas, particularly as it refers to the expression of dominance over First Nations Peoples.

3. See chapters 3 and 5 for a more extensive discussion of Mveng's theory of Anthropological Poverty.

4. Dussel's discussion on "other" is located in chapter 3.

5. See chapter 3 for further discussion of LaDuke's work regarding colonialism and its effects upon First Nations Peoples.

sung to entertain plantation owners, they also sang to comfort themselves and one another. They sang to express deep sorrow and resist their enslavement's inhumane conditions. They sang at work and worship, sang prayers to *their* God, and sang about aspirations of freedom.

The originators of these work and sorrow songs birthed them within the crucible of slavery. Yet these songs of resistance—misunderstood and mischaracterized as simplistic, barbaric, and animalistic—were mocked by whites and, as evidence of cultural appropriation of Black Genius, seeded the profitable entertainment genre of minstrelsy. White actors in blackface, or burnt cork makeup, derided and debased Africans as they mocked the lives and livelihood of the enslaved.

Minstrelsy, as a form of entertainment, became a tool to establish American cultural codes that disparaged and belittled African Americans. The debasement of the African through minstrelsy became an extension of American slavocracy and fostered Mveng's theory of Anthropological Poverty: the "depersonalization of the African . . . by discounting . . . all he had, [and] everything he did."[6] However, despite its insidious performance, minstrelsy failed to eradicate or replicate the depth of the genius of resistance and survival embedded within African American artistic expression and Black song. Through songs of resistance, enslaved Africans in America have bequeathed a legacy of artistic expression—poorly imitated but never duplicated by others—that echoes throughout generations. The creative genius of African American artists lives in their countercultural acuity to "shift the gaze"[7] of the disparaging narrative perpetrated by the colonizing culture about Black artists, Black bodies, and Black life through their on-stage presence and performances.

This legacy of song circuitously thrives in the presence of African American singers within the operatic genre, even now. Ancestral artists persisted, resisted, and dismantled boundaries and barriers imposed upon Black bodies by white gatekeepers of racist, xenophobic, and hegemonic exclusion policies and passed down their genius and resolve to survive and flourish within the artistic genre of opera to future generations.

Dean emeritus of the School of Music, Theater, and Dance at the University of Michigan bass-baritone Willis Patterson reflects on his early impressions of opera.

> The subject of opera in America conjures up images of European music with indistinguishable words, large ladies and men singing with pained expressions on their faces, big orchestras

6. Mveng and Lipawing, *Théologie*, 32.
7. Terrell, "Ten Tenets of Art, Episode 1."

conducted by very seriously expressioned white males, expen-
sively clad audiences—all of this taking place within the confines
of a formidable, seemingly inaccessible, high ceilinged building,
totally remote from my real world. These were the visions of
opera from the perspective of most African-American young-
sters in the 1930–1945 Depression days. They were images that
remained quite vivid until one significant, unexpected event
penetrated and gave us the reason to take a somewhat closer
look at this world of opera.[8]

On January 7, 1955, history was made when contralto Marian An-
derson became the first African American to be cast in a leading role at the
world-famous Metropolitan Opera (the Met) in New York City.[9] Singing
the role of Ulrica[10] the sorceress, the then forty-two-year-old singer dazzled
the integrated audience with the deep, rich timbre of her voice. Anderson's
performance had broken the seventy-two-year-long history of barring Afri-
can Americans from gracing the stage and the audience of the Met. Of this
monumental achievement, African American journalist and violinist Rosalyn
Story observes:

> Anderson, whose career had quietly and continuously broken
> barriers, dissolved hostilities and awakened the consciousness
> of an entire country . . . mirrored the progress of an entire move-
> ment of people advancing toward artistic and social equality.[11]

This accomplishment and victory had not come easily. America had
not embraced African Americans in the mainstream culture or the artistic
genre of opera. Though obstacles to her success were present at every level,
the classically trained Anderson had been singing professionally since 1925
at church recitals and concert halls in America and Europe. Her repertoire
included oratorios and arias from Western operas and the music of her
people, the spirituals. But in America, the question of race was always at
the forefront. She had sung to great acclaim in European concert halls but
was banned from appearing at the Lyric Theater in Baltimore.[12] On one oc-
casion, white concert ticket holders demanded refunds when they learned
that they would be seated in an integrated audience.[13]

8. Patterson, introduction to *Dialogues*, x.

9. Story, *And So I Sing*, 54. See appendix O: "Ms. Marian Anderson, Contralto."

10. Ulrica, a fortune teller or sorceress, is a main supporting role in the opera *Un Ballo Maschera* (*The Masked Ball*), an opera in three acts by Giuseppe Verdi.

11. Story, *And So I Sing*, 55.

12. Story, *And So I Sing*, 45, 53.

13. Story, *And So I Sing*, 53.

A nationwide controversy over her artistry ensued in 1939 when the Daughters of the American Revolution (DAR) blocked a planned concert at Constitution Hall in Washington, DC, publicly stating, "the hall is not available for a concert by Ms. Anderson,"[14] keeping in line with their policy of discrimination against Blacks.[15] In disapproval of their actions, First Lady Eleanor Roosevelt resigned from the DAR and, along with the National Association for the Advancement of Colored People (NAACP) and others, helped to reschedule her appearance at a free open-air concert on the steps of the Lincoln Memorial in Washington, DC.

On Easter Sunday, April 9, 1939, an integrated crowd of 75,000 people gathered on the National Mall "in gloating distance of the Daughters Constitution Hall"[16] to hear what has been called the most celebrated concert of Anderson's career. Secretary of the Interior Harold Ickes introduced her, "In this great auditorium under the sky, all of us are free. Genius, like justice, is blind. Genius draws no color lines."[17]

Story says this event "was more than a concert; it was a celebration of mankind's potential for humanity, and the triumph over intransigence and narrow-minded thinking was poetic."[18] Though she didn't consider herself a political activist, Anderson said, "I could see that my significance as an individual was small in this affair. I had become, whether I liked it or not, a symbol representing my people. I had to appear."[19] The resolve that her quiet personality exuded through the genius of her vocal artistry made her performance an act of defiant resistance against institutionalized systemic, embedded racism in the United States.

The success of this concert solidified her as one of America's greatest singers, yet racism continued to prevent her and every other African American classically trained opera singer from gaining access and attaining the full acclaim they deserved on the stages of America's opera houses. The significance of Anderson's Met debut and subsequent contract—fourteen years after her Lincoln Memorial victory—"broke down the barriers for all African-American artists and performers."[20] These barriers of racial divi-

14. Story, *And so I Sing*, 49.

15. Story, *And So I Sing*, 49.

16. Story, *And So I Sing*, 51.

17. Stamberg, "Denied a Stage," §18. See appendix P: "Ms. Anderson and Secretary Ickes" and appendix Q: "Ms. Anderson singing at the Easter Sunday Concert 1939—Lincoln Memorial."

18. Story, *And So I Sing*, 52.

19. Story, *And So I Sing*, 51, 52.

20. Stamberg, "Denied a Stage." That same year (1955) soprano Mattiwilda Dobbs was offered a contract and baritone Robert McFerrin became the first African American male to be cast in a principal role at the Metropolitan Opera.

sions were systemic within American culture and society and can be linked to the rise and acceptance of opera as a form of national entertainment. The parallel roots of discrimination against African Americans in the culture and the artistic genre of opera lie within the history of the United States.

As monumental as Anderson's debut at the Met was, it cannot be forgotten that she was but one of the gifted and talented African American women performing operatic music in America. There had been a centuries-long legacy of African American artists performing Western classical music in private recitals and concerts since the colonial period. Minstrel shows were no different.

The Roots of American Opera

When reviewing the history of opera as a form of entertainment in the United States, it is clear that opera is not an indigenous art form. European operas were imported to the American colonies and attended by the northern elite who wished to "use European cultural forms as a mark of class membership . . . [and] part of a social ritual designed to display status . . . exclud[ing] those people who were not aristocrats from opera audiences"[21] and creating social strata between themselves, the working class, and the poor. As such, opera attendance created social exclusiveness and maintained class distinctions. The excluded created other forms of theatrical genres as intentional satirical spoofs on European operas, creating different styles of theater that were affordable for working-class people. When the nation gained its independence, opera retained its popularity in the North, but for the most part, Southerners rejected it as "too British."[22] New forms of regional and national entertainment/theater became important generators of cultural codes as the fledgling nation began establishing its own identity apart from European influence.[23] Of carnivals, circuses, medicine shows,

21. Mahar, *Behind the Burnt Cork Mask*, 33, 154.

22. Yesterday's America, "How American Theater Has Prevailed." As British rule and culture were rejected in the former colonies, tenets of British society such as theater came to be almost abhorred in the new nation as it attempted to distance itself from vestiges of British control.

23. A distinctively different reception for opera existed in the French colonies of North America—in New Orleans particularly. French operas were accepted and accessible to the entire community and often included slaves in the audience. Even after the Louisiana Purchase the regional and cultural resistance to relinquishing French culture and language was evident in its embrace and production of operas as a major form of entertainment for the region. Dizikes develops this historiography in *Opera in America*, 25–26.

magic shows, side shows, and other variety shows, minstrelsy became one of the most popular forms of American entertainment.

Minstrelsy

In his book *Black Manhattan*, published in 1930, the composer of "Lift Every Voice and Sing," James Weldon Johnson, discusses the involvement of African Americans in the arts and American theater, giving a brief historical overview of the origins of minstrelsy which "borrowed" (appropriated, stole, plagiarized) from the artistic genius of enslaved Africans.

> The real beginnings of the Negro [*sic*] in the American theater were made on the minstrel stage. Negro minstrelsy as a popular form of professional entertainment, seems dead; nevertheless, this history cannot be reviewed without recognition of the fact that it was the first and remains, up to this time, the only completely original contribution America has made to the theater. Negro minstrelsy, everyone ought to know, had its origin among the slaves of the old South. Every plantation had its talented band that could crack Negro jokes, and sing and dance to the accompaniment of the banjo and the bones. . . . When the wealthy plantation owner wished to entertain and amuse his guests, he needed only to call for his troop of black minstrels. There is a record of at least one of these bands that became semi-professional and traveled around from plantation to plantation giving performances. . . . White actors very early realized the commercial value of Negro impersonation and as far back as the beginning of the nineteenth century began putting on single blackface acts.[24]

Originally, minstrel shows in America were traveling troupes of musicians, singers, dancers, and actors staging theatrical performances that included dramatic and comedic skits, song and dance, parodies of European operas, and satire aimed at non-English speaking immigrants. Minstrelsy was initially a commercial venture developed when America lacked a clearly definable national culture. With the inclusion of blackface, not only did it become a lucrative venture, it propagated the growing disdain and racial attitudes toward Blacks in America, making it a "malevolent strain of . . . alienated acting"[25] that kept the perceived differences between white

24. Johnson, *Black Manhattan*, 87, 88.
25. Brooks, *Bodies in Dissent*, 25.

working-class and poor people, and enslaved Africans in the forefront of America's developing cultural identity.

According to historian William Mahar, minstrelsy grew "from the rejection of opera and elitist forms of European theater as America searched for its own indigenous forms of entertainment."[26] He distinguishes between early minstrel shows and burnt cork makeup minstrel shows. "Early minstrel shows included a form of parody on all forms of European theater. . . . At its worst . . . [it] denigrate[d] members of other ethnic groups,"[27] especially enslaved Africans. Henry T. Sampson adds that "the early black minstrels were stereotyped depictions of the life and pursuits of black people from the period of their arrival on this continent to the time of and after their emancipation."[28] As white entertainers applied burnt cork makeup to their faces and drew more and more of their material from the songs and dances of enslaved African Americans, minstrelsy took on a different face—blackface.

Blackface minstrelsy as a form of entertainment can be directly linked to the formation of antebellum popular culture that contributed to the development of American attitudes, beliefs, and policies around race, gender, class, its justification for slavery, and the codification of denigrating "Negro" stereotypes. One popular group was the Christy Minstrels of Virginia, who

> continued the popularization of the "negro" stereotype in the most devastating manner . . . in his minstrel show. . . . Portion[s] of the show purported to show the "peculiarities of the southern negro" which included eating watermelons, stealing chickens, butchering language, and the worst of all, the "negro wench character" who was foul tempered and often attacked her husband with a skillet.[29]

These groups of traveling blackface minstrel shows emerged in the 1820s. Their popularity peaked during the 1840s and 1850s, evolving into a form of entertainment that endured for decades past the ending of the Civil War. In *Opera in America: A Cultural History*, music historian John Dizikes reported that traveling minstrel shows were initially imported from Europe and had been popular in England since the late eighteenth century. On American soil, "entertainers, performers with circuses . . . frequently appeared in blackface (burnt cork)"[30] performing theatrical sketches and

26. Mahar, *Behind the Burnt Cork Mask*, 5.
27. Mahar, *Behind the Burnt Cork Mask*, 6.
28. Sampson, *Blacks in Blackface*, 2.
29. Williams, "American Minstrelsy," §7.
30. Dizikes, *Opera in America*, 105.

dances that often negatively imitated African Americans. White actors blackened their faces with burnt cork makeup to present their distorted ideas of African American culture to mainly white audiences, intending to create and maintain distinctions between enslaved and newly emancipated African people and white Americans.

In *The Music of Black Americans: A History*, Eileen Southern reports that as early as 1769, white performers sang "Negro Songs," also called Ethiopian songs, in their attempt to portray and impersonate the lives of enslaved Africans. In this form of minstrel entertainment,

> two basic types of slave impersonations were developed: one in caricature of the plantation slave with his ragged clothes and thick dialect; the other portraying the city slave, the dandy dressed in the latest fashion. . . . The former was referred to as Jim Crow and the later as Zip Coon.[31]

In agreement with Southern's understanding, Dizikes purports that theatrical sketches imitating African Americans had been popular in America since the late eighteenth century. He describes such a performance by a white entertainer, Thomas Dartmouth Rice:

> [He] sang an African-American tune while he did a curious shuffle dance, the chorus of the song being marked by a jump with his heels clicking together. "Jump Jim Crow" became a sensation . . . and fueled the desire for more of these "Ethiopian songs."[32]

Employing the use of the word "Ethiopia" as a representation of all Black bodies and all African American culture, Ethiopian songs were considered any song that may have been sung on a plantation, supposedly representing Black life and instruments associated with the plantation; banjos, tambourines, fiddles, and bone castanets were considered Ethiopian instruments.[33] Johnson further explained:

> Minstrelsy was, on the whole, a caricature of Negro life, and it fixed a stage tradition which has not yet been entirely broken. It fixed the tradition of the Negro as only an irresponsible,

31. Southern, *Music of Black Americans*, 88, 89. Jim Crow and Zip Coon were negative monikers placed upon African Americans to represent them as either simpleminded, slow or lazy slaves content with their predicament or uppity Negroes who did not know their place in white American society.

32. Dizikes, *Opera in America*, 105.

33. Southern, *Music of Black Americans*, 92.

happy-go-lucky, wide grinning, loud laughing, shuffling, banjo playing, singing, dancing sort of being.[34]

Ken Burns, American filmmaker, historian, and PBS documentary writer and producer, documents and describes minstrelsy:

> Theaters featured the bizarre mongrel music of the minstrel show—so-called plantation melodies, often derived from authentic black songs and spirituals but turned into formal compositions by white and black songwriters, performed by whites blackened up as blacks (and often in later years by Blacks blackened up as whites playing blacks). For almost a century, the minstrel show would be the most popular form of entertainment in America, a ritualized blend of lively music, knockabout comedy, sophisticated elegance, the reinforcement of ugly and persistent stereotypes—and simultaneous unabashed enthusiasm for the music and dance of the country's most despised minority.[35]

Daphne Brooks, professor of African American and theater studies at Yale University, notes that minstrelsy reached its most significant popularity between 1846 and 1854, thereby making it "a force in the making of American popular culture and national identity formation."[36] Though initially intended to offer Americans alternative and affordable forms of entertainment to European operas, minstrelsy evolved into an agent of oppression, implanting into the minds of white Americans patriarchal notions of the preeminence of "whiteness" over the inferiority of "blackness" by discounting and denigrating black bodies and maintaining a posture of mastery and servitude by "keeping differences in view . . . and linking those differences to a policy of white supremacy and white working-class"[37] superiority.

Negative antebellum stereotypes placed upon enslaved Africans were imported into the Reconstruction and Jim Crow eras. Minstrelsy, as a form of popular cultural entertainment, became fertile ground for perpetuating racial hierarchies, hatred, and discrimination against African Americans. These primarily white theatrical performances categorized the enslaved and the newly emancipated according to the racial beliefs of the era. With white men masquerading on stage in burnt cork makeup, African Americans were racialized, dehumanized, and presented to primarily white audiences

34. Johnson, *Black Manhattan*, 93.
35. Burns and Ward, *Jazz*, 8, 9.
36. Brooks, *Bodies in Dissent*, 25.
37. Brooks, *Bodies in Dissent*, 25.

as different, deviant, subservient, and simple; these shows were intended to demean blackness and Black people.[38]

> The minstrel show relied on the repertoire of nonsense songs, puns and physical humor which fixated on "the relentless transformation of black people into things." Blackface jokes and songs revolved around the transmutation of black bodies into animals, furniture . . . and food.[39]

While blackface minstrelsy was a tactical root of establishing and reinforcing the racist and hegemonic xenophobic portrayal of African Americans within American society, African Americans were simultaneously taking to the stage to resist the negative narrow-minded stereotypes perpetrated against Black bodies. In direct contrast and with countercultural voices, African American artists developed performance strategies and techniques that empowered them to counter-intuitively articulate and divert the negative discourse of sociocultural hostilities displayed through white blackface performances.[40]

Minstrelsy maintained its popularity after the Civil War. Because venues for African American performers to practice their craft were scarce, many chose to be part of white minstrel shows as a source of income and a way to debunk the negative stereotypes that still persisted regarding Black bodies and culture.

> In spite of the debased portrayal of African Americans in the minstrel show genre, it did provide opportunities for African American performers and songwriters to perform or have their work put before white audiences. Some were creative in attempting to show African Americans in a better light while working within this restrictive form. For example, in the 1870s African American performers began including spirituals in the performances, creating a place for authentic African American songs to be presented to white audiences.[41]

This creativity was, in actuality, resistance theater. African American playwrights and artists penned and performed Black dramas within the genre of minstrelsy as a corrective tool of resistance through theatrical

38. Neklason, "Legacy of Blackface."
39. Brooks, *Bodies in Dissent*, 27.
40. Brooks, *Bodies in Dissent*, 3.
41. Library of Congress, "African American Song," §14.

presentations or "resistance performances."[42] Resistance performances created new countercultural, anti-white supremacist

> narratives of black culture that resist the narrow constraints of racist representation . . . [and] the colonial invention of exotic darkness which has historically been made to envelop bodies and geographical territories in the shadows of global and hegemonic domination.[43]

On the stages of many of these traveling minstrel shows were African American actors, singers, and dancers, sometimes performing in white minstrel shows but often touring with their own minstrel, concert, and opera companies.[44] The appearance of African American singers, dancers, composers, and playwrights was a bold move by a people determined to "resist, complicate, and undo [the] narrow racial, gender, sexual, and class categories in American . . . culture . . . [by] developing risky, innovative paths of resistance in performance."[45]

From Minstrelsy to Opera

Naomi André, David G. Frey Distinguished Professor of Music at the University of North Carolina and Seattle Opera's scholar-in-residence, suggests that although minstrelsy was sometimes a compromising avenue of generating income for African Americans, it was also a direct connection to opera performance. She explains, "Minstrelsy is the giant specter with which we must contend as we examine black participation in opera. While the two forms are quite distinct—opera and minstrelsy—they provided a complicated, interconnected history for black musicians."[46] Complementary scholarship of minstrelsy on the performance landscape is further addressed in an anthology and historical overview of Black musical shows by African American physicist, chemical engineer, and film historian Henry Sampson.

42. Brooks, *Bodies in Dissent*, 3.

43. Brooks, *Bodies in Dissent*, 6, 8.

44. In *Music of Black Americans*, 228–59, Southern briefly discusses the history of Black minstrelsy, its stars, composers and writers. For example, Sissieretta Jones had a traveling troupe called "Black Patti's Troubadours," Charles Hicks organized a troupe in Indiana called "The Georgia Minstrels," and other troupes such as "McCabe and Youngs Minstrels" and "Sawyers Colored Minstrels" toured throughout the country after the Civil War.

45. Brooks, *Bodies in Dissent*, 3, 4.

46. André, *Black Opera*, 31.

As far back as 1859 there were a few Blacks giving musical con-
certs throughout the Eastern states including Blind Tom, Black
Swan, Thomas J. Brown, Frederick Everett Lewis, the White-
house Sisters, Samuel Johnson, Joe White, and others.[47]

These were but a few African Americans performing in variety shows and
musical concerts throughout the United States before the Civil War. After
the Civil War, even more African Americans chose theater to express their
artistry and positions as political activists. However, to make a living, some
found it more lucrative to perform in blackface portraying African Ameri-
cans as "funny coons and black buffoons,"[48] perpetuating the negative black-
face legacy, thus making it difficult for Black actors and artists who were
doing all they could to resist and undo the harmful, destructive stereotypes.

While minstrelsy prevailed as the most popular form of entertain-
ment in the United States during the antebellum and post-Civil War eras,
it gradually gave way to the rise of burlesque—exhibitionist shows explic-
itly produced for white men—and eventually to the more family-oriented
production of vaudeville in the 1880s.[49] From the 1880s through the 1930s
vaudeville reigned as the most popular form of entertainment in the United
States. It replaced minstrelsy but maintained and broadened its theatricality
and public accessibility as the country expanded westward. Vaudeville also
staged blackface performances to perpetrate prejudicial and racial stereo-
types inherent within minstrelsy. However, the offensive use of blackface by
white actors did not cease as these two genres of entertainment faded into
radio and television production. Blackface, as a racially offensive medium,
continues into the twentieth and twenty-first centuries. As recently as Oc-
tober 2018, Megyn Kelly's morning show on NBC was canceled because of
her on-air remarks defending wearing blackface for Halloween costumes.
White politicians and public figures such as Alabama governor Kay Ivey,
Florida's former secretary of state Michael Ertel, Virginia governor Ralph
Northam, Virginia attorney general Mark Herring, night show hosts Jim-
my Fallon and Jimmy Kimmel, as well as Canadian prime minister Justin
Trudeau are among some of the most notable white people recently exposed
to have used blackface in their attempt to "imitate" African Americans and
African Canadians.[50]

Classically trained African Americans transitioned from minstrel
shows to vaudeville and graced the stages of theaters, concert halls, and

47. Sampson, *Blacks in Blackface*, 1.
48. Sampson, *Blacks in Blackface*, 1372.
49. Palmer and Garner, *American Masters*, season 12, episode 2.
50. Ahlgrim, "21 Celebrities and Politicians."

opera houses nationwide and in Europe. With repertoires consisting of European arias, art songs, oratorio, popular American ballads, and Negro spirituals, African American artists thrived and survived in this entertainment genre despite obstacles constructed around race. They resisted the negative and demeaning stereotypes perpetrated by minstrel and vaudeville show blackface performers through their own unique talent and artistry.

In her seminal work *And So I Sing: African-American Divas of Opera and Concert*, Roslyn Story reminds us that "classical music was as remote from black culture as America was from Europe, and the concept of a skilled black classical artist strained the most vivid imagination"[51] of white and Black audiences alike, while Sampson documents African Americans giving musical concerts throughout the Eastern states before the Civil War.[52] In the late nineteenth century, venues for classically trained African American singers were scarce. For many, the only opportunities offered to them were within the structure of minstrel and vaudeville shows. Even now, in the twenty-first century, opera has not attained traction as entertainment in mainstream popular culture. Yet, it appeals to a vast cross-sector of the population to draw in artists from every ethnicity. African American tenor and University of Michigan professor emeritus of voice George Shirley informs that among these artists,

> Black American singers of opera have always been relatively few in number for reasons external to the race as well as internal. We remain minorities in the profession numerically and racially, which should certainly come as no surprise in an art form that appeals to a minority of the majority in America.[53]

Shirley further explains what he believes to be the draw to this art form for the African American opera singer:

> Traditional sub-Saharan African tribal life centers upon ritual that embodies music, drama, and dance, the stuff of operatic performance. . . . Tribal ritual, sacred and secular is arguably never divorced from a spiritual *raison d'être* [purpose]; operatic performance . . . is an entertainment that can reach the level of spiritual experience when the work performed and the quality of its performance combines to transcend the level of mere entertainment. . . . Black opera singers make the same spiritual commitment to Vissi D'arte . . . as they do to "Done Made My

51. Story, *And So I Sing*, 1.
52. Sampson, *Blacks in Blackface*, 1.
53. Shirley, "Il Rodolfo Nero," 262. See appendix T.

Vow to the Lord." . . . The soul expressed in an aria is fairly easy
to identify with.[54]

The presence of a well-dressed African American female beautifully
and soulfully singing Western classical music while remaining connected
to embedded tribal ritual through song boldly resisted the negative nar-
ratives about the Black female body. As performers, these women's artistic
and theatrical bodies boldly disrupted negative stereotypes by "shock[ing]
audiences into reflection"[55] about their negative prejudicial and embedded
notions of African Americans, especially African American women. Even
within these sometimes demeaning artistic genres, the presence of African
American artists created what Colbert calls "rituals of repair, or the ability
to reproduce, recuperate, reenact, [and] resist."[56] Inherent pride and dignity
within the African American community, while simultaneously combating
the preconceived notions about the stereotypes whites expected to see on
stage, refuted whites' most vivid false imaginations.

The genius of Black performing artists is that they move with a "con-
scious action conceived and created as performance . . . a 'talking back' to
the mainstream class and racial consciousness."[57] As such, African Ameri-
can performers and performances presented "the potential of simultane-
ously forestalling and enabling social change . . . as resistance, affirmation,
subversive, and normative"[58] behaviors. Despite opposition, danger, and
oftentimes violence or the ever-present threat of death by lynching,[59] Af-
rican American artists persisted and became signifiers of resistance within
a hostile environment, artistically and politically. The late nineteenth and
early twentieth centuries saw a surge of African American artists on stages
across the country and in Europe in multiple capacities. African Americans
excelled in every artistic genre, from singers and dancers to playwrights and
composers. As signifiers of resistance and survival, they modeled before
their community and the nation the genius inherent within the artistic Af-
rican American body and soul. It will not be possible to explore the impact
of African Americans within every artistic genre due to the limitations of
the parameters of this research.

54. Shirley, "Il Rodolfo Nero," 262.

55. Colbert, African American Theatrical Body, 51.

56. Colbert, African American Theatrical Body, 51.

57. DeFrantz, "From Negro Expression," 6, 8.

58. DeFrantz, "From Negro Expression," 9.

59. Mitchell, "Black-Authored Lynching Dramas." Here Mitchell makes the correla-
tion between lynching and theatrical performances by Black performers as a direct
protest to this heinous injustice, assault, and violence against Black bodies.

Pioneering Artists

In heralding African American divas, it would be sacrilege not to acknowledge African American devos and their struggle to attain due prominence. In fact, Black male opera singers have had a more difficult time being accepted than their female counterparts.[60] The reluctance to cast them as a leading male against a white leading female is perpetuated by the stereotypes of Black males as hyper-sexed studs, rapists, and simpletons. Their story deserves comparably developed independent research. I can only add that among African American classically trained male musicians and singers for further research are Julius Bledsoe, Lawrence Winters, William Grant Still, Harry T. Burleigh, Roland Hayes, Paul Robeson, Todd Duncan, George Shirley, Alvy Powell, Terry Cook, Gregg Baker, Lawrence Brownlee, Chauncy Packer, Kevin Thompson, Kenneth Overton, Justin Michael Austin, and many others performing in American opera houses today. Therefore, while the focus of this project is the African American female opera singer from the late 1800s until the present, be sure to understand there have been and are African American male opera singers who have broken barriers, have made and are making an impact within this genre of American entertainment.

The Opera Divas

The commonality among the African American opera divas highlighted in this project is that through their performances they counter-culturally resisted, reframed, and overcame the dominant culture's narrative regarding the Black female body. By refuting and reconstructing the negative stereotypical images (of Mammy, Jezebel, the pickaninny, Aunt Jemimah, and Sapphire—among other denigrating stereotypes of Black women which grew from the fantastic imagination of whites about Blacks), they gained personal acclaim through their artistry, professional stage presence, tenacity, shrewd business acuity, perseverance, and refusal to succumb to the limits placed upon them based upon gender and race. The inherent artistic genius of these African American opera divas laid the foundation for generations to follow.

Mezzo-soprano Elizabeth Taylor Greenfield, also known as the Black Swan, was born a slave in Natchez, Mississippi, in 1824. Raised in Philadelphia by Quakers who supported her interest in the arts, she studied harp,

60. Cheatham, "Black Male Singers." Nettles mirrors these findings throughout *African American Concert Singers*.

guitar, piano, and voice. She made her professional singing debut in 1851 in Buffalo, New York, and subsequently toured New England and the Midwest. In 1854 she appeared in London before Queen Victoria in a private concert at Buckingham Palace.[61] Of her artistry and fortitude Brooks observes:

> Indeed, Greenfield and the classical black female performers who followed her would establish a field of cultural transgression to reanimate their socially circumscribed bodies and make themselves matter in a newly visible cultural context. Greenfield gave birth to a genealogy of black women's cultural play within classical music forms, and she exemplified the ways in which professional singing might operate as a vocation capable of rewriting black female iconography in the cultural imaginary.[62]

Upholding the tradition set by Greenfield were the Hyers sisters, Anna (soprano) and Emma (contralto), who gave classical concerts throughout the northern and western states in the 1870s; and soprano Marie Selika Williams, fluent in German and French, who concertized throughout the United States and Europe in the 1880s.[63]

One of the most popular female singers of Western classical music for both Black and white audiences was Sissieretta Jones, also referred to as "The Black Patti" as a comparison to the Italian soprano Adelina Patti. Jones made her concert debut in Philadelphia in 1888. Jessye Norman recounts that "she was on the main stage of Carnegie Hall in 1893, two years after its opening, singing 'Sempre Libera' from La Traviata."[64] Jones toured Europe, Asia, and Africa, and performed at the White House for Presidents Harrison, Cleveland, McKinley, and Theodore Roosevelt.[65] However, when she was invited to perform at the White House, she was still asked to enter through the back door.[66]

Twenty-two years before Anderson broke the color barrier at the Metropolitan Opera, Caterina Jarboro performed the leading role of *Aida* with

61. Johnson, *Black Manhattan*, 98, 99.

62. Brooks, *Bodies in Dissent*, 313.

63. Brooks, *Bodies in Dissent*, 313.

64. Scorca, "Jessye Norman's Next Act," 16. Norman, along with African American soprano Harolyn Blackwell and producer Adina Williams, was in the process of developing a documentary entitled "Sissieretta Jones: Call Her By Her Name" before her passing. Blackwell and Williams are continuing the project with an anticipated debut in 2021. Information about its content and planned release date may be found at Norman et al., "Sissieretta Jones: Call Her by Her Name!"

65. Story, *And So I Sing*, 9; and Brooks, *Bodies in Dissent*, 314. See Story and Brooks for a more complete historic account of African American women in American opera.

66. Scorca, "Jessye Norman's Next Act," 18.

the Chicago Civic Opera in 1933, making her the first African American singer to perform with a major opera company in the United States. The *New York Times* gave her a glowing review. Following this acclaimed performance, she appeared as Seleka in *L'Africaine* (*The African Woman*)[67] in New York, then as the lead in African American composer Clarence Cameron White's *Ouanga*[68] at the Chicago Ravinia Festival. The New York Metropolitan Opera Association invited her to become a member, but when they realized she was not Italian, they rescinded the very membership that they offered. Jarboro was of American Indian and African American descent, breaking barriers in opera for two marginalized and disenfranchised groups in America.

As demonstrated, Anderson did not arrive as an anomaly on the American opera music scene. She diligently honed her craft and stood on the shoulders of singers before her like Sissieretta Jones,[69] Elizabeth Greenfield, and Caterina Jarboro, who never made their way to the Metropolitan Opera stage but who paved the way for those to come. Before Anderson, other pioneering African American women, such as Flora Batson, Nellie Brown Mitchell, and Rachel Walker, performed opera on stages across America long before the women who are familiar in the recent American experience: Leontyne Price, Shirley Verrett, Martina Arroyo, Grace Bumbry, Jessye Norman, Kathleen Battle, Denyce Graves, Harolyn Blackwell, Barbara Hendrix, Angela Brown, and rising stars J'Nai Bridges, Pretty Yende (South African), Janinah Burnett, Angel Blue, Jacqueline Echols, LaTonia Moore, Indira Mahajan, and countless chorus members now on the rosters of opera houses across the country and the world—including me.

The twenty-first-century opera community more prevalently includes African American opera singers on the rosters and stages of American opera houses. There have been critical choices to make along the way, however: Does one respond to the artistic genre to which one is called or acquiesce to an artistic existence within a more popular musical genre generally ascribed to accommodate Black artists, e.g., pop, jazz, gospel, R&B, or hip hop? Though the strict racial barriers of the late nineteenth and early twentieth centuries have relaxed, many African Americans pursuing a career in opera have had to face what Melinda Boyd terms as an "aesthetic double

67. Meyerbeer, "Africaine."

68. White and Matheus, *Ouanga: A Haitian Opera*. Chapter 6 in *Blackness in Opera* by Bryan is devoted to White's opera, and explores the connections of African Americans to the Haitian Revolution, African culture, and the Harlem Renaissance. See Bryan, "Clarence Cameron White's Ouanga!" See appendix R: "African American Composers and Librettists."

69. See appendix S: "Sissieretta Jones, Soprano."

bind"[70]—held twixt and between two aesthetic worlds and cultures while not being fully accepted in either. Blacks in opera continue to be challenged with being considered too Black or "different" for the world of opera or too white acting/singing for the Black community.

Addressing racism within the profession, legendary African American soprano Jessye Norman recounts in her memoir *Stand Up Straight and Sing* more numerous moments than she cared to remember where racist remarks by whites, both intentional and unconscious, were made concerning her presence and abilities as an African American woman in an otherwise white world. "The pervasiveness and normalization of racist language was evident,"[71] uttered by some conductors, promoters, music critics, and acquaintances from which she recognized the "pervasive racism" embedded within the profession.[72]

The flip side of the aesthetic double bind is the challenge African American opera singers may experience within their own community. Soprano, mezzo-soprano, and a 2009 Kennedy Center honoree Grace Bumbry found that "returning home poses problems—sometimes the distance was too great, the contrast too sharp."[73] In an interview with Story, Bumbry explained:

> Going back to your early childhood [neighborhood] is not that easy, because so many of your early friends don't really understand what you're about. Oftentimes they tend to think you are putting on airs. I went through that. Where they thought, "oh well she's speaking all these languages, she's being snooty, she's being arrogant, you can't reach her." But what they fail to remember is that Grace made certain sacrifices to get there . . . they don't understand that.[74]

Pervasive racism within the profession and being misunderstood within one's own community are only two of the obstacles each of the opera divas mentioned here endured to reach the pinnacle of their careers. Others like Bumbry sacrificed the familiar, choosing to live in Europe where their artistry was better appreciated and where opportunities to perform major roles with major opera houses existed more than in the United States. While racism was present in Europe, opera was such an essential fabric of society that the quality of one's voice for a role won over an artist's ethnicity. Some African American opera divas sacrificed the notions of family and motherhood

70. Boyd, "Politics of Color," 226.
71. Norman, *Stand Up Straight and Sing*, 131.
72. Norman, *Stand Up Straight and Sing*, 129.
73. Story, *And So I Sing*, 155.
74. Story, *And So I Sing*, 155.

because the demands of the career required extensive travel, rehearsal, study, and concentration, leaving little time to properly build lasting intimate relationships or time to nurture a child. Yet each of these operatic artists, and the myriad others not mentioned and yet to come, sing as resistance to the still embedded, implicit racism within America. They perform what may be a restorative shifting of the gaze which allows the beauty of African American women to be beheld by those who see and hear—the dominant culture that insists on seeing Black women through tainted and blurred lenses and the African American community that does not wholly embrace her artistry and womanhood as authentic and not as a rejection of her Blackness.

Personal Journey: On the Stage

My circuitous route onto the opera stage has navigated my profession as an opera singer, as well as my scholarship as a Womanist theologian. My childhood soundtrack and first musical memories are of my mother and her sister's harmonious tones and the church mothers and fathers raising their voices in song. Without the privilege of private formal instrumental or voice lessons, public school music education programs offered basic clarinet lessons, school choral ensembles, drama classes, school plays, and high school musicals. Church choirs, conventions, and community choruses satisfied my artistic passion while I pursued a career as an educator. The serendipitous meeting of a professor of voice and recitalist at a religious conference revealed a musical giftedness beyond what had been a passionate pastime. She became my voice teacher, encourager, and friend, introducing me to pivotal formal and classical performance possibilities. Confidently owning my vocal abilities to produce a pleasing operatic sound, my teacher introduced me to professional church choir directors and community chorus directors who consistently hired me as a mezzo-soprano soloist for recitals and oratorios.[75] Thus began my bi-vocational profession—teacher by day, singer on nights and weekends.

The surge of confidence in my own vocal ability opened performance opportunities that profoundly reframed "how I spent my summer vacation." In the summer of 1995 and 1996, I toured Austria and Germany with the African American opera diva Grace Bumbry[76] and her Black Musical

75. Examples of oratorio are *Elijah* by Felix Mendelssohn or the *Ordering of Moses* by R. Nathaniel Dett, an African American composer.

76. Hamilton et al., *Metropolitan Opera Encyclopedia*, 58–59. Bumbry was a trailblazing African American mezzo-soprano most famous for her renditions of *Carmen* and *Salome*. Her biography, written by Brewer, is at Gracebumbry.com/biography.

Heritage Ensemble singing Negro spirituals and gospels by African American composers. Ms. Bumbry's goal was to preserve the rich music of slave songs, spirituals, and early gospel music by African American composers through this ensemble. With this same ensemble, I performed at Carnegie Hall in 1996 and was delighted to receive my first *New York Times* review describing me as a "promising soloist and smoky-voiced alto."[77] In the summer of 1997 I returned to Austria to perform in the world-acclaimed opera *Porgy and Bess*[78] at the Bregenzer Festspiele—a summer music festival held every July and August in the city of Bregenz, Austria, on the world's largest floating stage on Lake Constance. This was probably one of the most controversial productions of *Porgy and Bess* to date. The concept of German artistic director Götz Friedrich was particularly egregious to the American performers and music director. A 1997 *New York Times* article highlights the core of the controversy.[79]

That a Power far greater than myself forged my path to the opera stage is evident in that I was not a voice major and earned no music degrees. Yet, I have sung on stages with African American opera greats William Warfield, George Shirley, Jessye Norman, Kathleen Battle, Grace Bumbry, Florence Quivar, and Denyce Graves—to name a few—and performed under the batons of Roland Carter, Brazeal Dennard, Robert Harris, Julius Williams, Robert Ray, and Moses Hogan. I have been taught by Dr. Marilyn A. Thompson and coached by world-renowned vocal coaches Silvia Olden Lee, Benjamin Matthews, and Wayne Sanders. I have portrayed Harriet Ross in the opera *Harriet* by Leo Edwards for the acclaimed Opera Ebony, the longest-running African American opera company in American history. These early musical experiences continue to take me to a place of gratitude when I reflect on how opera drew me in, made space for my gift, and embraced my soul.

When I retired after twenty-five years as a home economics teacher, I could accept unexpected performance opportunities that I could never have taken advantage of while committed to a teacher's daily schedule. My once avocation projected this part-time singer onto the stage as a full-time, paid, professional opera singer. I auditioned for and was accepted into the New York City Opera's Associate Chorus for their productions of *Porgy and Bess* in 2000 and 2002.[80] In 2001 I played the Strawberry Woman for a

77. Pareles, "From a Diva and Choir." See appendix U: "Author with Ms. Bumbry" and appendix V: "Author with Ms. Bumbry and the Black Musical Heritage Ensemble."

78. Gershwin et al., *Porgy and Bess*.

79. Whitney, "Porgy and Bess in Austria." Additional information about the production and staging can be found at BregenzerFestspiele.com.

80. The "Live from Lincoln Center" performance of *Porgy and Bess* which I was

Porgy and Bess production in Tel Aviv, Israel, and revived the role in Detroit, Michigan, in 2003. From 2003 to 2009, I toured with New York Harlem Productions performing *Porgy and Bess*[81] exclusively in Germany, the Netherlands, Scandinavia, Japan, France, Belgium, Spain, and Italy for two- to three-month runs each.

Touring paused when I answered my call to further prepare for ministry and pursue the doctor of ministry—the professional degree for clergy persons—and accepted an administrative position at a seminary in Detroit, Michigan. Again, unexpected opportunities to perform while simultaneously being a student and administrator opened locally. Responding to the Michigan Opera Theater (MOT) call for local singers to audition for the chorus of a commissioned opera in 2005, I became part of their world-premiere production of *Margaret Garner*. Since my first MOT chorus, I performed in their 2006 production of *Porgy and Bess*, the 2007 production of *Turandot*, and the 2008 revival of *Margaret Garner* in Detroit and Chicago. Several shorter European tours of *Porgy and Bess* were scattered in between and after these performances.

Porgy and Bess became the major performance vehicle for realizing my musical dreams. With over one hundred performances of this classic opera worldwide in my repertoire, I marveled every time I stood on the stage of an opera house—there I was, having arrived by quite unconventional means and graced with immense favor. *Porgy and Bess* introduced me to world-class opera singers and expanded my worldview. Hence, I love this opera's narrative of love and forgiveness, community and faith, and the opportunity it has given many African American opera singers to launch their careers.

As impactful as my *Porgy and Bess* performances were, and my portrayal of Harriet Tubman's mother in *Harriet*, the opera that has most profoundly affected me personally is *Margaret Garner*. Through depicting an enslaved Black woman, I embodied and portrayed the experiences of my ancestors like no other to date. These and similar operatic experiences have brought me to this work as a participant observer conducting auto-ethnographic research. Using my personal tripartite Womanist experiences affords an intersectional approach to engage critically with opera's influence on both performers and audiences.

Working within opera's cultural and artistic space gives me tools that enable my Womanist view to reflexively peer through symbolic and metaphoric opera glasses to see with a reversed gaze not only the world

a part of in 2002 can be seen in its entirety on YouTube. FASinatra1, "George and Ira Gershwin's *Porgy and Bess*."

81. See appendices W and X: Author in Michigan Opera's *Porgy and Bess* ensemble.

of American opera from within but also from the balconies of American society and culture as a whole. Based on personal experiences and inquiry, I contend that viewing opera as social drama and performance art in the landscape of twenty-first-century genres of entertainment gives it the ability to affect and effect social change to initiate healing for the wounded psyches of the descendants of formerly enslaved and colonized peoples. Further, select operas have the potential to foster theological reflection and advance a corrective ethic to the negative narratives and denigrating stereotypes of African Americans that continue to be perpetrated by the dominant culture.

Summary

Through the lens of my autoethnographic location as a native-participant-observer, African American opera singer, preacher, teacher, Womanist theologian, and scholar, I peer through metaphoric opera glasses from my balcony perspective to uncover the historical roots of opera in America. I trace the racist practices within this revered musical genre through the growth of minstrelsy as a form of American popular cultural entertainment from the eighteenth through the early twentieth centuries. I explore and reveal ways that minstrelsy, especially blackface minstrelsy, became a generator of American racial and cultural codes linking the formation of antebellum popular culture with the development of American racist attitudes, beliefs, and policies justifying slavery and Jim Crow. Minstrelsy propagated and perpetuated racist ideologies and stereotypes denigrating and debasing Black and brown bodies, perpetuating American patriarchal notions of the superiority of "whiteness" and the inferiority of "blackness." Such was the fertile breeding ground of racial hierarchies, hatred, and discrimination against African Americans and other minority groups in this country.

Regardless of attempts to debase African Americans through blackface minstrel performances, the genius of the enslaved and newly freed Africans who appeared on the stages of minstrel shows is that they worked within the genre to disrupt, dispute, correct, and resist the harmful stereotypes about them and their communities that minstrelsy disseminated among white Americans. Classically trained African American artists took to the stages of white minstrel shows or produced their own as countercultural resistance performances. James Weldon Johnson, Roslyn Story, and Naomi André describe the pure genius of African American performers to resist negative stereotypes while creating a performance niche for themselves within what was intended to be a degrading environment.

Despite its negative associations, minstrelsy became the direct connection to opera for African Americans. After the Civil War, many African

Americans chose theater to express their artistry and political activism. Classically trained African American artists transitioned from the minstrel stage to the stages of concert halls and opera houses across America and Europe. Their elegant, excellent, and professional stage presence resisted, refuted, and reframed the negative narratives about Black bodies, intelligence, and lives. But these performers still faced the racist environment within the nation and the opera world to practice their profession. Elizabeth Taylor Greenfield, Sissieretta Jones, Caterina Jarboro, and other classically trained African American women broke long-held racial barriers by giving recitals on concert stages and performing in opera halls, thus paving the way for Marian Anderson to make her Metropolitan Opera debut in 1955. While the gatekeepers of white America's racist ideologies and practices continued to bar African Americans from concert halls and stages across the land, physically and metaphorically relegating them to the balconies of the opera hall as well as the whole of American society, Ms. Anderson's Met debut marked a significant breakthrough.

Breakthrough though it was, racism remained all-pervasive within the profession. Almost sixty years after Anderson's Met debut, Jessye Norman writes of intentional and unintentional racism within the opera world, the normalization of racist language, and the difficulty even she had working through the racism still embedded within the profession despite her professionalism, her command of the languages, her stage presence, and her popularity in her memoir *Stand Up Straight and Sing*.[82]

It is on the shoulders of these African American opera divas, Elizabeth Taylor Greenfield, Sissieretta Jones, Marian Anderson, Grace Bumbry, Jessye Norman, and others mentioned in this research, that I and other opera singers in the twenty-first century stand. Their resistance performances, tenacity, fortitude, struggles, and sacrifices made our journeys to the opera stage possible. Though vestiges of racism remain within the profession, we continue to stand and sing, using our voices, our bodies, our artistry, our songs, our stage presence, and our faith, as a testament and a legacy to the creative Black Genius that resists, survives, and thrives within systemic institutionalized embedded racism in the United States.

82. Norman, *Stand Up Straight and Sing*, 129, 131.

8

Act 3, Scene 1—Musical Soliloquy

At the Opera

I will praise the LORD as long as I live. I will sing
praises to my God with my dying breath.

—*PSALM 146:2 (NRSVUE)*

I don't know that there is any other way of telling the story
except through opera because opera has a way of magnifying
human emotions unlike any other art form.

—*TAZEWELL THOMPSON, AFRICAN*
AMERICAN STAGE DIRECTOR

Margaret Garner the Opera: Truth and Fiction

Historical Background

THE OPERA *MARGARET GARNER*[1] tells the story of enslaved Black people,
their faith traditions, and their struggle for dignity and freedom. It is

1. Danielpour and Morrison, *Margaret Garner*. The audio of this opera can be heard
in its entirety at Issuu.com and YouTube.com.

American grand opera explored through my lens as a Womanist theologian. Historical documents record that on January 27, 1856, twenty-two-year-old Margaret Garner (described as a mulatto in the Kentucky 1850 slave census)[2] along with her husband Robert, their children (Mary, Cilla, Tom, and Sam), and Robert's parents (Simon and Mary) made a bid for freedom by making their escape from Maplewood, a northern Kentucky plantation owned by Archibald Gaines, through the Underground Railroad into Cincinnati, Ohio. Their freedom was short-lived as they were pursued by slave catchers with weapons and captured by Gaines under the Fugitive Slave Act of 1850. Ohio was a free state, but federal law demanded that runaways, regardless of where they were re-captured in the United States, be returned to their southern slaveholders.[3]

When the house where the Garners had taken shelter was surrounded by white men intent on taking them back into slavery, Margaret made a drastic decision to prevent her children from ever being slaves again. It is believed that her intent was to take the life of each one, then herself. Grabbing a knife, she attempted to kill both boys but only succeeded in wounding them. She was, however, able to slit the throat of two-year-old Mary, killing her almost instantly. She attempted to kill the youngest child, Cilla, but was stopped by the slave catchers as they entered the house. All of the escapees were taken into custody. Margaret was arrested for killing her daughter, but deciding what "crime" to charge her with proved difficult. The laws of Ohio demanded that she be liable for murder; however, the Fugitive Slave Law allowed a federal commissioner to overrule the state's right to prosecute for murder. Gaines insisted that she be tried for destruction of property according to the Fugitive Slave Law, claiming that both Margaret and the slain Mary belonged to him, and therefore, Margaret had destroyed his property. Had she been tried for murder, the court system would have legally acknowledged her full humanity as a Black woman in America. Charging her with the destruction of property would maintain her non-person slave

2. Frederickson et al., *Gendered Resistance*, 1.

3. Editors of Encyclopaedia Britannica, "Fugitive Slave Acts." In US history Fugitive Slave Acts were statutes passed by Congress in 1793 and 1850 (repealed in 1864) that provided for the seizure and return of runaway slaves who escaped from one state into another or into a federal territory. "The 1793 law enforced Article IV, Section 2, of the US Constitution in authorizing any federal district judge or circuit court judge, or any state magistrate, to decide finally and without a jury trial the status of an alleged fugitive slave" ("Fugitive Slave Acts," §1). This law negated the fact that some free Black people were kidnapped and forced into slavery in the South, simply because they were Black. Read *Twelve Years a Slave* by Northup, the personal account of a free Black man kidnapped and forced into slavery from 1841 to 1853. Northup and Gates, *Twelve Years a Slave*.

status. The moral question remained: Was she guilty of committing murder or destroying property?

There were other fugitive slave trials during this era,[4] but this particular trial caught the attention of the country for weeks because of the child murder, or slave infanticide, at the center of the case. Abolitionists and anti-slavery proponents argued in the courts regarding Margaret's status, petitioning she be tried for murder. Newspapers carried the story nationwide. What rocked the country was the fact that a mother had committed infanticide, killing her own child in what appeared to be an attempt to prevent her from living as a slave. In her article "Infanticide," Talitha LeFlouria, associate professor of African American studies at the Carter G. Woodson Institute, University of Virginia, explains:

> Enslaved mothers often employed extraordinary measures to protect their children from enduring a life of slavery. Most scholars have contended that female slaves frequently endured physical brutality and sexual exploitation. These variables somewhat explain enslaved women's severe reactions to the slavery institution. Resistance was commonplace among slave women. . . . Infanticide was a practice that some enslaved women engaged in, frequently with the purpose of protecting their children from a life of perpetual bondage, or to hide a pregnancy from their owners. . . . Some enslaved women induced miscarriages, whereas others used violence to put an existing child to death. . . . The purposeful killing of slave children by their mothers has been most frequently portrayed as a heroic attempt to rescue their offspring from the horrors of slavery.[5]

Pro-slavery proponents depicted Margaret as a non-human monster capable of the heinous act of infanticide, thus justifying the need to keep Black people bound in slavery. Abolitionists explained her actions as that of a desperate mother who had experienced rape and sexual violence at her owner's hands and refused to allow her daughter to experience the same, thus justifying their reasons for bringing slavery to an end. Ultimately Margaret was charged with the destruction of property and brought to trial.[6] This particular trial and its outcome became the topic of national political discussion and helped to widen the rift between abolitionists and

4. Weisenburger, *Modern Medea*, 7. In 1854 escaped slave Anthony Burns was tried and taken back into slavery from Boston by federal marshals. In 1854 Stephen Pembrook and his sons Robert and Jacob were captured in New York and forcibly taken back into slavery. See National Archives, "Fugitive Slave Case: Stephen Pembrook."

5. LeFlouria, "Infanticide," 2:135.

6. Cincinnati History Library and Archives, "Margaret Garner: 1834–1858."

pro-slavery proponents before the Civil War.[7] It "became *the* most significant and controversial of all the antebellum fugitive slave stories. Was Margaret a cold-blooded murderer making a political statement against slavery, or was she a desperate mother really trying to save her family from a life of degradation?"[8] Or was she a Black woman who took her humanity and agency into her own hands, refusing to accept her proscribed existence in the institution of chattel slavery and remain a non-person in America?[9] Cultural anthropologist Delores M. Walters concludes:

> The Garner case symbolizes Black women's determination to resist their enslavement. In a single act of defiance, Margaret destroyed the master's "property" and his progeny. The dynamics of slavery in which race, gender and class play a significant role, help to explain Margaret's infanticide, her resistance to enslavement and likely her resolve to escape from sexual exploitation and physical abuse.[10]

Professor of English and co-director of the program in American Culture at the University of Kentucky Steven Weisenburger presumes that if Margaret did, in fact, destroy Gaines's progeny, "her child murder was a masterstroke of rebellion against the whole patriarchal system of American slavery."[11] There is evidence that at least two of her children had been fathered by her slaveholder, Gaines. Weisenburger reports that upon finding the dead child's body Gaines's behavior was strange at best. That Mary was his daughter is most probably evident in the recorded account of his actions upon finding her dead.

> Archibald Gaines appeared on the front porch of the house carrying little Mary's body and sobbing uncontrollably over her corpse. . . . The extremity of his grieving, and especially his clinging to the corpse, suggested then and now a still dearer relation to the little girl. . . . At Margaret's 1856 trial there were carefully coded insinuations that Archibald Gaines must be the [other] slave children's father. . . . Witnesses . . . look[ed] at the children's faces and [saw] Gaines's features. . . . It seems

7. Weisenburger, *Modern Medea*. Read for the detailed account of the events of the escape, arrest, and trial of the Garner family.

8. Roth, "'Blade Was in My Own Breast,'" 169–85.

9. Terrell, *Power in the Blood?*, 100.

10. Walters, "Margaret Garner."

11. Weisenburger, *Modern Medea*, 78.

reasonable to conclude that Archibald Gaines probably fathered one or more of Margaret's children.[12]

Poetry, essays, and newspaper articles were written about Margaret during and after the trial. Fictional stories were based on her true-life events. Shortly after the Civil War, however, Garner's story disappeared from American thought, and "she all but vanished from American Cultural history."[13] Her story resurfaced in 1987 and again in 2005, almost 150 years after the actual events, on the stage of the American grand opera.

Toni Morrison first retrieved this troubling piece of the American experience for the public in her 1987 novel *Beloved*, which was seeded by the facts of Margaret's infanticide. "Few of the novel's events coincide with historical fact. . . . Though . . . the Garner case symbolizes slavery's horror . . . *Beloved* insists that slavery as a whole constituted a historical trauma whose forgetting has put a people's collective sanity in chronic peril."[14] In writing *Margaret Garner*, the opera, Morrison reflects:

> Like other African Americans of that generation and even now you don't remember for purposes of survival. You forget about it [slavery] so you can go forward. Dwelling in that place was crippling. In *Beloved* it was about forgetting. In *Margaret Garner* it is about remembering . . . it is an incredible story, a tragedy about a loving mother . . . [surviving] the institution of slavery, forced to do incredible things yet remain human within a situation that is brutalizing and bestializing you. It is about the determination to assert your rights in the human race even if it meant claiming the lives of her own children.[15]

Recognizing that the impact of forgetting history creates collective amnesia and collective insanity for the formerly enslaved and enslavers is evidenced in the unfounded and continually perpetuated hatred of African Americans in this twenty-first century.

Personal Reflections[16]

On May 7, 2005, at the Michigan Opera Theater housed in the Detroit Opera House in downtown Detroit, Michigan, the newly commissioned opera

12. Weisenburger, *Modern Medea*, 75, 76.

13. Weisenburger, *Modern Medea*, 8.

14. Weisenburger, *Modern Medea*, 10.

15. Headlee, "Opera Tells Saga of 'Margaret Garner.'"

16. See appendix Y: "Author in *Margaret Garner*—Detroit Opera House," appendix Z: "Author in *Margaret Garner*—Detroit Opera House," and appendix AA: "Author in *Margaret Garner* Chorus."

Margaret Garner premiered to a packed house. With the musical score by Richard Danielpour and libretto by Toni Morrison, this long-awaited opera, five years in the making, co-commissioned by opera companies of Detroit, Cincinnati, and Philadelphia, was making its world debut. Every performer on stage, principals and chorus, became one voice telling an important story that accurately reflected a troublesome period in American history. For weeks the opera company had been in intense rehearsals learning the score, storyline, and staging. Indeed, we all knew the subject matter and that the opera was closely but not precisely based on the real-life and tragic events of this enslaved American woman named Margaret Garner. We knew that the librettist, Morrison, was the Nobel Prize–winning author of *Beloved*, which was also loosely based on the life of Margaret Garner, and we were thrilled when she joined us for rehearsals. Starring as Margaret Garner was world-renowned African American mezzo-soprano Denyce Graves, baritone Gregg Baker (Robert Garner), and soprano Angela Brown (Cilla). We were proud to be on stage with principal African American opera singers. However, I wonder now if we truly grasped the magnitude of the importance of this work and how, though it was an "old story," it had the potential to effect change in American society in the twenty-first century, not just through the story, but also through the presence of the African American librettist, director, and performing artists on stage. It became an artistic presentation of American collective memory—painful and wrenching, yet necessary to begin a conversation between Black and white Americans that could lead to healing American historical amnesia. It certainly had a profound effect on this performer.

Opening night was exciting for everyone involved: the principals, the chorus, and the audience. Performers came to the stage from our dressing rooms for the first call to places. The composer, librettist, conductor, and director gathered on stage behind the curtain to give words of encouragement to each of us, then made their way to their respective places, and everyone eagerly awaited the curtain to rise. With the conductor in the pit, his baton raised, the haunting overture began playing. As the curtain rose, act 1 began behind a scrim in veiled darkness depicting an auction block with the mournful melody of the slave chorus heard offering a prayerful lament and plea to their God to halt their inhumane treatment and keep them from being sold away. A slave auction meant a certain separation from family and friends. I took my place on stage with the other chorus members and, as the overture played, took on the persona and responsibility of momentarily becoming a female slave in antebellum Kentucky. The Margaret Garner story is part of my ancestral story. As the curtain rose, my voice joined others of the Black chorus as we sang the mournful laments and prayers of a people in

bondage longing to be free: "*No, no more, no, not more. Please, God no more! No, no more, no not more. Dear God, no more!*"[17]

To channel an authentic portrayal of slaves and slaveholders as was possible on the stage, director Kenny Leon decided to create an off-stage atmosphere replicating plantation life in Kentucky in 1850 within the confines of a twenty-first-century opera house. For the first time in the history of the Michigan Opera Theater, the always-integrated interracial chorus had been divided into two choruses—one Black, one white. Because the music was so different for each chorus there were separate rehearsals, which didn't alarm anyone about the upcoming change. The shock came when the two choruses were separated and divided into white- and Black-only dressing rooms without telling us beforehand. Chorus members became uneasy. This had never happened before. Having worked together in many productions for years, the chorus members had developed friendships and respect for each other and their talents. They had never been in a forced segregating situation before, and they expressed their dis-ease and concern. Living as most of us did in metro Detroit, we were used to working and socializing with each other (though I suspect some of the white chorus members may have lived in neighborhoods with no or very few African Americans). White chorus members would never have thought of themselves as racist or prejudiced or as benefactors or complicit in white privilege. This intentional separation made them very uncomfortable. The Black chorus members were also disturbed, feeling the tension of having to, if only temporarily, exist in a forced, segregated world. Management was made aware of our concerns. Though a petition was made asking to return to the usual alphabetical dressing room assignments, the chorus remained segregated for the run of *Margaret Garner*. This turned out to be an effective tactic because it elicited the kind of response that created the tension Leon needed—whites almost apologetic and Blacks somewhat angry. Leon's strategy worked. Opening night brought rave reviews:

> Saturday's world premiere of work by Nobel laureate Morrison and the gifted American composer Richard Danielpour was nothing short of revelatory. On the eve of Mother's Day, it was a sweeping panorama of a mother's love, seen through the veil of slavery during our country's most shameful time.[18]

> There are two choruses: African-American and white—which possess an infectious energy and haunting humanity.[19]

17. Danielpour and Morrison, *Margaret Garner*, 1–20.

18. Gelfand, review of *Margaret Garner*.

19. Rosenberg, "Honorable Effort."

Not enough can be said for MOT's double chorus—one of slaves, the other of townspeople. . . . The irrepressible life force of the slaves and the energizing self-confidence of the ruling class coursed through them respectively. Both groups sang with precision, animation and conviction.[20]

These reviews were not easily gained. Critics of the opera in both Black and white communities expressed concern about how telling this story might open old wounds of African Americans and offend descendants of white slaveholders. Was slavery an appropriate subject for a new opera? Why wasn't the African American experience post-slavery important enough to be a subject for opera? Michigan Opera Theater artistic director David DiChiera weighed these questions when deciding to commission *Margaret Garner*. He believed that *Margaret Garner* was an opera that paid tribute to and accurately expressed the experience of the African American community. Addressing these questions, DiChiera decided, "The power of what opera can bring to the stage is important enough to make it come to life again and again because that is the way people begin to understand one another's plights."[21] Speaking in 2005 with Celeste Headlee, a member of the Detroit production's Black chorus and National Public Radio host, composer Richard Danielpour said, "What we were dealing with was addressing arguably the most important unhealed wound in our nation's history. This is a subject that makes Afro Americans uncomfortable and also makes white Americans uncomfortable—which is exactly why we should be doing it. I know we don't want to remember this, but . . . if we don't go to the place that hurts, we will never heal."[22]

Of this work Morrison insists, "No human experience, however brutalizing, was beyond art. If it were then the brutalizers will have triumphed."[23] Conveying her thoughts in a session with a group of opera professionals, Morrison said she felt a special "obligation to translate into operatic [form] the history and experience of African Americans worthy of the idea, worthy to it and the enormous talent of African-American performers"[24] and that "this is a story about remembering. [I have] a responsibility to bear witness for those who could not speak for themselves."[25] *Margaret Garner*, the opera, bears witness and gives voice to one enslaved woman's story and

20. OperaWorld.com, unsigned review of *Margaret Garner*.

21. Ḥasnāwī et al., *Margaret Garner*.

22. Headlee, "Opera Tells Saga of 'Margaret Garner.'"

23. Bennett, "'Margaret Garner' Premiers at Chicago Theater.'"

24. Ḥasnāwī et al., *Margaret Garner*.

25. Headlee, "Toni Morrison."

personal sacrifice that may be a similar story for countless and nameless others and aligns closely with Thomas's premise of "releas[ing] the voices of those whose stories are untold."[26]

Ms. Graves expressed similar feelings, "This is a great responsibility, a heavy subject. We were touched and moved all the time . . . it was unpredictable and intensely personal; it is a story that hits home right in the center. It's real, not like Carmen or Delilah."[27] In preparation for the role, Ms. Graves visited the Maplewood Plantation in Kentucky where the real Margaret had been held as a slave, recognizing that "it existed because it was built on the backs of hundreds and hundreds of (Black) people at a great cost in blood and in breath."[28] On this visit, she took issue with and confronted a Gaines family descendent who expressed concern about her slave-holding family's reputation being assaulted in the opera, telling her that the truth about slavery and its effects on Black women, then and now, must be told regardless of how it made her feel. This descendant of slaveholders had no concept of how the effects of the evil and brutality, especially against women, within the system of American chattel slavery, was caused by one group's belief that they could own and control another group. In response, Ms. Graves clearly expressed her detestation of that system. Williams surmises slavery as systemic demonarchy and describes it as

> the demonic governance of black women's lives by white male and white female ruled systems using racism, violence, violation, retardation, and death as instruments of social control. . . . Demonarchy has its roots in American slavery, in the governance that allows black women to be used as breeder women [and] indiscriminately raped by white men.[29]

In establishing her "thesis about black women's oppression"[30] in America during and since slavery, Williams holds that the fictionalized narratives of African American women closely mirror the true lived stories of our enslaved ancestors. The works of Zora Neale Hurston (*Jonah's Gourd Vine* and *Their Eyes Were Watching God*), Margaret Walker (*Jubilee*), and Alice Walker (*The Color Purple*) are for Williams "religious narratives because

26. Thomas, "Womanist Theology," 15.

27. Ḥasnāwī et al., *Margaret Garner*. Graves compares the character Margaret Garner with Carmen (from the opera *Carmen* by Georges Bizet) and Delilah (from the opera *Samson and Delilah* by Camille Saint-Saëns) as operatic roles which she has portrayed with international acclaim.

28. Ḥasnāwī et al., *Margaret Garner*.

29. Williams, "Color of Feminism," 51.

30. Williams, "Women's Oppression," 59.

religious language, religious practices and religious issues help affect the resolution of the plots."[31] She holds that in the "black novel," these "narrative metaphor[s] mirror the faith, hopes, values, tragedies, failures and celebrations of an oppressed community"[32] and highlight the multidimensional assault of oppressions on Black women.[33] *Margaret Garner*, the opera, easily fits Williams's description of a religious narrative.

Perhaps unexpectedly, the audience was taken through difficult and unexpected collective anamnestic moments. In the theater, one was brought face-to-face with an abominable American historical fact, reminded of and forced to recall, remember, or learn about what some may never have seen or known before, what may never have been understood before, to feel the anguish of a woman, a family, a community enslaved by a system intent on subjugating and dehumanizing their very existence. Audience reactions ranged from quiet reflection to tears, gasps to standing ovations. No one left the theater untouched.

Performing as a company member brought a similar anamnestic response, however more intense than that of the audience observer. We became part of America's historical recollection, taking on the spirits of our Black and white ancestors. As descendants of slaves and slaveholders, we were the medium through which to tell this story. For me, it became personal. Portraying an enslaved woman was neither embarrassing nor degrading. Instead, it honored and paid tribute to the spirits of resistance, tenacity, and survival of these women. Remembering the stories my father told about his grandfather born into slavery, Henry Derricotte, brought me to wonder about the unknown slave woman who had given birth to him and to the women before her. Which one of them survived the Middle Passage and became my African ancestor? This production compelled me to search my paternal family tree online. The surprise revelation was finding the name of Henry's mother in the Georgia census of 1870—Delphia. The search revealed nothing further than 1870, but finding her name connected me even more deeply to my history and this story. Perhaps Delphia's spirit had been with me on that stage.

Analysis: Score, Libretto, and Historic Imagination

Analyzing select arias and choral portions of the opera will identify the subtle yet bold synergy between the orchestration and libretto locating the

31. Williams, "Women's Oppression," 59.

32. Williams, "Women's Oppression," 59.

33. Williams, "Women's Oppression," 59.

intersections of Womanist Theory and Theology, Black Performance Theory, and Womanist Anthropology through artistic expression. Morrison relied on actual historical accounts of the Garner escape and supplemental slave narratives to create her operatic characters. Slave narratives in written and oral forms which told the true life stories of desperation, daily life, and escape attempts, were recorded to convey two things: (1) personal stories that represented the race; and (2) stories intended to persuade the reader, usually a sympathetic white person, that slaves were in fact, human.[34] Building upon these sources and her own imagination, Morrison was able to develop a libretto that focused on the inner lives of the Black female characters and present on stage an awareness of those "unspeakable things unspoken."[35]

As Morrison intently relegated the white gaze and voice to the periphery in her novels, the same approach is assumed in the opera. Large portions of the score for the white chorus and principals are sung *un poco agitato* or *subito agitato* (agitated), *misterioso* (mysterious), or *staccato* (detached) in contrast with the smooth "solemn and soulful"[36] *dolce* (sweetly with tender emotion), *sonoro* (melodious, pleasant), or *doloroso* (sorrowful) portions for the Black characters and chorus. As scenes transition and thoughts are exchanged between Black and white characters there are sudden stark changes in tempo, indicating the transitions between each community's sentiments. Though the white perspective is integral to the totality of this portion of American history and is an important part of the opera, this analysis employs Morrison's and Terrell's understandings of shifting the gaze to intentionally focus on the story of the enslaved through the arias and choral pieces sung by the principal Black characters and Black chorus.

Understanding the interrelationship between the music and the lyrics, Morrison noted that "the words hold the music"[37] and that

> when you pair emotional language, nuanced language, language that is violent with music you get another level of perception and emotion. When I'm writing fiction I can make a sentence poetic or have a certain rhythm . . . , but when I write for the opera I am not competing with the music. The language must hold the music, even provoke the music so that the marriage is as perfect as we can make it and that provides, I think, the people in the

34. Morrison, "Site of Memory," 186.
35. Morrison, "Unspeakable Things Unspoken," 1–34.
36. Danielpour and Morrison, *Margaret Garner*.
37. Emetaz, "'Margaret Garner.'"

audience with deeper, clearer, and also more heartbreaking and more triumphant and more profound responses to the story.[38]

Danielpour, as the composer, explains, "the words in a sense inform, literally, and provoke the composer."[39] He felt that his greatest challenge in this opera was to musically portray the sense of transformation within the main character Margaret through all of her life experiences, born a slave but "who finds her own freedom within."[40] He and Morrison captured this transformation in Margaret's arias—"Love Triptych from Margaret Garner."[41]

> Triptych features Margaret Garner's understanding of love. These are Margaret's three feature arias in the opera, but each one shows her character's love in different ways. The first aria (Margaret's Lullaby) is a mother's love for her children. The second, (A Quality Love) is an understanding of herself as a person to be loved. The final movement (Intermezzo and Soliloquy) shows Margaret speak about love to God (or the Cosmos) in terms of a sense of dignity and self worth.[42]

Casting Margaret as a mezzo-soprano was intentional because the mezzo voice has a wide range from high C to low F and sits comfortably in a register that can convey the emotional transitions Danielpour and Morrison sought to create for the opera. Carrying the music and the message requires an artist's particular sensibilities, presentation, and character depiction. Mezzo-soprano Graves's portrayal of Margaret brought to this production and the stage the emotions that the composer and librettist intended. Her adept artistic instincts and the resonant, sonorous timbre of her voice made the character believable for the audience and performers alike. As required of the role, Graves expressed joy, sorrow, distress, anguish, torment, trouble, resolve, and most of all, love through her acting, voice, and personality.

Throughout the score, Danielpour's understanding of the roots of American music is evident, saying that "so much of what defines American music, as distinct from our European predecessors, is the presence of the African American element whether it happens to be blues or jazz or spirituals or gospel, they've all had a hand in shaping a sound that we consider to

38. Scott, "Mother's Desperate Act."

39. Emetaz, "'Margaret Garner.'"

40. Emetaz, "'Margaret Garner.'"

41. Danielpour and Morrison, *Three Mezzo-Soprano Arias*. "When all three arias are sung together the title 'Love Triptych from Margaret Garner' may be used." Inside front cover.

42. Danielpour and Morrison, *Three Mezzo-Soprano Arias*.

be our own."[43] Each of these African American musical elements—as well as call and response, work songs, and African chants—are heard throughout the entirety of the opera, woven throughout the orchestration, arias, and choral pieces of the Black chorus and principal performers.

As Morrison's historic imagination developed the lyrics for Margaret's arias, she carefully considered what might be the "truth about the interior life of a people who didn't write it (which doesn't mean that they didn't have it) if I'm trying to fill in the blanks that the slaves narratives left."[44] To this end it was vital for her to express what she imagined to be the inner life, the feelings, and emotions of Margaret Garner—how she loved her husband and children, how she loathed her treatment as an enslaved woman, how she longed for freedom for herself and her family. The melding together of Danielpour's compositional skills and Morrison's literary genius adeptly excavated Margaret's story by "unearthing the sources of the past in order to discover fragments to create a narrative for the present and the future [that] validates the past lives of enslaved African women by remembering, affirming, and glorifying their contributions."[45] Morrison's artistic use of metaphoric language and embedded theological implications assigned to the slave community throughout the opera gives us a view into their interior relationships with each other, God and Jesus, how they viewed their social status as non-persons, and how their worldview was "constructed from the interplay of social context, scripture, and traditions."[46] "Slaves . . . saw clearly the connections between Jesus' story and their reality yet chose willingly to walk the way of sacrifice by maintaining an ethic of love in an ethos of injustice . . . [in] conversation with the faith traditions they inherited from Africa and America."[47]

Resistance

I examine agency and resistance methods of Margaret at each life transition within the opera.

Act 1, scene 1 opens behind a darkened scrim. The Black chorus and principal artists stand on an imagined stylized auction block, dreading their impending purchase and separation from loved ones, prayerfully pleading, and call out to their God, "*No, no more. Please, God, no more! Dear God,*

43. Emetaz, "'Margaret Garner.'"

44. Morrison, "Site of Memory," 193, 194.

45. Thomas, "Womanist Theology," 491.

46. Grant, "Subjectification," 204.

47. Terrell, *Power in the Blood?*, 55, 100.

no more![48] The scrim is lifted, and the audience observes the depiction of slaves being whipped and prepared to be sold at auction. The anger and frustration of the enslaved are heard in the call and response between Margaret and the chorus:

> Margaret: *Ankles circled with a chain,*
> *Skin broken by a cane*
> *Bloody pillows under my head*
> *Wishing, praying I was dead;*
> *Master's brand is following me*
> *Rope can swing from any old tree;*
>
> Chorus: *Please God no more!!*

The auction begins but moments later is unexpectedly halted by the entrance of the new plantation owner, widower, and single father, Edward Gaines. Realizing that there would be no sale or family separation that day, those same voices were lifted in praise and thanksgiving to God, knowing that their prayers had been answered and they had been given

> *a little more time, a little more time,*
> *more time with the children we love . . .*
> *time with our brothers . . . time with our mothers . . .*
> *We feel the mercy of our Lord God*
> *with the gift/grace of a little more time . . .*
> *We feel the breath of our Lord God*
> *with the gift of a little more time.*[49]

In the opera's opening moments, expressions of the slave community's belief in a God who knew all about them are lifted in a mournful moan, and lament then becomes a celebratory gospel-style song of praise. This God, their God, not the "master's god," had answered prayer and was moved by the Spirit to deliver them from impending separation from family and friends in a brutal system that considered them chattel, not human.

Act 1, scene 2 opens with the syncopated sound of African drums. After a long, tedious day of work in the field and the big house, the community gathers for a bit of relief in singing a work song. Through song,[50] they could complain without repercussions about their mistreatment:

48. Danielpour and Morrison, *Margaret Garner: Libretto.* Unless otherwise noted, all of the lyrics in this section are from act 1, scene 1 of *Margaret Garner.* See appendix Y showing principals and chorus singing "No, No More!"

49. See this scene in appendix Z: "Author in *Margaret Garner.*"

50. Danielpour and Morrison, *Margaret Garner: Libretto.* Unless otherwise noted, all of the lyrics in this section are from act 1, scene 2.

Turn my face to the dying sun,
can't straighten my back till the work is done.
Plowed the fields, baled the hay;
going to dance on the lead mule's back some day.

Margaret leads the women singing of their work and forms of resistance in the big house:

Boss is happy at his plate, long as he gets his fowl.
If I stand at his cooking stove, his supper will be foul, believe it!

Cilla, Robert's mother (Angela Brown), is the community elder, a woman of wisdom, and the oral guardian of their beliefs and rituals. Prayer is one such ritual. As she offers prayer over their meal, she joins Margaret and Robert (Gregg Baker) in traditional African and African American call-and-response. As Cilla prays, Margaret and Robert join her, their responses indicated within parentheses.

Dear Lord in heaven, (Bless the Lord)
Make us grateful for our food, (Sweet Jesus)
Keep us well and in your sight. Protect those in danger (Take my hand)
And let us be guided by your heavenly light (Precious Lord)
Amen.

After the prayer and interplay between husband and wife, Margaret sings an aria expressing tender love (*dolce*) to her baby daughter in a lullaby.

Sad things far away, soft things come and play, lovely baby
Sleep in the meadow, sleep in the hay. Babies got a dreamin on the way
Bad things far away, pretty things here to stay
Sweet baby smile at me, lovely baby go to sleep
Sleep in the meadow, sleep in the hay. Baby's gonna dream the night away.

The white overseer, overhearing Margaret's lullaby, abruptly interrupts declaring that there will be no dreaming in the Garner house that night. Gaines has ordered Robert to work at a neighboring plantation while Margaret becomes a full-time, live-in server and cook in his house. Knowing that this means Margaret will become a sexual object for Gaines, Robert becomes enraged. In love, protection, and strength Margaret attempts to calm him down. She says that won't happen as long as Gaines's young daughter Caroline still lives in the house. For a time, she is right.

Act 1, scene 3 sets the story a few years later during Caroline Gaines's wedding reception at the Gaines plantation where Margaret serves. Caroline, her new husband, and her father have an open discussion about love. Caroline is fond of Margaret and values her opinion, so she thinks nothing

of asking her what she thinks about love. Margaret, knowing her "place," remains silent while Gaines protests that a slave can know nothing about love, therefore Margaret will have nothing to say. But Caroline insists: *"She has loved me, served me, taught me in these few years, watched over my sleep. Who knows better than she how to say what love is?"*[51] Gaines insists, *"Love is not in her vocabulary."* Margaret remains silent. Caroline, her new husband, and the guests all leave. Thinking she is alone, Margaret expresses her thoughts on love.

> *Are there many kinds of love? Show me each and every one.*
> *You can't, can you. For there is just one kind.*
> *Only unharnessed hearts can survive a locked down life.*
> *Like a river rushing from the grip of its banks, as light escapes the coldest star;*
> *a quality love—the love of all loves—will break away.*
> *When sorrow clouds the mind, the spine grows strong; no pretty words can soothe or cure what heavy hands can break.*
> *When sorrow is deep the secret soul keeps its weapon of choice:*
> *the love of all loves.*

Overhearing Margaret's words, Gaines is incensed and aroused by her response. The restraint keeping him from sexual advances toward her was gone. The wedding guests had departed, and Caroline was no longer in the house. Margaret and Gaines were alone. Act 1 ends as the audience watches Gaines overpower Margaret, leaving no doubt that he has raped her.

Act 2, scene 1 is set three years later. As the scene opens the calm Margaret of act 1 has grown agitated. One assumes that Margaret has continued working at the Gaines's house and that she has become his "sexual property." She may also have borne his child. In act 1, Margaret had one infant daughter, and now she has two children who she fears may be taken away from her. Cilla has recognized the change in her and attempts to calm her down: *"Margaret, you've changed so. Each time you visit I see less of you."*[52]

Concerned about her, Cilla explains to Margaret that plans for their escape to freedom are underway. Margaret's countenance abruptly changes. She once again sings the lyrics of her lullaby but at a faster tempo: *"Sleep my babies in the meadow, sleep my babies in the hay. My babies got some dreamin to do cause freedoms on the way."* A tender moment between Margaret and Robert takes place as he assures her that he knows what she's been through

51. Danielpour and Morrison, *Margaret Garner: Libretto.* Unless otherwise noted, all of the lyrics in this section are from act 1, scene 3.

52. Danielpour and Morrison, *Margaret Garner: Libretto.* Unless otherwise noted, all of the lyrics in this section are from act 2, scene 1.

since he was sent to the neighboring plantation and she was forced to work and live in the big house. He knows the second child may not be his, but he tells her, "*The string is cut. . . . The way is clear. . . . And the time has come. Cry girl.*" Cilla has decided not to make the journey with them but she prays for them and tells Margaret to "*save your children mother. . . . Don't mourn for me. When my family is safe I will be only near the cross, not on it,*" expressing the Christology of the enslaved.

In act 2, scene 2, Garner's escape has been foiled. Slave catchers and Gaines surround the shed where the family has hidden. Margaret cries out, "*No, no more,*"[53] an echo from the opening chorus. "*Why can't you let us be? Why can't you leave us alone?*" She desperately calls for help that does not come. Captured, Gaines tells her that his bed is cold and needs warming. Robert has been captured and separated from her and the children. As he calls out Margaret's name, telling her that he loves her, he is shot by Gaines. In that instant, Margaret picks up a knife, screams, "*Never to be born again into slavery!*" and kills her children.

Scene 2 ends with the prisoner Margaret sitting in a dark room alone, in despair and moaning in the deepest, darkest register of the mezzo voice—a low guttural dirge, sorrowful and mournful. Consoling herself, Margaret laments:

> *Darkness I salute you.*
> *Reason has no power here over the disconsolate.*
> *Grief is my pleasure, thief of my life, my lover now.*
> *Darkness I salute you.*

Act 2, scene 3 opens in the courtroom where Margaret is on trial. The judges and Gaines discuss the possible charges—murder or destruction of property. Margaret sits stoically quiet as the discussion becomes heated over the political issues of slavery and personhood. As the white townspeople make it clear that Margaret is not like them, she thinks to herself at first, "*I am not like you, I am me.*"[54] The more the debate about the pros and cons of slavery swirl around Margaret she becomes emboldened, stands up, and loudly enough for all in the court to hear proclaims, "*I am not like you, I am me.*" Speaking directly to the judges, she defiantly continues, "*You have no authority, I am not like you, I am me.*" In the higher mezzo-soprano range, she bellows, "*I am me!*" In this act of personal agency Margaret clearly

53. Danielpour and Morrison, *Margaret Garner: Libretto.* Unless otherwise noted, all of the lyrics in this section are from act 2, scene 2.

54. Danielpour and Morrison, *Margaret Garner: Libretto.* Unless otherwise noted, all of the lyrics in this section are from act 2, scene 3.

distinguishes herself from the whites surrounding her in the courtroom by declaring her humanity.

Scene 4 shifts outdoors, where gallows await the condemned Margaret's sentencing to hang for the destruction of property. She's led up the gallows, and a noose is placed around her neck. Cilla and the slave community stand at the base of the gallows singing, *"Margaret, dear God no more."*[55] Convinced at the last minute by his daughter that Margaret should not be put to death for this crime, Gaines obtains a stay from the court. Just before she is about to be hung, he runs to the gallows to halt the execution and have Margaret released into his custody. Hearing the news, Cilla joyfully cries out, *"Thank God, she will live! Do you hear that Margaret, you will live!"* Margaret contemplates what living means. For her, living meant returning to perpetual rape, to a life without the loves of her life, her husband, and her children. The very thought was unbearable. As everyone around her celebrates her pending release, the noose is still around her neck. Pondering her future, she takes the opportunity to make an unexpected final decision.

Stage directions indicate that Margaret sings this final aria or soliloquy in a "state of transcendence":

> *Oh yes, I will live . . .*
> *I will live among the cherished, it will be just so.*
> *Side by side in our garden, it will be just so,*
> *Ringed by a harvest of love.*
> *No more brutal days or nights. Goodbye sorrow.*
> *Death is dead forever. I live, O yes I live.*

With these words, Margaret Garner suddenly kicks the stool from beneath her feet, hanging herself on the gallows. Taking artistic liberty and drastically departing from actual historical events, Morrison's double infanticide and suicide in the opera's plot clearly drive the story line more toward what is thought were the real-life Margaret's intentions.[56]

In this state of transcendence, Margaret of the opera has resisted her predicament and removed herself and her children from the bonds and boundaries of slavery through the vehicle of death. Here metaphoric expressions of belief in God and a heavenly home are clear. For her, death equaled life, a life untouched by human entanglements. For slaves, heaven was a safe place where one could work "side-by-side" with a loved one in their own garden. Slave mothers had no control over the fate of their children. Margaret's actions claimed ultimate control over her children's destiny; they would

55. Danielpour and Morrison, *Margaret Garner: Libretto.* Unless otherwise noted, all of the lyrics in this section are from act 2, scene 4.

56. Baird, "Love Too Thick," 4.

not live as slaves. They would be dead in the earthly realm but alive, safe, and free in heaven, that spiritual realm. There they could not be touched by slavery and would not become coerced surrogates or sexual objects of a white man's whims. They would be *"ringed by love,"* the love of Jesus, ancestors who have gone before them, and their mother as she prepared to join them. Margaret owned full agency over the fate and the destiny of the children she had birthed, exacted her destiny by her hands, and declared liberation from slavery by ending her earthly life, fully expecting to see her children in heaven upon her arrival. Upon Margaret's death, Cilla cries out, *"Soon, soon, my bold-hearted girl I'll be there, I'll be there!"* in solidarity with her and the shared community belief in a heaven where there is freedom and liberation for all.

Summary

As a spectacular grand operatic artistic performance, *Margaret Garner*, through Morrison's historical imagination, presented a portrait of life in antebellum Kentucky from the plantation perspective of both slaves and slaveholders, thereby addressing cultural trauma, cultural amnesia, and collective memory. It would be impossible to tell the story of slavery without showing the perspective of the slaveholder and the enslaved, yet it was important for Morrison[57] to be sure that this story removed the "white gaze"[58] as the center of attention by focusing on the interior life, feelings and emotions[59] of one enslaved mother, having her humanity take center stage while relegating the white slaveholder's story to the periphery.

Margaret Garner presented for both audience and performers a collective anamnestic experience where the deep-seated, unhealed wounds of American slavocracy and American historical amnesia left unaddressed and untreated for generations were laid bare and opened through the artistic genre of grand opera. To continue to ignore the impact that slavery has had upon the nation and act as though this chapter of American history has not affected present-day American society or that it will fade away and slip into time only allows these deep, unhealed wounds to fester under scabbed over wounds and lesions. Scabs turn to scars, but the infected tissue lies underneath and continues to metastasize, causing residual pain and discomfort from the original wound.

57. See appendix BB: "Toni Morrison—Detroit Opera House."
58. Greenfield-Sanders, *Toni Morrison*.
59. Morrison, "Site of Memory," 191.

The original wound from which most Black Americans are still try-ing to heal is slavery. While not self-inflicted, the long-term residuals have created for many a harmful negative self-identity, as well as a continued relegation of Black people to the balconies of American society. For the descendants of some slaveholders and their sympathizers who continue to hold onto the misconceptions of their privilege and superiority, purport-ing the inferiority and negative stereotypes of Black people, the wound also spews unrestrained hatred and emboldened racism. In order for true heal-ing to take place, it is necessary for the descendants of former slaves and slaveholders to engage in deliberate and collective "anamnesis or retrieval of experience that is painful yet necessary for the healing and wholeness of the (American) psyche."[60] Experiencing the opera *Margaret Garner* as a staged social drama, which created a fourth wall experience for audience members, is one avenue with the power to bring us to the table to begin essential conversations.

60. Terrell, *Power in the Blood?*, 128.

9

Finale

Breaking the Fourth Wall

Teach me your way, O Lord, that I may walk in your truth.

—*Psalm 86:11a (NRSVUE)*

God and Nature first made us what we are, and then out of our own created genius we make ourselves what we want to be. Follow always that great law. Let the sky and God be our limit and Eternity our measurement.

—*Marcus Garvey*, Philosophy and Opinions

Black Genius

DESPITE OBSTACLES PLACED IN the paths of Americans of African descent, Black Genius has always persevered, empowering oppressed people to thrive and survive the hardships of Anthropology Poverty American style—enslavement, reconstruction, Jim Crow, and the covert systemic racism prevalent even in the twenty-first century. This work sings the praises of Black Genius as resistance through the arts, particularly the artistic genre of opera. Theater, notably Black theater, offers an avenue for African American performers to repair, renegotiate, and re-present the negative stereotypes and narratives around Black bodies by re-creating rituals of repair in stage

performances while simultaneously offering non-threatening spaces for white audiences to experience different people, cultures, and ideas and re-negotiate long-held implicit and inherited biases around Black bodies.

Primarily through the arts, resistance dramas, music, plays, and a Black presence in genres otherwise thought to be white Western forms of entertainment, Black Genius reigns as the countercultural voice correcting the negative narrative about Black bodies, intelligence, and personhood. Resistance has been subtle and overt. Despite countless attempts to erase, si-lence, mute, and dismiss them/us, Black voices have never been silent. Black voices have always been amplified through religious institutions, education, the arts, social activism, science, and literature. I've explored how opera has mirrored American racism and xenophobia and how opera has been a tool of resistance for Black artists, from Sissieretta Jones to Jessye Norman to the myriad of Black opera singers gracing the stages of American opera houses today. Each one of us, in our own way, has stood as resistance to segregation and denial within a genre that has not, for the most part, been welcoming, open, or affirming of Blacks in opera. I postulate that it is through opera—as composers, librettists, performers, and patrons—that new rituals to repair breaches in American society created by racist ideologies can emerge.

Breaking the Fourth Wall

Regardless of how Americans regard opera among the various entertain-ment genres, it remains true that most have never attended an operatic performance; and those who have, have not seen *Margaret Garner*. The fact remains that a considerable number of socially conscious operagoers of all ethnicities and social strata patronize the arts. Though some may attend for the entertainment factor alone, they have still placed themselves in a non-threatening environment where consciousness can be pricked, lessons learned about people groups and cultures not their own. Theater has the potential to raise awareness of social issues marginalized populations face.

Watching the drama played on stage takes the viewer out of their own world. Hearing and being engulfed by the songs—arias and choruses—that pierce the soul and emotions do not leave an audience untouched. If only for that moment, awareness has been raised that can direct some to re-examine their beliefs, ideas, and cultural biases. Through theater and opera attendance, negative narratives, attitudes, and behaviors can be confronted in a non-threatening atmosphere that can only be experienced through the social drama on the stage.

I surmise that, for any type of transformation to happen in the theater, the "fourth wall" must be broken. The stage in an opera house is built and designed with three physical walls: stage right, stage left, and backstage. The fourth wall is an imaginary barrier separating the audience from the actors, singers, and action on the stage. Actors don't acknowledge the audience; the audience members are spectators only, not involved in the activities on the stage, seated comfortably in their seats away from the staged activity. However, there are moments in a production when this fourth wall is broken or penetrated as performers intentionally or unintentionally draw audience members' emotions into the drama on the stage. In opera, this is done through the orchestration, the lyrics, and the performance/performer. In a recent conversation with Wayne Sanders, my vocal coach and the co-founder and musical and artistic director of Opera Ebony[1] in New York City, about breaking the fourth wall, he explained:

> The fourth wall is broken when honest moments in theater and honest acting evoke honest emotions from the audience, creating breakthrough moments in the theater. Audience members are drawn into the story through the truth experienced and exhibited on the stage. Each performer's development and portrayal of the humanity of the character they embody is relative to the reactions of audience members. This is not true of every production or every opera but within the black community there is an awareness that transcends the fourth wall. There is an historic reality in operas such as *Margaret Garner* and *Harriet* that audience members and actors share. Activity on stage may not transform the audience but it will make them aware of the social issues and the time and place of the plot's setting. It is through this awareness that the fourth wall is broken.[2]

Reminding me of audience reactions and comments generated after an Opera Ebony production in 2002 of *Harriet*[3] by Leo Edwards in which I played the role of Harriet Ross, Harriet Tubman's mother, Sanders expounded on how the fourth wall had been unintentional, albeit dramatically broken. As the story of Harriet played out on stage, audience members were touched, and emotions were raw and tied to the authentic, honest,

1. *Morning Call* Staff, "Opera Ebony."

2. Author conversation with Wayne Sanders, musical and artistic director of Opera Ebony, New York.

3. This performance took place at the Schomburg Center for Research in Black Culture in New York City and the Hochstein Performance Hall in Rochester, New York, in 2002. It can be seen in its entirety on YouTube. Appendix CC: "Author as Harriet Ross in *Harriet*."

staged expression of a mother's genuine concern for the safety of her child as I sang the African American hymn "Stand by Me"[4] and spiritual "I Am Bound for the Promised Land."[5] As he recounted these stories, I remembered the numerous audience member's reactions to the entire opera but to these songs in particular. One person spoke with both of us backstage, directing his comments to me: "When you sang, tears streamed down my face, and I felt as though I was a baby being lovingly rocked in my mother's arms." The truth of this character, her spirituality, and intense love for her child transferred to this and other audience members through my personal and historical embodiment of Harriet Ross as I held within my Black artistic body the embedded memories of my captured and enslaved ancestors. African American tenor George Shirley affirms this premise, contending that it is singing that transforms and lifts an audience.[6] During that performance, the wall between the audience and performers, the fourth wall, had been unintentionally broken.

Similarly, there is a comparable experience within the Black church. One can imagine a fourth wall or space between the pulpit or stage area, the preacher, the choir, and the congregants. Though the congregation is primarily an observer, it is also drawn into the ritualistic actions of proclamation, liturgy, and song, thereby participating in a communal experience. In Black worship, the fourth wall, that imaginary space between the audience/congregation and actors/preachers, is constantly breached and intentionally broken. The audience/congregation does not merely observe actions before them in the pulpit and choir loft but is also drawn into that same action by the clergy and choir, creating a community of purpose for resistance, restoration, and re-membering. I contend that, though not participatory, operas such as *Margaret Garner* offer moments when that imaginary space is breached, drawing audience members through the fourth wall by the music, the acting, and the plot, creating space for rememory, historical reorientation, and ritual reflection. There were multiple gradual fourth wall moments in *Margaret Garner* through which the audience was gradually drawn through. The first gentle pulling through the fourth wall reveals the capacity of an enslaved mother to love her child during Margaret's lullaby to her infant daughter in act 1, refuting the notion that slave women were incapable of maternal instincts. The second emotional pull through the fourth wall happens during the duet between Margaret and her husband Robert in

4. Tindley, "Stand by Me," 41. Tindley is an African American composer.

5. "I Am Bound for the Promised Land" is a traditional African American spiritual I remember hearing my grandfather sing during my childhood.

6. Shirley, "Il Rodolfo Nero," 274.

act 2, squelching the thought that enslaved couples could not genuinely love one another. The final dramatic pull through the wall happens at the unexpected turn of events at the gallows scene in the final act when Margaret asserts her humanity and complete agency in the act of defiance and faith by ending her earthly life.

Remember, Re-Tell, Rememory, Re-Member

Comfortably seated in the non-threatening atmosphere of the opera house, twenty-first-century audiences consisting of descendants of the enslaved and the enslavers, were geographically and historically transported to 1856: to Maplewood, a Kentucky plantation in the antebellum South. For audience members and performers alike, the opera *Margaret Garner* became a theatrical social drama aimed at combating cultural amnesia by creating a site of memory that reenacted difficult historical moments with the potential to create rituals of repair and restoration.[7]

Restoration can only happen when our country and society are courageous enough to remember, re-tell, and redress the painful truth of slavery American style, and the atrocities committed against First Nations People and other people of color. Remainders of centuries of racist, anti-black myths and fantastic imaginations about Black and Brown people created damaging stereotypes still embedded in the institutions, systems, and laws of America. The recent virulent, antithetical, anti-woke, history-banning, book-banning movement sweeping across the country is intended to erase the very history that this book aims to continue placing before the American public to begin the healing of traumatized communities. Both the descendants of the enslaved and the enslavers have been traumatized.

By re-telling the true story of this shameful period in American history through the opera *Margaret Garner*, Morrison created a site of memory for everyone in the theater. This performative moment symbolically re-ordered, re-oriented, resisted, and disrupted long-held anti-Black sentiment and inherent biases around Blackness: Black bodies, Black lives, Black expression, and Black love. It was a point of memory, or what Ms. Morrison calls a rememory, (the act of remembering a memory)[8] intended to address the national amnesia and collective cultural trauma around the horrors and vestiges of slavery in America.

Understanding the importance of memory for healing collective cultural trauma, Morrison said, "'Memories within' are the subsoil of my

7. Colbert, *African American Theatrical Body*, 51.
8. Morrison, *Beloved*, 43.

work. . . . My job becomes how to rip that veil drawn over proceedings too terrible to relate." [9] Ripping the veil or breaking the fourth wall allowed audience members to be drawn into the staged actions that depicted life for the enslaved.

This production gave opportunity for the artistic black bodies on stage to become a collective corrective, debunking lingering negative narratives and undoing and reframing labels placed on blackness by a culture steeped in white supremacy with notions of superiority. It afforded audience members space to examine their inherent biases about this period of American history and the intentional misinformation propagated about Black enslaved women as non-human without the same emotions, needs, and intelligence as whites that lingers into the 21st century.

Thomas recognizes that the act of remembering allows individuals and communities to acknowledge historical and contemporary realities that may remain painful. When allowed, those memories can become a re-membering, or the putting back together of healthy and whole individuals and communities. [10] Invoking collective memory and creating moments of cultural anamnesis, or a Sankofa moment, by intentionally remembering difficult historic events in a non-threatening environment empowers individuals and groups to move toward healing through history and can bring wholeness, restoration, and reconciliation.

A Balcony Hermeneutic

Throughout this work, I assumed a Balcony Position[11] to critically observe the historical underpinnings of American culture and society. The development of my Balcony Hermeneutic relies on the Balcony Perspective of a Womanist theologian's interpretive lens. Since the founding of the United States of America, the dominant society has determined who is acceptable based on ethnicity, an invented racial hierarchy, and social and political status. The dominant culture, Euro-Americans, created rules and regulations that denigrated Black people to society's metaphoric and actual outlying balconies. My contention is that while seated or restricted to the balcony, the

9. Morrison, "Site of Memory," 190–92.

10. Thomas, "Remember and Re-Member," 246.

11. See balcony seats at appendix I: "Church Balcony—Pulpit View," appendix J: "Mezzanine or First Balcony View—Detroit Opera House," appendix K: "Upper Balcony View—Detroit Opera House," appendix L: "Main Floor Stage View—Detroit Opera House," appendix M: "Center Balcony Stage View—Detroit Opera House," and appendix N: "'Nosebleed' Balcony Seating—Detroit Opera House."

balcony audience is privileged to an aerial or panoramic view of all activity
within the theater (entire society) and on the stage (political players making
arbitrary rules and laws). While the main floor audience (the dominant so-
ciety) operated in its perceived privilege implementing segregationist poli-
cies, the balcony audience has always been able to survey more broadly to
interpret and critique the behavior of white Americans and the society and
culture they created since 1776. Balcony Hermeneutics has developed out
of this perspective and is, therefore, my "Reversed Gaze"[12] calling out and
correcting the errant, dominant narratives about Black bodies, challenging
revisionist histories as told by the colonizer and the enslaver, and offering
healing ritual to those impacted by these demonic ideologies—a racial hi-
erarchy, white superiority, the Doctrine of Discovery, and Manifest Destiny.

Black Genius in Creating Rituals
of Restorative Resistance

The genius in creating new metaphorical language to construct theological
language has been established by Delores S. Williams in "Womanist Theolo-
gy: Black Women's Voices."[13] My sacred Womanist work has built upon hers
and the inherent artistic genius of African American performers to create
a Balcony Perspective that developed a Balcony Hermeneutic from which
nine tenets of Rituals of Restorative Resistance have been birthed. Creating
these cultural rituals as a healing paradigm shifts the gaze to bring healing
and restoration to communities of disenfranchised and marginalized people
negatively impacted by Western colonization and Anthropological Poverty.
In shifting the gaze, rituals resist the ideology of whiteness to intentionally
restore and return *all* humanity to existence under the "Gaze of God."[14]

The deconstruction of Western colonizing ideologies and episte-
mologies that fosters Anthropological Poverty, Political Poverty, Cultural
Deracination, and Environmental Poverty becomes the work of this Bal-
cony Hermeneutic. To simultaneously resist racism and xenophobia while
restoring and healing the psyches of generations of traumatized communi-
ties, Rituals of Restorative Resistance require physical and spiritual activity
and are also a critique and correction of American theological anthropol-
ogy. The nine tenets of Rituals of Restorative Resistance invoke collective
memory to become the anamnestic tools through which cultural amnesia

12. Ntarangwi, *Reversed Gaze*, xi.
13. Williams, "Womanist Theology" 70.
14. Mveng, "Cultural Perspective," 72.

and trauma begin to heal. They are: ruminate, remember, reclaim, repudiate, resist, reframe, restore, refresh, and reconnect.

Rituals of Restorative Resistance—Nine Tenets

1. *Ruminate*: reflectively observe and question one's present position, recalling and meditating on the systems and circumstances that brought you/us to this place.

2. *Remember*: allow memories or re-memory to come forth, to call to mind personal or historic communal past experiences.

3. *Reclaim*: take back, with a sense of pride, possession of ancestral cultural identity consisting of language, art forms, music, religions, spirituality, cosmology, and ways of being.

4. *Repudiate*: call out and reject the demonic forces that have systematically denigrated indigenous cultures, stripping people of their lands, resources, and dignity; to diminish the power these forces have attempted to exert over people, cultures, and countries.

5. *Resist*: oppose and confront racist and segregationist ideologies that have consigned Black and brown people to the balconies of American society.

6. *Reframe*: challenge the status quo and present history from the viewpoint of the colonized and enslaved (not a revisionist history but a corrective history); to correct false and misleading narratives around the superiority of whiteness and the inferiority of Blackness.

7. *Restore*: instill a sense of pride in individuals and communities that have withstood the effects of systemic injustices. Storytelling, such as opera, is one avenue of restoration.

8. *Refresh*: offer a quiet space where participants can reflect on and through the process of restoration.

9. *Reconnect*: communicate with others seeking to restore spiritual and emotional well-being to individuals and communities who have survived and thrived despite the sociopolitical and socio-historic conditions inflicted by the residuals of Anthropological Poverty.

The connecting component that allows the creation and enactment of Rituals of Restorative Resistance is remembering. Even those memories that are "too painful to remember"[15] must be excavated to move to a place of healing.

15. Holmes, *Joy Unspeakable*, 81.

Summary

The Balcony Hermeneutic advantages the intersectionality of Womanist Theology, Womanist Anthropology, and Black Performance Theory to critically examine how academic, theological/church, and performance/artistic epistemological genres can collaborate to "shift the gaze" toward a more inclusive view of humanity, cultures, and forms of artistic expression. Concerned about the future of the African American church and community, Delores S. Williams argues that neither the African American church nor community will thrive or survive because the history of our endurance, our faith traditions, the stories of the heroes/sheroes who played a role in the struggle for African American liberation are not being celebrated or remembered and will soon be forgotten.[16] As this research presents through philosophical, theological, artistic, and historical evidence, the Western/white gaze has negatively affected all aspects of humanity, "hijacked the image of God,"[17] and intentionally gazed upon itself as the progenitor and protector of all things "white" to the detriment of any on the periphery that it considered "other."

A Balcony Hermeneutic exposes the pernicious effects of the Western gaze on the non-white world since 1492. Together these disciplines offer remedies to reverse this gaze toward a more just and equitable worldview. Each discipline has developed tools of resistance to the hegemonic, racist, xenophobic, patriarchal systems inherent within American society. Together, the Balcony Hermeneutic and Rituals of Restorative Resistance become a powerful force to resist, deconstruct, correct and undo the effects of Anthropological Poverty, Cultural Deracination, Political Poverty, and Environmental Poverty.

Building upon the works of these scholars of color, I have created, within the Balcony Hermeneutic, Rituals of Restorative Resistance, a new ritual practice intended to undo the effects of Anthropological Poverty and initiate the healing of cultural trauma and cultural amnesia within the African American church and community. Though specifically designed for the African American community, these rituals and tenets can be adapted by any marginalized community and the whole of American society.

We are familiar with acts of resistance, but these rituals simultaneously resist oppression *and* restore wholeness to individuals and communities. Rituals of Restorative Resistance institute a paradigm shift from memorializing death to celebrating life, from focusing on violent, destructive acts intended to steal, kill, and destroy to centering around the resurrection or the

16. Williams, "Rituals of Resistance," 211.
17. Terrell, "Ten Tenets of Art, Episode 5."

coming to life again of individuals and communities that were not intended by the dominant oppressive systemic institutions to thrive or survive. Rituals of Restorative Resistance instill a sense of pride in African and African American history even before 1619. These Rituals are created specifically to promote healing, restoration, and community through sacred memory with liturgy that remembers and commemorates the life, suffering, and sacrifice of Jesus *and* enslaved African ancestors. We are no longer stuck *at* the cross but moved *toward* resurrection, resistance, resilience, and new life.

Conclusion: Curtain Call[1]
Rituals, Resistance, and Restoration

There is a balm in Gilead to make the wounded whole.

—*TRADITIONAL NEGRO SPIRITUAL*

Ritual is called for because our soul communicates things to
us that the body translates as need, or want, or absence. So we
enter into ritual in order to respond to the call of the soul.

—*MALIDOMA PATRICE SOMÉ, RITUAL*

The many and varied ways by which African and African Americans
responded to exploitation and oppression reveal theological
understandings and moral virtues that are deeply embedded in the
moral values of Africa. The time is right to identify and critically
appropriate this great treasure for religious and ethical reflection.

—*PETER PARIS, SPIRITUALITY OF AFRICAN PEOPLES*

THIS WORK HAS INVITED the reader/audience to attend a performance of
a metaphoric opera to critique American theological anthropology and
conduct an intentionally difficult anamnestic examination of the origins of
racism through the lens of Mveng's theory of Anthropological Poverty. It as-
serts throughout that the tenets of his theory also exist in America, as shown

1. See appendix DD for photo of the curtain call from *Margaret Garner*.

by tracing the racist history of the United States through the development of opera as a genre of cultural entertainment. African Americans and other marginalized minorities who have been forcibly consigned to the balconies of American society, culture, and institutions peer over the balcony railings to locate and excavate the historical underpinnings of Western philosophical thought which seeded false, invented racist ideologies.

Through the eyes of indigenous scholars, I've revealed ways by which the Doctrine of Discovery became Europe's self-proclaimed invitation to invade the non-European world, violently appropriating land, people, and resources, then erasing and whitewashing the histories, philosophies, spiritualities, and cosmologies of the invaded, colonizing Africa, Asia, and the Americas. Mveng's theory of Anthropological Poverty aptly describes the psychological and spiritual devastation of the people as the vestiges of colonization in Cameroon. Other indigenous scholars join him in identifying and otherwise naming for their people those same horrors as Political Poverty (Dussel, Latin America), Religious Colonialism and Environmental Poverty (LaDuke, North America), and Cultural Deracination (Mendoza, the Philippines).

My Balcony perspective becomes how this country's sociopolitical and sociocultural ideologies that have created racial and class structures are critiqued and corrected. Using a countercultural approach adhering to the corrective voices of philosophers, theologians, scholars, anthropologists, performance theorists, and performers of color, it holds up a decolonizing mirror as a reflective and reflexive activity while peering inside the structures of American society to dismantle unjust practices and systems. Employing autoethnography and my tripartite Womanist experiences allowed me to move as an operative among the intersecting worlds of opera, church, and the Academy in this pursuit. As a native participant and observer taking a reversed gaze, I used opera as a barometer to expose the racist, hegemonic, xenophobic portrayal of America on her stages of culture and society. Opera has also been the artistic genre that placed before the reader/audience the opportunity to witness the human condition in a non-threatening environment and connect with the onstage characters in a way that encourages them to think differently about the world—empowering them to move from being spectators to agents of social change.

Using my Womanist autoethnographic view from the balcony of American society where my opera singing colleagues and I have been systematically relegated, I've used my metaphoric Womanist opera glasses for an unobstructed view of the goings on in the theater (the whole of American society): those who have seated themselves on the main floor of the house (the dominant culture or the main-floor mentality), the staged production

(systematic societal injustices in judicial, political, educational, etc. plots), and the balcony audience (the marginalized and disenfranchised; Balcony People).

The voices of Balcony People operating from a Balcony Hermeneutic reverse and shift entrenched European ideologies of racism, which seed every injustice in America. Balcony people—protesters, preachers, artists, citizens, students, and allies—descend from the balcony and assume seats on the main floor. Balcony People are not passive, are not silently sitting in implied complicity, but rather, having observed the antics of stage actors and main-floor people, commence planning and implementing resistance strategies. Balcony People resist and challenge the main floor mentality. Operating from a Balcony Hermeneutic, we observe and critique, push back, and assert Balcony Agency and humanity amid a culture denying us the same.

The Balcony Hermeneutic shifts and reverses the vitriolic effects of the colonizing gaze and shifts the intellectual paradigm[2] by rejecting the whitewashing of history, anthropology, theology, and the arts. It deconstructs Western ideologies denigrating and marginalizing the cultural identities of Africa, Asia, and America's indigenous peoples. It rejects the white gaze,[3] particularly the white male voice naming it as peripheral, no longer allowing it to be the dominant voice or gaze by which the descendants of formerly colonized and enslaved people operate. It offers healing through a decolonized and corrected history by reframing, reversing, and shifting the world's gaze away from long-standing Western hegemonic single-system epistemologies by inserting a catastrophic paradigm shift.[4] It ushers in a fresh new theological hermeneutic, a Balcony Hermeneutic that promotes healing and liberation for all. It offers an all-encompassing potential for this hermeneutic to become the dominant worldview that places all humanity under the Gaze of God. I am one of the balcony people now operating from a Balcony Hermeneutic.

This research, in effect, has been a personal Ritual of Restorative Resistance. Each chapter employs an amnestic approach ushering the researcher and the reader through a ritualistic literary experience, a Sankofa moment, that resists and corrects the devastating effects that Anthropological Poverty has had on African Americans and the world. It has deconstructed and decolonized Western philosophical and theological underpinnings of racist ideologies through its nine tenants.

2. Cannon, *Katie's Canon*, 24.

3. Greenfield-Sanders, *Toni Morrison*.

4. Bial, *Performance Studies Reader*, 402.

I have *ruminated* by carefully considering and critiquing the historical events leading to colonization and enslavement. I have *remembered* the struggle of African American opera singers, and by default, every African American, to resist American racism as expressed through minstrelsy, blackface, and Jim Crow. As an African American performer, I have reclaimed the right to express my artistic gifts through song within the creative genre of opera. I have *repudiated* the claims of white supremacy, laying bare its false ideologies and racist practices by calling out the invented Western philosophical underpinnings of a false racial hierarchy that have encircled the globe. I have *resisted* the same denigrating ideologies through personal scholarship and stage performance. I have *reframed* and shifted the gaze of art concepts expressed in every culture as beautiful and acceptable. I have *restored* the dignity of Americans of African descent by instilling pride, reminding us of the genius of our ancestors and our humanity as we exist under God's gaze, being inferior to no one.

This work has *refreshed* the researcher and the reader by offering a safe, sacred space for reflection. It is a sacred space where balcony people can pause and reflect on the genius of our ancestors, their resistance, and their tenacity, which enabled them to thrive and survive despite centuries of oppressive systemic racism. By exploring world history through interdisciplinary and intersectional coalitions favoring indigenous balcony perspectives of formally colonized people, this research *reconnects* scholars the world over working to undo the effects of Anthropological Poverty, Cultural deracination, Political Poverty, and Environmental Poverty—each seeking to decolonize the minds of the formally colonized and permanently dismantle racism.

Epilogue

August 6, 2019

IN DECEMBER 1996, I was honored and blessed to perform with Opera Ebony at the Riverside Church in New York City for the PBS-televised benefit concert *Jessye Norman Sings for the Healing of AIDS*.[1] Headlining with Ms. Norman were Whoopi Goldberg, Elton John, Anna Deavere Smith, Bill T. Jones, Maya Angelou, and Toni Morrison. Greatness surrounded us. Ms. Morrison wowed us with her reading of Lessons from *Beloved*: "In this here place, we flesh; flesh that weeps, laughs; flesh that dances on bare feet in grass. Love it. Love it hard They do not love your neck un-noosed and straight. So love your neck." To be in the presence of her genius and engage her in light conversation was a phenomenally unforgettable experience.

Fast-forward to 2005. I was again privileged to be in her presence when I performed in the world premiere of Morrison's opera *Margaret Garner* at the Detroit Opera House. Her more familiar novel *Beloved* and the opera *Margaret Garner* are the same stories presented in different artistic mediums. How could I have imagined while reading *Beloved* so many years before that Morrison's personal touch would be my experience as she coached her characters to life through us for the grand opera stage? I was in awe of her aura and will forever cherish this and every word read, lyrically sung, or instruction received from this literary great and cultural icon.

Encountering the characters of the novel and the opera and personally experiencing Morrison's larger-than-life persona forged the axis upon which my research pivots—specifically *Margaret Garner: The Opera*. When Morrison joined the ancestors, I grieved as though I had lost a personal friend.

1. See Black Music Archive LIVE!, "Jessye Norman Sings for AIDS Healing"; and New York Public Library, "Jessye Norman Sings for the Healing."

Still, I am comforted by re-visiting her characters and recalling the Divine Grace which landed me before her presence. Rest in power, Ms. Morrison. Your legacy continues to empower descendants of formerly enslaved Black women and inspire us to pursue individual genius for cultural greatness. Thank you. Asé.

October 7, 2019

Reading about the death of Kenyan scholar and philosopher John Mbiti had me feeling the all-pervasive weightiness that death instills. While researching my project and writing my initial research, Mbiti became the fourth of my primary source scholars and artists to join the ancestors: Katie Cannon, Toni Morrison, Jessye Norman, and now John Mbiti.

Unreservedly relying on their scholarship, writing, and artistry evoked a familiarity and connectedness as if we had been longtime personal friends. Now with the ancestors peering over the balconies of heaven, their audible voices are silenced, yet their indomitable spirits live on through their written, recorded, and performed opuses. These legacies last and, altogether, feel surreal. I honor them and recognize their ancestral guidance as this project completes.

Rest in Power! Asé.

May 8, 2023

Touched by "Grace"
Dr. Grace Melzia Bumbry, KS (Kammersänger[2])
1937–2023

The call came last night at 11:30 p.m. The familiar voice said, "Jean, I don't want you to learn about this first on the Internet, so I'm calling you before the rest of the world knows. Grace has made her transition." Grace Melzia Bumbry had died. This news was unexpected and certainly not what I wanted to hear. It took a moment to settle myself and catch my breath. I knew you were recovering from a stroke, or so I'd prayed and hoped. I even called a few weeks ago to check on you but couldn't connect. Perhaps I know why now.

2. Kammersänger (Chamber Singer) is a title of honor bestowed upon distinguished opera singers by the Austrian government.

Wonderful, precious memories flooded my soul this morning. I recalled the first time I saw you in person at a New York concert and my first personal encounter with you when I auditioned for the Grace Bumbry Black Musical Heritage Ensemble in 1994. I was utterly in awe of your voice and presence and was almost too intimidated to sing for you. After that audition, you asked me to accompany you and two other singers to St. Louis, Missouri, where you presented a new organ to your home church and publicly announced the formation of the Ensemble. That you chose me to be part of this group was almost too surreal for this teacher, wife, and mother of five. Indeed, it differed from what a public-school teacher expected to do on the weekend. But there I was singing for you, your family, and your friends. That's when I realized something spectacular was happening in my life, exceedingly, abundantly, far above anything I had imagined.

Seeking comfort, I surrounded myself with photos and programs of the Ensemble's performances and travels, reminiscing and smiling. Yes, I saved them all: Carnegie Hall, Powell Hall, Mississippi Boulevard Church, the Salzburg Festival, concert halls, and opera houses in Austria and Germany, and I understood what an honor and privilege it was to be on stage with you as a handpicked member of the Bumbry Ensemble. There are photos of the entire Ensemble in our African attire, the places we traveled to, you and your team, and photos of you and me. One of my favorites is of you and me at the opening night gala after a *Porgy and Bess* performance in Amsterdam. Remember how surprised you were to see me there? I'll never forget the look of surprise and pride on your face. "Is that Jean? I thought that was you on the stage!" you said as you hugged me. I think the *P and B* cast members were surprised to know that you knew me, especially a few of the principals.

The Ensemble had stopped touring by then. I'd retired from teaching and decided to build on the confidence I'd gained performing with you to expand my professional musical experiences. I was there because you had faith in me, encouraged me, and told me my voice was special and could take me beyond the Ensemble. It has, Ms. B. Thank you.

Yes, Ms. B, I remember almost everything you told me; God knows what God is doing, and I was where I was musically regardless of my age based on God's timing; there would be people jealous of the opportunities being part of your Ensemble afforded, and they would sabotage or diminish me at every turn if given a chance. Don't give them a chance. But what encouraged me the most was hearing from your lips to my ears that *you* thought my voice was a uniquely special God-given gift. I still hear your words and will never forget them.

You were professional and no-nonsense regarding music and business, yet gentle, loving, spiritual, and encouraging. You were also funny, witty, and loved a joke. You were artist in residence at the University of Michigan a few years ago. I came to see you, and we attended a concert together. Something happened during the concert that struck your funny bone, and the comments you made under your breath with a straight face were hilarious. Maybe no one heard them but me, but I had to do all I could to keep it under control and not laugh out loud.

Ms. B, I am so grateful that the Creator caused our life paths to cross. Being part of your Ensemble and around you expanded my personal and professional horizons in innumerable ways, helping me to craft a new vision of myself. It enabled a shy, reluctant woman to develop confidence in her ability to sing and stand boldly in front of a crowd and deliver a message in song—*God Specializes*.[3] Now I can deliver a message in song and word, imitating your "Grace" under pressure. I would not be who I am today had it not been for the exposure you provided twenty-six singers who loved spirituals and gospel music of the Black tradition. You impacted me in more ways than you know. Thank you for being you and helping me see the world and its possibilities through your eyes. Without knowing it or trying to, you became a role model and mentor, helping mold me into a professional singer, scholar, and even preacher. Had the Creator not placed me in your hands when I was still shy and unsure of my gift, I would not be where I am today.

Ms. B, I am so grateful to have known you, traveled the world with you, and be counted among your friends. The world mourns an American opera icon. I mourn my friend. So, farewell, my friend, till we meet again. Take your rest with the Ancestors. I imagine I heard you singing as you entered your final rest, "King Jesus will be mine, I'm 'most done workin' with the crosses. And Heaven is my aim; I'll reach to heaven by and by."[4]

With love,
Jean—one of your Mighty Mezzos

3. Griffin and Martin, "God Specializes."
4. Bonds, "I'll Reach to Heaven."

Glossary

ALTO/CONTRALTO: Lowest female singing voice.[1]

ARIA: Solo piece with full orchestra accompaniment in an opera or oratorio.

BACKSTAGE: Area in an opera house or theater behind the stage, not seen by the audience, that houses rehearsal halls, dressing rooms, and space for set building, costume design, and makeup.

BALCONY: The upper rows of seating in a theater or opera house farthest away from the stage. These are usually the least expensive seats.

BARITONE: Mid-range male singing voice between tenor and bass.

BASS: Lowest male singing voice.

BLACKFACE: Makeup made of burnt cork or black grease paint used to cover the face of a performer in a minstrel show. When worn by a White actor it was intended as a negative caricature of an enslaved or newly emancipated African in America as a parody.

CHORUS: A group of singers usually singing in three- or more part harmony.

COMPOSER: Writer of the music of an opera, oratorio, or musical.

CONDUCTOR: Leader of the orchestra, principal singers, and chorus during a performance.

CURTAIN CALL: All of the members of the cast, with the conductor, director, and sometimes the composer, gathered together on the stage at the conclusion of the production to take final bows.

1. All definitions in this glossary are those of the author specific to this research.

DRAMATURG: The person responsible for preparing the libretto, program notes, and written materials for the printed program. The dramaturg may also be responsible for researching and suggesting future productions.

DUET: Musical piece for two voices or instruments.

ENSEMBLE: A group of singers or instrumentalists performing in three or more part harmony.

FINALE: The last musical number of an opera or musical.

FOURTH WALL: The imaginary "wall" between the performers on stage and the audience.

GALLERY: The highest portion of the balcony, usually two to four stories above the main floor, which is often difficult to access. It is often called the "nosebleed section."

LIBRETTIST: The person who writes the text for an opera or musical.

LIBRETTO: The text of an opera without the musical score.

MEZZO-SOPRANO: Mid-range female singing voice between soprano and alto.

MINSTRELSY OR MINSTREL SHOW: The most popular form of American entertainment during the antebellum, post-civil war, and early Jim Crow eras. Though a form of traveling musical theater consisting of comedy skits and song and dance, it is most known for its denigrating and demeaning portrayals of Blacks and Black culture by White actors wearing blackface makeup.

MUSICAL THEATER: A fully staged drama set to music for soloists, chorus, and dancers with spoken and sung dialogue.

OPERA/GRAND OPERA: A staged theatrical performance that conveys a story in a dramatic production involving an orchestra, singers, elaborate costumes, scenery, and lighting, usually presented in an opera house.

OPERA GLASSES: Specially designed but smaller binoculars intended for indoor use at theatrical productions that can be carried in a small purse or pocket.

OPERA HOUSE: A multifunctional building specifically designed for opera or other performing arts productions with ample audience seating, a stage, an orchestra pit, rehearsal halls, dressing rooms, and backstage space for set building, costume design, makeup, and production offices.

ORATORIO: Musical work for soloists, chorus, and orchestra usually based on a biblical text; performed without staging or elaborate costumes.

ORCHESTRA: A large group of musicians consisting of string, woodwind, brass, and percussion instruments led by a conductor.

ORCHESTRA PIT: The lower area between the stage and the first rows of audience seating where the orchestra sits and the conductor directs the orchestra and the singers.

OVERTURE: An instrumental piece that opens or introduces an opera, oratorio, or musical.

PERFORMANCE: Any staged performing arts production. Also, any human activity.

PERFORMING ARTS: Forms of entertainment consisting of acting, singing, dance, drama, comedy, spoken word, or musical presentations.

PLACES: A call by the stage manager for all performers (orchestra and singers) to take their positions to begin the opening act of a performance.

PRINCIPAL: Major singing role in an opera, oratorio, or musical.

RECITATIVE: Text of the libretto set to music to imitate the natural speaking voice. The recitative helps explain portions of the plot.

REHEARSAL: A scheduled session for the conductor, orchestra, and singers to practice and work through the score and scenes of an upcoming performance.

SCORE: All the music written for an opera, oratorio, or musical consisting of libretto and full orchestration.

SOLILOQUY: A solo or song sung to oneself usually by a principal character.

SOLO: Musical piece or performance featuring a single singer or instrument.

SOPRANO: The highest female singing voice.

STAGE: Where a performance takes place, usually in a theater.

STAGE DIRECTIONS: Instructions to performers from the composer and/or librettist, written into the score, explaining how lines should be sung and where the characters should be and interact with each other on stage.

TENOR: The highest male singing voice.

THEATER: A building or outdoor area (amphitheater) that provides performance space for all types of performing arts and artists. Also, a place for audiences to experience movies or live performances.

TRIO: A song or musical piece sung or performed by three singers or instruments.

Appendices

Appendix A
Author's Opera Glasses

Author's personal opera glasses.
Photographer: Jean Derricotte-Murphy, © September 20, 2020.

Appendix B

Balcony View—Detroit Opera House

Photographer: Jean Derricotte-Murphy, © January 18, 2020.

Appendix C

Pope Alexander VI's Papal Bull, May 4, 1493

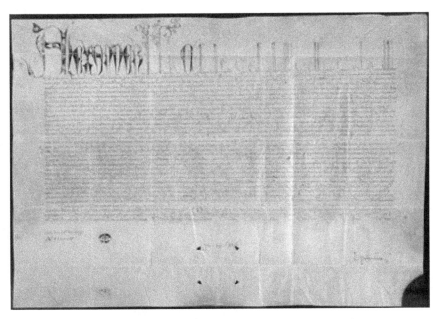

Papal Bull Inter Caetera issued by Pope Alexander VI in 1493. (https://commons.wikimedia.org/wiki/File:Inter_caetera_1493-05-04.jpg.)

Appendix D

"On Indian Removal" by President Andrew Jackson

Excerpt of President Andrew Jackson's message to Congress,
"On Indian Removal," justifying his order. December 6, 1830.
(Records of the United States Senate, 1789–1990; Record Group 46; National
Archives. arcweb.archives.gov/arc/action/ExternalIdSearch?id=5682743.)

Appendix E

Indian Removal Act Documents Signed by Jackson

Pages one and two.
President Jackson's signature appears on page two of the document.
Indian Removal Act; May 28, 1830; Enrolled Acts and Resolutions of Congress,
1789–2011 (General Records of the United States Government, Record Group
11. https://www.docsteach.org/documents/document/indian-removal-act.)

Appendix F
Boturini Mayan Codices

Museo Nacional de Antropología in Cancún, Quintana Roo, Mexico.
Photographer: Jean Derricotte-Murphy, © February 9, 2020.

Appendix G

Boturini Mayan Codices

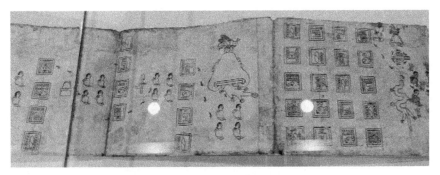

Museo Nacional de Antropología in Cancún, Quintana Roo, Mexico.
Photographer: Jean Derricotte-Murphy, © February 9, 2020.

Appendix H

Dresden Mayan Codices

Museo Nacional de Antropología in Cancún, Quintana Roo, Mexico.
Photographer: Jean Derricotte-Murphy, © February 9, 2020.

Appendix I

Church Balcony—Pulpit View

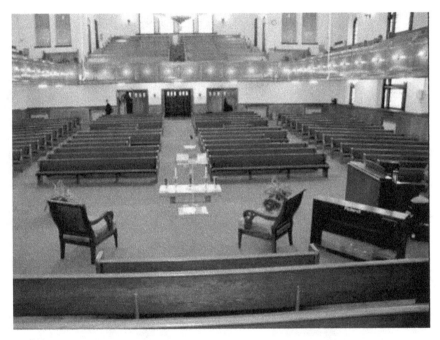

The Historic New Mt. Zion Missionary Baptist Church, Detroit, Michigan.
Photographer: Jean Derricotte-Murphy, © September 9, 2015.

Appendix J

Mezzanine or First Balcony View—Detroit Opera House

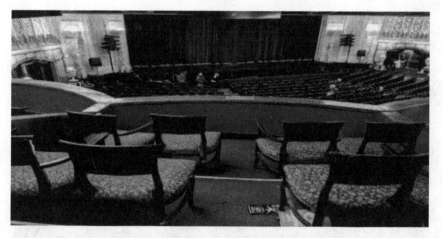

View of the orchestra pit, stage apron, and main floor center,
right and left seats from the mezzanine, or first balcony.
Photographer: Jean Derricotte-Murphy, © January 18, 2020.

Appendix K

Upper Balcony View—Detroit Opera House

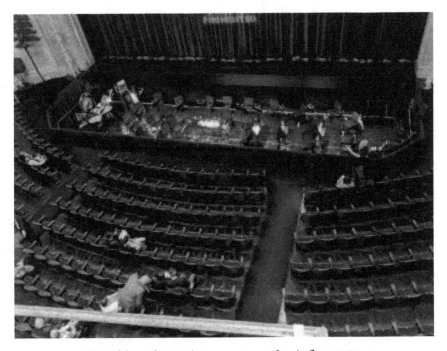

View of the orchestra pit, stage apron, and main floor center,
right and left seats from front row of the upper balcony.
Photographer: Jean Derricotte-Murphy, © January 18, 2020.

Appendix L

Main Floor Stage View—Detroit Opera House

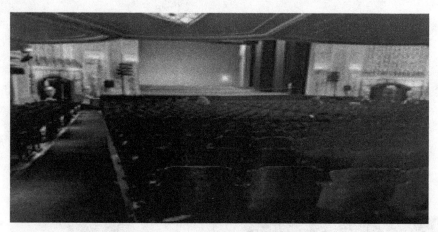

View of the stage from the main floor left seats.
Photographer: Jean Derricotte-Murphy, © January 18, 2020.

Appendix M

Center Balcony Stage View—Detroit Opera House

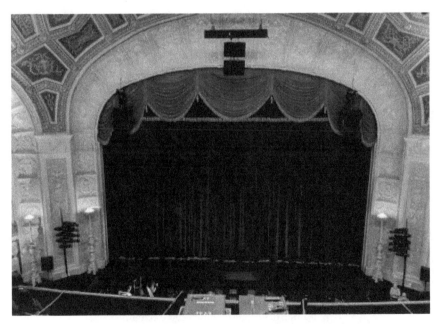

View of balcony rail, lighting board, orchestra pit, and
closed curtain from the upper balcony front row seats.
Photographer: Jean Derricotte-Murphy, © January 18, 2020.

Appendix N

"Nosebleed" Balcony Seating—Detroit Opera House

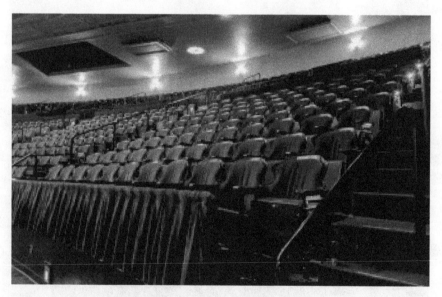

View of balcony seating showing top tier and steep steps
leading to the upper "nosebleed" section.
Photographer: Jean Derricotte-Murphy, © January 18, 2020.

Appendix O

Ms. Marian Anderson, Contralto

Appendix P

Ms. Anderson and Secretary Ickes

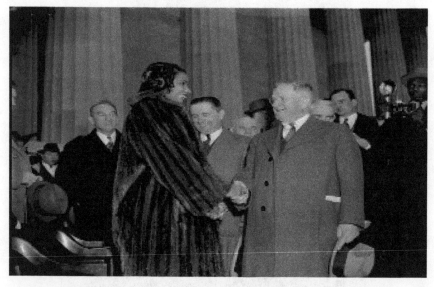

Ms. Anderson shaking hands with Secretary Ickes, USA Secretary of the Interior,
at the Easter Concert at the Lincoln Memorial, April 9, 1939.
Public domain. (https://picryl.com/search?q=marian%20anderson%20%201939.)

Appendix Q

Ms. Anderson and Audience, Easter
Sunday 1939—Lincoln Memorial

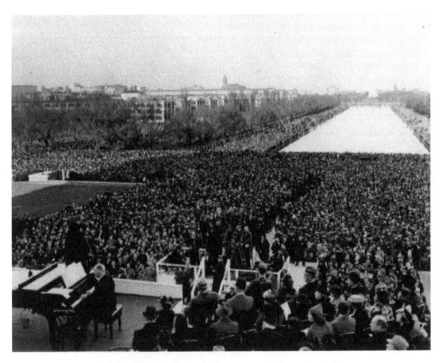

Ms. Anderson singing before a crowd of 75,000 at the
Lincoln Memorial on Easter Sunday, April 9, 1939.
Public domain. (https://commons.wikimedia.org/wiki/
File:MarianAndersonLincolnMemorial.png.)

Appendix R

African American Composers and Librettists

An excerpted list of operas by African American composers and librettists compiled by the author.

Opera	Composer and Librettist	Year
Virginia's Ball	John Thomas Douglas	1868
Martyr	H. Lawrence Freeman	1891
Treemonisha	Scott Joplin	1911
Voodoo	Harry Lawrence Freeman	1928
Blue Steel	William Grant Still	1934
Ouanga: A Haitian Opera in Three Acts	Clarence Cameron White and John Frederick Matheus	1939
Troubled Island	William Grant Still	1939
A Bayou Legend	William Grant Still	1941
A Southern Interlude	William Grant Still	1942
Highway 1 USA (Revised)	William Grant Still	1963/2021
Frederick Douglass	Dorothy Rudd Moore	1985
The Life and Times of Malcolm X	Anthony Davis and Thulani Davis	1985
Blake	H. Leslie Adams and Daniel Mayers	1986
Sojourner Truth	Valerie Capers	1986
Oh Freedom	Lena McLin and Benjamin Matthews	1990
Journin'	Benjamin Matthews	1991
Amistad	Anthony Davis	1997
The Meetin'	Pamela Baskin Watson	1998
Harriet	Leo Edwards	2001

Opera	Composer and Librettist	Year
Wakonda's Dream	Anthony Davis and Yusuf Komunyakaa	2007
I Dream: The Story of a Preacher from Atlanta	Douglas Tappin	2010
Champion: An Opera in Jazz	Terence Blanchard and Michael Christofer	2013
Dark River: The Fannie Lou Hamer Story	Mary D. Watkins	2014
Harriet Tubman: When I Cross That Line to Freedom	Nkeiru Okoye	2014
Blue	Jeanine Tesori and Tazewell Thompson	2015
Lilith	Anthony Davis and Allan Harris	2015
The Opera of Marie Laveau	Akua Dixon	2015
Fire Shut Up in My Bones	Terrence Blanchard and Kasi Lemmons	2019
The Central Park Five	Anthony Davis and Richard Wesley	2019
Marion's Song	Damien Sneed and Deborah Moulon	2020
Holy Ground	Damien Geter and Lila Palmer	2022
Omar	Rhiannon Giddens and Michael Abels	2022
The Passion of Mary Cardwell Dawson	Carlos Simon and Sandra Seaton	2022
The Factotum	Will Liverman	2023
The Johana People: A Legacy of Struggle and Triumph	Hannibal Lokumba	2023
This Little Light of Mine: The Story of Fannie Lou Hamer	Chandler Carter and Diana Solomon Glover	2023
Treemonisha: New and Extended Version	Damien Sneed	2023
American Apollo	Damien Geter	2024
Loving vs. The State of Virginia	Damien Geter	2025

Appendix S
Sissieretta Jones, Soprano

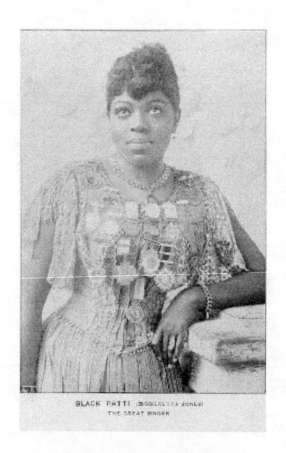

BLACK PATTI (SISSIERETTA JONES)
THE GREAT SINGER

Appendix T

Author with George Shirley

Tenor and Professor Emeritus George Shirley with author at the Brazeal Dennard Chorale Fiftieth Anniversary Concert, Detroit, Michigan, June 25, 2023. Photographer: Jean Derricotte-Murphy, © June 25, 2023.

Appendix U

Author with Ms. Bumbry

Post concert reception. Author's personal collection. July 1995.

Appendix V

Author with Ms. Bumbry and the Black
Musical Heritage Ensemble

Author is seated on the front row, third from right.
Author's personal collection. Salzburg, Austria, July 1995.

Appendix W

Author in Porgy and Bess—*Detroit Opera House*

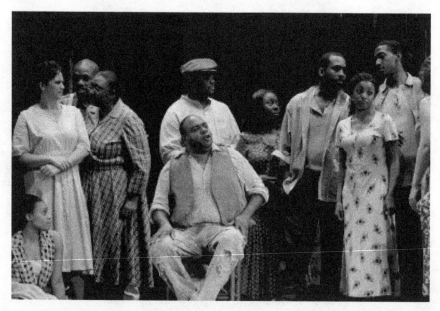

Michigan Opera Theater Production, 2006. Seated center is Alvy Powell as Porgy.
Author is standing second from left. Photo courtesy Detroit Opera House.

Appendix X

Author in Porgy and Bess—*Detroit Opera House*

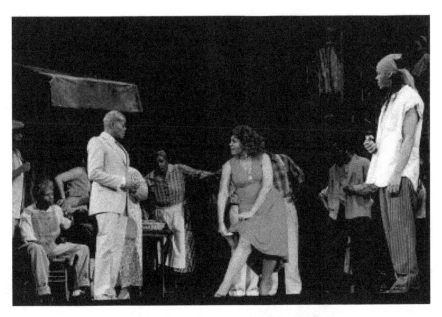

Lisa Daltirus as Bess, Jubilant Sykes as Sportin' Life, Timothy Blevins as Crown
Author seen in background between them.
Photo courtesy of Detroit Opera House.

Appendix Y

Author in Margaret Garner—*Detroit Opera House*

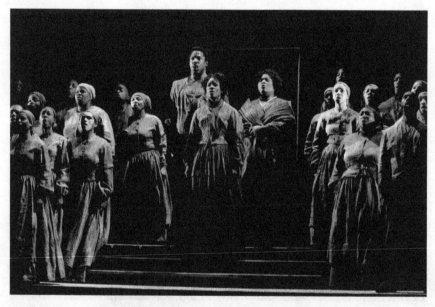

Michigan Opera Theater Production, 2005.
Margaret Garner, act 1, scene 1. Center stage are Gregg
Baker as Robert Garner, Denyce Graves as Margaret Garner,
and Angela Brown as Cilla, Robert's mother singing
"No, No More" with the slave chorus, expressing the sorrow of the enslaved.
The dark lighting indicates the gravity of this scene.
Author is standing second from the right on the first row.
Photo courtesy Detroit Opera House.

Appendix Z

Author in Margaret Garner—*Detroit Opera House*

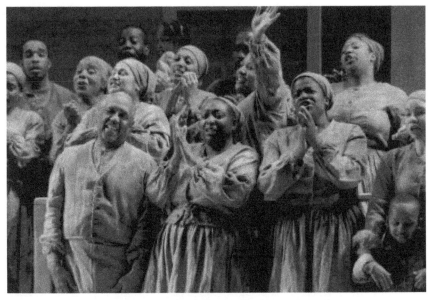

Michigan Opera Theater Production, 2005.
Act 1, scene 1, after the auction has been halted, slave families are rejoicing.
The lighting change to brighten the stage indicates the shift from sorrow to rejoicing.
Here is the Michigan Opera Theater Chorus rehearsing "A Little More Time."
The author is front row center.
Photo courtesy Detroit Opera House.

Appendix AA

Author in Margaret Garner *Chorus*

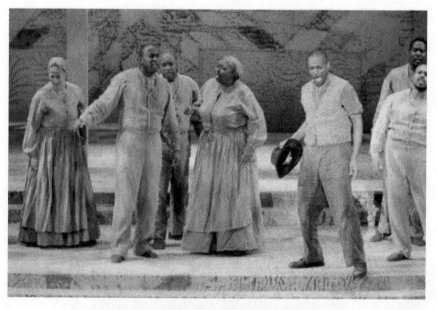

Act 1, scene 2. Harvest time, chorus singing a work song.
Author is in center.
Photo courtesy Detroit Opera House.

Appendix BB

Toni Morrison—Detroit Opera House

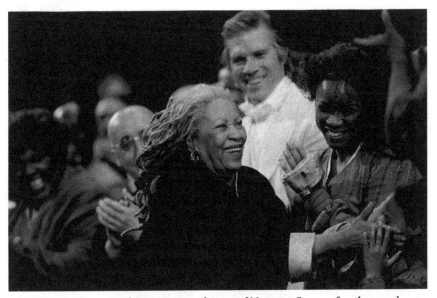

Toni Morrison gives her congrats to the cast of Margaret Garner after the opera's
world premiere on Saturday, May 7, 2005 in Detroit at the Detroit Opera House.
© Rashaun Rucker, USA Today Network.

Appendix CC

Author as Harriet Ross in Harriet

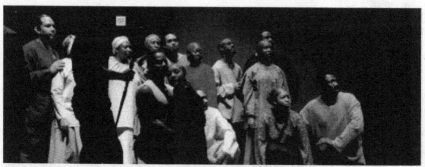

Opera Ebony's production at the Schomburg Center for Black
Culture in New York, 2002. Author indicated by yellow tag.
Photographer: Terry A. Murphy, ©2002.

Appendix DD

Curtain Call

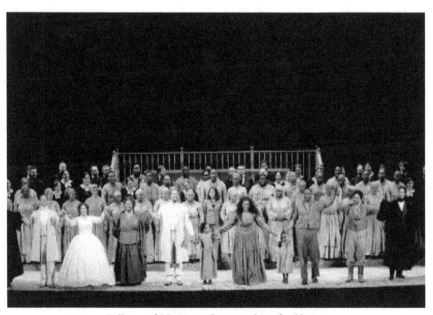

Full cast of *Margaret Garner* taking final bows.
Photo courtesy Detroit Opera House.

Bibliography

Adamson, Peter. *A History of Philosophy without Any Gaps.* New York: Oxford University Press, 2014.

Africans in America. "Indian Removal." PBS. https://www.pbs.org/wgbh/aia/part4/4p2959.html.

Ahlgrim, Callie. "21 Celebrities and Politicians Who Have Been Criticized for Wearing Blackface." *Business Insider*, September 19, 2019. https://www.insider.com/celebrities-who-wore-blackface-2018-10.

Alexander, Jeffrey C., et al. *Social Performance: Symbolic Action, Cultural Pragmatics, and Ritual.* Cambridge: Cambridge University Press, 2006.

Alexander, Michelle. *The New Jim Crow: Mass Incarceration in the Age of Colorblindness.* Rev. ed. Foreword by Cornel West. New York: New Press Perseus Distribution, 2012.

Al Tinawi, Muhammad. "The Impact of Colonization on the African Writer's Psychological Behavior." *Global Journal of Arts, Humanities and Social Sciences* 3.12 (December 2015) 235. https://eajournals.org/gjahss/vol-3issue12december-2015/the-impact-of-colonization-on-the-african-writers-psychological-behavior/.

Amt, Emilie. "Down from the Balcony: African Americans and Episcopal Congregations in Washington County, Maryland, 1800–1864." *Anglican and Episcopal History* 86.1 (2017) 1.

Anderson-Leavy, Lisa. "Feminist Anthropology." *Oxford Bibliographies Online*, May 6, 2016. http://www.oxfordbibliographies.com/view/document/obo-9780199766567/obo-9780199766567-0007.xml.

Anderson, Marian. "Marian Anderson Quotes." Quotestats.com. https://quotestats.com/author/marian-anderson-quotes/.

André, Naomi. *Black Opera: History, Power, Engagement.* Champaign: University of Illinois Press, 2018.

Angelou, Maya. "Art for the Sake of the Soul." In *Even the Stars Look Lonesome*, 119–134. New York: Random, 1997.

Baird, Julie. "A Love 'Too Thick': Slave Mothers and Infanticide." 2004. https://www.macmillanlearning.com/studentresources/highschool/english/easywriterhs4e/student_writing_models/baird_a_love_too_thick_slave_mothers.pdf.

Bass, George Houston. "Folk Traditions as Referents for Black Ritual Drama." *Black Scholar* 25.2 (Spring 1995) 14.

Beauchamp, Zack. "Brexit Was Fueled by Irrational Xenophobia, Not Real Economic Grievances." *Vox*, June 27, 2016. https://www.vox.com/2016/6/25/12029786/brexit-uk-eu-immigration-xenophobia.

Bedard, Michael Thomas. "The Immigrant Experience: Irish, Italians, Germans, Poles, Jews, Japanese, and Arabs." No longer available online.

Bennett, Joy T. "'Margaret Garner' Premiers at Chicago Theater—Denyce Graves Gives Soaring Voice to Libretto by Author Toni Morrison." *Ebony* 64.1 (November 2008).

Bial, Henry. "Performance Studies 3.0." In *The Performance Studies Reader*, edited by Sarah Brady and Henry Bial, 402–11. 3rd ed. New York: Routledge, 2016.

Bikos, Konstantin. "How Does the Mayan Calendar Work?" n.d. https://www.timeanddate.com/calendar/mayan.html#:~:text=A%20date%20in%20the%20Mayan.

Biography.com. "Richard Wagner Biography." April 27, 2017. https://www.biography.com/musician/richard-wagner.

Black Music Archive LIVE! "Jessye Norman Sings for AIDS Healing, Benefit Concert, 1996." YouTube video, June 22, 2022. https://www.youtube.com/watch?v=7JqqKrmM7Wk&ab_channel=BlackMusicArchiveLIVE%21.

Bolles, A. Lynn. "Seeking the Ancestors: Forging a Black Feminist Tradition in Anthropology." In *Black Feminist Anthropology: Theory, Politics, Praxis, and Poetics*, edited Irma McLaren, 24–48. New Brunswick, NJ: Rutgers University Press, 2001.

Bonds, Margaret. "I'll Reach to Heaven." Mutual Music Society, New York. 1946.

Bontemps, Arna. *Great Slave Narratives*. Boston: Beacon, 1969.

Botticelli, Sandro. *Madonna with Child and Singing Angels*. Circa 1477. https://www.art.com/products/p15327272155-sa-i6891314/sandro-botticelli-madonna-with-child-and-singing-angels-about-1477.htm.

Boyd, Melinda. "The Politics of Color in Oscar Hammerstein's Carmen Jones." In *Blackness in Opera*, 212–35. Chicago: University of Illinois Press, 2012.

Branstetter, Leah. "Opera Commercials." YouTube playlist, May 5, 2014. https://www.youtube.com/playlist?list=PLCF2CFFE02F9EA110.

Bregenzer Festspiele. "Bregenzer Festspiele 1997." Bregenzerfestspiele.com, n.d. https://bregenzerfestspiele.com/en/node/86.

Bregenzer Festspiele Chronik. "Der Bregenzer Festspiele." Chronik.bregenzerfestspiele.com, n.d. http://chronik.bregenzerfestspiele.net/de/chronik?dp_search_year_nid=411&cnid=531&spos=5559#showContentand.

Brewer, David Lee. "Grace Bumbry Biography." *Grace-Melzia Bumbry*, n.d. Gracebumbry.com/biography.

British Broadcast Company News Service. "EU Referendum Results." BBC News, 2020. https://www.bbc.com/news/politics/eu_referendum/results.

Brooks, Daphne. *Bodies in Dissent: Spectacular Performances of Race and Freedom, 1850–1910*. Durham: Duke University Press, 2006.

Brunyate, Roger. "Back to the Source: Exploring the *Ordo Virtutum*." 2005. https://web.archive.org/web/20170827091831/http://www.peabodyopera.org/essays/ordo98/.

Bryan, Karen M. "Clarence Cameron White's Ouanga! In the World of the Harlem Renaissance." In *Blackness in Opera*, edited by Naomi André et al, 116–40. Chicago: University of Illinois Press, 2012.

Buckenmaier, Chester, III. "If You Tell a Big Lie Big Enough and Tell It Frequently Enough, It Will Be Believed." *U.S. Medicine*, June 10, 2018. https://www.usmedicine.

com/editor-in-chief/if-you-tell-a-big-enough-lie-and-tell-it-frequently-enough-it-will-be-believed/.

Burns, Ken, and Geoffrey C. Ward. *Jazz: A History of America's Music*. New York: Knopf, 2000.

Campbell, Josephine. "Musical Theatre." *Salem Press Encyclopedia*. Pasadena, CA: Salem Press, 2017.

Cannon, Katie G. *Black Womanist Ethics*. American Academy of Religion Academy Series. Atlanta: Scholars, 1988.

———. *Katie's Canon: Womanism and the Soul of the Black Community*. New York: Continuum, 1995.

Carey, Brycchan. "Slavery Timeline 1400–1500: A Chronology of Slavery, Abolition, and Emancipation in the Fifteenth Century." July 24, 2013. http://www.brycchancarey.com/slavery/chrono2.htm.

———. "Slavery Timeline 1801–1900: A Chronology of Slavery, Abolition, and Emancipation." Last modified April 9, 2003. http://www.brycchancarey.com/slavery/chrono6.htm.

Chamberlain, Muriel Evelyn. *The Scramble for Africa*. New York: Routledge, 2014.

Cheatham, Wallace McClain. "Black Male Singers at the Metropolitan Opera." *The Black Perspective in Music* 16.1 (1988). 3–20. http://dx.doi.org/10.2307/1215123.

Cincinnati History Library and Archives. "Margaret Garner: 1834–1858." http://library.cincymuseum.org/aag/bio/garner.html.

Clark, Kelly James, et al. *101 Key Terms in Philosophy and Their Importance for Theology*. Louisville, KY: Westminster John Knox, 2004.

Colbert, Soyica Diggs. *The African American Theatrical Body: Reception, Performance, and the Stage*. New York: Cambridge University Press, 2011.

———. "Rituals of Repair." In *The African American Theatrical Body: Reception, Performance, and the Stage*, 194–230. Cambridge: Cambridge University Press, 2011.

Cole, Johnnetta B. Foreword to *Black Feminist Anthropology: Theory, Politics, Praxis, and Poetics*, edited by Irma McClaurin, ix–xi. New Brunswick, NJ: Rutgers University Press, 2001.

———. "Ritual and Belief Systems: Introduction." In *Introduction to Anthropology for the Nineties: Introductory Readings*, edited by Johnnetta B. Cole., 381–88 New York: Free, 1988.

Conquergood, Dwight. "Performance Studies: Interventions and Radical Research." *Drama Review* 46.2 (2002) 145–56.

Cordell, Dennis D. "French Colonies—Cameroon." *Discover France!*, n.d. https://www.discoverfrance.net/Colonies/Cameroon.shtml.

Danielpour, Richard, and Toni Morrison. *Margaret Garner: An Opera in Two Acts*. Full opera vocal score and synopsis. New York: Associated Music. https://issuu.com/scoresondemand/docs/margaret_garner_vs_27160.

———. *Margaret Garner: Libretto*. New York: Associated Music. https://issuu.com/scoresondemand/docs/margaret_garner_libretto_27160.

———. *Three Mezzo-Soprano Arias from Margaret Garner*. Voice and piano. New York: Associated Music, 2007.

Danielpour, Richard, et al. *Margaret Garner: Opera in Two Acts*. Piano vocal score. New York: Associated Music, 2007.

DeFrantz, Thomas F. "From Negro Expression to Black Performance." In *Black Performance Theory*, edited by Thomas F. DeFrantz and Anita Gonzalez, 1–15. Durham: Duke University Press, 2014.

Denzin, Norman K. "The Call to Performance." In *Performance Ethnography: Critical Pedagogy and the Politics of Culture*, 3–23. https://books.google.com/books?id=vV roqatD6oMC&printsec=frontcover#v=onepage&q&f=false.

Derricotte-Murphy, Jean. "Paul Tillich: Reflection Paper." Chicago Theological Seminary, Chicago, Illinois, 2015.

———. "Porgy and Bess Speak to the African-American Church." DMin diss., Ecumenical Theological Seminary, Detroit, 2008.

Dictionary.com. "Anamnesis." http://www.dictionary.com/browse/anamnesis.

———. "Balcony." https://www.dictionary.com/browse/balcony.

———. "Gallery." https://www.dictionary.com/browse/gallery.

Dizikes, John. *Opera in America: A Cultural History*. New Haven, CT: Yale University Press, 1993.

Domise, Andray. "Yes, a MAGA Hat Is a Symbol of Hate." *Maclean's*, January 25, 2019. https://www.macleans.ca/opinion/yes-a-maga-hat-is-a-symbol-of-hate/.

D'onofrio, Alexandra. "Anthropology and Theology." *The International Encyclopedia of Anthropology*. 2018. https://doi.org/10.1002/9781118924396.wbiea2268.

Dube, Musa W. "Reading for Decolonization (John 4:1–42)." *Semeia* 75 (1996) 37–59. https://www.researchgate.net/publication/283072159_READING_FOR_DECOLONIZATION_JOHN_41-42.

Duerden, Dennis. "The 'Discovery' of the African Mask." *Research in African Literatures* 31.4 (Winter 2000) 29–47.

Duignan, Brian. "Enlightenment." *Encyclopaedia Britannica* online. Last updated January 2, 2024. https://www.britannica.com/event/Enlightenment-European-history.

Dunbar-Ortiz, Roxanne. *An Indigenous Peoples' History of the United States: ReVisioning American History*. Boston: Beacon, 2014.

Dussel, Enrique D. "Eurocentrism and Modernity (Introduction to the Frankfurt Lectures)." *Boundary* 2 20 (1993) 65. http://www.umass.edu/legal/Benavides/Spring2005/397U/Readings%20Legal397U%20Spring%202005/2%20Dussel.pdf.

———. "From Critical Theory to the Philosophy of Liberation: Some Themes for Dialogue." *Transmodernity: Journal of Peripheral Cultural Production of the Luso-Hispanic World* 1.2 (2011) 26. https://escholarship.org/uc/item/59m869d2.

———. *The Invention of the Americas: Eclipse of "the Other" and the Myth of Modernity*. Translated by Michael D. Barber. New York: Continuum, 1995.

———. "The Philosophy of Liberation, the Postmodern Debate, and Latin American Studies." 2008. https://enriquedussel.com/txt/Textos_Articulos/348.2004_ingl.pdf.

———. "Transmodernity and Interculturality: An Interpretation from the Perspective of Philosophy of Liberation." *Transmodernity* 1.3 (2012).

Dussel, Enrique, and Alessandro Fornazzari. "World-System and 'Trans'-Modernity." *Nepantla: Views from South* 3.2 (2002) 223. https://enriquedussel.com/txt/Textos_Articulos/332.2002_ingl.pdf.

Dussel, Enrique, and Gary MacEoin. "1492: The Discovery of an Invasion." *CrossCurrents* 4 (1991) 437–52. https://www.jstor.org/stable/24460351.

Dwyer, Collin. "'Racist' and 'Shameful': How Other Countries Are Responding to Trump's Slur." National Public Radio, *The Two-Way*, January 12, 2018. https://www.npr.org/sections/thetwo-way/2018/01/12/577599691/racist-and-shameful-how-other-countries-are-responding-to-trumps-slur.

Elvin, Mark. "A Working Definition of 'Modernity'?" *Past and Present* 113.1 (1986) 209–13. https://doi.org/10.1093/past/113.1.209.

Emetaz, Greg. "'Margaret Garner.'" Video, 11:55. *New York Times*, September 12, 2007. https://www.nytimes.com/video/arts/music/1194817098432/margaret-garner.html.

Encyclopaedia Britannica. "Africa." *Encyclopaedia Britannica*. Last updated August 14, 2023. https://www.britannica.com/place/Africa-Roman-territory.

———. "Caravel." *Encyclopaedia Britannica*. Last updated August 8, 2023. https://www.britannica.com/technology/caravel.

———. "Fugitive Slave Acts." *Encyclopaedia Britannica*. Last updated December 4, 2023. https://www.britannica.com/event/Fugitive-Slave-Acts.

———. "Imperialism." *Encyclopaedia Britannica*. Last updated January 1, 2024. https://academic.eb.com/levels/collegiate/article/imperialism/42213.

———. "Mesoamerican Civilization." *Encyclopaedia Britannica*. Last updated February 3, 2024. https://academic.eb.com/levels/collegiate/article/Mesoamerican-civilization/52210.

European Center for Populism Studies. "Big Lie." November 28, 2021. https://www.populismstudies.org/Vocabulary/big-lie/.

Fantastic Four. "The Whole World Is a Stage." Ric-Tic Records, 1967. https://genius.com/Fantastic-four-the-whole-world-is-a-stage-lyrics.

FASinatra1. "George and Ira Gershwin's *Porgy and Bess*—The Complete 2002 Lincoln Center Production." YouTube video, June 16, 2017. https://www.youtube.com/watch?v=HdRTfqGy9TE.

Feinman, Gary M. "The Prehispanic Mesoamerican World: Framing Interaction." In *Interregional Interaction in Ancient Mesoamerica*, edited by Joshua D. Englehardt and Michael D. Carrasco, 34–50. Louisville: University Press of Colorado, 2019. http://muse.jhu.edu/book/65965.

Ferris, Sherri. "Opera Protocol Tips." Protocol Professionals, Inc., n.d. https://www.protocolprofessionals.com/tips_opera.htm#behave.

Finckel, Emeline Wong. "Navigating Shared Space: Audience Agency and Passivity in Environmental and Immersive Theater." BA thesis, Wesleyan University, Middletown, Connecticut, 2014. https://digitalcollections.wesleyan.edu/object/ir-1498.

Frederickson, Mary E., and Delores M. Walters, eds. *Gendered Resistance: Women, Slavery, and the Legacy of Margaret Garner*. Urbana: University of Illinois Press, 2013. https://muse.jhu.edu/book/27453/.

Frej, Willa. "Here Are the European Countries That Want to Refuse Refugees." *HuffPost Canada*, September 9, 2015. https://www.huffpost.com/entry/europe-refugees-not-welcome_n_55ef3dabe4b093be51bc8824.

Garvey, Marcus. *Philosophy and Opinions*. Edited by Amy Jacques-Garvey. New York: Universal, 1923.

Gelfand, Janelle. Review of *Margaret Garner*. *Cincinnati Enquirer*, May 9, 2005. https://cincinnati.newspapers.com/image/102551325/?terms=Janelle%20Gelfand&match=1.

Gershwin, George, et al. *Porgy and Bess*. Secaucus, NJ: Warner Bros., 1935.

Giovetti, Olivia. "The Top 10 Politically-Charged American Operas." Operavore, October 3, 2011. https://www.wqxr.org/story/162203-top-10-politically-charged-american-operas/.

Glyndebourne. "10 Times Opera Stole the Scene at the Movies." Glyndebourne.com, 2017. https://www.glyndebourne.com/tour/10-times-opera-stole-the-scene-at-the-movies/.

Gonzalez, Jose B. "Latin American Independence Days." *Latino Stories: The Credible Source for Latino Literature, Latino Film, and Latino Studies*, December 3, 2023. https://latinostories.com/latin-american-independence-days/.

Grant, Jacqueline. "Subjectification as a Requirement for Christological Construction." In *Lift Every Voice: Constructing Christian Theology from the Underside*, edited by Susan Brooks Thistlethwaite and Mary Potter Engle, 207–20. Maryknoll, NY: Orbis, 1998.

Greenfield-Sanders, Timothy, dir. *Toni Morrison: The Pieces I Am*. Magnolia Pictures, 2019.

Griffin, Gloria, and Roberta Martin. "God Specializes." BMG Rights Management, Warner Chappell Music, 1958.

Griffith, D. W., dir. *The Birth of a Nation*. March 21, 1915. https://www.imdb.com/title/tt0004972/.

Gyekye, Kwame. *An Essay on African Philosophical Thought: The Akan Conceptual Scheme*. Cambridge: Cambridge University Press, 1987.

Haithman, Diane. "A Wuv Affair with Arias." *Los Angeles Times*, December 4, 2005. https://www.latimes.com/archives/la-xpm-2005-dec-04-ca-popera4-story.html.

Hamilton, David, and Aliki Andris-Michalaros, with the Metropolitan Opera Guild. *The Metropolitan Opera Encyclopedia: A Comprehensive Guide to the World of Opera*. New York: Simon and Schuster, 1987.

Hanich, Julian. *The Audience Effect: On the Collective Cinema Experience*. Edinburgh: EUP, 2018.

Harlow, Barbara. Introduction to *The Scramble for Africa*. Vol 2, *Archives of Empire*, edited by Mia Carter and Barbara Harlow, 1–9. Durham, NC: Duke University Press, 2004.

Harrison, Faye V. "Anthropology as an Agent of Transformation: Introductory Comments and Queries." *Decolonizing Anthropology: Moving Further toward an Anthropology for Liberation*. Arlington, VA: American Anthropological Association, 1991.

———. *Decolonizing Anthropology: Moving Forward toward an Anthropology for Liberation*. Arlington, VA: American Anthropological Association, 2010.

———. "Writing against the Grain: Cultural Politics of Difference in the Work of Alice Walker." *Critique of Anthropology* 13.4 (1993) 402.

Ḥasnāwī, Muṣṭafá, dir. *Margaret Garner*. Huit Production, Cityzen Télévision, Copap. Facets Video, 2007.

Hatcher, Evelyn Payne. *Art as Culture: An Introduction to the Anthropology of Art*. 2nd ed. Westport, CT: Bergin & Garvey, 1999.

Headlee, Celeste. "Opera Tells Saga of 'Margaret Garner.'" Interview. National Public Radio, *Weekend Edition*, May 7, 2005. https://www.npr.org/transcripts/4633538.

Heyer, René. "Annihilation Anthropologique et Anthropologie de la Vie: Une Discussion Critique des Thèses du P. Mveng." *Théologiques* 19.1 (2011) 136–37.

Hmsarthistorian. "Engelbert Mveng: A Theology of Life Expressed in Art." *Indigenous Jesus: Exploring the Intersection of Indigenous Visual Art and the Gospel of Jesus Christ* (blog), January 26, 2012. http://indigenousjesus.blogspot.com/2012/05/engelbert-mveng-theology-of-life.html.

Holmes, Barbara Ann. *Joy Unspeakable: Contemplative Practices of the Black Church*. 1st ed. Minneapolis: Fortress, 2004.

———. *Joy Unspeakable: Contemplative Practices of the Black Church*. 2nd ed. Minneapolis: Fortress, 2017.

Hospers, John. "Philosophy of Art." *Encyclopaedia Britannica online*. Last updated October 4, 2022. https://www.britannica.com/topic/philosophy-of-art.

Hoya, Robyn. "Video Roundup: Musicals Based on Operas." The Musical Stage Company, May 31, 2017. https://musicalstagecompany.com/musical-notes/video-round-musicals-based-operas.

"I Am Bound for the Promised Land." Traditional African American Spiritual. Public domain.

"I Got a Robe." Traditional African American spiritual. Public domain.

Imbriano, Robe, and Tom Yellin. *Amend: The Fight for America*. Episode 1, "Citizen." Hosted by Will Smith et al. Aired 2021 on Netflix.

Johnson, E. Patrick. "Blackness and Authenticity: What's Performance Got to Do with It?" In *Appropriating Blackness: Performance and the Politics of Authenticity*, 1–16. Durham: Duke University Press, 2003.

Johnson, James Weldon. *Black Manhattan*. New York: Knopf, 1930. https://ia800709.us.archive.org/1/items/blackmanhattan00john_1/blackmanhattan00john_1.pdf.

Keller, James M. "Notes on the Program: Overture to *The Bartered Bride*." New York Philharmonic Archives, 2017. https://archives.nyphil.org/index.php/artifact/53bd7663-8935-4847-8634-6d4fff58f252-0.1/fullview#page/1/mode/2up.

Kennicott, Philip. "Is Opera Still Relevant." *Opera News* 71.2 (2006) 35–37.

Khrystyna K. "Esthetics or Aesthetics." Reply on Preply.com, 2017. https://preply.com/en/question/esthetics-or-aesthetics.

Kisak, Paul. *Aesthetics: The Nature of Art, Beauty and Taste*. CreateSpace, 2015.

Kohn, Margaret, and Kavita Reddy. "Colonialism." *The Stanford Encyclopedia of Philosophy*, Fall 2017. Edited by Edward N. Zalta. https://plato.stanford.edu/archives/fall2017/entries/colonialism/.

LaDuke, Winona. *All Our Relations: Native Struggles for Land and Life*. Chicago: Haymarket, 1999.

———. "Our Bodies, Our Communities and Our Self-Determination." *Canadian Dimension* 30.1 (February/March 1996).

———. *Recovering the Sacred: The Power of Naming and Claiming*. Cambridge: South End, 2005.

Lang, Andrew. *Myth, Ritual and Religion*. Vol. 2. London: Longmans, Green, 1901. https://www.gutenberg.org/files/36794/36794-h/36794-h.htm.

Lasala, Angelica. "The Earliest Opera Ever Written Is over 800 Years Old . . . and It's by a Woman." *WFMT*, July 5, 2017. https://www.wfmt.com/2017/07/05/earliest-opera-ever-written-800-years-old-woman.

LeFlouria, Talitha L. "Infanticide." In *Gail Library of Daily Life: Slavery in America*, edited by Orville Burton, 2:135–36. Detroit: Gale 2000.

Library of Congress. "African American Song." 2015. https://www.loc.gov/item/ihas.200197451.

———. *Born in Slavery: Slave Narratives from the Federal Writers' Project, 1936–1938*. https://www.loc.gov/collections/slave-narratives-from-the-federal-writers-project-1936-to-1938/about-this-collection/.

Longley, Robert. "A Brief History of Cameroon." *ThoughtCo.*, September 14, 2020. https://www.thoughtco.com/brief-history-of-cameroon-43616.

Lorde, Audre. *The Master's Tools Will Never Dismantle the Master's House*. London: Random, 2018.

LumenLearning.com. "What Is Art? Thinking and Talking about Art." *Boundless Art History*, 2011. https://courses.lumenlearning.com/boundless-arthistory/chapter/what-is-art/.

Macik, Madison, and Todd Zimmerman. "Spanish Exploration Timeline." Sutori. https://www.sutori.com/en/story/spanish-exploration-timeline--w3f9hLoswgqv C1gZwAP19D7h.

Maddow, Rachel. "Trump Sees American Foes Not Russia Greatest Threat." MSNBC, March 17, 2023. https://www.msnbc.com/rachel-maddow-show/maddowblog/trump-sees-american-foes-not-russia-greatest-threat-rcna75447.

Madison, D. Soyini. Foreword to *Black Performance Theory*, edited by Thomas F. DeFrantz and Anita Gonzalez, vii–x. Durham, NC: Duke University Press, 2014.

Mahar, William John. *Behind the Burnt Cork Mask: Early Blackface Minstrelsy and Antebellum American Popular Culture*. Champaign: University of Illinois Press, 1999.

Mancini, Mark. "15 Pieces of Classical Music That Showed Up in Looney Tunes." *Mental Floss*, July 31, 2015. http://mentalfloss.com/article/66672/15-pieces-classical-music-showed-looney-tunes.

Margolin, Emma. "Who Really First Came Up with the Phrase 'Make America Great Again'?" NBC News, September 10, 2016. https://www.nbcnews.com/politics/2016-election/make-america-great-again-who-said-it-first-n645716.

Masolo, Dismas. "African Sage Philosophy." *The Stanford Encyclopedia of Philosophy*. Last updated spring 2016. https://plato.stanford.edu/archives/spr2016/entries/african-sage/.

Mbiti, John S. *African Religions and Philosophy*. 2nd rev. ed. Gaborone, Botswana: Heinemann, 1990.

Mburu, Elizabeth. *African Hermeneutics*. Plateau State, Nigeria: Hippo, 2019.

McClaurin, Irma. "Forging a Theory, Politics, Praxis, and Poetics of Black Feminist Anthropology." In *Black Feminist Anthropology: Theory, Politics, Praxis, and Poetics*, edited by Irma McClaurin, 1–23. New Brunswick, NJ: Rutgers University Press, 2001.

McConachie, Bruce. *Engaging Audiences: A Cognitive Approach to Spectating in the Theater*. New York: Palgrave Macmillan, 2008.

Memmi, Albert. *The Colonizer and the Colonized*. New York: Orion, 1965.

Mendieta, Eduardo. "Philosophy of Liberation." *The Stanford Encyclopedia of Philosophy*, Winter 2020. Edited by Edward N. Zalta. https://plato.stanford.edu/archives/win2020/entries/liberation/.

Mendoza, S. Lily. "Back from the Crocodile's Belly: Christian Formation Meets Indigenous Resurrection." *HTS Theological Studies* 73.3 (2017) 1–8. http://dx.doi.org/10.4102/hts.v73i3.4660.

———. "New Frameworks in Philippine Postcolonial Historiography: Decolonizing a Discipline." In *Race and the Foundations of Knowledge: Cultural Amnesia in the Academy*, edited by Jana Evans Braziel and Joseph Young, 155–73. Champaign: University of Illinois Press, 2006.

———. "Tears in the Archive: Creating Memory to Survive and Contest Empire." In *Among Us: Essays on Identity, Belonging, and Intercultural Competence*, edited by Myron W. Lustig and Jolene Koester, 223–45. Boston: Pearson, 2005.

Merriam-Webster Dictionary. "Amnesia." https://www.merriam-webster.com/dictionary/amnesia-.

———. "Big Lie." https://www.merriam-webster.com/dictionary/big%20lie.

———. "Colonization." https://www.merriam-webster.com/dictionary/colonization.

———. "Lie." https://www.merriam-webster.com/dictionary/lie.

———. "Malignancy." https://www.merriam-webster.com/dictionary/malignant.

———. "Opera." https://www.merriam-webster.com/dictionary/opera.

———. "Perform." https://www.merriam-webster.com/dictionary/perform.

The Metropolitan Opera. "Learn More about Met Opera on Demand." n.d. https://www.metopera.org/season/on-demand/Learn-More/.

———. "The Met: Live in HD." https://www.metopera.org/season/in-cinemas/.

———. "Saturday Matinee Broadcasts." https://www.metopera.org/season/radio/saturday-matinee-broadcasts/.

Meyerbeer, Giacomo. *L'Africaine (the African Woman): A French Opera in Five Acts*. Italian Text with English Translation. 1865. Boston: Oliver Ditson, 1866. Library of Congress. https://www.loc.gov/resource/musschatz.11194.0/?sp=4&r=-1.816,-0.088,4.632,1.518,0.

Miller, Robert J. "The Doctrine of Discovery, Manifest Destiny, and American Indians." In *Why You Can't Teach United States History without American Indians*, edited by Susan Sleeper-Smith et al., 87–100. Chapel Hill: University of North Carolina Press, 2015.

Miller, Stuart Creighton. *Benevolent Assimilation: The American Conquest of the Philippines, 1899–1903*. New Haven, CT: Yale University Press, 1982.

Mills, Charles Wade. *Blackness Visible: Essays on Philosophy and Race*. Ithaca, NY: Cornell University Press, 1998.

Minster, Christopher. "10 Facts about the Spanish Conquistadors." ThoughtCo, February 28, 2021. https://www.thoughtco.com/facts-about-the-spanish-conquistadors-2136511.

Mitchell, Koritha. "Black-Authored Lynching Dramas Challenge to Theater History." In *Black Performance Theory*, edited by Thomas F. DeFrantz and Anita Gonzalez, 87–98. Durham: Duke University Press, 2014.

Molette, Carlton. "Ritual Drama in the Contemporary Black Theater." *The Black Scholar* 25.2 (1995) 24–29.

More, Mabogo P. "African Philosophy Revisited." *Alternation* 3.1 (1996) 109–29. https://journals.co.za/doi/pdf/10.10520/AJA10231757_185.

Morning Call. "Opera Ebony Nurtures African American Singers." March 31, 2002. https://www.mcall.com/news/mc-xpm-2002-03-31-3388578-story.html.

Morrison, Toni. *Beloved: A Novel*. New York: Vintage International, 2004.

———. "Memory, Creation, and Writing." *Thought: Fordham University Quarterly* 59.4 (1984) 385–90.

———. "Playing in the Dark." *Literary Theory: An Anthology*, edited by Julie Rivkin and Michael Ryan, 1005–16. 2nd ed. Hoboken: Blackwell, 2004.

———. "The Site of Memory." *Inventing the Truth: The Art and Craft of Memoir*, edited by Russell Baker, 183–200. New York: Houghton Mifflin, 1995.

————. "Unspeakable Things Unspoken: The Afro-American Presence in American Literature." *Michigan Quarterly Review* 28.1 (Winter 1989) 1–34. http://hdl. handle.net/2027/spo.act2080.0028.001:01.

Moss, Justin. "Opera in TV Commercials." *HuffPost*, July 1, 2012. https://www.huffpost. com/entry/opera-in-tv-commercials_b_1669470.

Mveng, Engelbert. *L'Afrique dans l'Eglise: Paroles d'un Croyant*. Paris: Harmattan, 1986.

————. *L'Art d'Afrique Noire: Liturgie Cosmique et Langage Religieux*. Paris: Masion Mame, 1964.

————. "Black African Arts as Cosmic Liturgy and Religious Language." In *African Theology En Route*, edited by Kofi Appiah-Kubi and Sergio Torres, 137–42. Maryknoll, NY: Orbis, 1979.

————. "A Cultural Perspective." In *Doing Theology in a Divided World*, edited by Sergio Torres and Virginia Fabiola, 72–75. Maryknoll, NY: Orbis, 1985.

————. "Paupérisation et Développement en Afrique." Peuplesawa.com, June 8, 2015. http://www.peuplesawa.com/fr/bnlogik.php?bnid=667&bnk=24&bnrub=1.

————. "Third World Theology—What Theology? What Third World? Evaluation by an African Delegate." In *Irruption of the Third World: Challenge to Theology*. Papers from the Fifth International Conference of the Ecumenical Association of Third World Theologians, August 17–29, 1981, New Delhi, India. Virginia Fabella and Sergio Torres, editors. New York: Orbis, 1981.

Mveng, Engelbert, and B. L. Lipawing. *Théologie, Libération et Cultures Africaines: Dialogue sur L'Anthropologie Négro-Africaine, Essai*. Yaoundé Cameroun Paris: Présence Africaine, 1996.

National Archives at New York City. "Fugitive Slave Case: Stephen Pembrook." https:// www.archives.gov/nyc/exhibit/stephen-pembrook.html.

NC Bookwatch. "Theda Perdue, the Cherokee Nation and the Trail of Tears." Season 11, episode 1107. Public Broadcasting System, August 21, 2008. https://www.pbs.org/ video/nc-people-theda-perdue-cherokee-nation-and-trail-tears/.

Neklason, Annika. "The Legacy of Blackface Ralph Northam Didn't Understand." *Atlantic*, February 16, 2019. https://www.theatlantic.com/entertainment/archive/2019/02/ legacy-blackface-ralph-northam-didnt-understand/582733/.

Nettles, Darryl Glenn. *African American Concert Singers before 1950*. Jefferson, NC: McFarland, 2003.

New Webster's Comprehensive Dictionary of the English Language. "Ritual." Deluxe ed. New York: American International, 1987.

New York Public Library. "Jessye Norman Sings for the Healing of AIDS." Concert video. https://www.nypl.org/research/research-catalog/bib/b22030494.

New York Public Radio. "Saturday Morning Cartoons: Wabbits and Wagner." *WQXR Features*, July 27, 2013. https://www.wqxr.org/story/309080-saturday-morning-cartoons-wabbits-and-wagner/.

Nigellus. "Nosebleed Seats." UrbanDictionary.com, November 18, 2007. https://www.urban dictionary.com/define.php?term=nosebleed%20seats.

Nkrumah, Kwame. *Consciencism: Philosophy and Ideology for De-Colonisation*. London: Panaf, 1970.

Norman, Jessye. *Stand Up Straight and Sing*. New York: Houghton Mifflin Harcourt, 2014.

Norman, Jessye, et al. "Sissieretta Jones: Call Her by Her Name!" Woke Up Famous, n.d. https://www.wokeupfamousllc.com/sissierettajones.

Northup, Solomon, and Henry Louis Gates. *Twelve Years a Slave*. New York: Penguin, 2012.

Ntarangwi, Mwenda. *Reversed Gaze: An African Ethnography of American Anthropology*. Urbana: University of Illinois Press, 2010.

O'Neil, Sinéad, et al. "Opera Audiences and Cultural Value: A Study of Audience Experience." (2014). https://qmro.qmul.ac.uk/xmlui/handle/123456789/6543.

Opera Ebony. "Frederick Douglass and Harriet Tubman Part 1." YouTube video, April 4, 2021. https://www.youtube.com/watch?v=1xssgomekL4&t=2782s&ab_channel =OperaEbony.

Opera Ebony. https://www.operaebony.org/.

Opera Philadelphia. "Opera 101." 2019. https://www.operaphila.org/your-visit/opera-101/ or links?

OperaWorld.com. Unsigned review of *Margaret Garner*. *Opera World Online*, n.d. May 10, 2005. No longer available online.

Palau, Josep. "Giuseppe Verdi: Uniting Italy with Music." *National Geographic History*, January/February 2017. https://www.nationalgeographic.com/history/ history-magazine/article/verdi-operas-italy-national-identity#:~:text=Born%20 alongside%20Italy's%20press%20for,part%20of%20Italy's%20national%20identity/.

Palmer, Greg, and Rosemary Garner, dirs. *American Masters*. Season 12, episode 2, "Vaudeville: An American Masters Special." PBS. Aired October 8, 1999. https:// www.pbs.org/wnet/americanmasters/vaudeville-about-vaudeville/721/.

Pareles, Jon. "From a Diva and Choir, Hope, Sass and Obbligatos." *New York Times*, February 19, 1996. National edition.

Paris, Peter J. *The Spirituality of African Peoples: The Search for a Common Moral Discourse*. Minneapolis: Fortress, 1999.

Parker, Nate, dir. *The Birth of a Nation*. BRON Studios, Phantom Four, and Mandalay Pictures, October 7, 2016. https://www.imdb.com/title/tt4196450/.

Patterson, Willis. Introduction to *Dialogues on Opera and the African-American Experience*, edited by Wallace McClain Cheatham, x–xvii. Lanham: Scarecrow, 1997.

Polzella, Donald J., and Jeremy S. Forbis. "Relationships between Traditional Music Audience Participation and Pro-Social Behaviors." *Empirical Studies of the Arts* 32.1 (2014) 109–20.

Price, Leontyne. "Leontyne Price Quotations." QuoteTab.com. https://www.quotetab. com/quotes/by-leontyne-price.

Rains, Frances V. "Indigenous Knowledge, Historical Amnesia and Intellectual Authority: Deconstructing Hegemony and the Social and Political Implications of the Curricular 'Other.'" In *What Is Indigenous Knowledge: Voices from the Academy*, edited by Ladislaus Semali and Jo Kinchloe, 317–31. Garland Reference Library of Social Science. New York: Palmer, 1999.

Rare Classix. "Margaret Garner Act II." YouTube video, September 12, 2015. https:// www.youtube.com/watch?v=-oJhonx8600.

Read, Gray. "Theater of Public Space: Architectural Experimentation in the Théâtre de L'Espace (Theater of Space), Paris 1937." *Journal of Architectural Education* 58.4 (2005) 53–62. https://www.researchgate.net/publication/230297600_Theater_of_ Public_Space_Architectural_Experimentation_in_the_Theatre_de_l%27espace_ Theater_of_Space_Paris_1937.

Roberts, Maddy Shaw. "What's the Difference between an Opera and a Musical?" Classic FM Digital Radio. No longer available online.

Rodriguez, Cheryl. "Anthropology and Womanist Theory: Claiming the Discourse on Gender, Race and Culture." *Womanist Theory and Research* 2.1 (1996) n.p. http://anthropology-bd.blogspot.com/2008/06/anthropology-and-womanist-theory.html.

———. "A Home Girl Goes Home: Black Feminism and the Lure of Native Anthropology." In *Black Feminist Anthropology: Theory, Politics, Praxis, and Poetics*, edited by Irma McClaurin, 233–57. New Brunswick, NJ: Rutgers University Press, 2001.

Romero, Dennis. "Why Opera? The Politics of an Emerging Genre." *Journal of Interdisciplinary History* 36.3 (Winter 2006) 401–9.

Rosenberg, Donald. "Honorable Effort Lacks Contrast, Drama, Pace." Review of *Margaret Garner, Cleveland Plain Dealer*, May 9, 2005. https://cleveland.newsbank.com/search?text=Honorable%20Effort%20Lacks%20Contrast%2C%20Drama%2C%20Pace&content_added=&date_from=&date_to=&pub%5B0%5D=CPDB.

Roth, Sarah N. "'The Blade Was in My Own Breast': Slave Infanticide in 1850s Fiction." *American Nineteenth Century History* 8.2 (2007) 169–85.

Runcie, James, dir. *Hildegard of Bingen*. United Kingdom, 1994. https://www.imdb.com/title/tt0163451/.

Sampson, Henry T. *Blacks in Blackface: A Sourcebook on Early Black Musical Shows*. 2nd ed. Lanham: Scarecrow, 2014.

Sartwell, Crispin. "Beauty." *The Stanford Encyclopedia of Philosophy*, Winter 2017. Edited by Edward N. Zalta. https://plato.stanford.edu/archives/win2017/entries/beauty/.

Schechner, Richard. *Between Theater and Anthropology*. Philadelphia: University of Pennsylvania Press, 2010.

———. *Performance Studies: An Introduction*. New York: Routledge, 2006.

———. *Performance Theory*. New York: Routledge, 2004.

Scorca, Marc. "Jessye Norman's Next Act." *Opera America*, April 4, 2019. www.operaamerica.org/magazine/spring-2019/jessye-norman-s-next-act/#:~:text=Jessye%20Norman%20has%20embarked%20on,Jones%20(1868%2D1933).

Scott, Bruce. "A Mother's Desperate Act: 'Margaret Garner.'" Interview with Toni Morrison. National Public Radio, November 19, 2010. https://www.npr.org/2010/11/17/131395936/a-mother-s-desperate-act-margaret-garner.0.

Shirley, George. "Il Rodolfo Nero, or the Masque of Blackness." *Blackness in Opera*, edited by Karen M. Bryan et al, 260–74. Chicago: University of Illinois Press, 2012.

Smedley, Audrey. "Origins of the Idea of Race." *Anthropology Newsletter*, November 1997. http://www.pbs.org/race/000_About/002_04-background-02-09.htm.

———. *Race in North America: Origin and Evolution of a Worldview*. 3rd ed. Boulder, CO: Westview, 2007.

Somé, Malidoma Patrice. *Ritual: Power, Healing, and Community, Echoes of the Ancestors*. London: Penguin, 1993.

Southern, Eileen. *The Music of Black Americans: A History*. 2nd ed. New York: Norton, 1983.

Stamberg, Susan. "Denied a Stage, She Sang for a Nation." National Public Radio, April 9, 2014. https://www.npr.org/2014/04/09/298760473/denied-a-stage-she-sang-for-a-nation.

Story, Rosalyn M. *And So I Sing: African-American Divas of Opera and Concert*. New York: Amistad, 1993.

Strickland, Lloyd. "How Western Philosophy Became Racist." *IAI News*, January 10, 2019. https://iai.tv/articles/the-racism-of-the-western-philosophy-canon-auid-1200.

Stuchtey, Benedict. "Colonialism and Imperialism, 1450–1950." European History Online, January 24, 2011. http://www.ieg-ego.eu/stuchteyb-2010-en.

Suna-Koro, Kristine. "The Ecstasy of Lament: Opera as a Model of Theology." *Theology Today* 63.1 (2006) 66–87.

Terrell, JoAnne Marie. *Power in the Blood? The Cross in the African American Experience*. Bishop Henry McNeal Turner/Sojourner Truth Series in Black Religion. Maryknoll, NY: Orbis, 1998.

———. "Ten Tenets of Art, Episode 1." *Shift of the Gaze: Arθeology for Our World*. Interview by Michael Kimpan. Podcast. n.d. https://soundcloud.com/user-236115806/ten-tenets-of-art-episode-1.

———. "Ten Tenets of Art, Episode 3." *Shift of the Gaze: Arθeology for Our World*. Interview by Michael Kimpan. Podcast. n.d. https://soundcloud.com/user-236115806/ten-tenets-of-art-episode-3.

———. "Ten Tenets of Art, Episode 5." *Shift of the Gaze: Arθeology for Our World*. Interview by Michael Kimpan. Podcast. n.d. https://soundcloud.com/user-236115806/ten-tenets-of-art-episode-5.

———. "Ten Tenets of Art, Episode 8." *Shift of the Gaze: Arθeology for Our World*. Interview by Michael Kimpan. Podcast. n.d. https://soundcloud.com/user-236115806/ten-tenets-of-art-episode-8.

Thomas, Linda E. "Anthropology, Mission and the African Woman: A Womanist Approach." *Black Theology* 5.1 (2007) 11–19.

———. "Remember and Re-Member." *Journal of Supervision and Training in Ministry* 14 (1992) 241–52.

———. *Under the Canopy: Ritual Process and Spiritual Resilience in South Africa*. Studies in Comparative Religion. Columbia: University of South Carolina Press, 1999.

———. "Womanist Theology, Epistemology, and a New Anthropological Paradigm." *Cross Currents* 4 (1998) 488–99.

Tillich, Paul. "Art and Society." In *On Art and Architecture*, edited by John Dillenberger and Jane Dillenberger, 11–41. New York: Crossroad, 1989.

———. "Art and Ultimate Reality." In *On Art and Architecture*, edited by John Dillenberger and Jane Dillenberger, 139–57. New York: Crossroad, 1989.

———. "The Demonic in Art." In *On Art and Architecture*, edited by John Dillenberger and Jane Dillenberger, 102–18. New York: Crossroad, 1987.

———. "Fine Art and Architecture." In *On Art and Architecture*, edited by John Dillenberger and Jane Dillenberger, 204–13. New York: Crossroad, 1987.

Till, Nicholas. "The Operatic Event: Opera Houses and Opera Audiences." In *Cambridge Companion to Opera Studies*, edited by Nicholas Till, 1–22. Cambridge: Cambridge University Press, 2012. https://www.researchgate.net/publication/292498073_The_operatic_event_Opera_houses_and_opera_audiences.

Tindley, Charles Albert. "Stand by Me." *Songs of Zion, Supplemental Worship Resources*, edited by J. Jefferson Cleveland and Verolga Nix, 41. Nashville: Abingdon, 1981.

Tommasini, Anthony. "Opera? Musical? Please Respect the Difference." *New York Times*, July 7, 2011. https://www.nytimes.com/2011/07/10/theater/musical-or-opera-the-fine-line-that-divides-them.html.

Townes, Emilie M. "Womanist Theology." https://ir.vanderbilt.edu/bitstream/handle/1803/8226/TownesWomanistTheology.pdf?sequence=1.

Turner, Victor Witter. *The Anthropology of Performance*. Performance Studies Series. New York: Paj, 1988.

———. *From Ritual to Theatre: The Human Seriousness of Play*. New York: Paj, 1982.

———. *The Ritual Process: Structure and Anti-Structure*. New Brunswick, NJ: Aldine Transaction, 1969.

Uebersax, John. "Anamnesis." http://www.john-uebersax.com/plato/words/anamnesis.htm.

UNESCO. "Performing Arts (Such as Traditional Music, Dance and Theatre)." Intangible Cultural Heritage. https://ich.unesco.org/en/performing-arts-00054.

Upstander Project Editors. "Doctrine of Discovery." Upstanderproject.org, n.d. https://upstanderproject.org/firstlight/doctrine.

Verdi, Giuseppe. *Un Ballo in Maschera (The Masked Ball): An Opera in Three Acts*. https://www.metopera.org/discover/synopses/un-ballo-in-maschera/.

Volbrecht, Christy. "Cultural Trauma and Collective Identity." January 6, 2013. https://www.slideshare.net/christyvollb/cultural-trauma-and-collective-identity.

Walker, Alice. *In Search of Our Mothers' Gardens: Womanist Prose*. Orlando: Harcourt Brace Jovanovich, 1983.

Walters, Delores M. "Margaret Garner." In *The Encyclopedia of Emancipation and Abolition in the Trans-Atlantic Word*, edited by Julius P. Rodriguez, 1:244–45. New York: M. E. Sharpe, 2006.

Waugh, Alexander. *Opera: A New Way of Listening*. New York: Stewart Tabori and Chang, 1996.

Weisenburger, Steven. *Modern Medea: A Family Story of Slavery and Child-Murder from the Old South*. New York: Macmillan, 1999.

White, Clarence Cameron, and John Frederick Matheus. *Ouanga: A Haitian Opera in Three Acts*. 1939.

Whitney, Craig R. "Porgy and Bess in Austria: A Long Way from Catfish Row." *New York Times*, August 25, 1997. https://www.nytimes.com/1997/08/25/theater/porgy-and-bess-in-austria-a-long-way-from-catfish-row.html.

Williams, Delores S. "The Color of Feminism: Or Speaking the Black Woman's Tongue." *Journal of Religious Thought* 43.1 (1986) 42–58.

———. "Hagar in African American Biblical Interpretation." In *Hagar, Sarah, and Their Children: Jewish, Christian, and Muslim Perspectives*, edited by Phyllis Trible and Letty M. Russell, 171–84. Louisville: Westminster John Knox, 2006.

———. "Rituals of Resistance in Womanist Worship." In *Women at Worship: Interpretations of North American Adversity*, edited by Marjorie Walton and Janet R. Proctor-Smith, 215–23. Louisville: Westminster John Knox, 1993.

———. *Sisters in the Wilderness: The Challenge of Womanist God-Talk*. Maryknoll, NY: Orbis, 1993.

———. "Womanist Theology." In *Women's Visions: Theological Reflection, Celebration, Action*, edited by Ofelia Ortega, 112–26. Geneva: World Council of Churches, 1995.

———. "Womanist Theology: Black Women's Voices." *Christianity and Crisis* 47.3 (March 2, 1987) 66–70.

———. "Women's Oppression and Lifeline Politics in Black Women's Religious Narratives." *Feminist Studies in Religion* 1.2 (1985). http://www.fsrinc.org/article/1135/.

Williams, Sybil R. "The American Minstrelsy: Remembering Africa, Birthing America." Signature Theater, n.d. https://www.sigtheatre.org/scottsboro/the-minstrel-show-in-the-scottsboro-boys/the-american-minstrelsy-remembering-africa-birthing-america/.

Yancy, George. *Reframing the Practice of Philosophy: Bodies of Color, Bodies of Knowledge.* Albany: State University of New York Press, 2012.

Yesterday's America. "How American Theater Has Prevailed through History." *Yesterday's America* (blog), 2013. https://www.arcadiapublishing.com/navigation/community/arcadia-and-thp-blog/july-2018/how-american-theatre-has-prevailed-through-history.

Yudell, Michael. "A Short History of the Race Concept." In *Race and the Genetic Revolution*, edited by Sheldon Krimsky and Kathleen Sloan. New York: Columbia Scholarship Online, 2011. https://doi.org/10.7312/columbia/9780231156974.003.0001.

Index

Dunbar-Ortiz, Roxanne, 70
Dussel, Enrique, 12, 59, 63, 65

E

Elvin, Mark, 62
enslavement, 7, 14, 16–17, 20, 26,
 63–64, 92, 94, 115, 135–36, 161,
 178. *See also* slavery
Environmental Genocide, 59
Environmental Poverty, 12, 68, 82
epistemic violence, 72, 76
epistemology, 4, 7, 12, 40, 49–53, 55, 82
Era of Great Terror, 28
ethnology, 9, 125
eurocentrism, 29–30, 41, 61–63, 129
European Enlightenment, 28, 41
Exceptionalism, 17–18, 26

F

feminist, 7, 9–10, 12, 31, 34, 43–48, 56
First Nations Peoples, 135
fourth wall, 126, 177–78
Frej, Willa, 43
Fugitive Slave Act, 159
Fugitive Slave Law, 159

G

Garner, Margaret, 1–2, 5–6, 13, 54, 87,
 90, 92, 94, 127–32, 155, 158–82,
 188, 192, 228–31, 233
gaze of God, 12, 81, 101, 105
Gemmill, Mickey, 69
genius, 13, 103, 125, 135–36. *See also*
 Black genius
genocide, 17, 24, 30, 58–59, 64, 68–70,
 78
glocal, 49–50
Gonzalez, Anita, 49, 65
Graves, Denyce, 6, 113, 120, 130, 151,
 154, 163, 228
Greenfield, Elizabeth Taylor, 89, 115,
 149–51, 157
Gyekye, Kwame, 31, 39, 56

H

Haithman, Diane, 110
Harrison, Faye, 47
Hatcher, Evelyn, 97
Hegel, Georg, 28–30, 33, 41, 67, 135
hegemony, 17–18, 24, 37, 46, 50–51, 67,
 88, 114
historic imagination, 167, 170
historical amnesia, 4, 14, 16, 18, 26, 163,
 176
Hitler, Adolf, 19–20, 22, 26, 110
Holmes, Barbara A., 5, 12, 84–87, 92–93
Hospers, John, 96
Hyers, Anna, 150
Hyers, Emma, 150

I

Ickes, Harold, 138, 218
identification, 119, 125, 133
Imago dei, 25
Imperializing Texts, 34–35, 89
Indian Removal Act, 17, 70
Indigenous Environmental Network, 71
Indigenous knowledge, 4, 74
Indigenous people, 4, 17–18, 23, 25, 35,
 51, 61, 63–66, 68, 71
Indigenous returning, 133
infanticide, 160–62, 175
Insurrection, Capitol, January 6, 2021.,
 15, 19
invasion, 16–17, 25, 33, 61, 66–67,
 69–70, 81, 89
invisible ink, 89

J

Jackson, Andrew, 17, 70, 206
Jarboro, Caterina, 150–51, 157
Jesus, 16, 18, 22, 24, 26, 79, 81, 83, 170,
 172, 176. *See also* Christ
Jim Crow, 7, 142–43, 156, 178. *See also*
 New Jim Crow
Johnson, E. Patrick, 52, 54, 70
Johnson, James Weldon, 140, 156

Printed in the USA
CPSIA information can be obtained
at www.ICGtesting.com
LVHW092045181124
796982LV00002B/92

* 9 7 8 1 6 6 6 7 7 2 2 5 8 *